VISIONS
— OF —
MUSIC

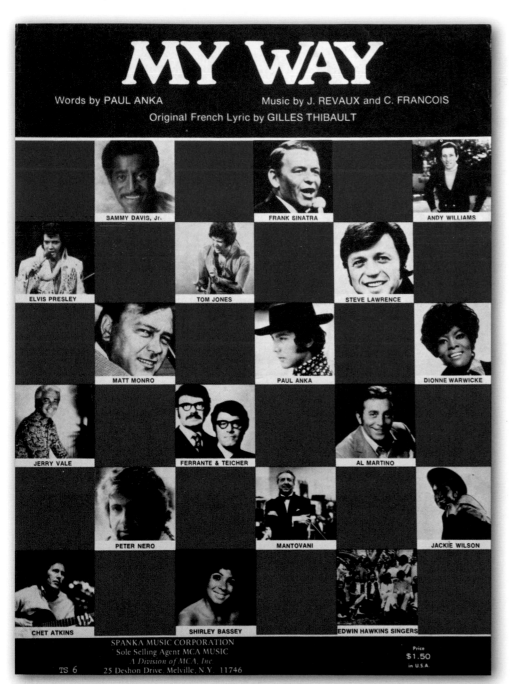

My Way (1968)

From Sammy and Frank, to Elvis and Mantovani, to Andy Williams and Shirley Bassey, a multitude of performers, as seen on the sheet music cover, have recorded this dramatic song "their" way. It was based on an existing French song, but given original English lyrics by Paul Anka, who wrote them with Frank Sinatra in mind. The theme of having lived well with few regrets has universal appeal, and the combination of a singable melody with meaningful lyrics and a strong performance equals great hit potential. Songs like this have always been the mainstay of the printed music industry.

VISIONS

OF

MUSIC

SHEET MUSIC
IN THE
TWENTIETH CENTURY

TONY WALAS

Hal Leonard Books
An Imprint of Hal Leonard Corporation

Published in 2014 by Hal Leonard Books
An Imprint of Hal Leonard Corporation
7777 West Bluemound Road
Milwaukee, WI 53213

Trade Book Division Editorial Offices
33 Plymouth St., Montclair, NJ 07042

All sheet music is from the author's personal collection.
Printed in the United States of America

Book design by Damien Castaneda

Library of Congress Cataloging-in-Publication Data

Walas, Tony.
 Visions of music : sheet music in the twentieth century / Tony Walas.
 pages cm
 Includes bibliographical references.
 ISBN 978-1-4803-8738-6
1. Sheet music--United States--History--20th century. 2. Popular
music--United States--History and criticism. I. Title.
 ML3477.W33 2014
 780.26'309730904--dc23
 2014034664

www.halleonardbooks.com

CONTENTS

VII *Preface*

IX *Acknowledgments*

XI *Prelude*

1 PART ONE: SHEET MUSIC IN THE TWENTIETH CENTURY, 1900–49

3 Playing the Intro

7 A New Century: Fresh Sounds, Dance Fads, and the Latest Inventions

25 Age of the Illustrators: Love, Loss, and a Sense of Fashion

49 Vaudeville and Broadway: Early Popular Entertainment

67 Roaring Through the Twenties: Music in the Air and on the Screen

85 Into the Thirties: Swinging Out of the Depression

105 Forging Through the Forties: War and Recovery

129 Patriotism and War

147 Novelty Songs: Just for Fun

163 PART TWO: SHEET MUSIC IN THE TWENTIETH CENTURY, 1950–99

165 Playing the Changes

167 Into the Fifties: Ballads, TV, and the Birth of Rock 'n' Roll

191 Rockin' Through the Sixties: A Revolution in the Air

219 Introducing Diversity in the Seventies: New Trends and New Names

247 The Eighties and Nineties: A Splintering of Styles

275 Patriotism, Politics, and Protest

295 Novelty Songs: Just for More Fun

317 *Postlude*

319 *Bibliography/Sources*

PREFACE

The idea for doing a book slowly started to surface from my brain about five years ago. At that point, I had been collecting sheet music for more than twenty-five years and had amassed over four thousand titles (currently it's closer to five thousand). All are safely stored away—individually inserted into archival sleeves and then deposited in archival storage boxes, arranged by size (oversize or regular), category (popular music or show/movie/TV material), and decade. Yes, I am a self-admitted geek when it comes to this. I've always lived by the motto "A place for everything, and everything in its place."

It dawned on me that there were quite a few fascinating and fun covers among my collection, but no one would ever get to see them but me. That didn't seem right. Thus I began traveling the long and sometimes winding road that would lead me down the path to the book you hold in your hands.

Music is meant to be heard. Yet there is a whole subculture of the music industry that has always existed that is solely devoted to the production of music on the printed page: sheet music. In the world of antiques, sheet music is classified under the category of "ephemera," which are printed or paper items that were originally expected to have only short-term usefulness or popularity, according to the Wikipedia dictionary. The fact that so many of these old music titles have survived at all is astonishing, probably due more to the sheer quantities produced than any conscious effort for preservation.

Looking at these increasingly fragile artifacts from the past reminds us of our history—social and political as well as musical.

Songwriters and composers wrote about what they saw in the world around them, reflecting the values and prejudices of the time, and presenting their outlook on the human condition.

Sheet music is something to be used, yet also a thing to be saved and visually enjoyed. The covers can give us a keen insight into the world as it was, and they reflect the passage of time, a world long forgotten. It is the memories and history they invoke that transcend the music they contain.

It's only when we stop and examine these covers that we can truly appreciate the artistic elements of style that were used to promote the sale of this sheet music. We need to connect with these pieces from the past, and preserve them, before we lose the remarkable perspective, the visual delight, the colorful history that they represent.

The existence of printed music is an aspect of our popular culture that is fading away from our awareness, but one that deserves to be remembered and treasured. This book is a visual time capsule of the progression and evolution of sheet music in the twentieth century. But even more, it is a "vision," not just of music, but of us.

The selection you see is meant not as a complete history but merely a sampling of the highlights of my collection, with a little background included.

I hope you enjoy it.

Tony Walas
May 2014

ACKNOWLEDGMENTS

This book has been a labor of love for me, though at times it felt like I was attempting one of the labors of Hercules. However, there are some people without whose help I could not have completed the task.

First and foremost is my wife, Cindy. Many, many thanks to her, for everything. Not only is she a musician (as am I), but she also worked for a time in the print music department of a large music store in Chicago, so she "understands" sheet music. Our shared interest in music, and thankfully similar tastes, made it easier for me to share my enthusiasm with her. Her support throughout my long years of collecting enabled me to acquire the various titles necessary to do this book. The willingness she has shown, allowing me to take over an extra bedroom in order to store my prized collection, gave me a place to work from. In writing the text for this volume, I could always rely on her help and feedback in organizing my thoughts into a relatively coherent presentation. Her great eye for technical detail, along with her ability to proofread and make specific suggestions, has enabled me to make this a better volume.

I am strongly indebted to Marion Short for her five wonderful volumes on collectible sheet music (see bibliography). Her books opened my eyes to the tremendous variety of published titles from the early part of the twentieth century, and educated me as to many of the names and personalities involved with them. They showed me that I was not alone in my appreciation of the beauty and evolution of American popular sheet music.

Thanks to Keith Mardak, John Cerullo, and Carol Flannery at Hal Leonard—Keith for recognizing my "vision"; John and Carol for helping me clarify and expand that vision, and having the technical expertise, along with their staff, to bring it to reality as painlessly as possible for me.

Finally, I am grateful to all of those songwriters, musicians, artists, and illustrators, throughout the past century and more, who wrote the catchy music and imaginative lyrics and presented us with the eye-catching sheets. Without their creative efforts, the world would have been a poorer place.

Dedicated to musicians and artists everywhere, whether successful or struggling, and to those who appreciate and enjoy the work they do.

To quote the title from the 1973 hit by David Essex, "Rock On."

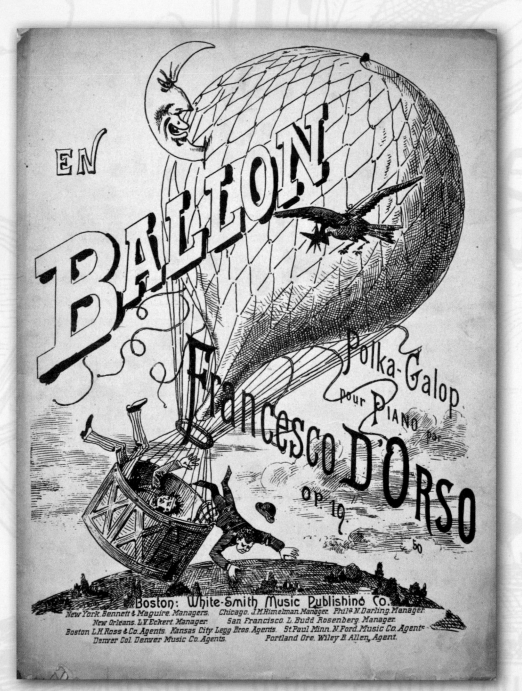

***En Ballon* (circa 1870)**
Humorous cover art depicting the dangers of lighter-than-air flight. The various problems to look out for: falling out of the basket, having a bird puncture the air bag, or running into the moon. Fantastic illustration meant to draw attention to the music and encourage sales.

PRELUDE

Vintage popular sheet music has two natures. Its primary function is to pass along the musical ideas of a composer, which is the actual transcription of a composition. A secondary feature, and the main one for collectors, is the visual impact of the cover itself. The individual artwork designed to promote and sell that title, the photo of the performer or composer, and the slice of history that the cover represents—all are aspects that make sheet music important and collectible.

We have to backtrack and look at the legacy of sheet music in the few decades before the turn of the twentieth century to fully appreciate the changes to come. It is necessary to understand the relative importance of sheet music in that era. There were no recordings, no radio or TV; music needed to be heard or played *live*. This was the only way to hear the newest tunes. Sheet music provided the means to do that. It truly was the life blood of the music industry, and it would help establish the songs and the stars with the general public. It was product and advertising, all rolled into one.

In the period between the Civil War and 1880, popular sheet music was limited in scope. It was mainly descriptive piano pieces on battle subjects, patriotic melodies, minstrel show and folk tunes, and sentimental ballads. Sheets would have ornate lettering and ornamentation, though at times a design or illustration could be used. The covers were basic and functional, generally in black and white. Most importantly, there was little promotion done on the part of publishers to sell or market the titles to the public.

This was still a time when Victorian-era morality continued to have a strong influence on lifestyles, even in America. The main themes of Victorian popular music were home, children, mothers, romanticized love, and loss. The trend was toward very sentimental ballads with predictable story lines, tending towards "tear-jerkers." Contemporary issues were generally not addressed, leading to a repetitive and stilted form, with generally mediocre results. In spite of that, they sold very well. The songs seemed to complement the spirit of the times.

Current events and special occasions were also prime subjects for sheet music.

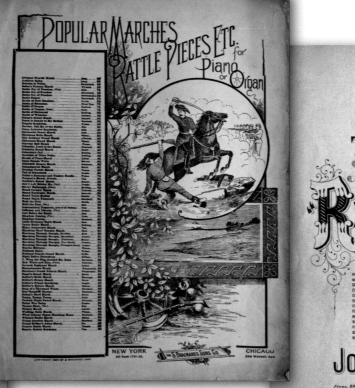

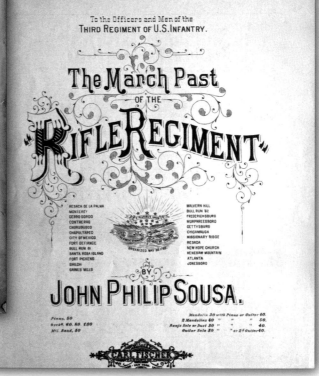

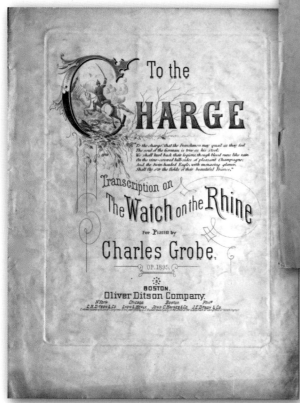

Popular Marches/Battle Pieces, Etc. . . . **(1866)**
Looking back to the Civil War. This particular piece is for the Battle of Manassas, with an elaborate engraving illustrated by Harrell.

March Past Of The Rifle Regiment **(1886)**
John Philip Sousa, famous for his marches, wrote and dedicated this piano piece to the "Officers and Men of the Third Regiment of U.S. Infantry." It lists the important battles they were in and the unit's motto.

To The Charge **(1870)**
Charles Grobe did this variation of the German national hymn at the time, called the "Watch On The Rhine." Traditional look and theme to this lithograph.

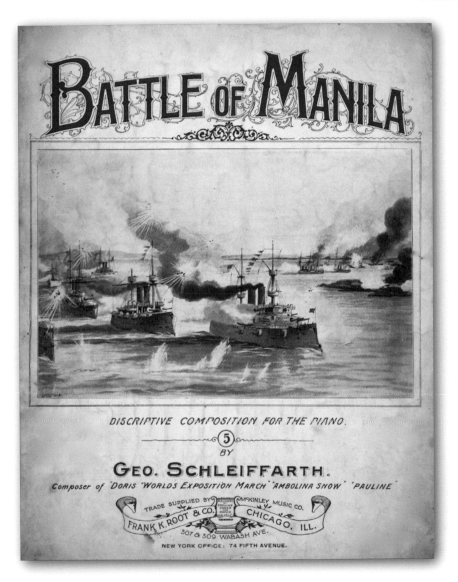

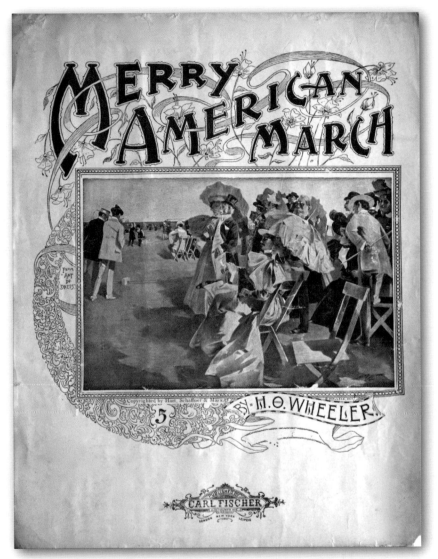

Battle Of Manila (**1898**)
Celebrating the American naval victory by Admiral Dewey during the course of the short Spanish-American war in 1898. It was a dramatic international incident, and was one of our first foreign entanglements. The battle lasted just a few hours, with only nine Americans wounded. Exciting image of steaming American warships pictured with exploding shells and ships on fire.

Merry American March (**1897**)
Depiction of elegantly dressed couples at the beach. Men wearing fancy suits and hats with women in long, puffy-sleeved dresses, sitting on wooden chairs. Copy by Hart, Schaffner and Marx, the famous clothiers. Not quite how we would picture a day at the beach today.

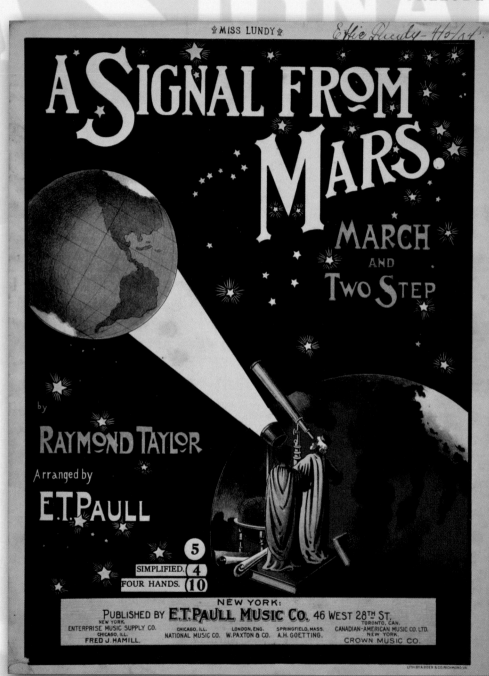

Signal From Mars (**1901**)
Dynamic E. T. Paull illustration showing the inhabitants of the Red Planet observing Earth and signaling with a spotlight. The public fascination at the time about potential life on Mars led the author Edgar Rice Burroughs to serialize stories about it in *All-Story Magazine* in 1911. These later became famous as his John Carter on Mars "Barsoom" books.

As the end of the nineteenth century drew near, a few serendipitous things happened. Beginning around 1880, a rising tide of popular songs and pieces—generated by the songwriters in residence at New York's growing music district, called Tin Pan Alley—came into existence. The composers, many of whom were music publishers as well, initially produced more of the standard melodramatic ballads and marches, as well as comic novelty numbers. However, they soon became more open to other influences, both social and cultural. Songs were now being written to appeal to the public's taste. These start-up music publishers were the first to have an eye for business and an ear for music. Songwriters took inspiration from events in the news, as well as absorbing and spreading the new music sounds that evolved from the black minstrel shows—namely, the "cakewalk." It was a strutting dance step that formed the basis of a syncopated music style that would fascinate the public for the next few decades: ragtime. Most importantly, these publishers aggressively promoted their material, sending out "song pluggers" to get exposure for the music through performers in shows and theaters around the country.

In 1894, publisher E. T. Paull Music Company, along with their printer, Hoen and Company Lithographers, developed new printing processes that allowed them to inexpensively create unique full-color illustrations on sheet music covers. The piano pieces, with their attractive appearance, caught the public's attention, and sales took off.

This was a turning point for the evolution of sheet music. The success convinced other publishers to provide sheet music with more eye-catching artwork and dynamic color—grabbing attention, giving a visual stimulus, and encouraging sales.

The timing was perfect. People were ready for a change, and there was a large, untapped market for new songs. This is when the music *business* really got started. Sales did so well that it was not uncommon for a single sheet music title to sell over a million copies in the 1890s. It didn't take long for some advertisers to see the potential of this vast audience. The popularity of sheet music was such that, for a while, a few companies gave away free music with product advertising on the back—an early example of corporate sponsorship for music.

A trend started as more design elements, and even a sense of humor, was introduced. Sheets became more personable, appealing, and even charming, entering the new century. Not only was the whole look of sheet music altered, but also the subject matter of songs went through a drastic change. This was an obvious indication of what was happening in the country, which would carry over into the new twentieth century.

Sheet music had become a well-accepted part of life by the turn of the century. A colorful new appearance, new themes and subjects more relevant to everyday life, and a host of emerging songwriters set the stage for what would be a golden age of sheet music to come.

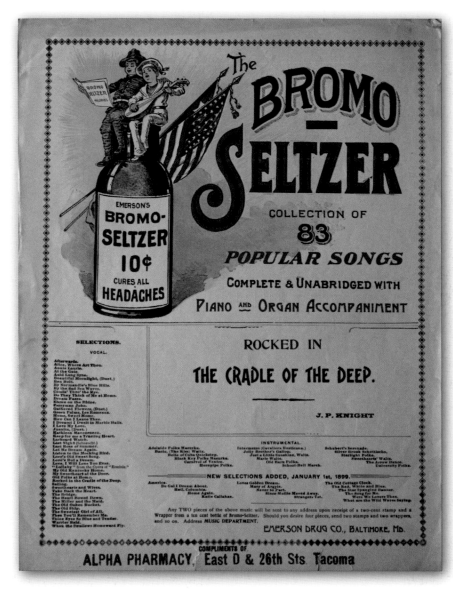

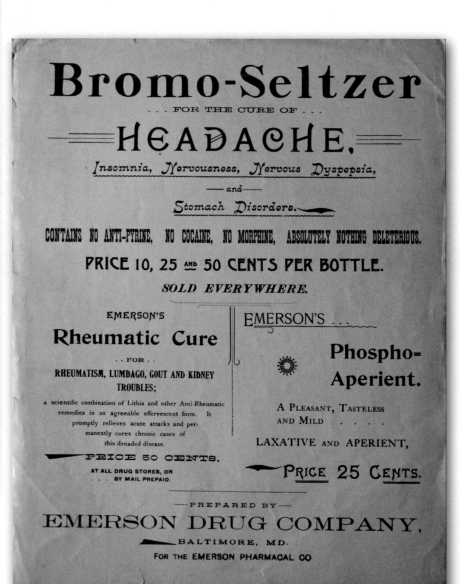

Bromo Seltzer/Rocked In The Cradle Of The Deep (1899)
Promotional piece printed by Emerson Drug Company and stamped "Compliments of Alpha Pharmacy." Text on the back tells potential customers, "contains no anti-pyrine, no cocaine, no morphine, absolutely nothing deleterious."

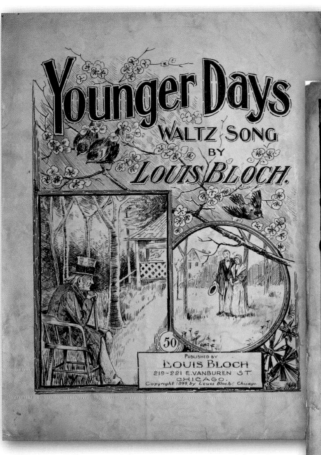

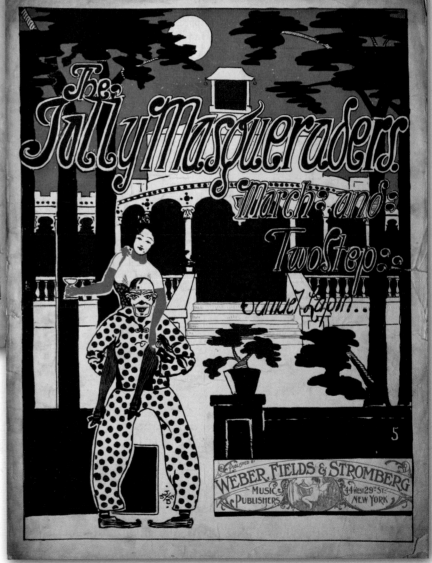

Younger Days (1899)

A smartly dressed elderly man contemplates the past. Looking back from old age, he remembers the good days that are gone, and looks forward to meeting up with his "loved one" after death. Still a very Victorian subject for a popular song.

Jolly Masqueraders (1899)

A fairly risqué illustration of a corseted woman with a drink in hand, riding piggy-back on her costumed companion. Masquerade parties, a popular social function, were a chance for people to break away from convention and assume a different personality for a brief time.

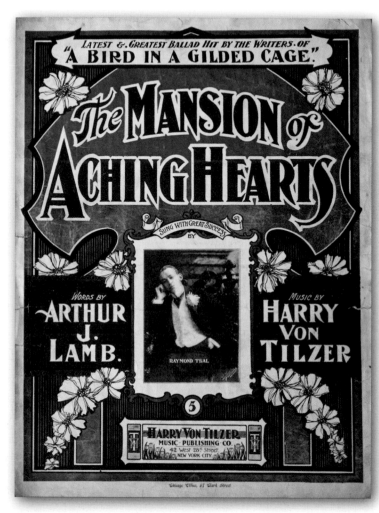

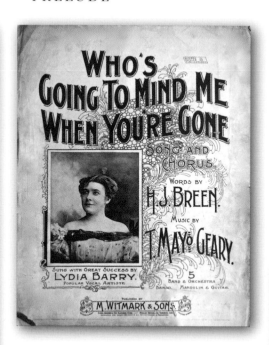

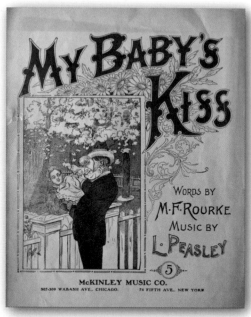

Who's Going To Mind Me When You're Gone (1898)
Listed as "Sung with great success by Lydia Barry—popular vocal artiste." The first refrain is sung from the perspective of a child who has already lost her mother, to her father as he goes off to war. The second refrain is from the father's viewpoint concerning his daughter's future, as he lies dying on the field of battle. The ultimate answer is . . . God.

Mansion Of Aching Hearts (1898)
Concerning a woman who pays the emotional price for choosing a life of wealth over true love. Written by the prolific composers Arthur Lamb and Harry Von Tilzer.

I Love You In The Same Old Way (1896)
A husband pledges his undying love at his wife's graveside. Sung by Maxwell and Simpson, in photo, with original illustration.

My Baby's Kiss (1896)
Illustration of a couple with a child on the cover. Tender lyrics by M. F. Rourke about a baby being a source of joy: *"There is nothing sweeter, better, than my baby's kiss."*

At A Georgia Camp Meeting (1897)

A scene of elegantly dressed blacks. Even though Frederick "Kerry" Mills was a white composer, his adoption and promotion of a traditional black dance style called "cakewalk" added a sense of respectability to the music. He soon helped make this sound more acceptable to a white audience, which in turn opened the doors for black composers.

This turn-of-the-century title became a best seller, previewing the syncopated sounds of the emerging ragtime music. It started a dance sensation for both young blacks and young whites around the country, causing the older generation some shock and dismay. This is a scenario that would be repeated a number of times over the next hundred years, as music changed and every new style was looked down on by the establishment and denounced. Some things never change.

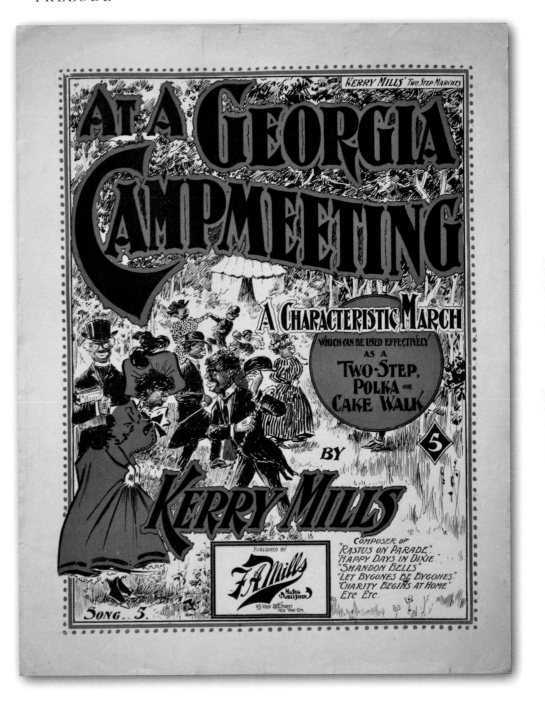

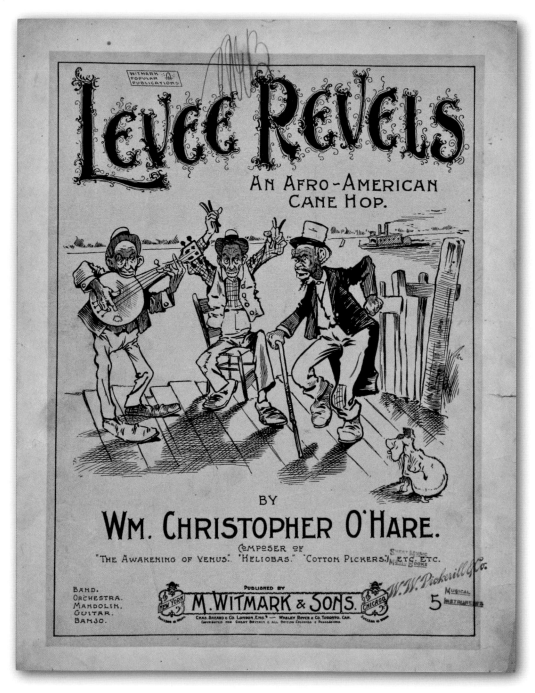

The foundation was laid. The next hundred years would show how the composers, publishers, and performers built upon this framework to create a vast body of music, reflecting all aspects of our society and culture. It was a catalog of songs and themes that became the true life blood of the American experience, and played an essential part in our relationship to each other and to the world.

Music is an inescapable part of our history, especially throughout the twentieth century. As individuals, we would play, sing, and dance to a range of beats never even imagined. As a country, we would be swept away by waves of the exciting new sounds to come. All of this, and more, can be seen by examining, enjoying, and appreciating the covers of the sheet music that was produced. They give us a literal, visual record of the music and the times—genuine "visions of music" if you will.

Sit back and relax . . . dim the lights . . . cue the music and enjoy. If you know the tune, feel free to sing along.

Levee Revels (1898)

Caricatures of three older blacks on the banks of a levee, with a riverboat in the background. One is playing the banjo, while another is keeping time with a pair of wooden rhythm bones, and the last is dancing while holding a cane. Amusingly, the scene is being observed by a small dog, scratching his ear. The subject of blacks in society would appear more and more on sheet music covers in the coming years, usually in the context of vulgar racial stereotypes that would be called "coon songs."

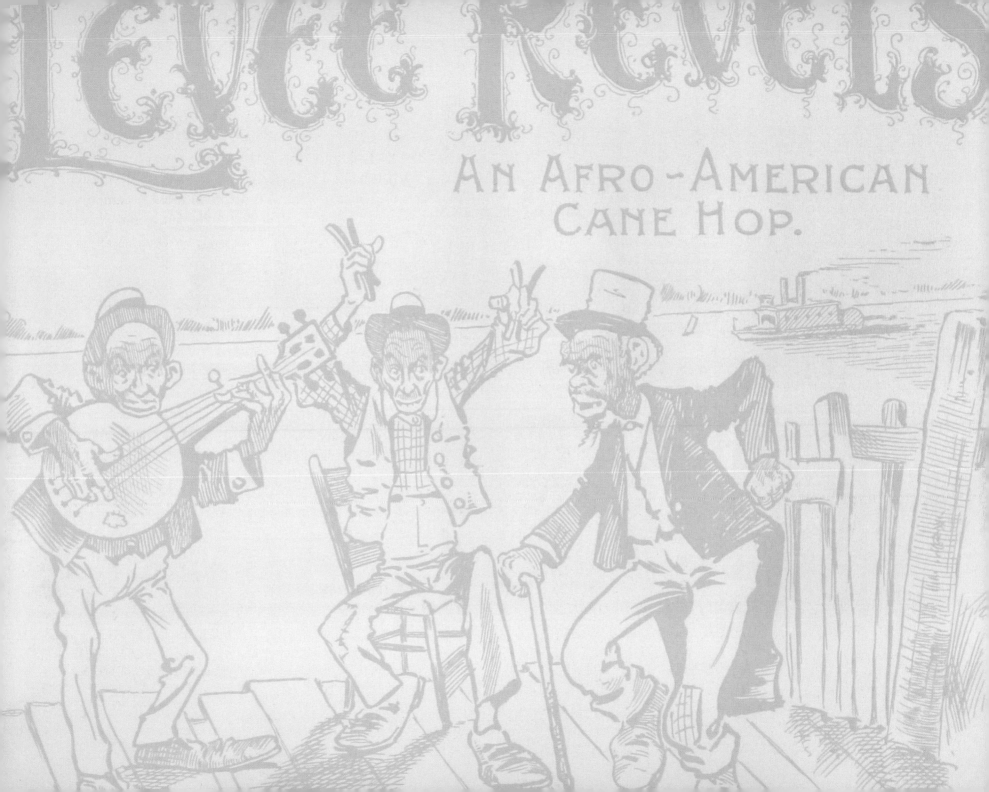

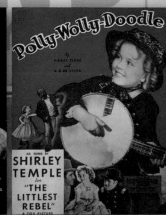
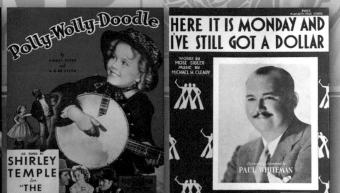
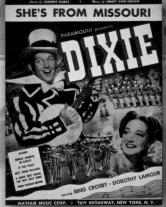
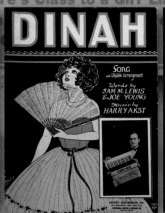

PART ONE

SHEET MUSIC IN THE TWENTIETH CENTURY

1900–49

NOTABLE SONGS, 1900-49

Summertime (1935)—George Gershwin

St. Louis Blues (1914)—W. C. Handy

Ain't Misbehavin' (1929)—Fats Waller

It Don't Mean A Thing (1932)—Duke Ellington

Alexander's Ragtime Band (1911)—Irving Berlin

Sweet Georgia Brown (1925)—Bernie, Pinkard & Casey

God Bless The Child (1941)—Billie Holiday

Jeepers Creepers (1938)—Mercer & Warren

If You Knew Suzie (1925)—DeSylva & Meyer

Shine On, Harvest Moon (1909)—Bayes & Norworth

Get Happy (1929)—Arlen & Koehler

Some Enchanted Evening (1949)—Rodgers & Hammerstein

I Want A Girl (1911)—Harold Von Tilzer

Minnie, The Moocher (1931)—Cab Calloway

I'm Just Wild About Harry (1921)—Sissle & Blake

Let Me Call You Sweetheart (1910)—Whitson & Friedman

Zip-A-Dee-Do-Dah (1945)—Gilbert & Wrubel

Yankee Doodle Dandy (1918)—George M. Cohan

Route 66 (1946)—Bobby Troup

Over The Rainbow (1939)—Harburg & Arlen

School Days (1907)—Cobb & Edwards

In The Mood (1940)—Garland & Razaf

Ain't We Got Fun (1921)—Whiting, Egan & Kahn

Heebie Jeebies (1926)—Louis Armstrong

Stompin' At The Savoy (1936)—Goodman, Sampson, Webb & Razaf

Old Man River (1927)—Hammerstein & Kern

In The Good Old Summertime (1902)—Shields & Evans

T'Aint Nobody's Bizness If I Do (1922)—Bessie Smith

Pennies From Heaven (1936)—Burke & Johnston

I Get A Kick Out Of You (1934)—Cole Porter

PLAYING THE INTRO

Long before all of our current distractions, music was *the* main entertainment focus in most every household. Pianos and instruments were common, and the study of music was encouraged as part of a well-rounded education. The ability to play music was an important aspect of social life. Families would gather around the piano and sing. It certainly was a "different" age.

The history of printed sheet music in the twentieth century is a reflection of the times themselves. In the first fifty years, music changed dramatically, along with society. Popular music would see radical changes in composition, lyrical content, even distribution. The overall look of sheet music would go through a set of changes accordingly. Because of paper shortages during the First World War, the actual size of sheets would be reduced starting around 1918, from the previous oversize 11 x 14 inches to our now standard 9 x 12 inches.

Starting with the emergence of a number of new styles of music, this musical transformation brought to the country the increased energy and distinctive sounds that were the hallmarks of American progress. During this time period, we saw ragtime, jazz, blues, swing, and early rhythm and blues all leading us down the path of musical exploration and experimentation. Everything was new and exciting.

At the same time, the development and awareness of popular songwriters, lyricists, and performers put a spotlight on the personalities themselves. Early sheet music would often put a photo of the artist or performer on the cover, giving many people their first view of him or her. Increased exposure to music through the inventions of the era (the phonograph, radio, and movies with sound) upped the ante even higher. Technology would alter how and where it was heard, and would influence the music as well. Put together as a whole, it was a period of constant transformation, growth, and evolution.

Sheet music played a significant part in all of this. In its heyday, "Millions of Copies Sold" was a standard line on many titles. Songs helped get us through "The War to End All Wars," Prohibition and the Roaring Twenties, the Great Depression, a Second World War. They were part of the social climate, and helped influence the thoughts and feelings of the general public. This wasn't to last forever, but for now, sheet music was king. Through these covers, we can not only appreciate our musical heritage but also glimpse a vision of our past—and learn more about ourselves. It's a very personal course in Music History 101.

SELLING THE SONGS

It's amusing to observe and record the over-the-top phrases used to promote sheet music of this era, especially between 1900 and 1930. It seems that the rules for truth in advertising were much more lax, or the desire to grab the attention of potential customers just led to some very *strong* statements.

These are the actual quotes found on the front and back covers of the music, sometimes referring to other songs in the publishers' catalog. It is in the grand tradition of publishers and imaginative copywriters everywhere . . .

From simple and straightforward lines:

"Try this over on your piano"
"New song sensation"
"Ask your dealer to demonstrate them"
"Copies for sale wherever music is sold"
"Should be in every home"
"On sale at all music stores"
"Be sure to get copies of these big song hits"
"Something new! Just off the press!"
"These songs may be obtained for your player piano or talking machine"

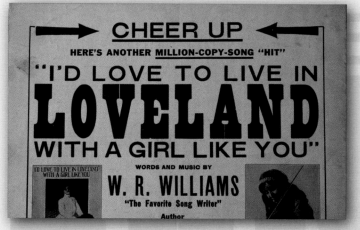

Close-up of back cover blurb.

To more influential phrases:

"A valuable acquisition to your music room"
"Some new numbers, sure to be popular"
"The up-to-the-minute song hit"
"Exceedingly effective for home and studio use"
"A song you'll love to play"
"You can't go wrong, with any 'Feist' song"
"Have you a copy of this big instrumental hit?"
"A wonderful haunting melody combined with a lilting lyric"
"Songs you should never forget"
"You always find a big singer behind a 'Mills' song"

"A new delightful song of charm and merit"
"No home is complete without a copy"
"Instantaneous song hit"
"If you like beautiful melodies, you'll like this song"
"A sensational song hit"
"Our latest popular successes"
"The novelty song hit of the season"
"You will want these numbers"
"The unexpected sensational dance craze"

And finally, to truly outlandish statements:

"The best song out—everybody says so"

"Cheer up, here's another million copy song hit"

"Sensation of the century"

"The most wonderful song ever written"

"Positively the greatest song for the home ever published"

"The sweetest and most appealing ballad written in years"

"Song hits that will live forever"

"This is the most talked of and the biggest selling song in America today"

"The greatest song of all times"

"A high class darkey song"

"The wonder song of the age"

"You ask for it—everybody likes it—you will buy it"

"The best song of its kind ever written in America"

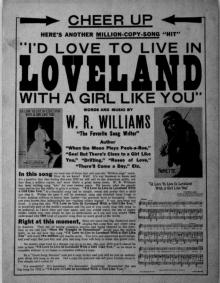

Remarkable copy from song sheet on left:

"In this song we have one of those that will pass the 'Million copy' mark. How do we know? Well! It's our business to know and it's a positive fact that during this year 1912 we will sell to the American public not less than a million copies, and most likely a great many more . . . a beautiful song and so simple, sweet and pretty that a child can sing it. Within the year, it will be hummed, sung and whistled from Coast to Coast, making millions of hearts beat lighter—the greatest boon to humanity. Have you ever known that indescribable joy—making others happy? If not, you have not lived. A song like this . . . is positively part of the world's sunshine and I'm sure if you could sing this song to an audience . . . and you could watch the sea of happy smiles before you, you would be just as enthusiastic as I am and you would *then* understand why *this* kind of popular song does so much good in the world. . . .

"It's wonderful! It's haunting! It's heavenly! Inspiring! Remember! the one big song for 1912 is **'I'd Love to Live in Loveland With a Girl Like You.'**"

SIX CYLINDER KID

IN MY

HAROLD HAWKINS

HAL. E. PARIS

GEO EVANS

INTRODUCED AND POPULARIZED BY

PARIS, HAWKINS & WELLS

BEN SHIELDS

A NEW CENTURY

FRESH SOUNDS, DANCE FADS, AND THE LATEST INVENTIONS

"Meet me in St. Louis, Louis,
Meet me at the fair,
Don't tell me the lights are shining,
Any place but there,
We will dance the Hoochee Koochee,
I will be your Tootsie Wootsie,
If you will meet me in St. Louis, Louis,
Meet me at the Fair"

Meet Me In St. Louis, Louis (**1903**)
Words and music: Andrew Sterling and
Kerry Mills

At the turn of the twentieth century, printed music was on the verge of dynamic growth. New music styles would develop, and creative inventions would carry these sounds to a wider audience more quickly than ever. The attention of the listening public would switch from the classical repertoire to a growing number of popular "crazes."

On April 30, 1904, the St. Louis World's Fair opened to celebrate the centennial of the 1803 Louisiana Purchase. It was a year late, due to delays in organization and construction, with the participation of forty-three (out of forty-five) US states and 62 foreign countries. The theme was

"innovations and inventions," and it celebrated a time of great optimism in the country. The fair ended up being a great success, attended by millions, and helped highlight the vast potential in our country. The American barons of industry were in full swing, and our nation was on the brink of tremendous change. Belief in "progress" was the underlying theme.

The World's Fair was traditionally a time and place where the general public could see and wonder at the newest ideas, inventions, scientific marvels, and cultures. At a time when access to information was severely limited, it was the best way to get exposure to these trends and bring that information back home.

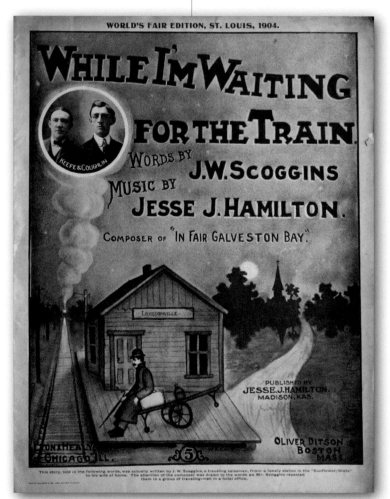

WORLD'S FAIR EDITION, ST. LOUIS, 1904.

WHILE I'M WAITING FOR THE TRAIN.

WORDS BY J.W. SCOGGINS

MUSIC BY JESSE J. HAMILTON.

COMPOSER OF "IN FAIR GALVESTON BAY."

PUBLISHED BY
JESSE J. HAMILTON.
MADISON, KAS.

OLIVER DITSON
BOSTON
MASS.

While I'm Waiting For The Train
(**1904**)
Song of a traveling salesman, from a station named "Lonesomville" to his wife at home. World's Fair Edition, St. Louis, 1904.

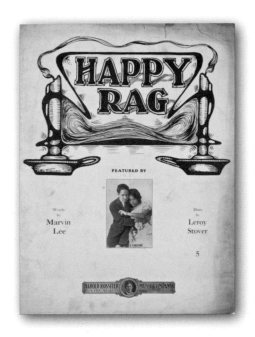

Happy Rag (**1910**)
Featured by the performing duo "Tempest & Sunshine."

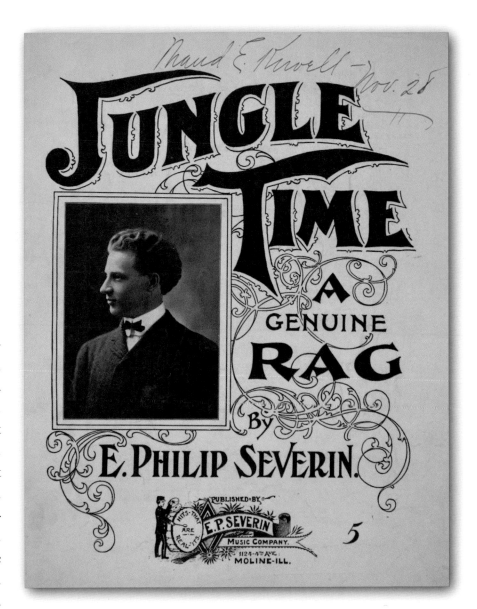

One of the key things that gained popularity at the Fair was ragtime music. It was featured prominently, with a visit by Scott Joplin, whom we now consider one of its greatest composers. He wrote a piece called "The Cascades" specifically for one of the attractions. Even though ragtime had originally appeared a few years earlier, it was given a tremendous boost in public interest because of the fair. This new music was heard in the right place, at the right time, and got the right exposure. America, and soon the world, became "rag" crazy.

The new century of music came in with the piano sounds of ragtime and its signature syncopated rhythm. Something different . . . enticing . . . fresh. Joplin was a key figure, but others jumped on the bandwagon. Rags were everywhere; everyone wanted to play them. Publishers couldn't print them fast enough. Sheet music sales boomed. Everyone and anyone began writing rags. Subjects were limitless. If it had the word *rag* in the title, it was almost a guaranteed success.

Jungle Time—A Genuine Rag (**1905**)
Written and published by E. Philip Severin, with decorative cover and great period photo of the composer.

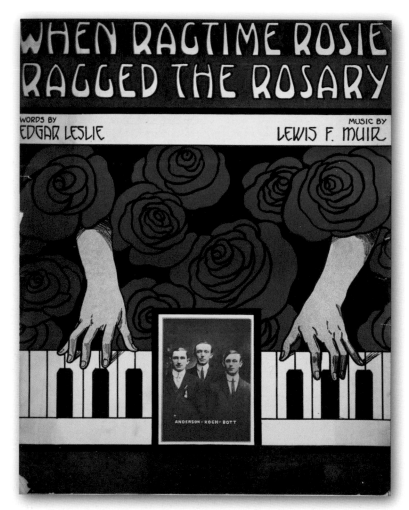

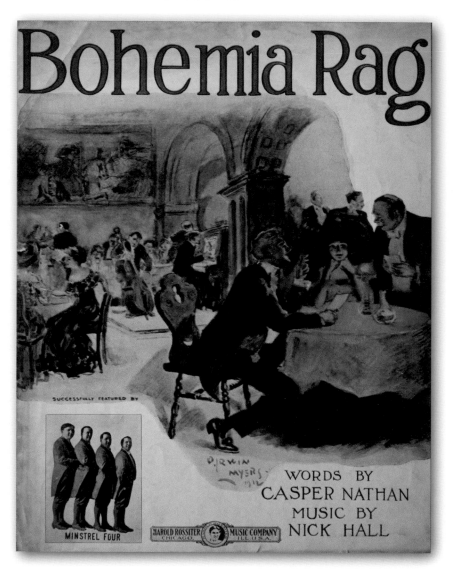

When Ragtime Rosie Ragged The Rosary (1911)
Before a service, Parson Lee finds out that his organist is missing and asks for volunteers from the congregation. Ragtime Rosie goes up and does a rousing ragtime version of "The Rosary," which was a well-known sacred tune at the time written in 1898 by Ethelbert Nevin. It shocks the parson, but gets the congregation up dancing and clapping like a revival. The parson finally gains control by reminding the people, *"This ain't no minstrel show."* Words by Edgar Leslie, music by Lewis F. Muir.

Bohemia Rag (1912)
Ragtime music was written to reflect on all aspects of life, even elegant café society: *"I've nothing to do till tomorrow, You've nothing to do today, so let's spend the time with music sublime."* Lyrics by Casper Nathan, with the music by Nick Hall. Note the musicians playing in the background. Photo of Minstrel Four.

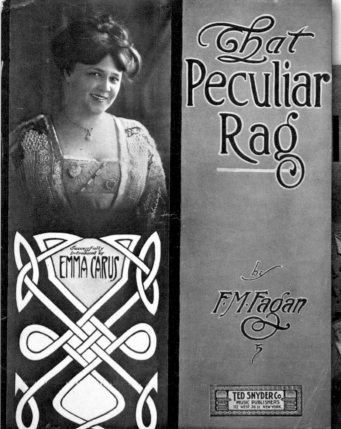

That Peculiar Rag
(1910)
Ragtime song, successfully introduced by Emma Carus, pictured on the cover.

That International Rag (1913)
Even the young Irving Berlin composed rags. He wrote "Alexander's Ragtime Band," his first huge hit, in 1911. Two years later, he came up with this song reflecting how many other countries are giving up their own traditional music in favor of ragtime, and saying that America is to blame. According to Berlin's lyrics, *"What did you do America . . . there's syncopation in the air, they've got the fever everywhere . . . the world goes 'round to the sound of the International Rag."* Here, Uncle Sam is conducting a chorus of people from around the world, singing from copies of this song. Interestingly, neither of his songs were written in a true ragtime style, but just used the terms. The Gypsy Countess in the photo. Cover by Pfeiffer.

A DEPLORABLE INTERLUDE

The study of history is a survey not just of highlights but of lowlights as well. One of the most shameful aspects of early sheet music is the portrayal of blacks on the covers, which definitely reflected the views of society at the time. There was a tradition of performers in blackface, which moved from the early minstrel shows into vaudeville, without an emphasis on racism. But for a short period in the beginning of the century, an interest in what were called "coon" or "darkey" songs became popular. It was a style of vocal song with crude, racist lyrics and demeaning covers relating to obvious and blatant stereotyping. This would be a difficult period, with only rare concessions to equality. Sheet music was an unfortunate mirror to this as well.

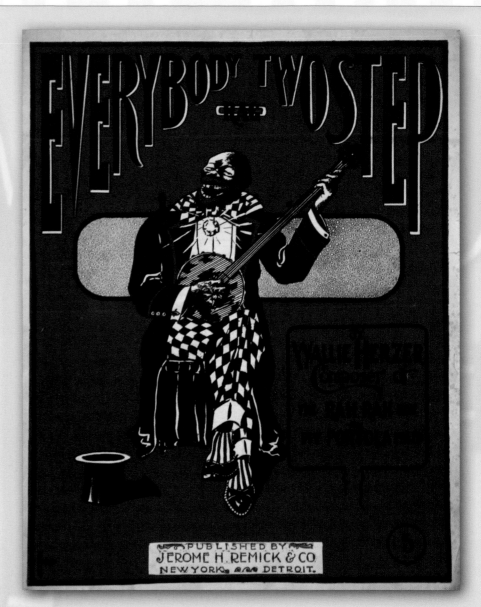

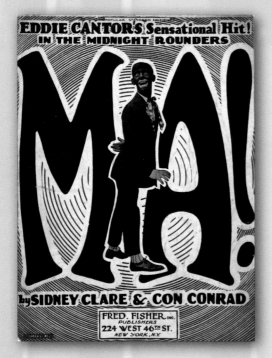

***Ma!* (1921)**
Eddie Cantor became famous for roles in blackface, as pictured on this cover with an over-sized title. Listed as his "sensational hit in the *Midnight Rounders*."

***Everybody Two Step Rag* (1910)**
Minstrel-show banjo player in an outlandish costume.

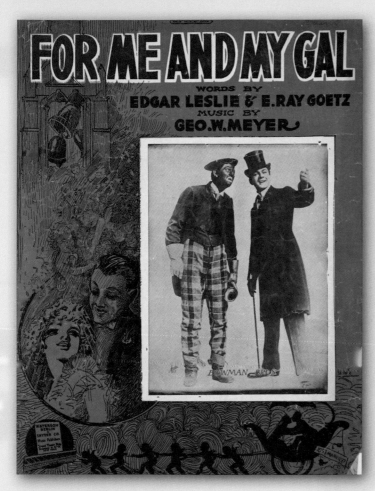

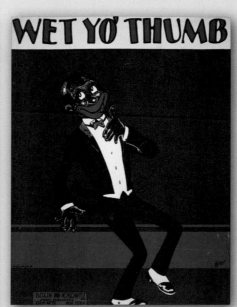

Wet Yo' Thumb (1923)
Caricature of a dancing black performer in a tuxedo. The lyrics have him explaining a new dance. It involves licking your thumb and moving your hand down your side and shaking it like a tambourine while strutting around. Illustration by Politzer.

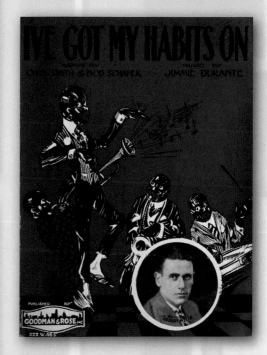

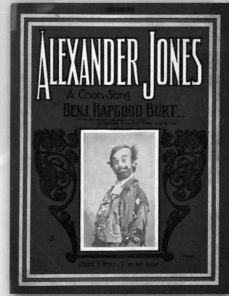

For Me And My Gal (1917)
Barbelle illustration of wedding bells, and a just-married couple seen in silhouette being pulled in a carriage by cherubs. Photo of a character in blackface, from a Bowman Brothers vaudeville skit.

Alexander Jones (1909)
Coon song with photo of vaudeville performer Nat Wills. Cover design by Starmer.

I've Got My Habits On (1912)
A black dancer performs in front of a group of jazz musicians. As to the habits he has, the lyrics go, *"Some folks got a habit for sleepin', some folks got a habit to snore, but I got a habit for just one thing, that's struttin' on a ballroom floor."* Lyrics by Chris Smith and Bob Schafer. Cover by Wohlman.

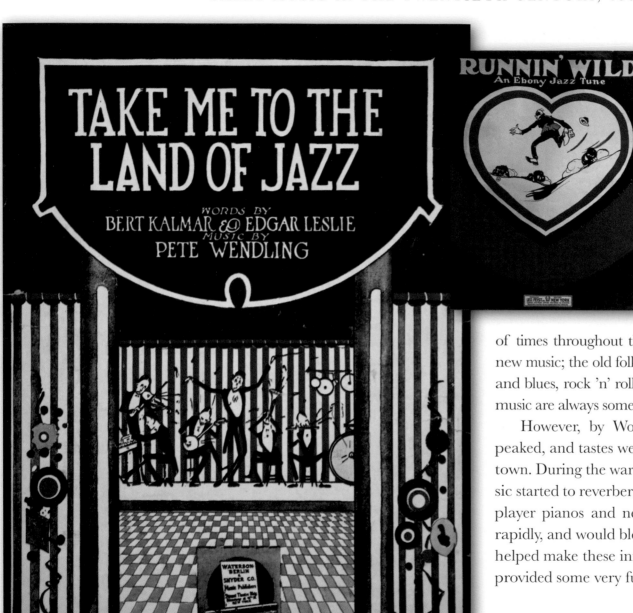

Runnin' Wild (1922)
A piece that would become a standard jazz tune with traditional jazz and Dixieland bands for decades.

Ragtime appealed to the public, and was listened to mostly by the younger generation. It was initially reviled and denounced by many people (mostly older), the serious music establishment, and religious leaders. This is the same scenario that would happen a number of times throughout the century. The young people loved the new music; the old folks hated it. Substitute jazz, swing, rhythm and blues, rock 'n' roll, rap—you get the idea. The changes in music are always something to annoy the older generation.

However, by World War I, the rush of ragtime had peaked, and tastes were changing. It wasn't the only game in town. During the war years, the tones of another type of music started to reverberate through households as well, on their player pianos and new phonographs: early jazz. It spread rapidly, and would bloom in the twenties. Again, sheet music helped make these innovative sounds accessible to all. Plus it provided some very fun-looking covers.

Take Me To The Land Of Jazz (1919)
The sound of jazz was taking the country by storm. Now everyone wanted to go hear it.

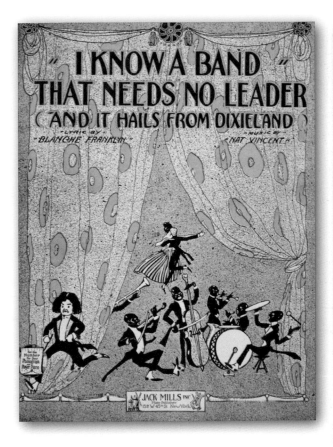

I Know A Band That Needs No Leader (And It Hails From Dixieland) **(1910)**
A vibrant black jazz band, drawn by Wohlman, is shown playing wildly. The white conductor, seen in the lower left, is pictured running away.

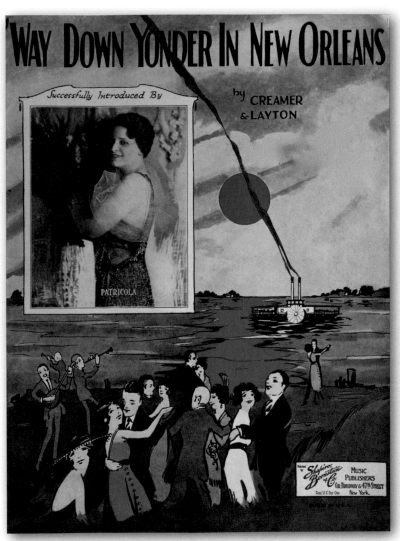

Way Down Yonder In New Orleans **(1922)**
An energetic scene with well-dressed people dancing to a trio of jazz musicians playing on the banks of the Mississippi. A paddlewheel steamboat passes by as the sun sets. New Orleans is considered the "birthplace of jazz" and was the origin of the name "Dixie," more commonly used to describe the South in general. Another Wohlman cover, with photo of Patricola, the singer.

The transition from coon songs and cakewalks to ragtime and jazz underlined the gradual, and sometimes grudging, acceptance of the ideas of black composers as valid music sources. In doing so, it also helped develop respect for black culture as a whole. More than almost anything else, this music gave people a chance to see beyond racial barriers. Acceptance is the first step on the long road to equality. It was only with the black influence that true American music was born, finally breaking from the old European traditions.

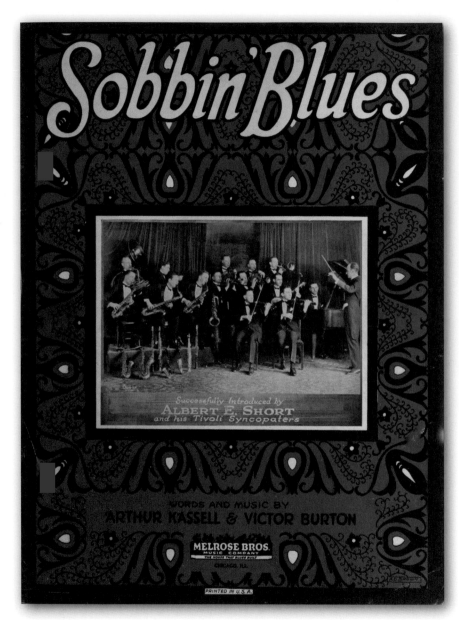

Sobbin' Blues (1923)
Photo caption reads, "Successfully introduced by Albert E. Short and his Tivoli Syncopaters."

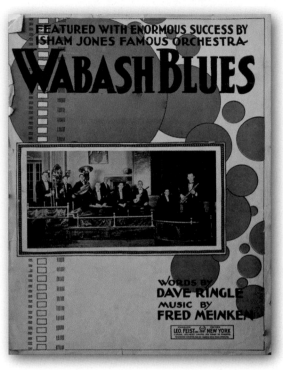

Wabash Blues (1921)
Featured with enormous success by the Isham Jones Famous Orchestra, seen in the photo.

Another black-influenced music style called "blues" gained national attention about the same time, due to the compositions of W. C. Handy. He became known as the "Father of the Blues," and he helped steer the course of music. Now, everywhere you went, there were bands playing the new popular jazz and blues titles.

On sheet music, photos identifying the groups gave people a chance to follow their favorites as the bands traveled or recorded. Theaters and clubs would promote themselves by featuring these bands. This would ultimately evolve in a decade or so into the big bands of the thirties.

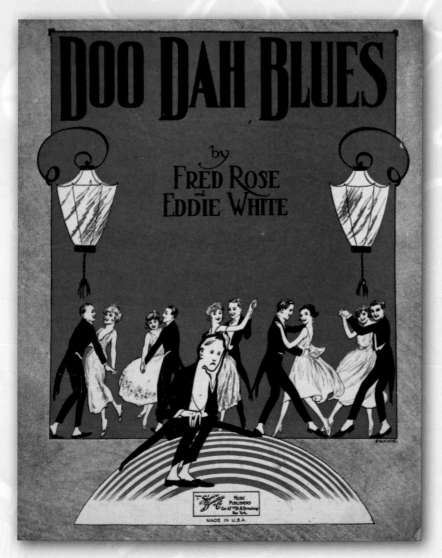

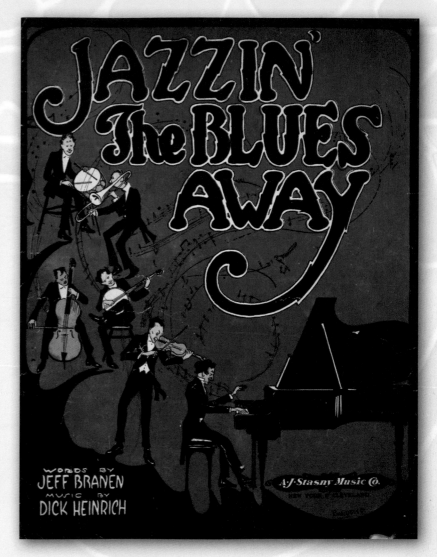

Doo Dah Blues (1922)

In the midst of a group of happy, dancing couples, a well-dressed man has the blues because *"Just only yesterday, my sweetie went away, I thought 'twas all in play, but when I heard her say 'Doo Dah, goodbye to you, Doo Dah, that means I'm thru.'"* He sits and wishes for her to return and rid him of this feeling. Great graphic by Starmer. Music and lyrics by Fred Rose and Eddie White.

Jazzin' The Blues Away (1918)

Using the words of Jeff Branen, *"Mister Jazz and his band, they sure do make you feel grand, my goodness how they can play, while with your baby you sway, they are jazzin' the blues away."* The song also mentions that jazz music *"fills you with pep."* Barbelle artwork has the music notes swirling around in the air, creating an overall dynamic feeling.

Tizzy Wizzy (**1904**)
The two-step was a particular style of dance move. Very busy-looking cover, with circles and ornate designs.

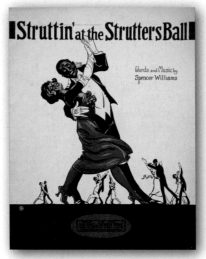

Struttin' At The Strutters Ball (**1922**)
Early version of a dance contest: *"You should have seen Miss Lizzie Brown, dressed in a green Parisian gown, lookin' snappy, feelin' happy, shakin' from the shoulders down . . . When the band begins to play, with that prize we're gonna walk away."* Famous composer of the time Spencer Williams wrote the words and music, with pairs of strutting couples featured on the cover. The two people in the foreground show an obvious sense of enjoyment with their performance.

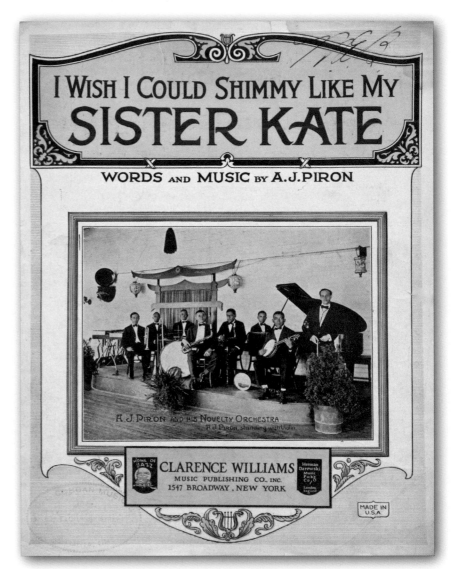

During the first quarter of the century, a rapid succession of new dances was introduced that would sweep the country. Among them was the Shimmy, Fox Trot, Black Bottom, One Step, and Two Step—and of course, the Charleston. Dancing was *the* social activity of the era. People had to have the latest new hits to play, sing, and dance to at home.

I Wish I Could Shimmy Like My Sister Kate (**1922**)
Doing the shimmy involved a woman shaking her upper torso by alternating her shoulders forward and back rapidly while holding her arms down and to the side. For the times, it was considered a somewhat scandalous dance. Pictured is A. J. Piron and His Novelty Orchestra, which became the best-paid black band in New Orleans.

Here's a selection of sheet music covers, highlighting the new dancing craze. It's also interesting to note that dancing was a very formal occasion, with men in tuxedos and women in fancy gowns. People really got dressed up for this recreational ballroom dancing.

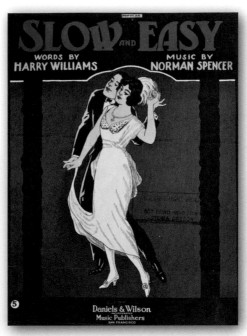

Slow And Easy (1919)
The lyrics by Harry Williams have the couple complaining that their feet hurt because of new shoes. The only way they can continue dancing is to *"take it slow and easy."* Any further interpretation of the words is up to you . . .

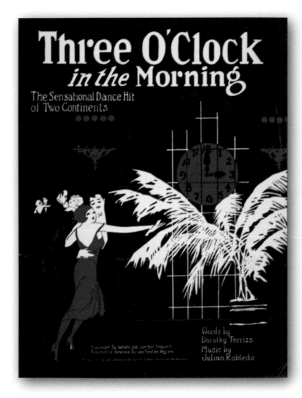

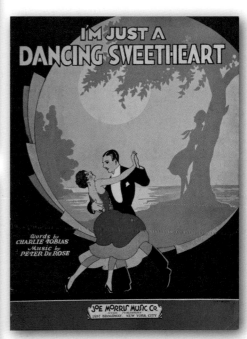

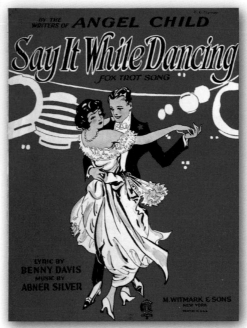

Three O'Clock In The Morning (1922)
A song about dancing through the night till 3 a.m. and still wanting *"one more waltz with you,"* at least according to Dorothy Terriss, who wrote these words.

Say It While Dancing (1922)
The perfect time to tell someone you love them.

I'm Just A Dancing Sweetheart (1931)
Young woman goes dancing with many men but fails to find her true love. She is tired of the fact that, in spite of these partners, she hasn't connected with the right man. In the black-and-white background, she sees herself alone.

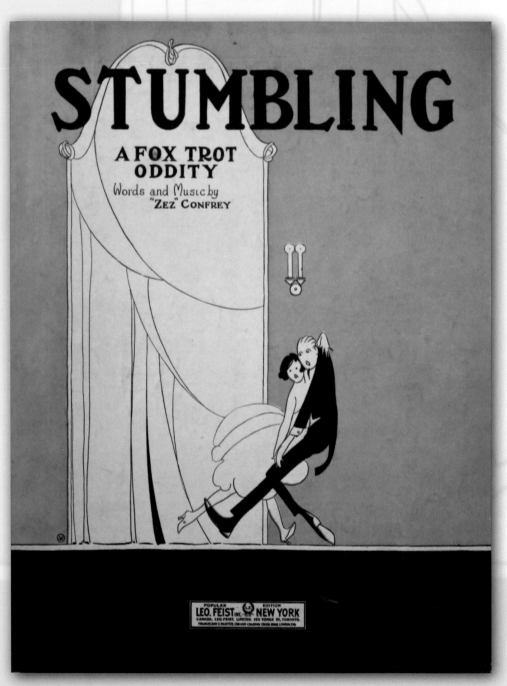

Stumbling (1922)

A tongue-in-cheek song that pokes fun at the strange dance steps that were all the rage. Available in both vocal and instrumental arrangements, the song version describes a dancer who constantly stumbles around the dance floor, stepping on his partner's toes and falling down. While doing so, he tries to convince her that his actions are really just the latest dance step. Even the description "A Fox Trot Oddity" is cleverly matched to the piece. Wonderful artwork on the cover seems to catch the action perfectly, especially the expressions on the couple's faces. Zez Confrey became famous for his novelty pieces for piano, particularly "Dizzy Fingers" and "Kitten On The Keys."

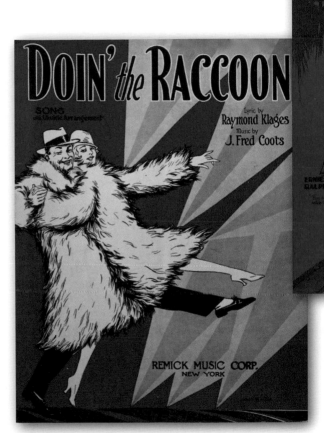

Jing-A-Ling-A-Ling (**1925**)
She thinks about the haunting melody she can't get out of her head. Shadow figures in the background show the band and dancers. The song is described on the cover as a "Jingling Fox Trot Song."

Crazy Rhythm (**1923**)
The lyrics of the song imply that dancing to the rhythm of hot jazz gives the same effect as having a drink, and since jazz is not banned, Prohibition is pointless. Dynamic cover with rays of light fanning out among some traditional jazz instruments.

Doin' The Raccoon (**1923**)
The big trend for male college students was wearing oversized raccoon coats. Of course, there had to be a dance. Here, a couple share a coat while doin' the Raccoon.

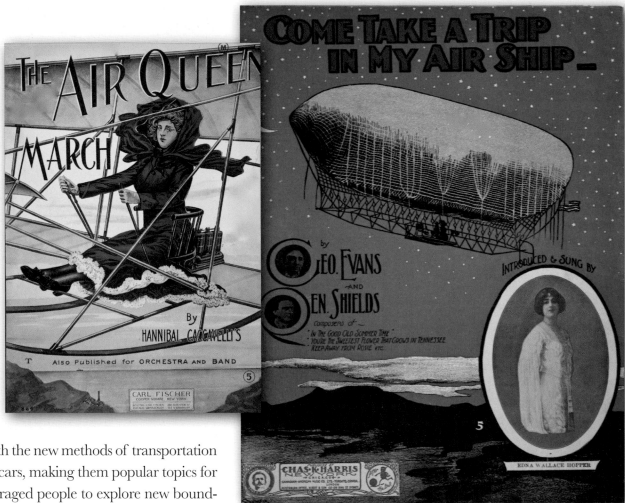

Air Queen March (1912)
A woman at the controls of an early airplane, wearing highly impractical attire.

There was great fascination with the new methods of transportation like airships, airplanes, and motor cars, making them popular topics for songs. These travel options encouraged people to explore new boundaries and opened up areas of independence, especially for women, who by the end of the second decade would finally get the vote.

As our nation continued to grow and change, it is clear that music helped to spread the hopes, dreams, and fads of a nation poised to become the most influential country in the world. Sheet music shows us how it happened.

Come Take A Trip In My Air Ship (1904)
Even though it was written a year after the Wright Brothers' first flight, the song shows that lighter-than-air ships were still considered an acceptable means of flying, with the incentive of "*No one to watch while we're kissing, no one to see while we spoon, come, take a trip in my air ship, and we'll visit the man in the moon.*" The composers Geo. Evans and Ren. Shields wrote this song, along with the standard "In The Good Old Summer Time."

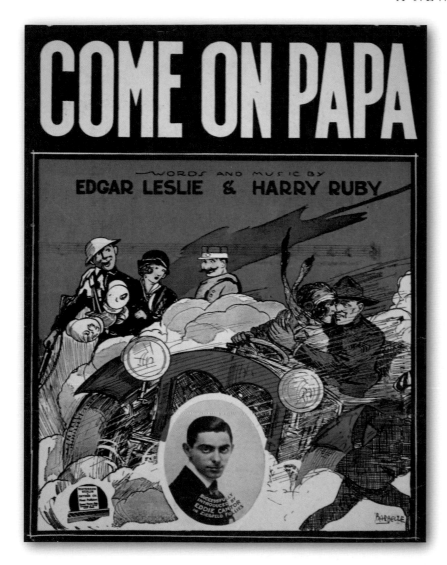

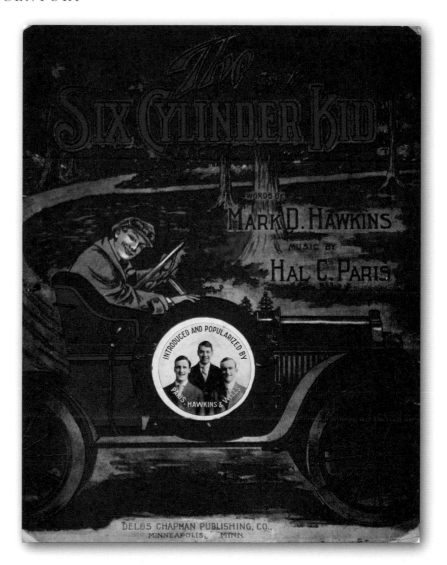

Come On Papa (1918)

World War I–themed song by the composers Edgar Leslie and Harry Ruby, in which a French woman picks up and flirts with American soldiers: *"Sweet Marie, in gay Par-ee, had a motor car, it filled her heart with joy, to drive a Yankee boy."* She drives quickly, scattering pedestrians and sending up clouds of dust. The chorus goes, *"Come on papa, hop in ze motor car, sit by mama, and hold ze hand."*

Six Cylinder Kid (1909)

According to the lyrics by Mark Hawkins, he was *"Dressed up in goggles, he felt like a king, as he steered the machine he would sing, I'm a dandy, all the candy, the real Six Cylinder Kid."* Unfortunately, the song ends with him racing a train and crashing, but crawling from the wreck, still singing the song. Photo of performers cleverly placed inside of the spare tire.

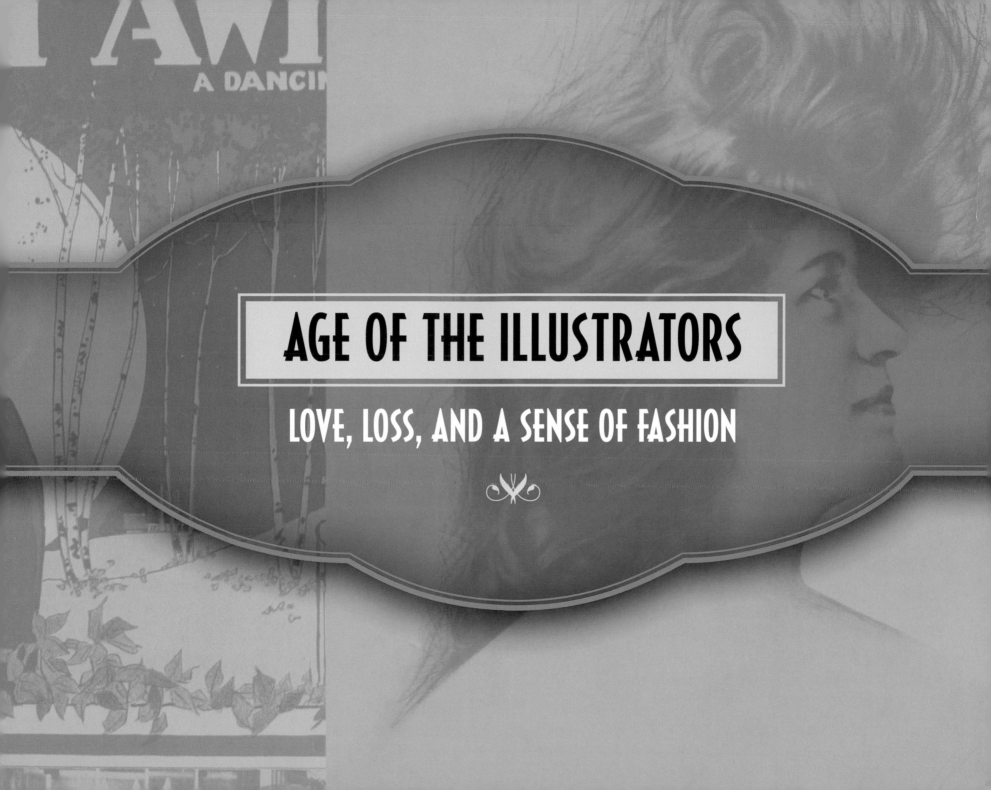

AGE OF THE ILLUSTRATORS

LOVE, LOSS, AND A SENSE OF FASHION

"Oh! You beautiful doll,
You great big beautiful doll,
Let me put my arms around you,
I could never live without you"

Oh, You Beautiful Doll! (1912)
Words and music: Seymour Brown and Nat Ayer

The golden age of sheet music illustration was roughly from 1900 to the mid-1930s. During that stretch, the output and quality of the art produced for the covers was exceptional. With the music business being very competitive, visual interest and attractiveness were key elements of sheet music sales.

Many times it was a staff artist on the publisher's payroll who churned out the beautiful covers as needed. Or it could have been a freelance person, just doing a job on commission. Over the course of time, certain illustrators became prolific, and generated such popularity that they would even sign the cover artwork itself. Each developed a *style* that became identifiable. The influences of the decorative art nouveau movement early on and of the later art deco style, characterized by bold outlines and streamlined forms, was often seen on the sheet music covers.

A number of extremely talented artists emerged. Names like Starmer, Barbelle, Pfeiffer, Leff, Takacs, and Harris produced hundreds of beautiful covers during this period. Their covers are sought after by collectors, who value the great craftsmanship that went into their design. Some illustrators became household names, and their popularity alone probably sold many sheet music titles that otherwise would not have had success. In this instance, music and art went hand in hand.

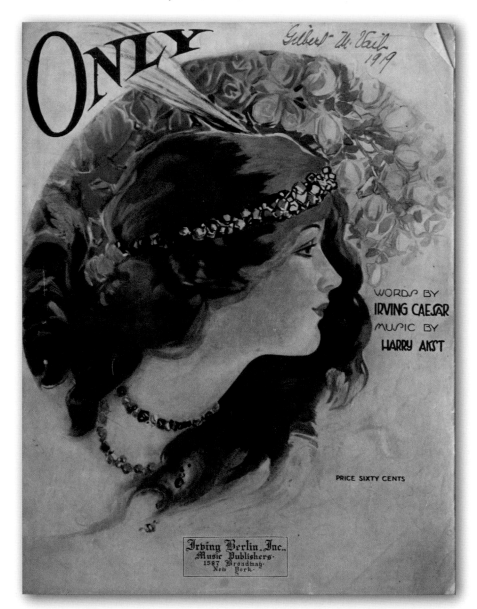

Only (1919)
Gorgeous portrait of a young woman with flowing hair held back by a fashionable jeweled headband, by an unknown artist.

Portraiture, especially of women, has always been a favorite subject of artists. It's no surprise that a fair number of sheet music titles were graced with female images. Having these produced as illustrations to promote the sale of songs just adds to the overall enjoyment, appreciation, and delight. These songs were not just music but also true American art.

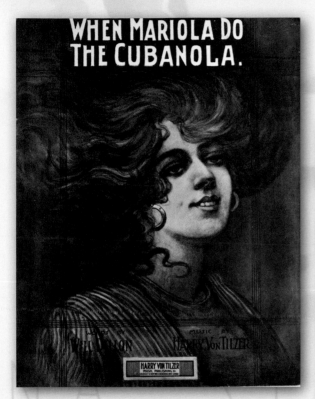

When Mariola Do The Cubanola (1910)
The Cubanola Glide was a dance step introduced in 1909 by this same composer, Harry Von Tilzer. In this song with words by Will Dillon, Mariola starts to do the dance with a mesmerizing effect on those around her: *"When she glide, glide, you heart-a she's a touch-a, ev'ry little movement has meaning very much-a, Salome she cry, and say-a goodbye, when Mariola do the Cubanola."*

Please Save The Last Dance For me (1905)
An extravagant hairstyle dominates this very lifelike portrait by Henrich.

That's Love (1934)
Smoldering cigarette . . . smoldering look. Exquisite rendition of Anna Sten in her American debut in the movie *Nana*, based on Zola's famous novel of the boulevards and music halls of Paris.

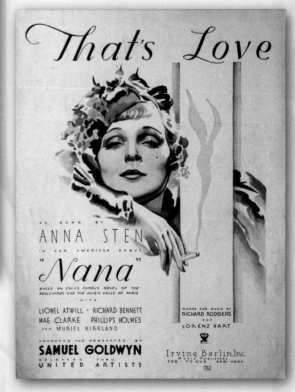

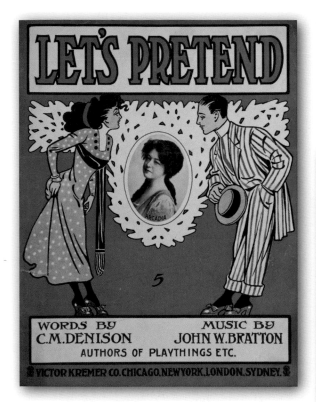

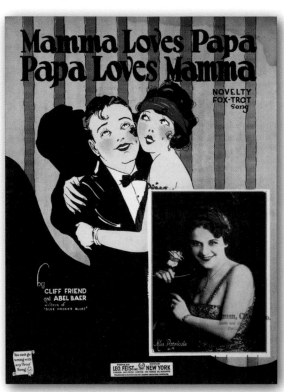

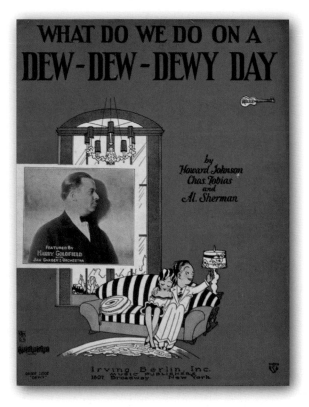

Mamma Loves Papa, Papa Loves Mamma (1923)
According to the couple, they are happy because they both love doing the same things, such as hugging and squeezing to begin with. Must be infatuation. Photo of a smiling Miss Patricola.

Let's Pretend (1910)
The characters Bess and Joe dream about being rich, having a big mansion, and being in love. They realize at the end that they'll be happy with *"just a dollar or two, and a cottage with you, with just love to rule our hearts away."* Words and music by Denison and Bratton. Pictured is the performer Arcadia.

What Do We Do On A Dew-Dew-Dewy Day (1927)
When it starts to rain and he can't leave, he has a plan. Some of the options he offers her are kissing, cuddling, and turning off the lights. After her folks decide to stay home as well, they really don't know what to do.

Love has always been a universal subject for all of the arts, especially music. The relationship between men and women has remained a constant source of material for songwriters throughout the ages. These pieces from the early part of the twentieth century are remarkably amusing and imaginative.

One look at the subjects, the sentiments, the concerns gives us a unique insight into the times. These were songs that displayed a feel for the human condition. Some were serious. Many were light-hearted and upbeat but meaningful nonetheless. Even a sense of humor was apparent.

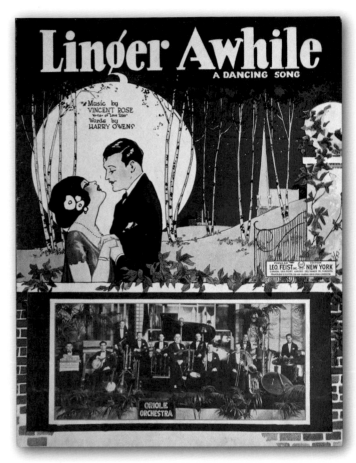

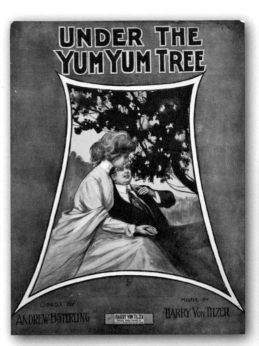

Under The YumYum Tree (1910)

A loving couple, finding the perfect location. *"That's the Yumiest [sic] place to be, when you take your baby, by the hand, there'll be something doing down in Yum Yum land, that is the place to play, with your honey, and kiss all day, when you're all by your lonely, you and your only."* Lyrics by Andrew Sterling.

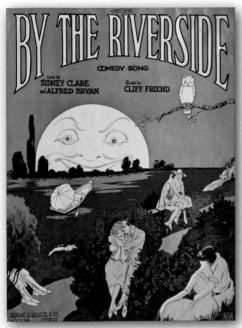

Linger Awhile (1923)

Gazing into each other's eyes, this couple seems clearly in love. They try to delay parting until the very last moment, because time seems like an eternity when they are apart. Large photo of the Oriole Orchestra. Cover by JVR.

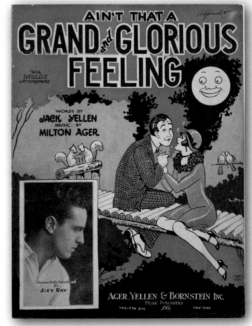

By The Riverside (1922)

Beneath a large, smiling moon, these couples make the most of their time, with a winking owl looking down on them. Starmer illustration.

Ain't That A Grand And Glorious Feeling (1927)

Another smiling moon . . . another couple in love . . . another Barbelle cover. It's all about the wondrous effect that love has on people. Their pose is reflected by the wildlife in the background. Joey Ray in photo.

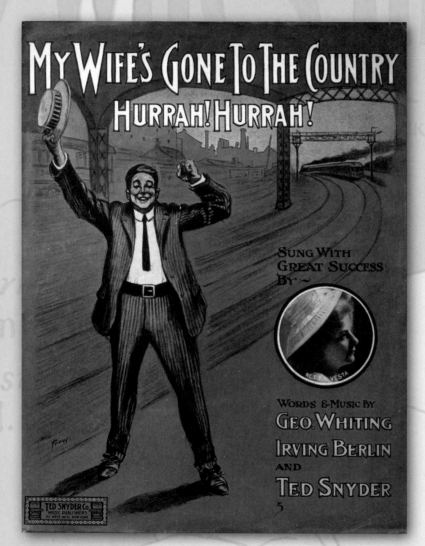

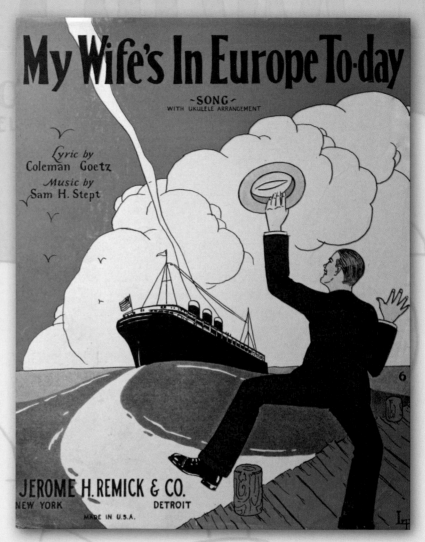

My Wife's Gone To The Country Hurrah! Hurrah! (1909)
With his wife's train receding into the distance, a well-dressed husband shows ela-
tion over her departure on this cover by Frevy. The song goes on to relate his activi-
ties afterward with a total of six verses, each followed by the chorus: *"She thought it
best, I need a rest, that's why she went away, she took the children with her, Hurrah! Hurrah!, I
don't care what becomes of me, my wife's gone away."* It's not good to be that obvious these
days. Words and music by the trio of Geo. Whiting, Irving Berlin, and Ted Snyder.

My Wife's In Europe To-day (1927)
A cover with the same theme and a similar look, almost two decades later.
This song goes on for five verses, listing his thoughts and actions. He
goes out every night without fear of being found out; he quits his job and
doesn't complain about his money running low, because he knows he's
had fun. What she will say when she returns might be another matter . . .
Illustration by Leff.

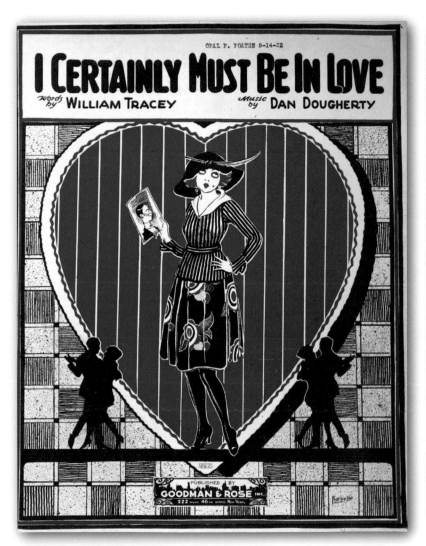

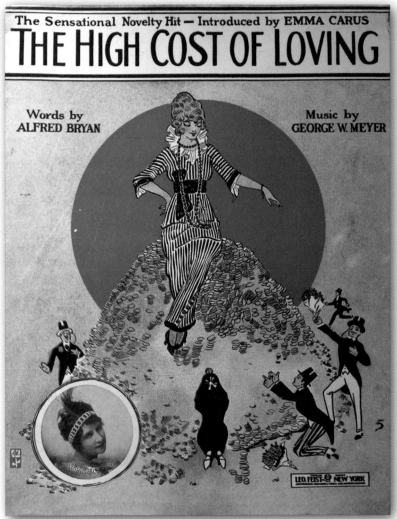

I Certainly Must Be In Love (1922)

Amazing visual use of stripes and lines on the sheet music cover by Barbelle, broken only by the floral pattern on her skirt. The young woman is framed by a heart, while her facial expression and posture tend to cast doubt on the subject of her affection. *"Mamie McShane was a dumb, dizzy dame, that lived over on First Avenue, she couldn't be beaten, for dancin' and eatin', those two things were all that she knew."* Words by William Tracey.

The High Cost Of Loving (1914)

With well-dressed, wealthy men surrounding her and trying to get her attention, the woman sits on a huge stack of their money. *"Each night they'd linger around cabarets, she could spend money in ten different ways, after each drink, or a moment later, all of his change, she would tip the waiter."* From the male perspective, *"Every Mary and Jane, want to bathe in champagne, so I'll have to stop loving a while."* Advertised as "the sensational novelty hit—introduced by Emma Carus," with words and music by Alfred Bryan and George Meyer. Morine Coffey is pictured, wearing a feathered headband.

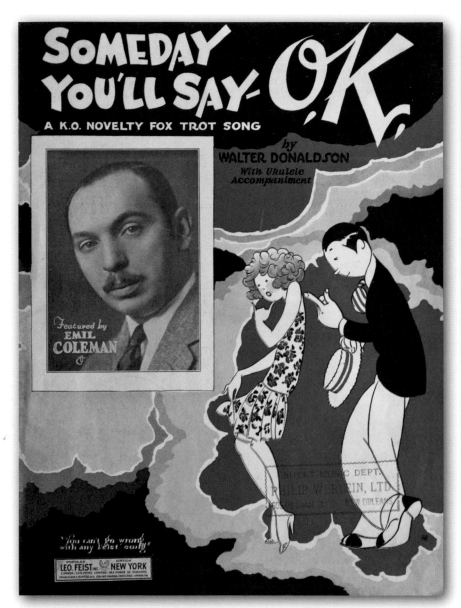

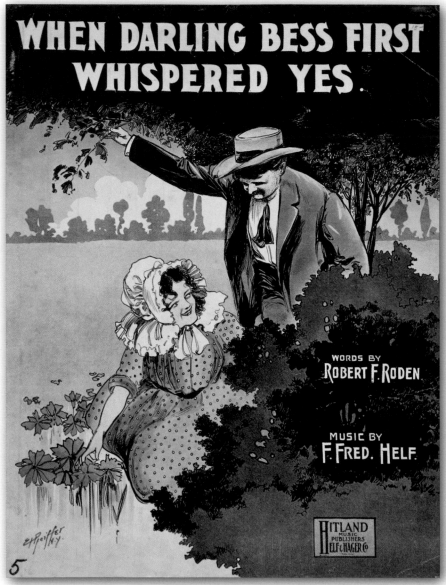

***Someday You'll Say—O.K.* (1927)**
Another stylishly dressed couple. He is very persistent about winning her affection, and warns her that he will never give up, so she should just relent. Large photo inscribed "Featured by Emil Coleman."

***When Darling Bess First Whispered Yes* (1908)**
In the lyrics by Robert Roden, a man reminisces about how the *"sweetest of life's golden days comes back to me."* With the Pfeiffer illustration showing the couple coming out from behind the bushes, the only question is what did she say yes to?

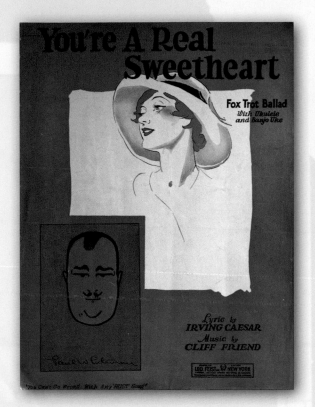

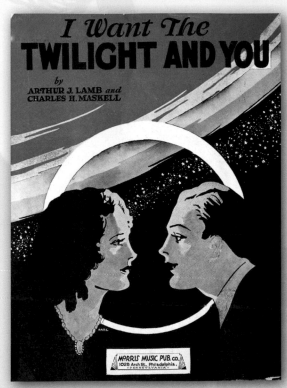

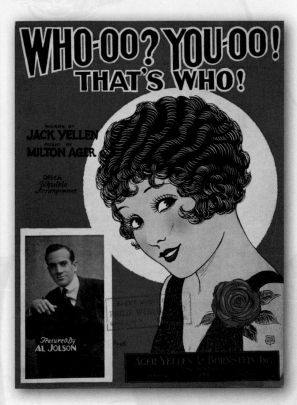

You're A Real Sweetheart (1928)
A simple sketch of a woman's head and hat. The song tells of a sweetheart who sticks with you through good and bad. Caricature of Paul Whiteman, the famous band leader, on the cover.

I Want The Twilight And You (1920)
Drawing of a star-struck couple staring into each other's eyes, looking forward to the end of the day when they can finally meet again: *"I am longing to see your dear face, and pining for your fond embrace."* Music and lyrics by Arthur Lamb and Charles Maskell.

Who-oo? You-oo! That's Who! (1927)
The lyrics ask a bunch of questions, but the answer is always the same (and obvious). It is beyond a doubt that the person the singer admires is the best. Quite a coy look from the rosy-cheeked young woman drawn by Barbelle. Al Jolson in the photo.

I'm Yours For Tonight (1932)

Silhouette of a man smoking and staring up into the nighttime sky, where he sees a vision of his sweetheart. Beguiling artwork credited to "Hap" Hadley studio.

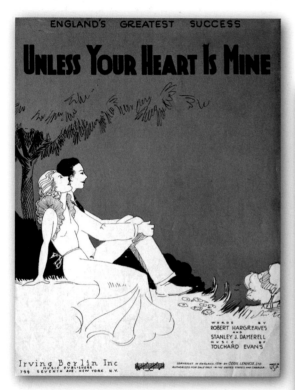

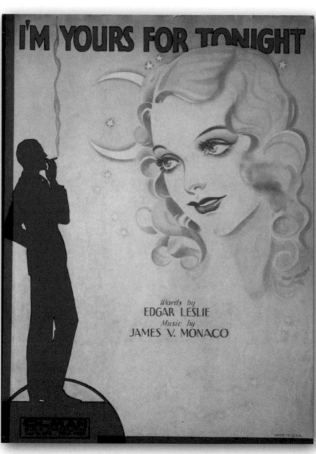

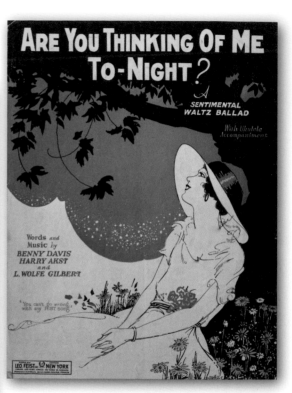

Unless Your Heart Is Mine (1934)

A very clean and simple illustration. A couple sit outside and consider the future, thinking that without each other's love, life wouldn't be the same. Originally a big hit in England, it was distributed in the United States by the Irving Berlin Publishing Company.

Are You Thinking Of Me To-Night? (1927)

Though separated, she's thinking of him and hoping that he is thinking of her. Framed by the branches of the tree and the flowers on the ground, she leans back and gazes at the stars.

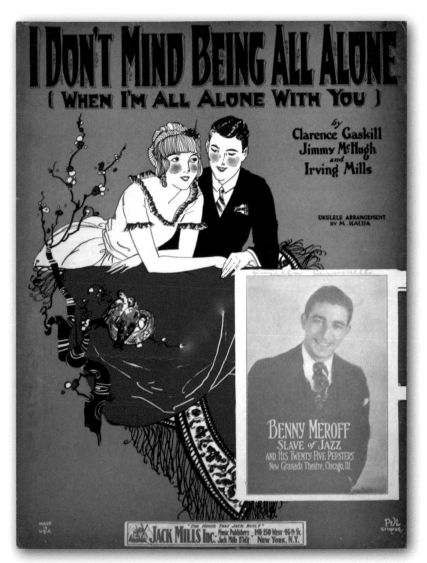

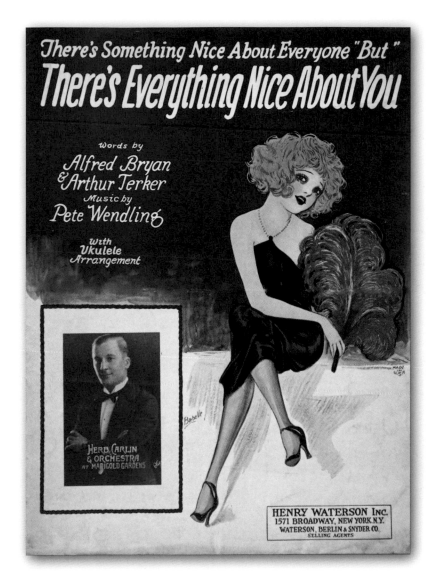

I Don't Mind Being All Alone (When I'm All Alone With You) (1926)
Kind of a cute and ingenious play on words. The blushing couple is mirrored by the "love birds" in the nest. Photo of Benny Meroff, which describes him as "Slave of Jazz And His Twenty-Five Pepsters, New Granada Theatre, Chicago, ILL."

There's Something Nice About Everyone "But" There's Everything Nice About You (1927)
A stunning vision of the typical twenties flapper holding a feathered fan, done by Barbelle. According to the lyrics, she has everything her man needs. Photo of Herb Carlin and Orchestra at Marigold Gardens.

Love can have a downside as well. It can also lead to heartbreak, disappointment, sadness. These songs and their covers show us this other side. From personal regret to unmistakable sorrow—it's all here, drawn with an amazing ability that shows a personal understanding of the subject. All of this was done just to help the publishers sell more music.

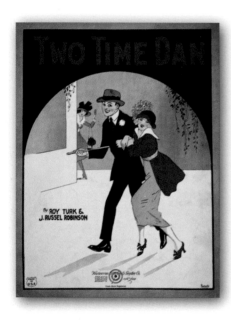

Two Time Dan (1923)
Blissfully unaware that he's been caught, a man plays the field and can't stay true to any one girl. The lyrics refer to Heinz's 57, an advertising slogan in use since 1896, mentioning that Dan has that many girls, plus more. Sounds like trouble. Barbelle cover.

I Hate To Lose You, I'm So Used To You Now (1918)
An amusing Barbelle illustration with a winged, cupidlike cherub wearing a cowboy hat, holster, and gun and pulling a lasso that is roped around the woman. She worries, *"Who am I goin' to love, now that you've turned me down."* Lyrics by Grant Clarke.

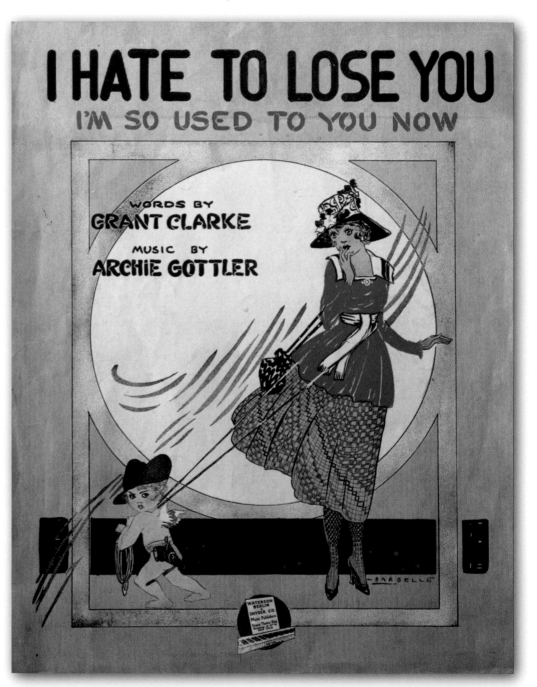

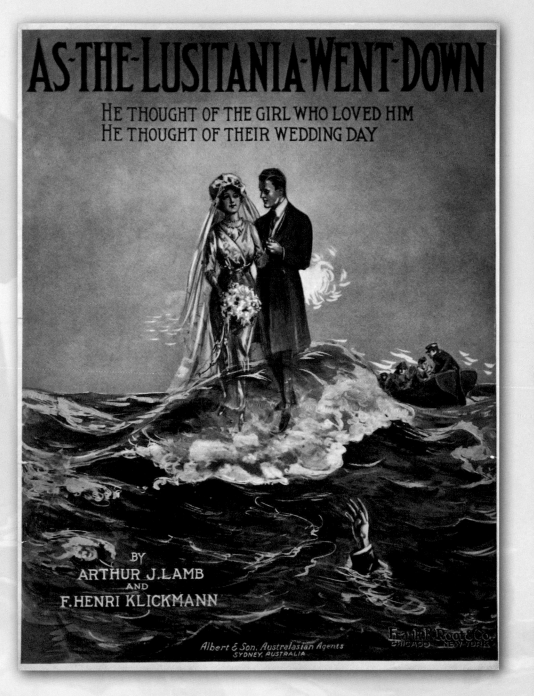

As The Lusitania Went Down (1915)

A dramatic image of a tragic event. On Friday, May 7, 1915, the British Cunard Line ocean liner *Lusitania*, while on a route from New York to Liverpool, was torpedoed and sunk by a German U-boat. It only took eighteen minutes to go under, and the attack claimed 1,198 people.

In the lyrics, written by Lamb and Klickmann, a man heroically gives up his seat on the lifeboat to a woman with a child; then he reflects on his own life. As the chorus goes, *"He thought of the girl who loved him, he thought of their wedding day, as he looked on the angry ocean, eager to seize its prey, he thought of his poor old mother, in a little southern town, and sadly he sighed, thy will be done, as the Lusitania went down."*

Note the ghost image under the water and the hand reaching up. Also pictured is one of the only six (out of forty-eight) lifeboats that managed to get successfully launched.

The inside cover contains an "in memoriam" tribute to all those affected by this disaster.

What's The Use? **(1930)**
She tries to get over the guy who left her for someone else, but she's having a hard time doing it. Fine illustration of a woman with a melancholy expression. Featured by Ozzie Nelson and His Orchestra, as listed on the photo.

I'm Going To Leave You **(1904)**
Starmer illustration surrounds a large photo of Ida Emerson, in an elaborate turn-of-the-century gown with feathered hat.

Why Do I Lie To Myself About You? **(1936)**
Woman in a very art deco--style dress tries to confront her feelings over a breakup. She knows that even though they have separated, she still loves him. Classy-looking Jorj Harris cover.

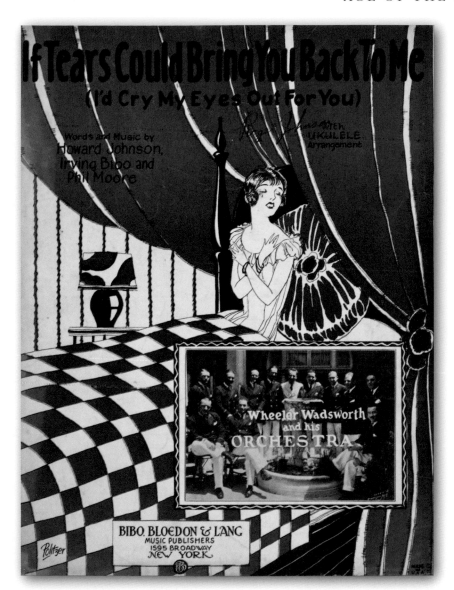

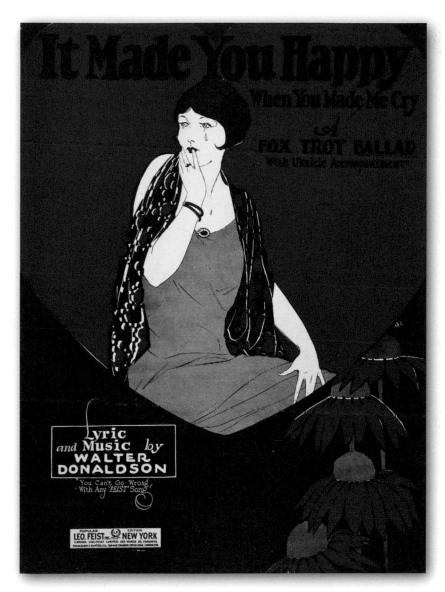

***If Tears Could Bring You Back To Me (I'd Cry My Eyes Out For You)* (1926)**
Nicely contrasting patterns on the bedcover, wallpaper, lampshade, and drapery, drawn by Politzer. She's lost her love, with no idea how to get him back. Photo of Wheeler Wadsworth and His Orchestra.

***It Made You Happy When You Made Me Cry* (1926)**
Image of a tearful woman sitting within the background of a large heart. Wearing a plain dress but with a fancy patterned scarf, brooch, and bracelet. Perfect example of the jilted woman. Love is just not fair, I guess.

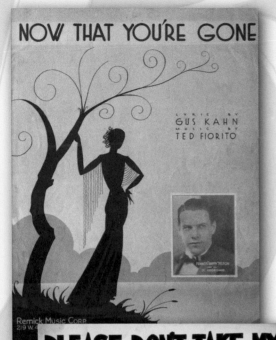

Now That You're Gone (1931)
Striking female silhouette in a stylized landscape. She contemplates an uncertain future without her man. Illustration by Harris. Photo inset of Francis "Happy" Felton and His St. Georgians.

Blue (1922)
Barbelle drawing of a seated woman with a forlorn expression and posture. Despondent over a relationship that ended, and thinking about whether *"we made a blunder, and lots of time I wonder, if you're blue too."* Words by Grant Clarke and Edgar Leslie. Circular photo of Jean Granese on cover.

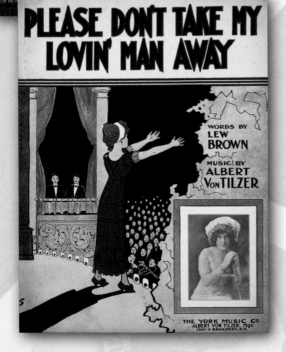

Please Don't Take My Lovin' Man Away (1912)
Sung to the "other woman" who is trying to steal her man. With the lyrics by Lew Brown, it goes, *"So on my knees, I beg you please, kiss his pictures in the frames, call him all the sweetest names, write him letters ev'ry day, I won't mind the things you say, 'cause I love him only."* Drawn from the perspective of a stage, with performer Ruby Norton pictured.

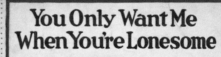

You Only Want Me When You're Lonesome (1926)
Very stylized cover with repeated design elements throughout. The long, beaded necklace and earrings are not only echoed around her wrist and armband, but also used around the entire illustration and title box. In addition, her long thin fingers are repeated in the tails of the swallows.

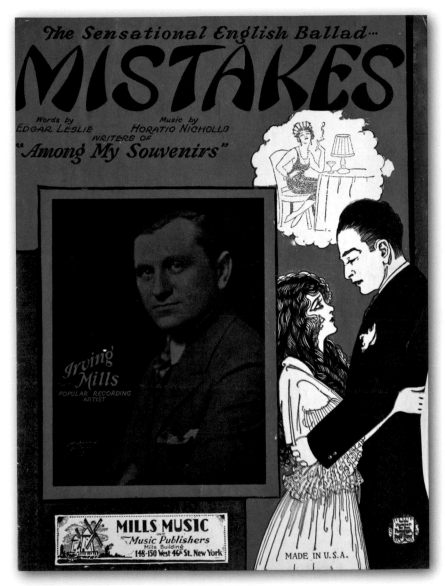

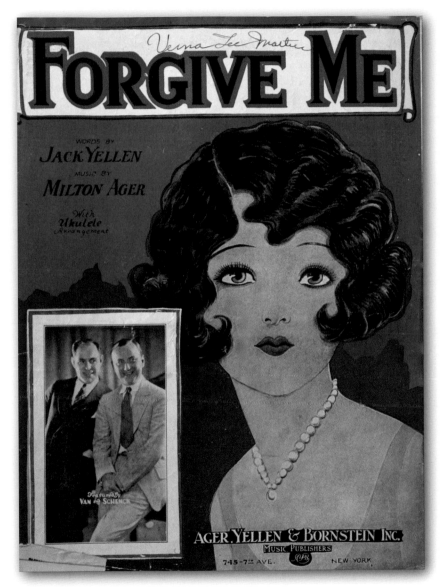

Mistakes (1928)
Some memory seems to haunt them, but whether it is from her past or his is not clear. The song does go on to say that the biggest mistake they made was splitting up. Irving Mills, in the photo, went on to become one of the biggest music publishers of the era.

Forgive Me (1927)
Close-up portrait by Barbelle of a classic twenties beauty staring out at us. She begs forgiveness and asks for another chance. How could anyone turn that face down? The photo on the cover states "featured by Van and Schenck."

We can easily see the evolution of styles in clothing through the covers of sheet music. They graphically represent the changing fashions of the day, and the subjects' hairstyles and apparel accurately model the period. People dressed with a more elegant and formal look, which was reflected in the covers.

You Never Can Tell (1920)
A question mark surrounds this couple, but it's more about the guy trying to understand women: *"After all you will agree, that woman is a mystery, it really is distressing, the way she keeps you guessing."* Certainly one of the eternal questions about the male/female relationship, conveyed through the lyrics of Lew Brown. Their expressions speak volumes on the subject. Wonderful image by R. S.

If You Can't Get A Girl In The Summertime (You'll Never Get A Girl At All) (1915)
An interesting illustration by Barbelle of a day frolicking at the beach circa 1915, around a framed photo of Lillian Mascot. Well-dressed couples in fancy attire are not what we visualize today as a normal beach outing.

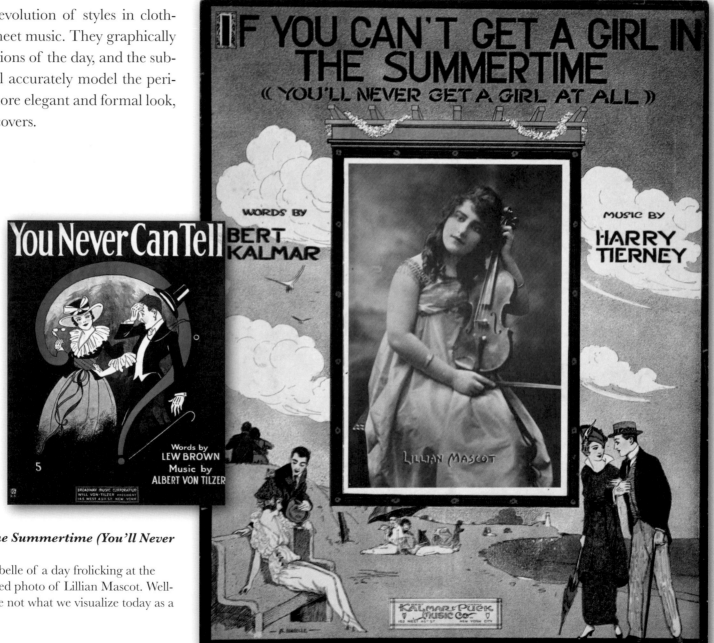

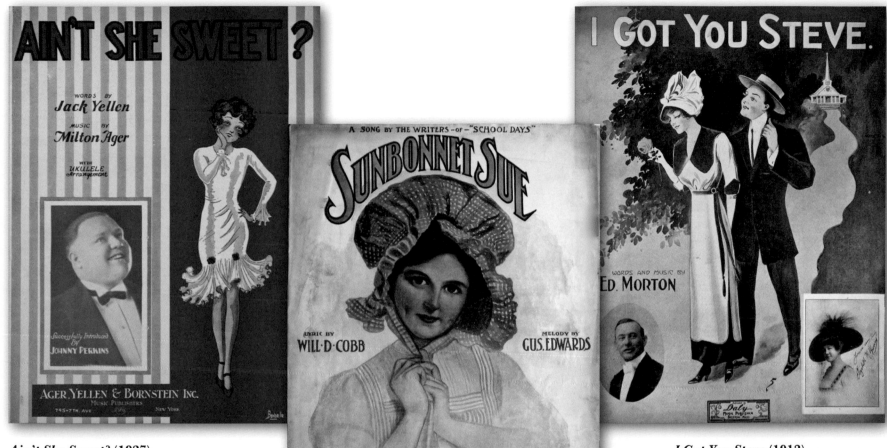

Ain't She Sweet? (1927)
Catchy song that became a well-known standard. Barbelle artwork pictures the typical twenties look— a young woman with bobbed hair wearing a shortened sheath dress. Recorded by many singers, this sheet says, "Successfully introduced by Johnny Perkins."

Sunbonnet Sue (1908)
Early on, the bonnet was standard headwear for women outdoors. A somewhat country, rural look, it quickly was replaced by the more "fashionable" city styles. The illustration lets the rest of her outfit fade into the background.

I Got You Steve (1912)
Cover by Pfeiffer shows a young couple out for a stroll. When they stay out past dark, she can't get back home and *"when she cried oh Steve what shall I do, then that good natured boy just sighed, let's find a parson then come home with me."* It seems that was her plan all along . . . Photos of the writer Edward Morton and performer Elizabeth Murray at the bottom.

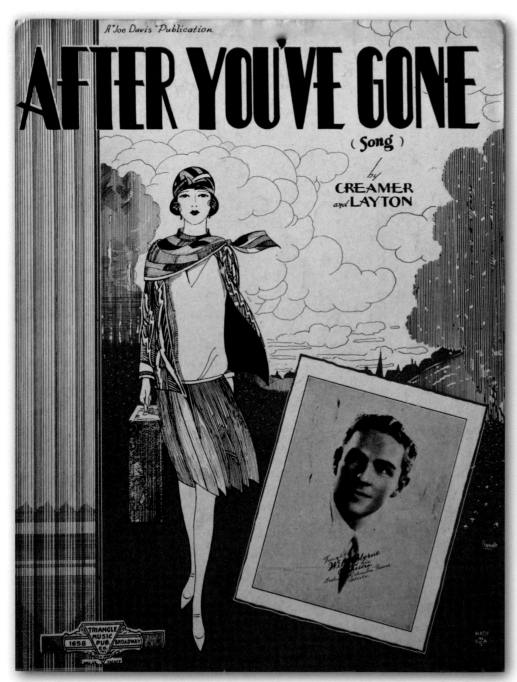

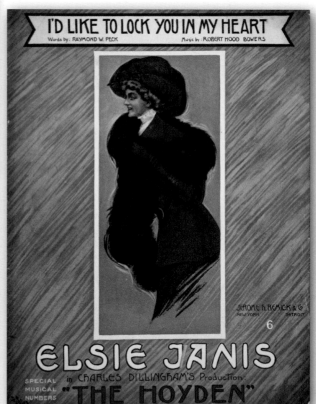

After You've Gone (1929)
A very stylish young woman with her bag packed and heading out. The singer reflects that after their breakup, she won't be the one with regret and remorse. This tune was a big hit for the singer Bessie Smith, who was known as the Empress of the Blues.

I'd Like To Lock You In My Heart (1907)
Detailed drawing of actress Elsie Janis, who appeared in the stage production of "The Hoyden," pictured in a striking red suit and gloves, with a matching feather in her hat and wearing a fur stole. A simple background emphasizes the image with a white border.

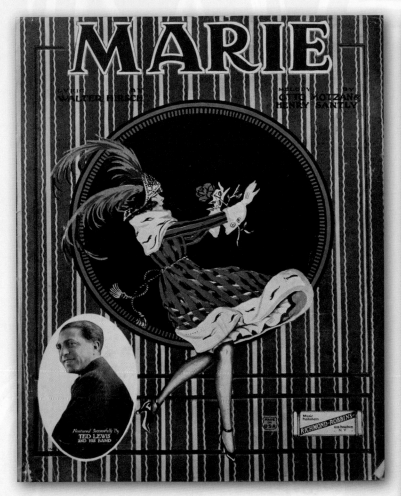

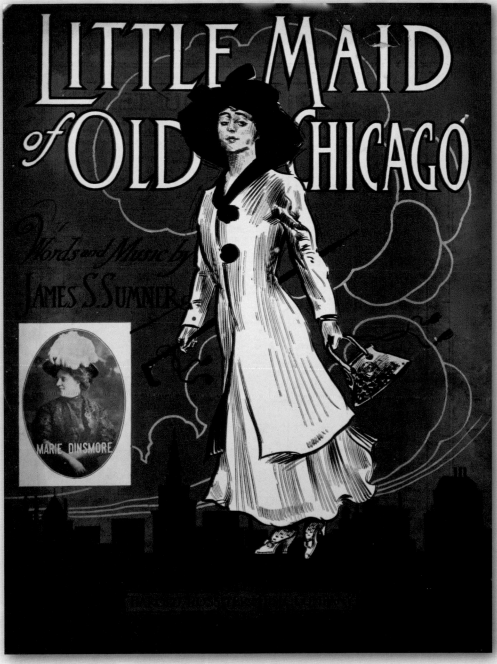

Marie (1921)

Featuring a "pretty young thing" who seems to swirl onto the cover. She's wearing a stylish striped coat, complementing the background design, and a twin-feathered hat. Photo caption reads, "Featured successfully by Ted Lewis and his band." Wohlmann cover.

Little Maid Of Old Chicago (1910)

Sung to one of the emerging class of urban women, who is pictured in the air above the skyline. She is smartly dressed with matching accessories, with an equally fashionable Marie Dinsmore in photo.

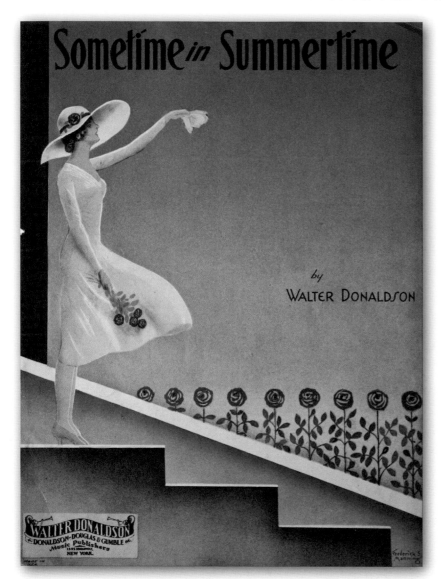

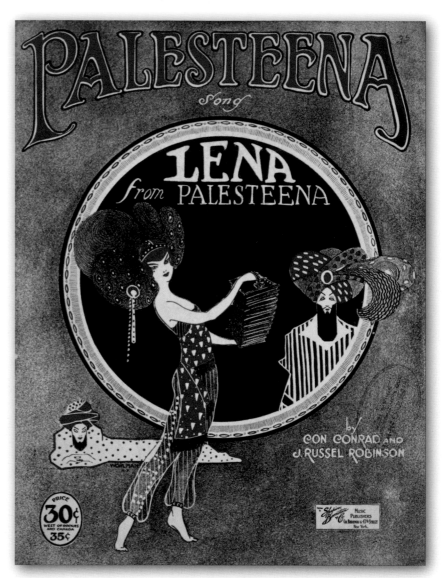

Sometime In Summertime (1931)

All about getting and losing a love in the summer and hoping that she will find someone again. She waves goodbye from the top of the stairs, while roses from the flower bed are repeated in her hand and hat. Simple but effective use of design on this cover by the illustrator Frederick Manning.

Palesteena (1920)

Exotic-looking illustration by Wohlmann, with elaborate art deco--inspired design. Note the different patterns used as fill on the clothing and headdresses. *"Lena is the queen of Palesteena, just because they like her concertina . . . she heard that Arab whisper, oh Lena, how I love your instrument."* Words and music by Con Conrad and J. Russel Robinson.

We see that music, art, and fashion can all be prone to extreme changes, local trends, and subtle differences. These covers show us not only the evolution in clothing and dress but also the way people were expected to look and behave. A mirror to the times.

The age of the great illustrators, with their wonderful artwork, lasted a few decades but then declined. Creating unique works of art just became too expensive. After this, the look of sheet music began to change, and it would never be quite the same again.

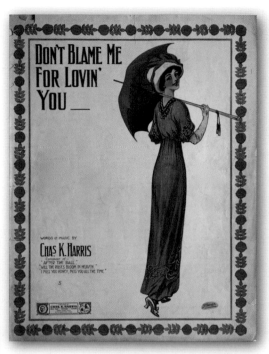

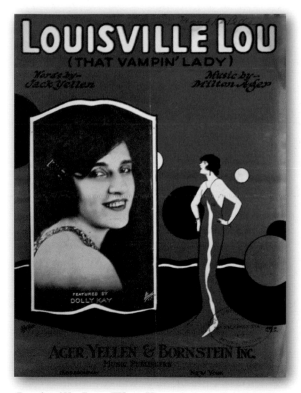

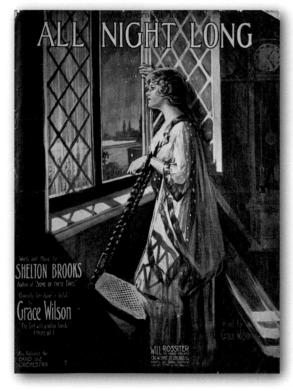

Don't Blame Me For Lovin' You (1911)
Surrounded by a border of roses, this cover by Starmer pictures an attractive young woman looking back over her shoulder with an enchanting gaze, wearing a stylish Empire-waisted hobble skirt with a parasol and hat. It's this vision of loveliness that causes the singer to say, *"When you're around my heart's a-palpitatin' very queer."* Written by Chas. K. Harris, who also composed the standard "After The Ball."

All Night Long (1912)
Gorgeous illustration, with a quality almost like a painting. Mostly monotone in composition, the use of color only on the woman's face and hair focuses the attention on her longing expression.

Louisville Lou (That Vampin' Lady) (1923)
The definition of a *vamp* is a woman who uses sexual attraction to attract and exploit men. In the song, Lou is described as a master of breaking hearts with her superb use of the shimmy shake. Cover by Politzer has her long gown artistically flowing into the abstract background. Featured by Dolly Kay, as listed on the photo.

...in Paris

B

Eigh

Geo

Sc

ARD

EDGAR
KELLER '10

BOOK & LYRICS
BY

COLLIN

COMEDY SCENES BY
ie WHITE & WILLIAM K.
LYRICS BY
G. DE SYLVA & LEW BR

VAUDEVILLE AND BROADWAY

EARLY POPULAR ENTERTAINMENT

"Mammy . . . Mammy . . .
I'd walk a million miles,
For one of your smiles,
My Mammy"

My Mammy (1920)
Words and music: Joe Young, Sam
Lewis, and Walter Donaldson
Sung by: Al Jolson

For over thirty years, from the 1890s through the 1920s, vaudeville was the most popular diversion in the country. It started as a form of popular entertainment aimed at the middle class, and was priced at a fraction of the cost of normal Broadway-style stage productions. Standards relating to language and presentation were strictly enforced on its performers, to ensure a "safe" and polite environment for their audiences. It was usually performed in theaters, and it was seen as a wholesome amusement, suitable for families.

Vaudeville was a combination of animal acts, musical performances, magicians and jugglers, and sight gags, loosely tied together by an emcee. Because of this,

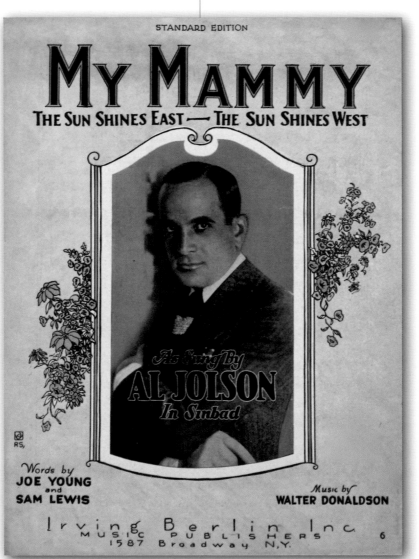

the regular theater establishment looked down on this mass entertainment as inferior, but it did draw big audiences.

Almost every city worth its name had some sort of music hall—a place to gather, socialize, and hear the latest songs. At the time, the options for other forms of recreation were still very limited for most people. Live performances were the way to experience music. Sheet music was the main way to gain access to the songs themselves.

An established vaudeville circuit existed around the country, and the promoters booked shows to keep the theaters busy. This became a nurturing ground for many of the performers who would later cross over into both regular theater productions and, eventually, movies. People like Al Jolson, Eddie Cantor, W. C. Fields, Sophie Tucker, Ted Lewis, and others became national stars.

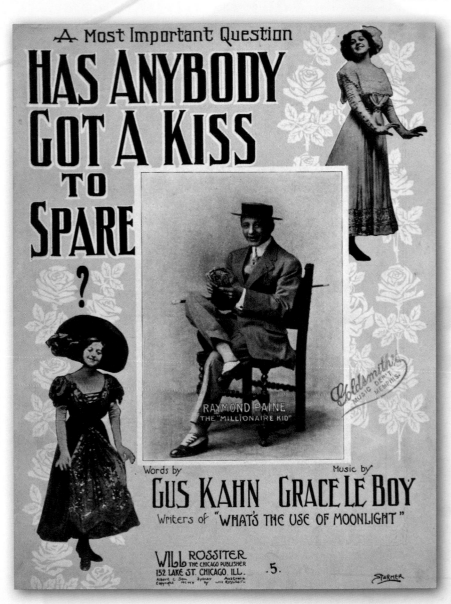

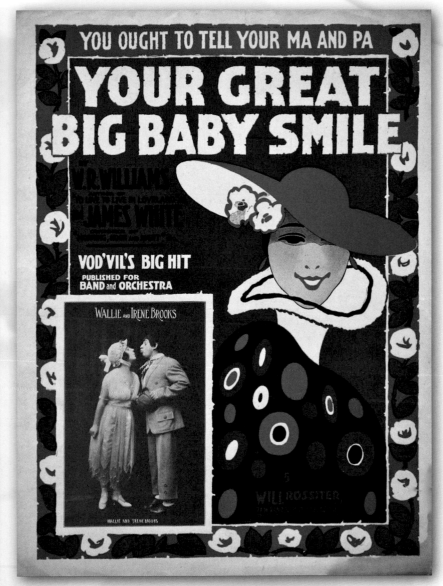

Has Anybody Got A Kiss To Spare? (1910)
Starmer-designed cover, with main photo of Raymond Paine, the "Millionaire Kid." Lyrics by Gus Kahn read, *"I'm looking for a miss, who is looking for a kiss."* As the cover states, "A Most Important Question." Wonderful period photos and attire.

Your Great Big Baby Smile (1916)
Comical vaudeville photo insert of husband-and-wife duo Wallie and Irene Brooks. Elegant cover design by Starmer.

Al Jolson is considered by many to have been the first true popular music star. He got his start on the vaudeville stage, and he was one of the few people to successfully move to early films without missing a beat.

He connected with audiences like no other performer of his time. His charisma on stage, combined with an identifiable singing style, carried him through his career. At times wearing blackface (long after most others had stopped doing it), he would get down on one knee to sing a dramatic finale and "bring down the house." A person with the talents to match his ego, his influence changed the nature of popular music.

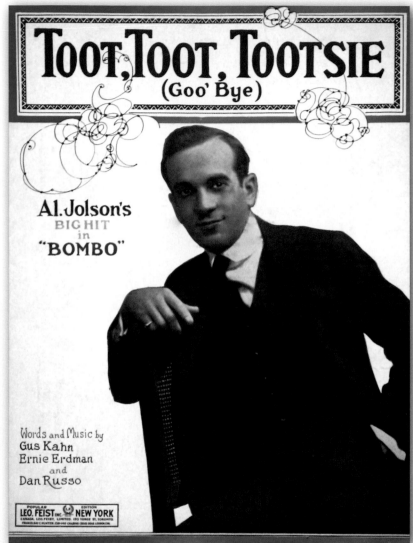

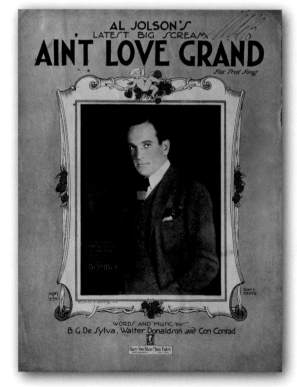

Ain't Love Grand (1922)
Humorously listed as "Al Jolson's latest big scream," the song reflects on the joys of love: *"There's really nothing like it . . . It's wonderful! It's marvelous!"* Words and music by the songwriting trio of DeSylva, Donaldson, and Conrad.

Toot, Toot, Tootsie (Goo' Bye) (1922)
In the slang of the day, a "tootsie" was a young, available woman. In this song, written by Kahn, Erdman, and Russo, a man reluctantly parts from his love and tells her, *"Kiss me, Tootsie, and then, do it all over again, watch for the mail, I'll never fail, if you don't get a letter then you'll know I'm in jail."* This is one of Al Jolson's classic songs from the show *Bombo*.

Two contemporaries of Jolson are pictured on these covers. Eddie Cantor was another successful vaudeville showman who was featured in a number of the *Ziegfeld Follies* and other revues. Like Jolson, he appeared in blackface in many roles, both onstage and in the movies. Besides choosing great material to perform, he also cowrote many of his hits.

Ted Lewis was an entertainer, singer, and band leader, known for his somewhat corny and overemotional presentations. Often performing wearing a battered top hat, he was known for his famous catchphrase "Is everybody happy?" Vaudeville itself flourished until the coming of the "talkies" in the late twenties, when theaters converted to films.

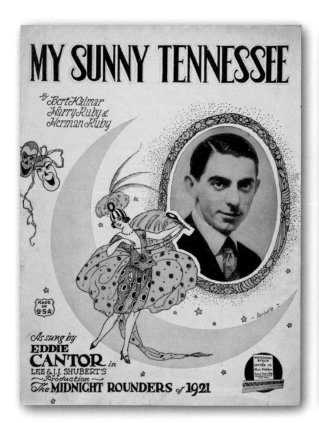 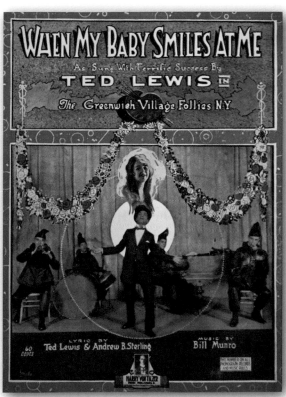 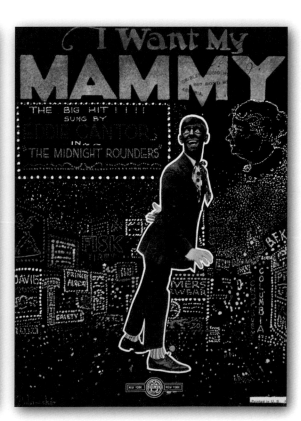

My Sunny Tennessee (1921)
"Make me what I wanna be, a rolling stone just rolling home, to my sunny Tennessee." Sung in the production of *The Midnight Rounders Of 1921*. Photo of Eddie Cantor in stylized frame, with illustration by Barbelle. Written by Bert Kalmar, Harry Ruby, and Herman Ruby.

When My Baby Smiles At Me (1920)
Barbelle-designed cover, with Ted Lewis fronting a very oddly costumed band in the *Greenwich Village Follies*. He wrote the words as well, along with Andrew Sterling: *"It's just a glimpse of heaven, when my baby smiles at me."*

I Want My Mammy (1921)
Eddie Cantor from *The Midnight Rounders* in blackface, with the lights and signs of Broadway behind him. In his dreams, he looks back with fondness to his mother and concludes, *"Then my cares fade away."* Words by George Wehner.

Musicals on Broadway continued in their own tradition, usually following a plot or story line, as opposed to the rotating series of skits and unrelated acts that made up vaudeville performances. Later, variations called "revues" appeared that, even though comprised of short sketches, were usually formed with an overriding theme or concept. This led directly to what would eventually become some of the most elaborate staging ever seen, as featured in extravaganzas like the *Ziegfeld Follies* and its various imitators.

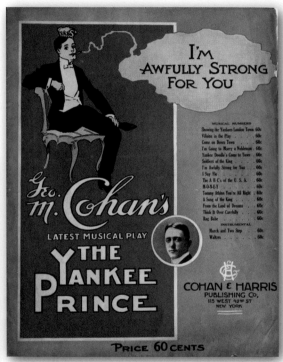

Oh Johnny, Oh Johnny, Oh (1917)
Starring Anna Held, who was married for a short time to Florenz Ziegfeld and was said to have given him the inspiration to start his *Follies*. The show *Follow Me* came out in 1917 after they divorced, but she died a year later in 1918.

Dixie I Love You (1906)
The setting for *The Time, The Place and The Girl* is a sanitarium and hotel in the mountains of Virginia. In those days, it would have been more the equivalent of a spa, or somewhere to get away, relax, and recover from whatever is bothering you. The perfect spot to meet someone, and a good setting for a show.

I'm Awfully Strong For You (1908)
One of the earlier musicals written by George M. Cohan, *The Yankee Prince* was more of a satire on rich American fortune hunters. The seated gentleman on the cover is smoking a cigar and wearing a crown with a dollar sign on the front of it. Being "strong" for someone implies a great depth of feeling: *"You needn't say you love me, for I'm pretty sure you don't, but tell me that you like me and there's nothing I won't be glad to do."*

I Fell In Love With Polly (1904)

From the Broadway show *The Maid And The Mummy*, which was billed as a musical farce in three acts. Other songs from the show are listed, such as "No Doubt You'd Like To Cuddle Up To Baby," "Maggie Got Another Situation," "I'm So Dizzy" and "My Gasoline Automobile." Great illustration of maid teasing mummy.

Coral Isle (1911)

Fantastic use of design and color in this illustration for *The Pearl Maiden*, a show that only ran for twenty-four total performances in 1912. Not much information remains about the show, but we are still left with this wonderful cover.

Jane (1903)

The operetta *Babes In Toyland* by Victor Herbert became one of his first big hits on the Broadway stage. It's a fantasy about children on a journey through menacing woods who arrive at a magical city called Toyland. The cover is bordered by imaginative toy figures.

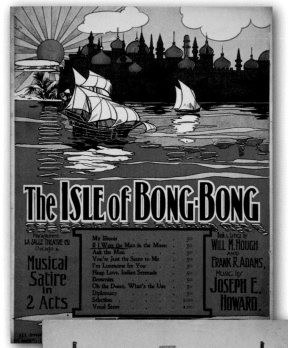

If I Were The Man In The Moon (1905)
Mythical and exotic settings were always a draw for theatergoers. Here it's *The Isle Of Bong-Bong*, with an eye-popping illustration by Starmer. With a line by Will Hough and Frank Adams like *"My heart is beating ragtime, when I know that you are near,"* the song clearly references to the audience the popular music style of the time. Other songs from the show include "Oh The Deuce What's The Use," "Heap Love Indian Serenade," and "Ask The Man."

Chin-Chin Open Up Your Heart And Let Me In (1915)
Very Oriental-looking cover from the production *Hip-Hip-Hooray*, performed at the famous New York Hippodrome. This theater was called the world's largest by its builders in 1905, seated fifty-three hundred people, and featured lavish spectacles.

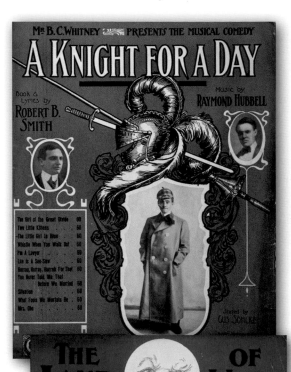

Little Girl In Blue (1907)
This song is from a musical comedy with the amusing title *A Knight For A Day*. Pictured are the composers at the sides, with the central photo of John Slavin, who played the leading role of a lawyer. Some other selections listed are "Life Is A See-Saw," "I'm A Lawyer," and the intriguing title "You Never Told Me That Before We Married." Another Starmer cover.

A Heart To Let (1906)
From the show *The Land Of Nod*. "Going to the land of Nod" is a colloquial reference to sleeping and dreaming, with some of the other songs from the show referring to "The Girl You Dream About" and "When You Grow Tired Just Let Me Know." The winking moon and the elaborate house of cards are by Starmer.

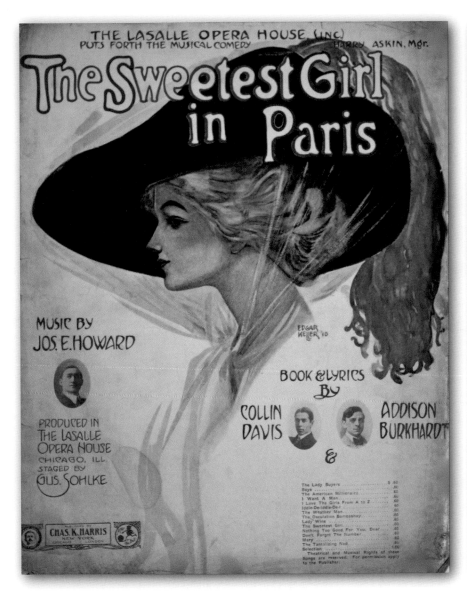

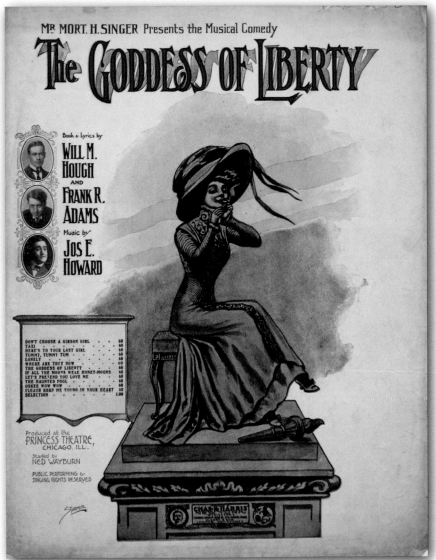

I Want A Man (1910)
Song from *The Sweetest Girl In Paris*, with a gorgeous illustration by Edgar Keller of a young woman wearing a large hat with feathers, held on by a scarf. More songs from the show include "The Osculation Bombashay," "I Love The Girls From A--Z," and "Nothing Too Good For You, Dear."

If All The Moons Were Honey-Moons (1909)
Starmer cover portraying Miss Liberty as a "modern" woman, putting down her torch to sit and smoke a cigarette. Her outfit almost seems overwhelming, but reflects the clothing of the period. According to the cover, this musical comedy of *The Goddess Of Liberty* was produced at the Princess Theatre in Chicago.

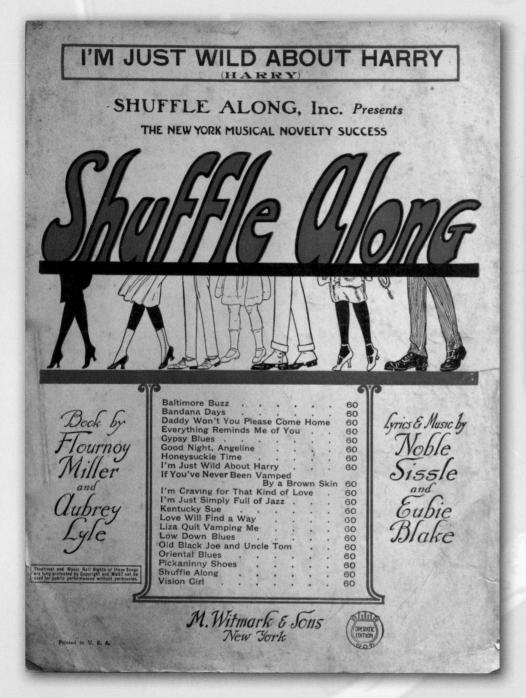

Digga-Digga-Do (1928)

Although promoter Lew Leslie was white, as were the songwriters, the *Blackbirds Of 1928* follows in the footsteps of *Shuffle Along*, with an all-black cast. The show was also very successful, with a long run of sold-out performances on Broadway. This song went on to become a swing standard and was recorded by many artists over the years, from Artie Shaw to Big Bad Voodoo Daddy. The show is also remembered for the first appearance of Bill "Bojangles" Robinson, the tap dancer, and his number "Doin' The New Low-Down." The not-so-subtle use of blackbirds is reflective of the racial stereotyping at the time.

I'm Just Wild About Harry (1921)

Shuffle Along was a landmark show that broke the color barrier. It became the first major production written, directed, and acted entirely by blacks on the New York stage. The story was taken from an old vaudeville sketch and was an enormous success, running over 480 performances and leading to other similar shows.

A Young Man's Fancy (The Music Box Song) (1920)

Advertised as being from the Revusical (revue/musical?) comedy *What's In A Name*. Note the life-size portrayal of a music box in the amusing photo. The sheet music contains a special note: "The beautiful effect of an Old-Fashioned Music Box can be had by playing the chorus in the manner suggested on the following page," and then it shows a second arrangement.

You're The Cream In My Coffee (1928)

A big hit from the show *Hold Everything*, this song has remained a standard. An appropriate cover, considering the show was centered around boxing. Observe the tiny cupid by the corner bell. Cover by one of the few female illustrators, Helen Vandoorn Morgan.

As show performances gradually became more sophisticated (and daring), they evolved into elegant theater productions and revues. They became more organized, stylized, visual—as opposed to the ordinary acts in vaudeville. Promoters like Florenz Ziegfeld, who in 1907 presented his *Follies* for the first time, established an approach that would be forever identified with his name—specifically, lavish, dazzling shows that were famous for having beautiful chorus girls wearing elaborate outfits.

Along with this, Ziegfeld used the talents of popular songwriters and lyricists working in Tin Pan Alley at the time (Berlin, Gershwin, Cohen, etc.) to write feature songs for his shows. Much was done to showcase the music, and it didn't hurt to add a bevy of attractive dancers, sometimes in outlandish costumes or scantily clad.

His shows, and those of other imitators, become famous. Not only could you see the *Ziegfeld Follies* but also *George White's Scandals*, *Music Box Revue*, *Greenwich Village Follies*, the *Vanities*. Some ran for almost twenty years. Succeeding editions become more provocative and bold, revealing more and more. Ziegfeld's *Follies* went from being suggestive to more explicit, but never quite to full nudity. Some of his competition pushed the limits even further, using veils and fans in almost burlesque performances. The scandalous nature gave the shows an even bigger draw.

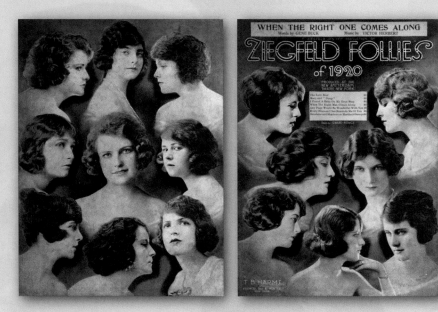

When The Right One Comes Along (1920)
A rare and unusual sheet featuring photos, on the front *and back* cover, of the gorgeous showgirls from the *Ziegfeld Follies Of 1920*.

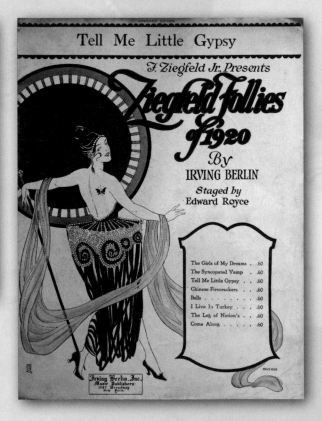

Tell Me Little Gypsy
(1920)
Fanciful illustration by the Rosenbaum Studios for a Berlin song from the *Follies*. The singer consults a fortune teller and wants to know if he will find true love.

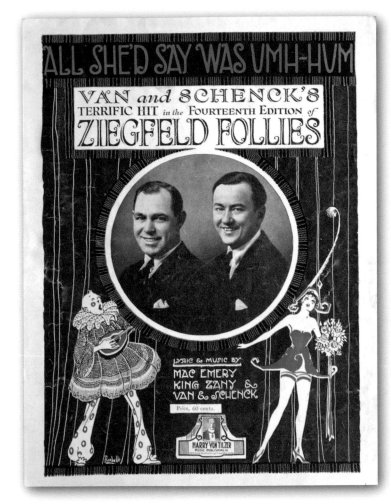

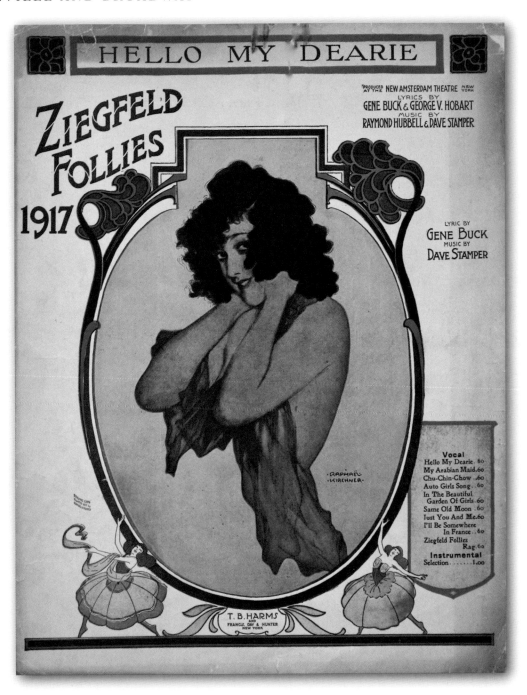

All She'd Say Was Umh-Hum (1920)

Fanciful costumes on the cover of this "terrific hit" illustrated by Barbelle, from the fourteenth edition of the *Ziegfeld Follies*. A large central photo of the two singers Van and Schenck, who worked as a duo with Ziegfeld for a number of years.

Hello My Dearie (1917)

An alluring look from this art nouveau cover by Raphael Kirchner, who also did magazine illustrations and poster art. Wearing a backless dress, this chorus girl sums up the mood and appeal of the *Ziegfeld Follies*.

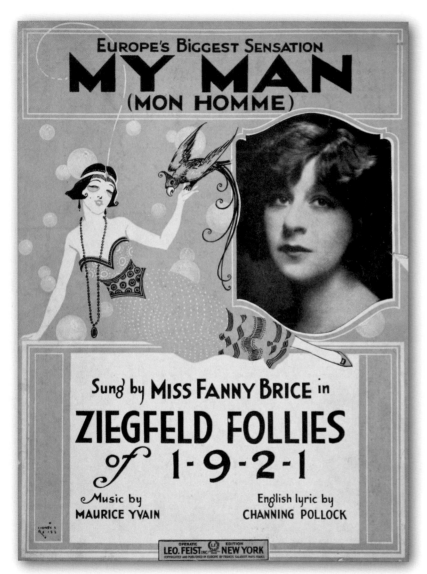

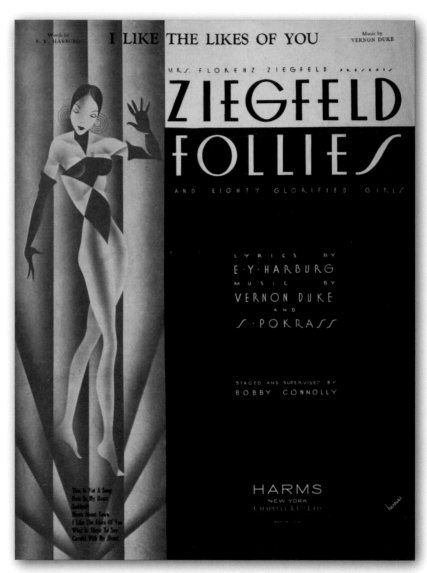

My Man (Mon Homme) **(1920)**

Fanny Brice became one of the best-known performers of the *Follies*, and went on to great success in both film and radio. This was her signature song for years. The cover design shows great detail in the different patterns used on the woman's dress. Barbra Streisand eventually portrayed Brice's life in the Broadway musical (and movie) *Funny Girl.*

I Like The Likes of You **(1933)**

When Florenz Ziegfeld died in 1932, his wife continued the shows for a few years, but by this time it was basically over. The cover by Harris has an enticing and sophisticated image, along with the mention of the show "and eighty glorified girls." Although the draw always was the women, the music gained the spotlight as well, and Harris and others helped introduce the new music of the Jazz Age.

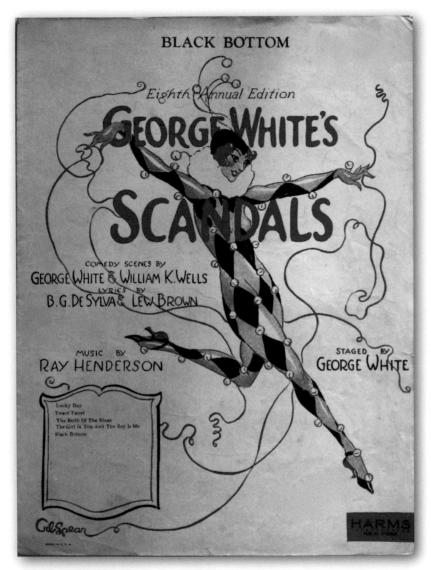

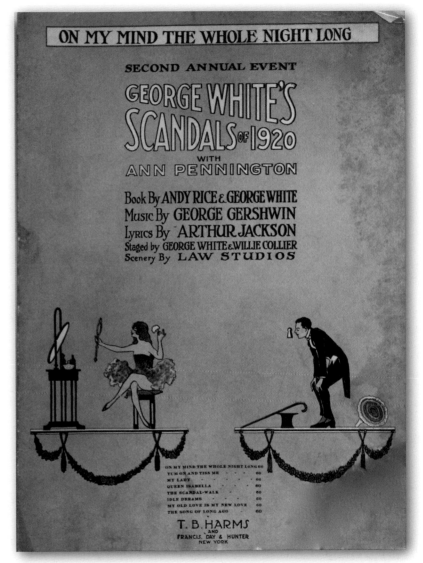

Black Bottom (1926)

This song/dance became a national sensation, replacing the popularity of the Charleston, after being featured in the eighth edition of *George White's Scandals* in 1926 at the Apollo Theater. Harlequin-costumed figure with bells dancing on the cover, with flying ribbons that cleverly flow from the illustrator's name at the bottom.

On My Mind The Whole Night Long (1920)

George Gershwin provided the music for *George White's Scandals Of 1920*. The actress/singer/dancer Ann Pennington was one of the top stars with the *Ziegfeld Follies*, and switched between both shows. Cover shows a man in full evening attire peering through a keyhole into a woman's dressing room.

By this time in the twenties, films were starting to draw audiences away from stage productions. The effect was especially dramatic in those movies with the new addition of sound: "talkies." The response of promoters like Earl Carroll was to have the girls as nude as possible, barely (pun intended) concealing them with a constantly moving screen of feathers and fans that attempted to hide their assets.

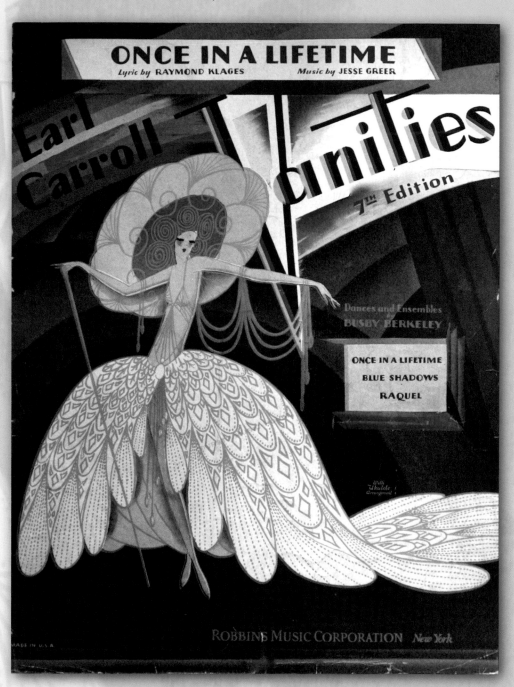

Once In A Lifetime (1928)

This cover, from the seventh edition of the *Earl Carroll Vanities*, highlights the trend toward more nudity. The female figure has only strands of fabric covering here, except for the outlandish hat and large feathered skirt, which is open in the front. Although the cover is unsigned, it is definitely in the art deco style of the artist Erte, who did work for Ziegfeld, George White, and even the Folies Bergère in Paris.
It is also mentioned on the cover that the dances and ensembles were staged by Busby Berkeley. He would soon go on to even more success with the arrival of full-blown movie musicals in the thirties.

The *song* quickly became an important feature of the show. Some of these titles are still familiar, and they represent the foundation of the Great American Songbook. The age of the phonograph and the player piano had begun. You could now hear these modern melodies without going anywhere.

People would get together to listen, absorb, enjoy. Everyone wanted copies of the sheet music, and the publishers made sure they could obtain it by advertising "for sale at all music dealers or wherever music is sold, or send direct to the publisher." Printed music was in hot demand.

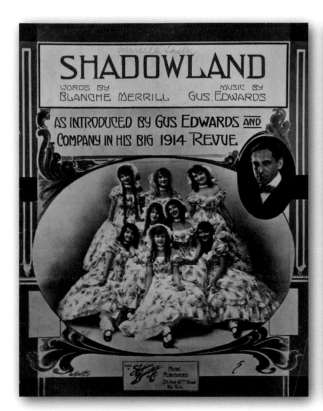

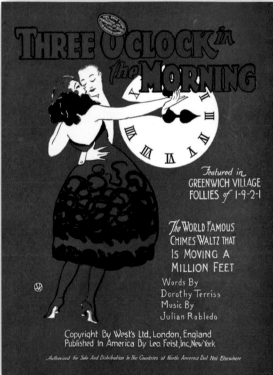

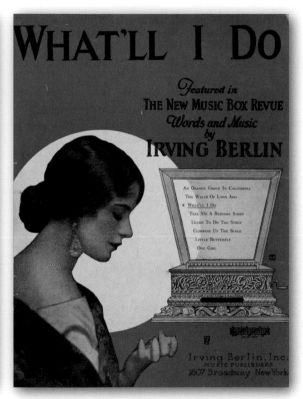

Shadowland (1914)
A very charming group of girls pictured on this cover from *Gus Edwards And His Big 1914 Revue*. Edwards was a songwriter and promoter during vaudeville, and he discovered many future talents like Eddie Cantor and the Marx Brothers. Cover design by Pfeiffer.

Three O'Clock In The Morning (1921)
This cover is a great example of what is called the fadeaway art technique, used by a number of illustrators. In it, the clothing of a subject (here the man's) is painted the same color as the background and becomes one with it. The song was in the *Greenwich Village Follies Of 1921.*

What'll I Do (1924)
The prolific songwriter Irving Berlin not only started his own publishing company but also opened a theater called the Music Box with a partner. It showcased his own stage production called the *Music Box Revue*. This sheet is another one of the many songs he wrote that has stood the test of time and become a standard.

ROARING THROUGH THE TWENTIES

MUSIC IN THE AIR AND ON THE SCREEN

Ev'ry morning, ev'ry evening,
Ain't we got fun,
Not much money, Oh! but honey,
Ain't we got fun

Ain't We Got Fun (1921)
Words and music: Kahn/Whiting

Even though "Ain't We Got Fun" was written early in the decade, the lyrics seem to foreshadow life in the twenties. When we think about this time period, we have images of flappers with bobbed hair dancing the Charleston at wild parties . . . Rudy Vallee singing through a megaphone and capturing the hearts of his listeners . . . Prohibition, speakeasies and bathtub gin . . . silent movie stars like Charlie Chaplin, Harold Lloyd, Buster Keaton, Rudolph Valentino . . . F. Scott Fitzgerald and *The Great Gatsby* as a part of daily existence. A growing fascination with glamour and celebrities was being formed.

This was a period of optimism and belief in progress. Innovations and technology were continuing to transform everyday life. The growing use of the phonograph, the advent of radio, the latest moving pictures with sound—all gave the public listening experiences that just ten years previous would have been impossible. This was the cutting-edge technology of the time, and everyone jumped on board.

Women now had the vote and started to be more liberated in life and love, which became a strong topic for songs. They began acting more independently and thinking about careers. People everywhere were not only rebelling against the values of the previous generation but breaking away from their style of music as well. Something new was in the air.

The spontaneous sound of jazz started to enliven the public—hot jazz. Scratchy recordings by Louis Armstrong, King Oliver, and Jelly Roll Morton showed the way. Coming from the notorious red-light district of Storyville in New Orleans, this music had a raw energy. There was a tinge of the exotic . . . forbidden . . . mysterious. White musicians like Paul Whiteman copied the style and popularized it, helping jazz became acceptable and mainstream. It would have a lasting influence on society and life in general. This *was* the Jazz Age.

Everywhere you looked, bands were springing up. Hotels and clubs were now featuring their own "orchestras" to attract new customers, and this led to an explosion of musicians who moved around the country, spreading the latest sounds even more. Sales of sheet music helped keep the tunes in circulation and often had photos of the groups on the cover, which reinforced the status of the band leaders and the music. This exposure would lead to greater things in the thirties.

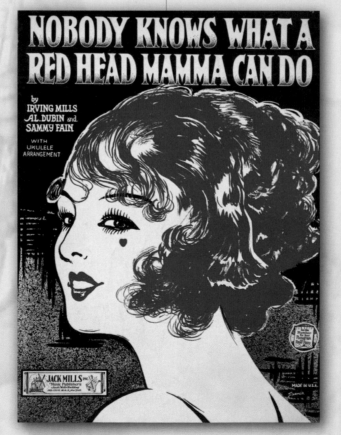

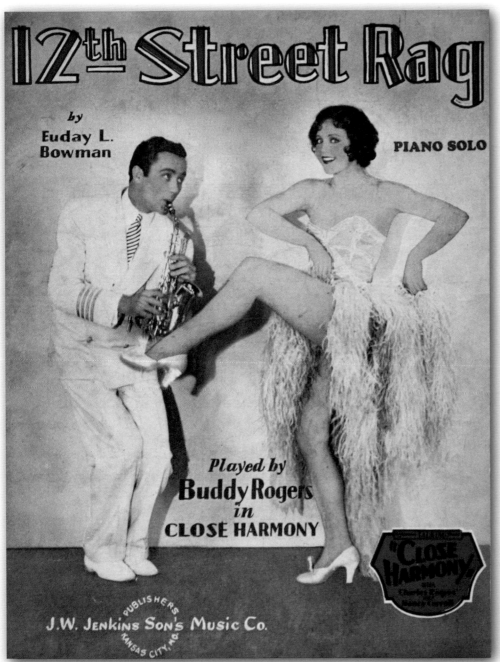

12th Street Rag (1919)

This rag was already ten years old and well known when used in the 1929 talkie, *Close Harmony*, with Buddy Rogers and Nancy Carroll. The cover epitomizes the fun atmosphere of the twenties right up to the end of the decade.

Chicago (That Toddling Town) (1922)

A song written by Fred Fisher and made famous decades later by Frank Sinatra was promoted at the time as a "novelty dance sensation." *"On State Street, that great street, I just want to say, just want to say, they do things they don't do on Broadway."* Photo of M. Speciale and His Carlton Terrace Orchestra on the cover.

Dreamy Melody (1922)
Large, wide-angle shot of Les Stevens and His Clover Gardens Orchestra, with an array of their instruments neatly placed in front of them. The lyrics by Koehler, Magine, and Naset refer to the melody and explain, *"I don't know why it haunts me so, I seem to hear it everywhere I go."*

You Are Too Sweet For A Dream (1924)
The *Leviathan* was a trans-Atlantic passenger liner in the twenties. She was well appointed, and became a popular symbol of US prestige and power. Her orchestra even did a number of recordings for Victor records at the time. Pictured here is Paul Whiteman's Orchestra, being led by the ship's music director, Nelson Maple.

Collegiate (1925)
Pictured are the Coon-Sanders Night Hawks, who were one of the most successful white jazz bands of the era, next to the Original Dixieland Jazz Band. "Collegiate" was one of the first songs recorded with an electrical microphone instead of an acoustic horn, which had been in use since the very beginning of recording on wax cylinders. It resulted in better sound and more possibilities in the studio. A piano-solo version of this song was later famously played by Chico Marx in the movie *Horse Feathers* (1932).

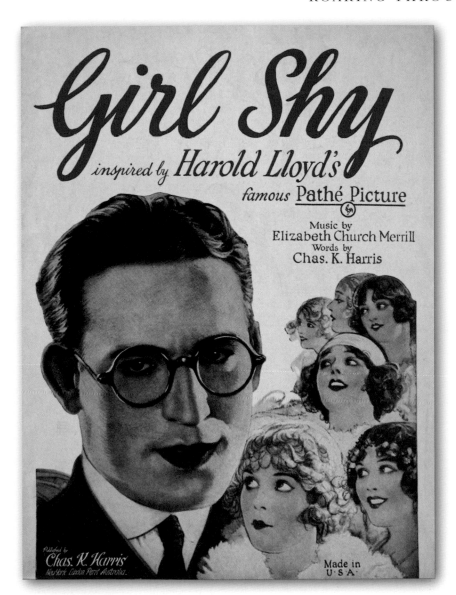

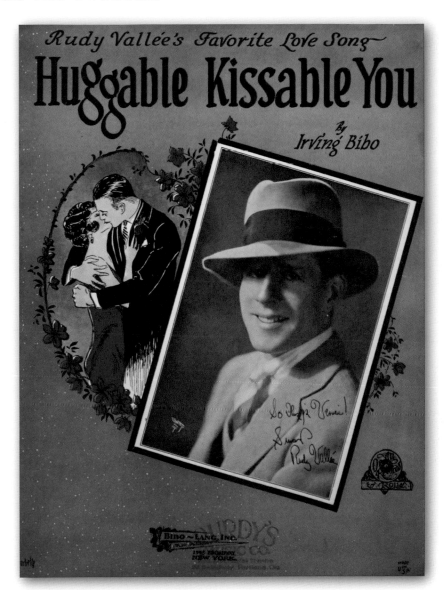

Girl Shy (1924)
Silent-film star Harold Lloyd became identified with wearing round glasses, which he used for one of his screen characters. In this movie, he is so shy around women that he stutters and can hardly speak to them, but this doesn't seem to make any difference, considering the many adoring looks he is getting.

Huggable Kissable You (1929)
Background illustration by Barbelle of a couple hugging and kissing, with inscribed photo signed by popular film heartthrob and singing sensation of the time Rudy Vallee. Promoted as "his favorite love song."

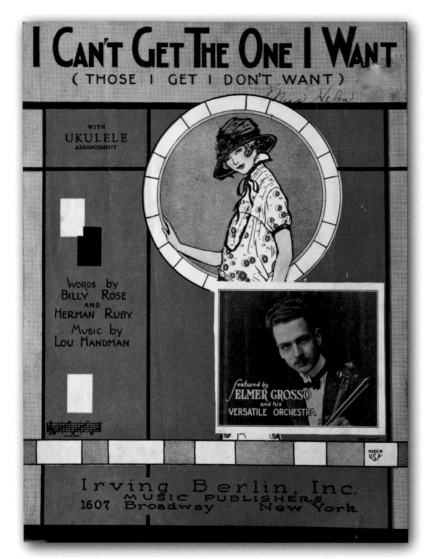

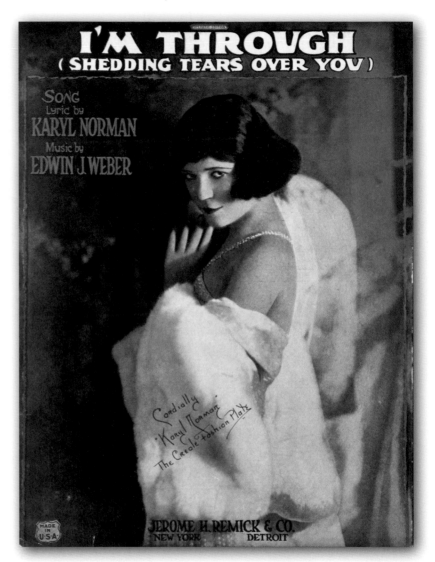

I Can't Get The One I Want (Those I Get I Don't Want) (1924)
The sheet music for this song about the disappointments of love has a cover design by Perret. Photo in the lower right says, "featured by Elmer Grosso and his Versatile Orchestra."

I'm Through (Shedding Tears Over You) (1922)
Inscribed on the photo "Cordially Karyl Norman—The Creole Fashion Plate" by a very successful vaudeville female impersonator whose real name was George Francis Peduzzi. During his performances, he would quickly change clothes and gender, depending on the song to be presented. He traveled across the country from show to show with his mother, who made his fashionable gowns. It's no wonder that the captivating look and smile on the sheet music cover are somewhat sly.

Dream Kisses (1927)
The illustrator Barbelle has given us a peek inside the woman's dreams, to what she's missing in real life. She can picture in her mind her dream man, but when she wakes up, he's nowhere to be found. But she doesn't stop dreaming. Photo of Van and Schenck, who were originally a harmonizing duo from vaudeville.

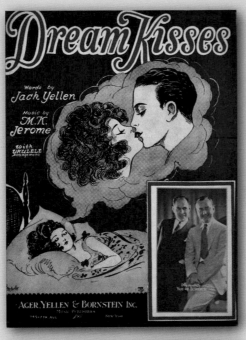

A New Kind Of Man (With A New Kind Of Love For Me) (1924)
P&L Studios provide the interesting artwork for this song, with Maurice Hyman pictured. Her ideal man has lots of kisses and hugs for her. He is sweet and kind, and has every sort of wonderful quality. Sounds a little bit too optimistic to me.

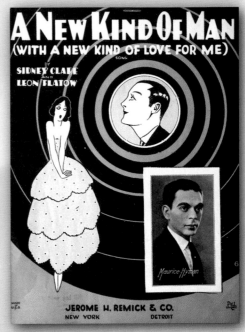

The One I Love Just Can't Be Bothered With Me (1929)
Love isn't always reciprocated. He may love her, but she has a choice of many suitors, as seen in the array of photos on her dressing table. Delightful drawing shows her putting on her lipstick using a heart-shaped mirror. Featured by Chester Gaylord, who is pictured.

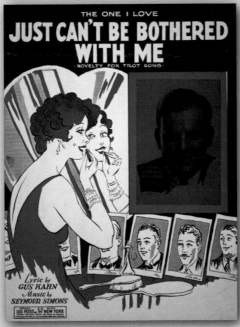

My Pet (1928)
Another song describing the attributes of a loved one, this one from a man's perspective. Using the word *pet* in two different connotations, he not only describes his cherished or special woman (a noun), but also that he likes to kiss and cuddle her (a verb). Essentially, making out with his girlfriend. Charming Barbelle illustration, with photo of Birge Peterson.

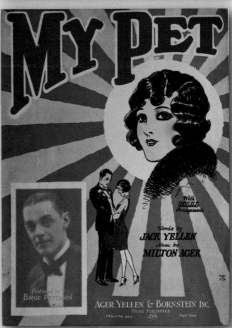

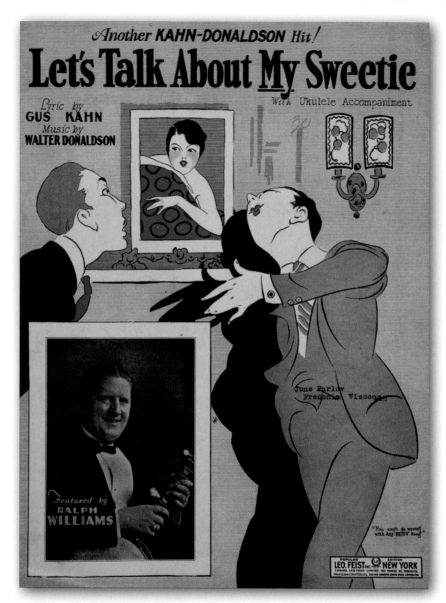

Let's Talk About <u>My</u> Sweetie (1926)
Is it love . . . or infatuation? Amusing sheet music illustration from 1926. Check out the different expressions on all three faces. The stylish Ralph Williams is seen in the photo, with his banjo.

When The Red, Red, Robin Comes Bob, Bob, Bobbin' Along (1926)
This popular song has been recorded by a score of performers over the years, in addition to "Pam and Peggy, the Garvin Twins" seen on the cover, illustrated by Leff. First made famous by Al Jolson (the twenties) and then Lillian Roth (the thirties); later versions came out by Doris Day in 1953 and Bing Crosby in 1956.

I Love My Baby (1925)
Classic Starmer illustration next to a large photo of the California Hummingbirds, a harmonizing vocal trio of Adler, Weil, and Herman. While the couple embraces in the garden under a full moon, a baby serenades them while playing a guitar. (?)

UKULELE MUSIC IN THE AIR

Playing the ukulele was very popular in the twenties. Here's an interesting and amusing illustration by Starmer that I found on the inside cover of a song sheet from 1924. The main image features a docking zeppelin with a cascade of sheet music books falling from the control gondola to the crowd below. The ad reads, "A Zepp-load of Zippy Uke Ditties brought in by the zephyrs of demand."

A listing of books published by Jack Mills, shown with descriptions:

Mills Comic Songs For The Ukulele—*"A galaxy of rib-ticklers for your next party. Every verse a howl."*

Hotsy Totsy Songs For The Ukulele—*"Chock full of Uke-novelties you'll love to play."*

Uke McGluke Songs For The Uke—*"Uke McGluke is the Duke of all ukists. He is to ukuleles what corn beef is to cabbage."*

Jack Mills Popular Songs For The Uke—*"Gives you the uke arrangements of some of the leading popular song hits."*

Mills Self Instructor For The Ukulele—*"A meaty method that has been edited by experts and requires very little study."*

A note at the bottom informs us that "the ukulele in the home is a sign of happiness. You can learn to play it in an hour. Great for parties, picnics, hikes, amateur shows, camp-fire bakes, barbeques, etc." Considering the resurgence of this instrument in the twenty-first century, it brings to mind the saying "Everything old is new again."

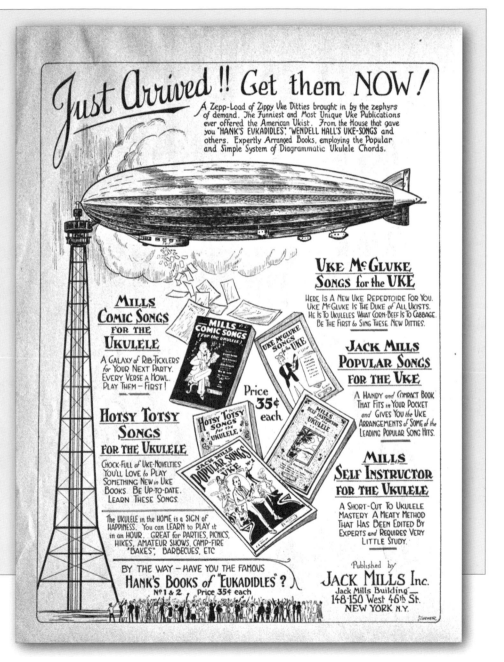

By the time the twenties arrived, movies had already been out for over a decade. The earliest films were silent, with music added by piano, organ, or even orchestra at the theater itself (not only to add interest and excitement, but also to drown out the sound of the noisy early projectors).

By 1926, movies started to introduce sound, and the "talkies" revolutionized entertainment. Immediately, songs became a driving force and a prominent feature of this invention. Films started to take the place of vaudeville in the theaters. For a while, they both shared billings, but eventually audiences clamored for these new movies with talking and singing, and vaudeville began to fade away.

It was a logical progression from the theaters and revues of Broadway to songs on the silver screen. And it didn't stop there. By the end of the twenties, individual tunes turned into full-blown movie musicals. Songs were set into stories, as opposed to stand-alone features. Dance numbers were often included. The stage was set (so to speak) for the next twenty-five years and more, and musicals on the big screen became a significant draw for Hollywood.

All of this exposed more people to a multitude of music, quicker than ever. Sheet music now promoted these new shows with photos of the stars and performers on the covers, often in stills from the movie itself. It was perfect publicity for both.

Glad Rag Doll (1929)

Cautionary song to women about the perils of fast living: having fun while you're young, but ending up alone and discarded after a while. This bluesy number has been recorded by many singers over the years, most recently by Diana Krall in 2012, but the movie *Glad Rag Doll* itself has been lost, with no prints surviving.

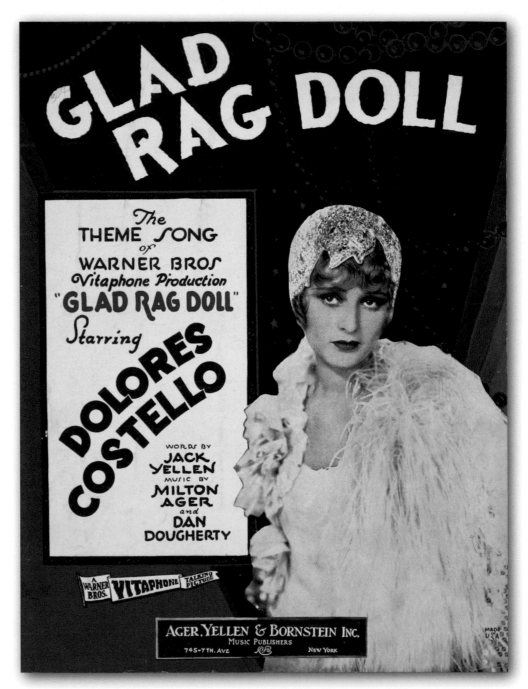

Sonny Boy (1928)

One of the earliest partial-sound films to gain widespread exposure, *The Singing Fool* was the first to show the potential for launching hit songs in movies. In an ironic twist, it was because of Al Jolson, who had become famous in vaudeville, that movies turned into the vehicle to overtake and replace it. Within five years, vaudeville was all but gone. Fortunately for Jolson, he was able to make a successful transition.

The sound on this film was heard using the Warner Bros. Vitaphone system (as promoted on the cover). While better than any of its rivals at the time, it relied on a cumbersome process that recorded the sound on a separate disc at the time of filming. It then had to be synchronized with the projection of the movie at the time of playback. Theaters needed special equipment, and if not done just right, it could be a disaster. For a while, it was good enough . . .

Soon, a competing method called Movietone developed and was purchased by Fox Films (soon to merge and become Twentieth Century Fox) for its movies. This system recorded the sound to a track on the same strip of film that had the picture. This proved to be the best solution, and it is a variation of how films are still made today (except for digital movies).

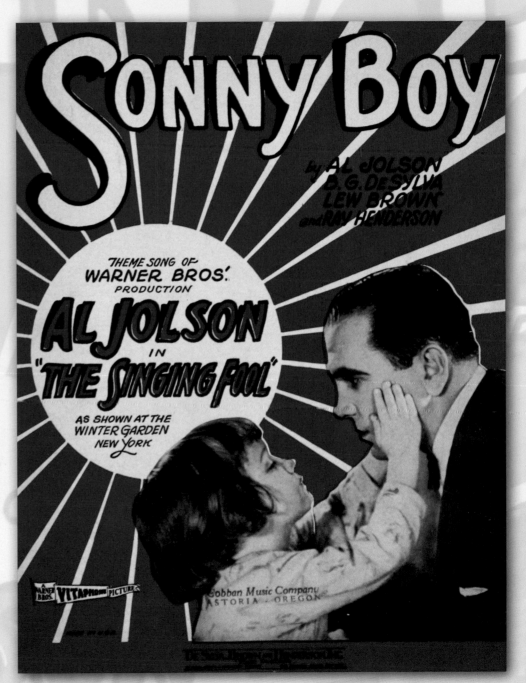

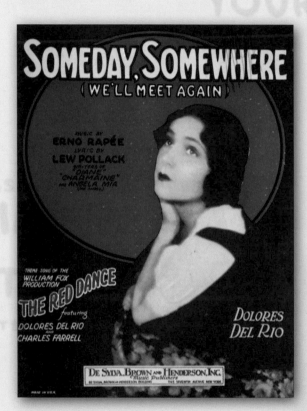

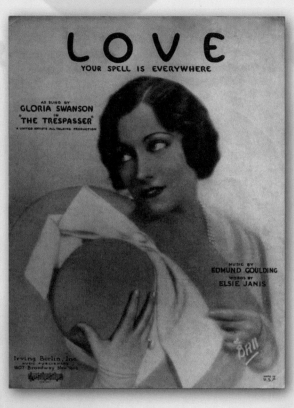

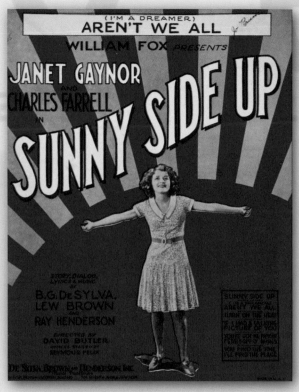

(I'm A Dreamer) Aren't We All (1929)
This romantic comedy, *Sunny Side Up*, by the song-writing team DeSylva, Brown and Henderson, plays on the theme of Cinderella. Janet Gaynor, another highly popular silent film star, sings her way from nothing straight into the arms of her loved one. The previous year, she earned the first-ever Academy Award for Best Actress.

Love (Your Spell Is Everywhere) (1929)
Originally shot as a silent film, *The Trespasser* was quickly remade with sound and was the talkie debut for actress Gloria Swanson. The movie did well, but Swanson did not have as many lucrative film roles with talkies as she did with silent movies.

Someday, Somewhere (We'll Meet Again) (1928)
The Red Dance was a film romance/drama starring Dolores del Rio, who was an exotic-looking Mexican actress and considered one of the most beautiful women of the time.

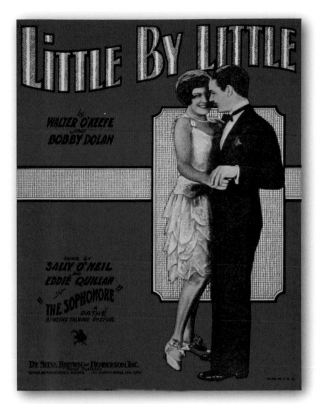

Little By Little (1929)
Even though *The Sophomore* was a "singing talking picture," this is another lost sound film, with only the silent version surviving. Luckily, there still is the sheet music for some of the songs. The well-dressed couple sing to each other and slowly realize they are meant to be together. Pictured are Sally O'Neil and Eddie Quillan.

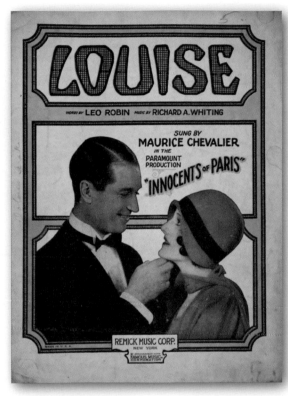

Louise (1929)
The *Innocents Of Paris* was Paramount's very first musical production and the first American role for French actor Maurice Chevalier. He is still identified with the lyrics from this song, as it became almost his signature tune. He continued to make films well into the 1960s.

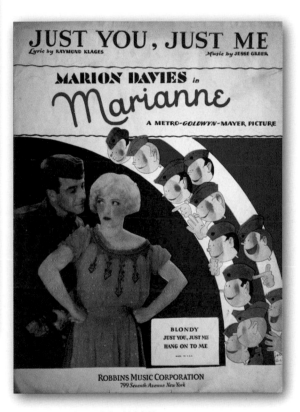

Just You, Just Me (1929)
One of the 1916 Ziegfeld girls, Marion Davies appeared in many silent films, but she is most remembered for being romantically involved with William Randolph Hearst. In this MGM talkie feature, *Marianne*, she is a French farm girl who falls in love with an American soldier in World War I. Comical soldiers surrounding the couple were drawn by a top cartoonist and illustrator of the twenties, John Held.

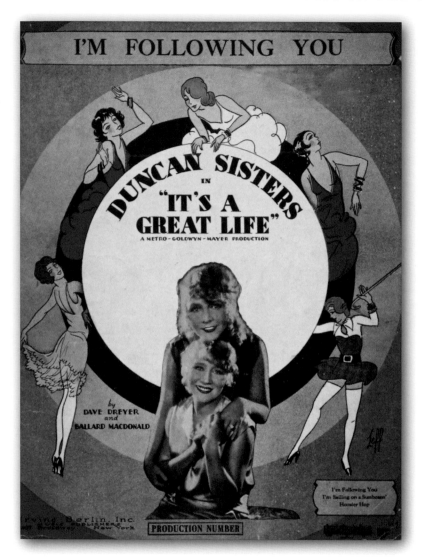

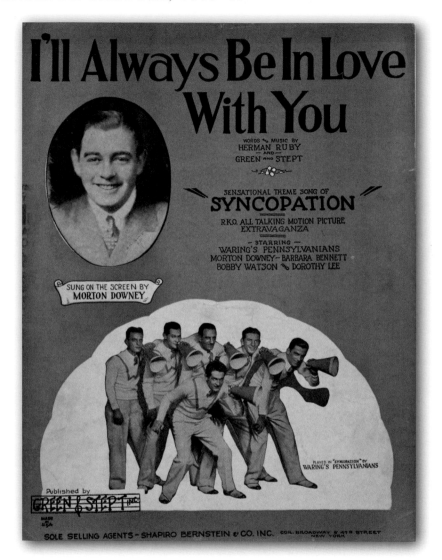

I'm Following You (1929)

A real-life vaudeville sister act, the Duncan Sisters starred in the 1929 film *It's A Great Life*. This was to be their only major attempt in the movies, and it did not do well at the box office, in spite of several scenes filmed in Technicolor. They continued in show business as night-club entertainers for decades, with only occasional forays into films. Stylish female figures by Leff frame the cover, surrounding the photo of the two sisters.

I'll Always Be In Love With You (1929)

The film *Syncopation* was promoted by the studio as the "R.K.O. All Talking Motion Picture Extravaganza." This theme song was sung by Morton Downey, with backing by Fred Waring's Pennsylvanians. They are shown on the cover using the period-style megaphones to amplify their voices. The tune has remained in the performing repertoire since, as a standard blues/jazz number.

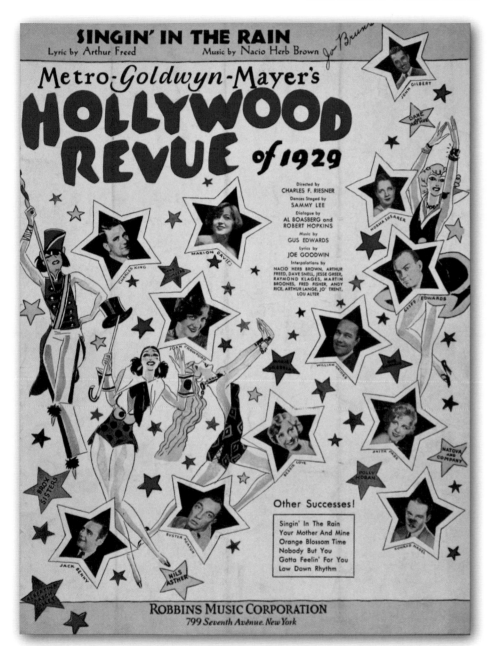

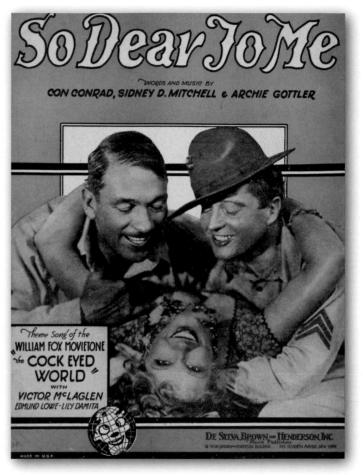

So Dear To Me (1929)

The story of *The Cock Eyed World* revolves around two Marines who are constantly fighting over the same women. It is considered to be the first real movie sequel, following *What Price Glory* from 1926.

Singin' In The Rain (1929)

This is the same song performed by Gene Kelly in the 1952 show *Singin' In The Rain*. The original version was featured in the *Hollywood Revue Of 1929*, a production designed to showcase MGM's roster of talent. Amid the drawings of dancing showgirls are photos of the stars (inside of stars) including Joan Crawford, Marion Davies, Buster Keaton, Jack Benny, and others.

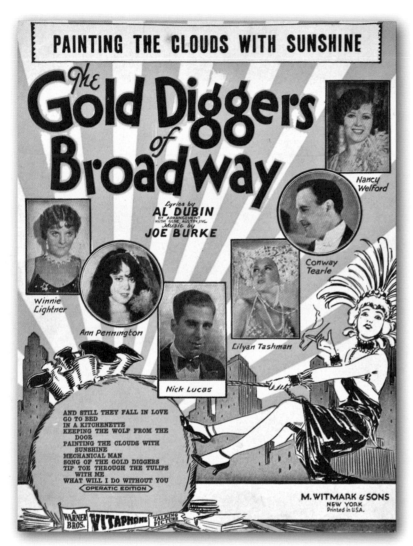

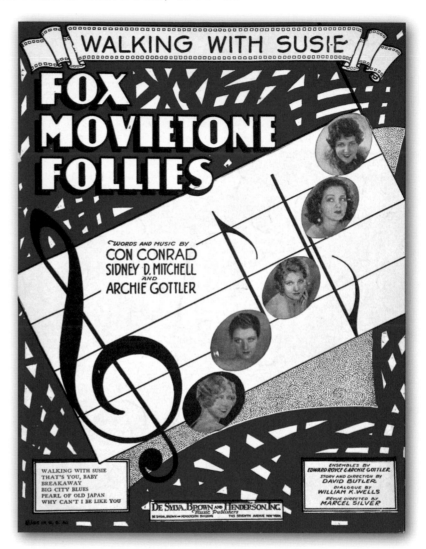

Painting The Clouds With Sunshine (1929)

This was the hit song from *Gold Diggers Of Broadway*, which is the first of five Warner musicals to use the phrase "gold diggers." According to the lyrics, it's all dependent on your attitude toward life and the situations that develop. Also included in the list of songs is the title "Tip Toe Through The Tulips With Me," which resurfaced in the 1960s with Tiny Tim (and his ukulele). Photos of the performers on front, with drawing of a showgirl smoking and tightening a large bag of gold.

Walking With Susie (1929)

Pictures of five unidentified but highly photogenic women from the feature on the cover. They appear as notes on a music staff, with a large treble clef on the left. In the song, all sorts of maladies are listed when in the company of Susie, but it's all due to the effect of love. Other songs from the production are "Why Can't I Be Like You" and "Big City Blues." Unfortunately, this is another film believed to be lost.

By the end of the twenties, the movie companies, in an effort to gain quick access to a large number of songs, went on a buying frenzy to get material, and established publishing catalogs to feed their growing need to fill pictures with songs. For the most part, Tin Pan Alley was now effectively under the control of Hollywood, and many of its composers were drawn west. The future of Tin Pan Alley would never again have the same impact, with few exceptions.

The public's appetite for popular music, in all its forms, became insatiable. Even through the Stock Market Crash of 1929, this interest continued to expand and never slowed down. In fact, music picked up speed, and developed a new rhythm, as it entered the early years of the thirties.

It began to swing . . .

True Blue Lou (**1929**)
Great art deco--style cover from the "all talking, singing, dancing production" *The Dance Of Life*. The plot is about life on the road for two struggling entertainers, played by Hal Skelly and Nancy Carroll on the cover. Some of the other listed titles are "The Flippity Flop," "Ladies Of The Dance," "Cuddlesome Baby," and "King Of Jazzmania."

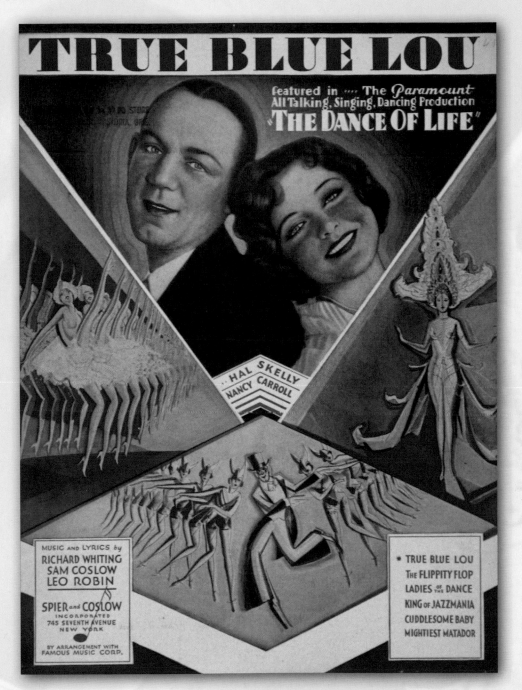

ANDY RAZAF
Music by
MEADE (Lux) LEWIS

As conceived
and introduced by

BOB
CROSBY

AND HIS ORCHESTRA

Published as

SONG
PIANO SOLO

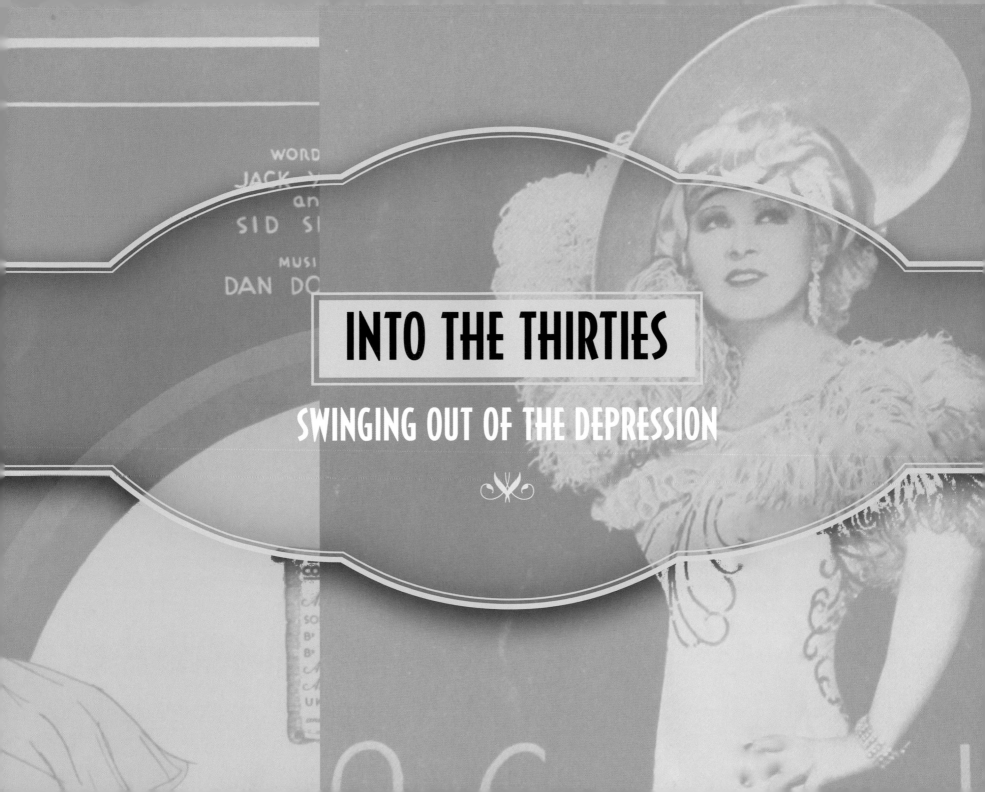

INTO THE THIRTIES

SWINGING OUT OF THE DEPRESSION

While the look of some sheet music continued to be influenced by the art of the illustrators, the use of photography dramatically increased. As the decade advanced, photos of the performers become more prominent, and shots from movies, sometimes in a photo montage, would grace the covers.

As jazz continued to grow in popularity, it also evolved into larger ensembles. Enter the big band era. The arrangements could be sweet or swingy, tasteful or gimmicky, but each orchestra had its own distinctive sound and style. Most even had their own theme songs. Of course, a big band needed a charismatic leader, who would become its face to the public. Benny Goodman, Chick Webb, Glenn Miller, Tommy Dorsey, Guy Lombardo, Cab Calloway, Count Basie, Duke Ellington—all became well known at the time and continue to hold a place in music history.

The bands and their leaders became a draw for movies as well. They would be featured on sheet music covers and theater posters wherever possible, to grab the public's attention.

These groups helped lure millions into dance halls, nightclubs, and movie palaces, creating an excitement that did much to help people escape from the realities of the Great Depression.

Radio now became the major provider of home entertainment. Live radio broadcasts blanketed the country. People would faithfully tune in to catch their favorites and gather around to hear music and shows from everywhere.

With the new music from all these different sources, another series of modern dances hit the country. The Jitterbug, Lindy Hop, and others—all got people "in the mood." Once again, music provided a necessary healing force.

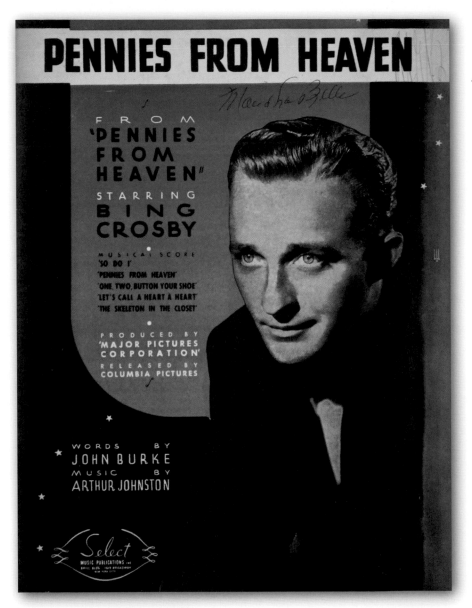

Pennies From Heaven **(1936)**
Bing Crosby sang this wishful theme from the movie of the same name, during the heart of the Depression.

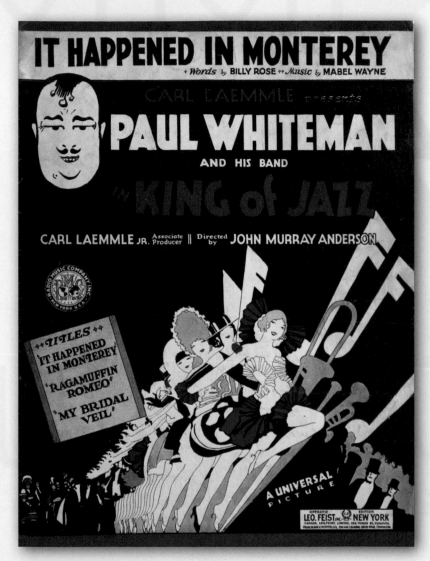

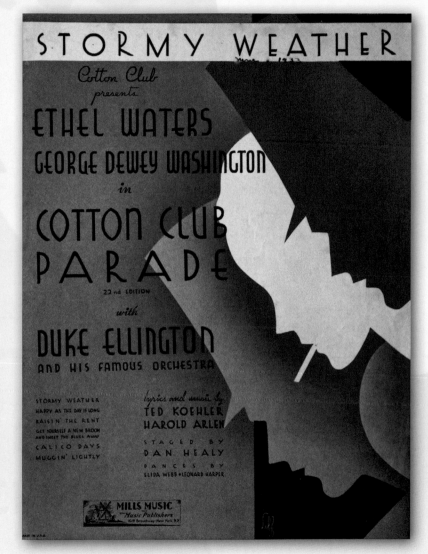

It Happened In Monterey (1930)

The *King Of Jazz* was Universal Picture's first big revue, focusing on the music of the Paul Whiteman Orchestra, and was an early release filmed entirely in two-color Technicolor. While it contained a very diverse selection of material, it became best known for the opening sequence featuring Gershwin's *Rhapsody In Blue*. The movie was also the film debut of Bing Crosby, a Whiteman vocalist.

Stormy Weather (1933)

Outstanding Leff illustration of three silhouetted profiles. The *Cotton Club* was the most famous nightclub in New York's Harlem neighborhood, where though the performers were black, the audience was restricted to whites. Sung by Ethel Waters with Duke Ellington and His Orchestra, this is the original version. With lyrics reflecting both the country's Depression and the singer's personal loss, it instantly became a standard.

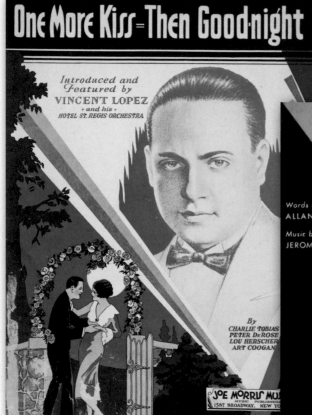

One More Kiss—Then Goodnight (1931)

Vincent Lopez already had a ten-year career as a bandleader by 1931. He'd had his own musical radio show since 1921, and was responsible for giving many players, such as Artie Shaw, Jimmy and Tommy Dorsey, and Glenn Miller, their start. The romantic couple pictured on the cover are trying to prolong their evening together, while the larger drawing is of Lopez, who "introduced and featured" the song with his Hotel St. Regis Orchestra.

Chatterbox (1939)

That's Right—You're Wrong was Kay Kyser's first movie feature, "with all his band." It was a formulaic comedy based on his real-life radio program "Kay Kyser's Kollege Of Musical Knowledge." He is fittingly dressed as a professor on the cover.

And The Angels Sing (1939)

Few people came close to the musical and social influences that Benny Goodman had during the thirties. He is credited with driving the sound of swing into popular culture, and was a strong believer in pushing for integrated bands. Pictured here with lyricist Johnny Mercer and trumpeter Ziggie Elman.

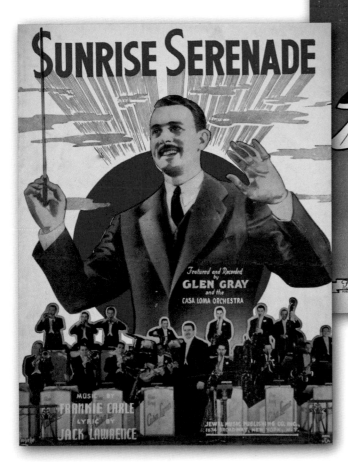

Sunrise Serenade (1938)
Bandleader Glen Gray is shown conducting his Casa
Loma Orchestra. They were one of the most successful
dance bands, touring from 1929 until they disbanded in
1950, due to his ill health.

Blue In Love (1934)
The agony and ecstasy of being in
love, as introduced by Guy Lom-
bardo and His Royal Canadians,
another top big band. They were
known for their "sweet" sound,
which tended toward the overly senti-
mental and schmaltzy. Lombardo be-
came identified with his New Year's
Eve broadcasts, which continued
for almost fifty years. Cover image
conveys the intense look between this
elegantly dressed couple.

Yancey Special (1938)
Bob Crosby and His Orchestra, along with a smaller
ensemble, the Bob-Cats, played a version of swing with a
more New Orleans/Dixieland style than his competitors,
using more traditional jazz tunes instead of pop songs. His
older brother was Bing Crosby.

Here's a fun selection of three song sheets, all from 1931. Song-writers and illustrators continued to explore the subjects of love and romance. These are universal themes, with mainstream appeal. It helps to have amusing titles and illustrations as well.

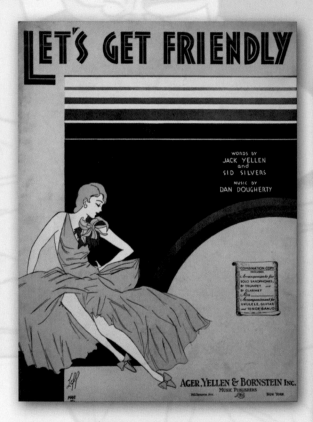

Let's Get Friendly (1931)
A very forward and obvious song, with a captivating illustration by Leff. With overt references to shades for windows and cozy dark corners, it's clear that this woman with the oversize corsage on her dress is ready for anything.

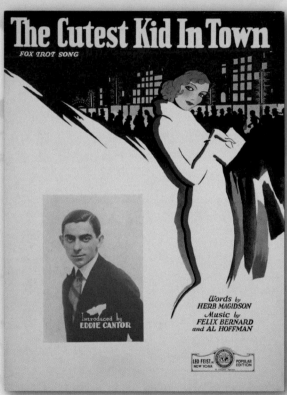

The Cutest Kid In Town (1931)
The song alludes to the Ziegfeld shows and how this woman has them beat. Sly, topical reference coming from Eddie Cantor, in photo. Seductive look from the image of the young woman on the cover.

Pardon Me Pretty Baby (Don't I Look Familiar To You) (1931)
Well-dressed man tries various pickup lines on a smartly attired young lady. He's sure he's seen her before, so he goes through a list of places and events. In spite of her negative responses, he finishes by asking her if they should get together anyway. Persistence can pay off in the long run. Cover by Barbelle.

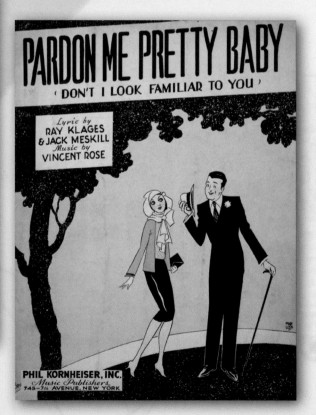

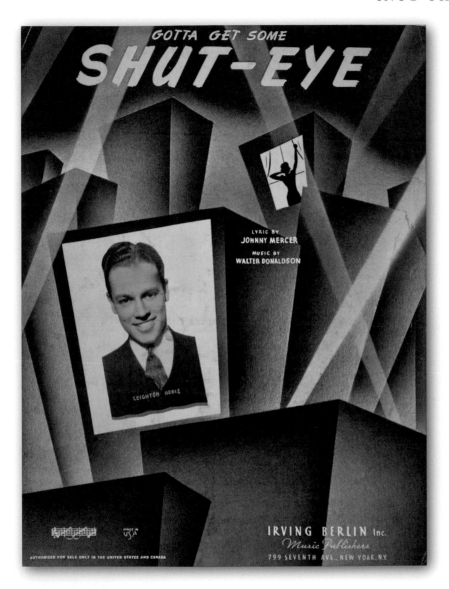

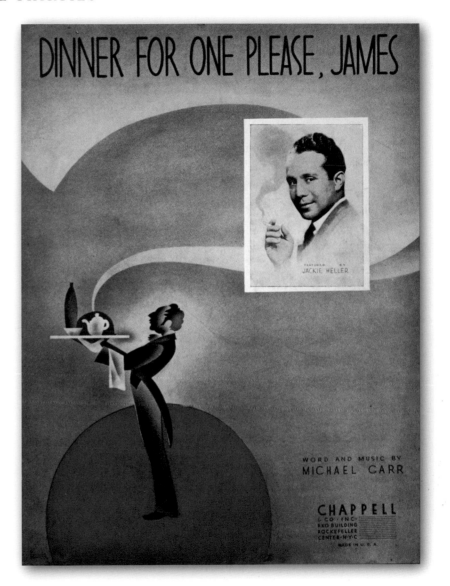

(Gotta Get Some) Shut-Eye (1939)
A mix of searchlights and stylized buildings combine to create an engaging visual effect. The singer needs to get to sleep because she has a lot of things to dream about. She's can't wait to fantasize over the kisses and hugs of her true love. Photo of Leighton Noble on the cover.

Dinner For One Please, James (1935)
Mr. B. instructs his loyal butler that his wife will not be dining tonight, since she has just left him. It appears his best friend has run off with her, having lied to his wife about a nonexistent infidelity by her husband. That's certainly taking it calmly. Featured by Jackie Heller, in photo—smoking.

The trend in movies was toward escapism. Bigger than life. Big casts, big productions. Glamour was the key element for Hollywood. Busby Berkeley productions generated extravagant visual creations and sequences that could never be done live. For people starving for diversion and seeking relief from their everyday existences, this was *magic*.

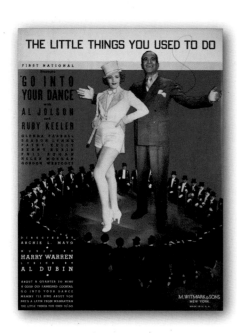

The Little Things You Used To Do (1935)
When *Go Into Your Dance* was made, Al Jolson and Ruby Keeler were married, and this was the only time they starred together in a full-length production. They're surrounded here by a squadron of extras in fancy dress.

No More Love (1933)
A lavish Busby Berkeley presentation that takes place in ancient Rome. The cover shows one of the famous scenes, where a group of Goldwyn chorus girls are presented in a slave market wearing long hair . . . and little else. Certainly lives up to the fitting title for the film: *Roman Scandals*. Photos of Eddie Cantor (in blackface) and Ruth Etting.

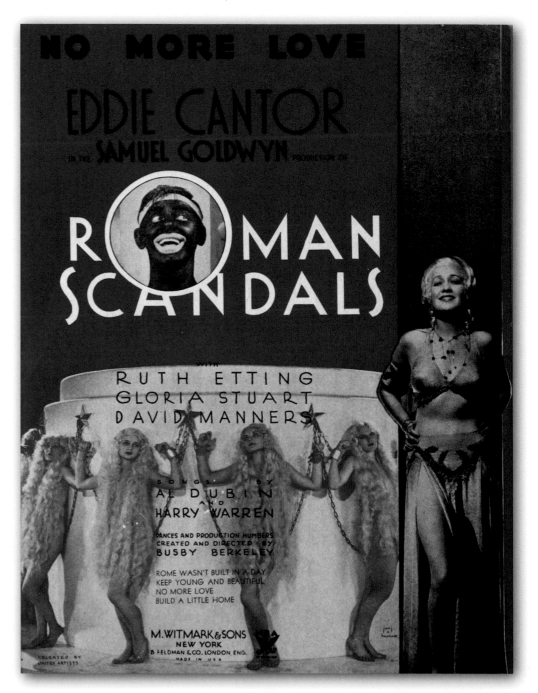

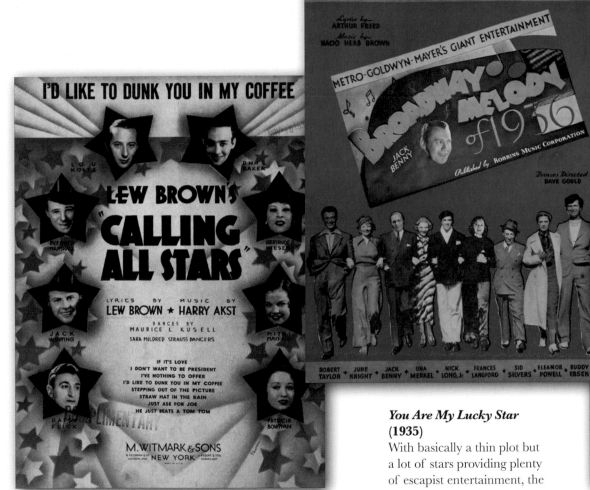

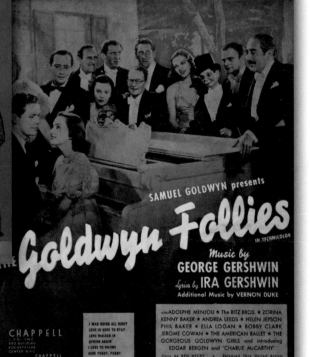

I'd Like To Dunk You In My Coffee (1934)

What a marvelous title for a love song, from Lew Brown's *Calling All Stars*. In the lyrics, there are multiple references to different types of food and drink, all with the conclusion that the loved one would be a very tasty treat. Mmmmm.

You Are My Lucky Star (1935)

With basically a thin plot but a lot of stars providing plenty of escapist entertainment, the *Broadway Melody Of 1936* was perfect for the middle of the Depression. It was billed at the time as "M-G-M's Giant Entertainment." The large cast is arranged across the cover, featuring Jack Benny and a young Buddy Ebsen.

Love Walked In (1938)

Even with an odd cast ranging from a ventriloquist and his dummy to a ballerina and an opera star, *The Goldwyn Follies*' real attractions were the early use of three-color Technicolor, the gorgeous Goldwyn Girls, and the music of George and Ira Gershwin. Sadly, George died during the production, making these his last songs.

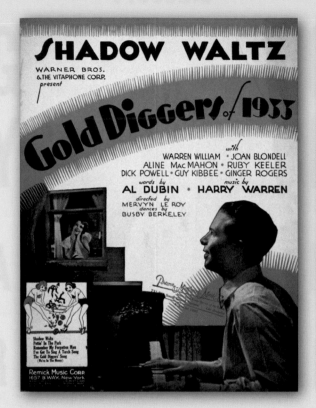

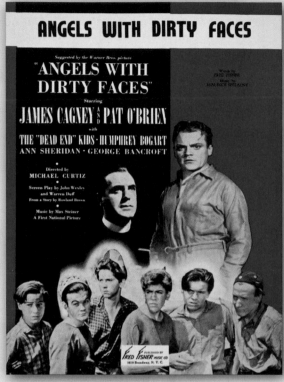

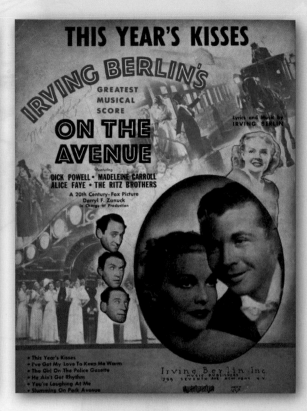

Shadow Waltz (1933)

Gold Diggers Of 1933 was another installment of this Warner Bros. series. It was highlighted with more dazzling numbers by Busby Berkeley. Comical illustration in the lower-left corner of the sheet music shows two sparsely clad young ladies sifting the belongings of a couple of well-dressed men through a sieve and separating them from their money.

Angels With Dirty Faces (1938)

James Cagney and Pat O'Brien portray the gangster and the priest: two friends that grow up and go in different directions. The moral is that choices get made and we live (or die) with the results. The realities of the Depression, tinged with a note of optimism. Many films of this era tried to provide these types of messages, in order to assure the public of hope for the future.

This Year's Kisses (1937)

On The Avenue highlighted the songs of one of the great American composers, Irving Berlin. Other hits from this show were "I've Got My Love To Keep Me Warm" and "He Ain't Got Rhythm." Elaborate staging and production about the problems of getting a new show ready for opening night. Sort of a "behind the scenes" look at Broadway productions.

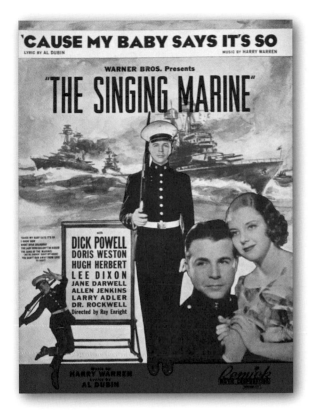

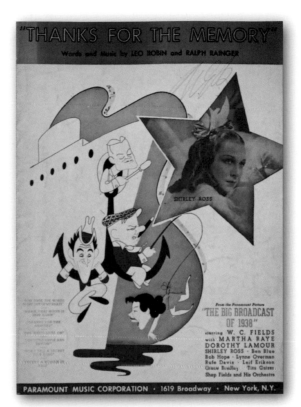

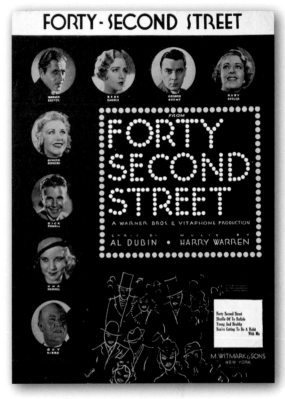

'Cause My Baby Says It's So (1937)
Winning an amateur talent contest while in the Marines makes for some difficult situations for Dick Powell in *The Singing Marine*. But it's nothing that more songs and a few Busby Berkeley show-stoppers can't overcome. Plenty of singing, dancing, and patriotism.

Thanks For The Memory (1937)
The Big Broadcast Of 1938 is notable for being the film debut of Bob Hope, who sings this song on screen. Over time, it became his theme song/ signature tune. With lines that were delivered with heartfelt sincerity, it had just the right mix of fond remembrances, humor, and melancholy.

Forty-Second Street (1932)
Probably the most realistic of the New Deal--era musicals (and one of the most successful), *Forty-Second Street* had themes about pulling together under a strong leader and how hard work will pay off in the end. It was exactly what the public needed during the 1930s. Busby Berkeley had more big dance routines, especially this title-track finale.

The early movies gave us the first wave of Hollywood stars. Whether through comedies, dramas, or musicals, these people gained celebrity status and swept the country by storm. Audiences couldn't get enough of them.

Comedies were very popular in the thirties. They gave audiences a reason to feel good and brought joy to people during this harsh period. Dramas usually preached a moral, which was seen as advice on how to live. Musicals produced hummable tunes, and they all sold a lot of sheet music.

The entire world was introduced to the Marx Brothers, Mae West, Bing Crosby, Clark Gable, Jean Harlow, Ginger Rogers, Shirley Temple, Fred Astaire, Joan Crawford, Dorothy Lamour, and countless others, and they've been with us ever since.

Alone (1935)

A Night At The Opera is a classic Marx Brothers movie that takes a swipe at the upper class of society (and the serious pretensions of opera) while including numerous routines of Marx Brothers craziness and Groucho's never-ending supply of double entendres.

Pictured on the sheet music of "Alone" are Allan Jones and Kitty Carlisle, who sing this ballad, with the Marx Brothers mugging it up overhead.

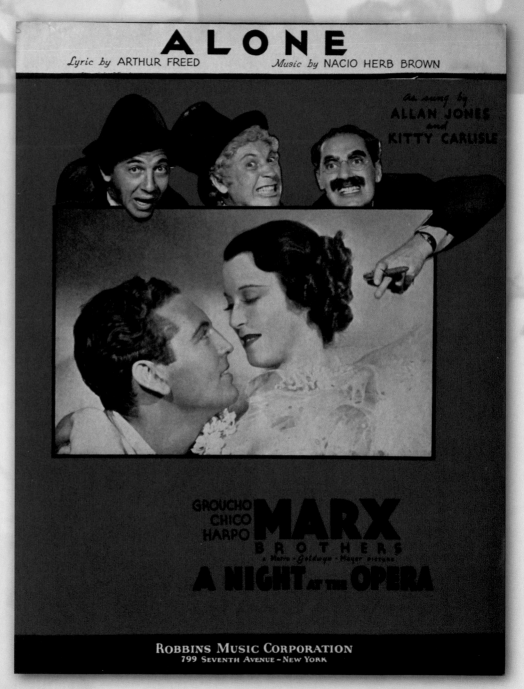

Buckin' The Wind (1933)
This song is from one of Bing Crosby's least-known early Paramount musicals, *Too Much Harmony*. It includes the Depression-era sentiment of being safe from exterior factors and managing to survive. Note the logo at the bottom for the NRA (National Recovery Administration—with the motto underneath, "We Do Our Part"). This act was passed by Congress in 1933 to stimulate economic recovery, but it only lasted two years before the Supreme Court voided it. Only sheets from those two years would have the logo.

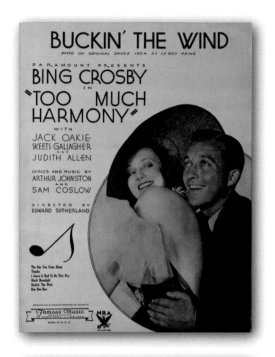

Come To Me (1931)
In *Indiscreet*, Gloria Swanson stars and sings in only her third talkie. According to the tagline of the movie, "Through one indiscretion—a woman with a future became a woman with a past." The star is shown half-reclining on a deco couch.

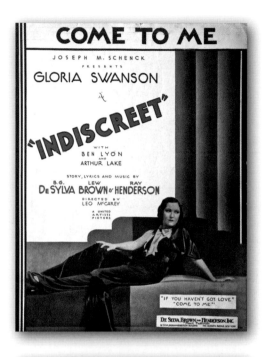

How Long Will It Last (1931)
Joan Crawford gets top billing over newcomer Clark Gable in the MGM drama *Possessed*. As his mistress, she sings and asks the age-old question concerning her long-term future with him. I think she really does know the answer . . .

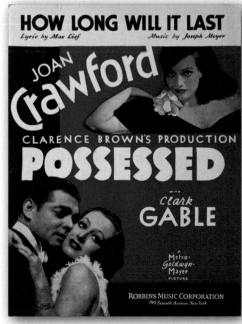

Hold Your Man (1933)
The box office success of *Hold Your Man* was due to the now-established star Clark Gable and the attractive Jean Harlow. Their film romance starts scandalously, but ends properly as they get married, both having spent time in prison to atone for their various misdeeds. Harlow was one of the biggest female stars in the thirties, known as the "Blonde Bombshell" for her almost-platinum-colored hair. However, her career was cut short by kidney failure in 1937. She was only twenty-six.

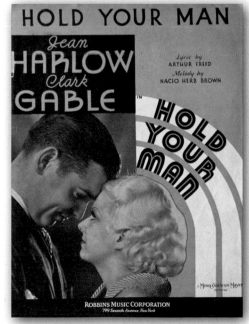

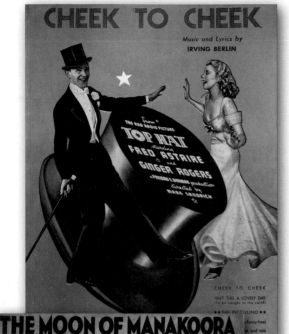

Cheek To Cheek (1935)

Top Hat is arguably the best of the Fred Astaire and Ginger Rogers musicals, with dynamic dance numbers and a wonderful score by Irving Berlin. The fancy-dressed couple is seen on the sheet music cover, with a large top hat as a marquee. Escapism entertainment during the depths of the Depression.

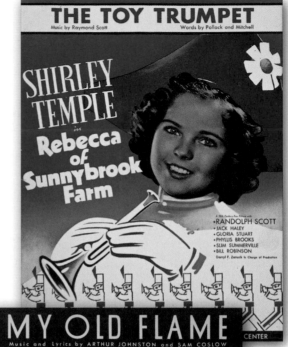

The Toy Trumpet (1938)

Ten-year-old child sensation Shirley Temple had already starred in a number of features by the time *Rebecca Of Sunnybrook Farm* came out. The final scene of this movie shows her and Bill "Bojangles" Robinson dancing on a flight of stairs, dressed as toy soldiers. She was the top box-office draw from 1935 to 1938, according to a *Motion Picture Herald* poll.

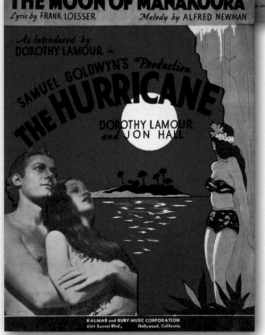

Moon Of Manakoora (1937)

The Hurricane is one of Dorothy Lamour's early movies. Taking place on the mythical South Sea island of Manakoora, it gives her an excuse to run around in a skimpy sarong to good effect, something she would wear with frequency in future films. In the forties, she would become one of the biggest stars around.

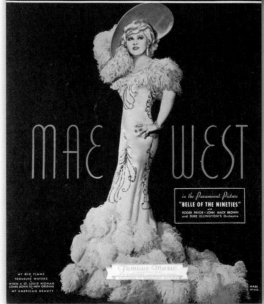

My Old Flame (1934)

From her witty one-liners ("It's better to be looked over than overlooked") to her stage presence, Mae West was a force to be reckoned with as a burlesque queen during the 1890s in *Belle Of The Nineties*. Appearing in period costume does nothing to diminish her sexual attraction. Also in this, her fourth film, is a performance by Duke Ellington.

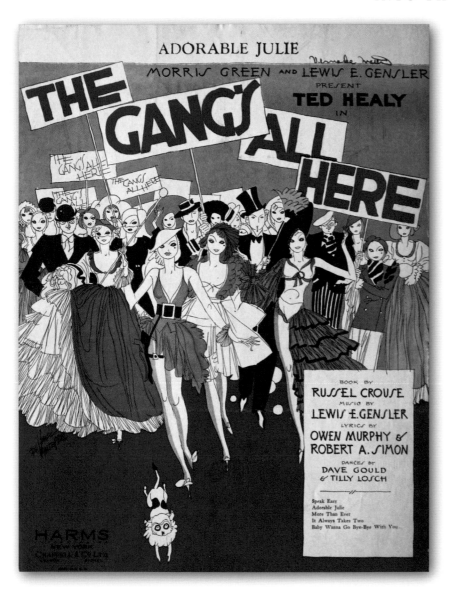

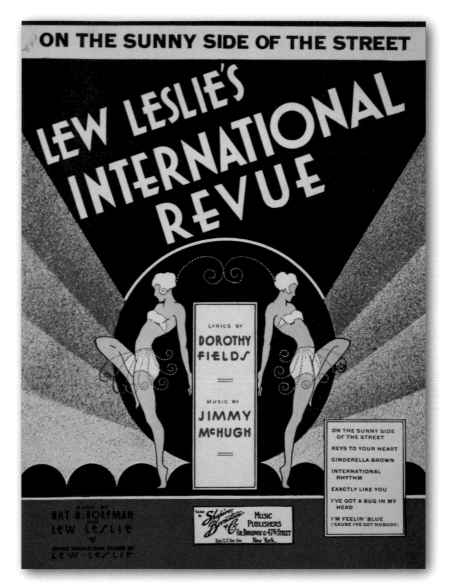

Adorable Julie (**1931**)

Fantastic cover illustration by Patterson for this song from the show *The Gang's All Here*. We're faced with a "gang" of fancy-costumed people, advancing toward us and carrying signs announcing the obvious. Other songs listed from the show are "Speak Easy," "It Always Takes Two" and "Baby Wanna Go Bye-Bye With You."

On The Sunny Side Of The Street (**1930**)

Lew Leslie was famous for introducing black performers to the Broadway stage. This production of his *International Revue* contained a hit song that encouraged a positive outlook in the early years of the Depression. The song would quickly become a standard. Mirror-image deco-style cover.

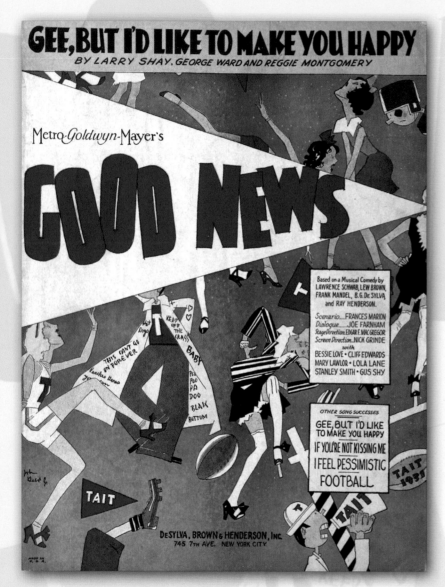

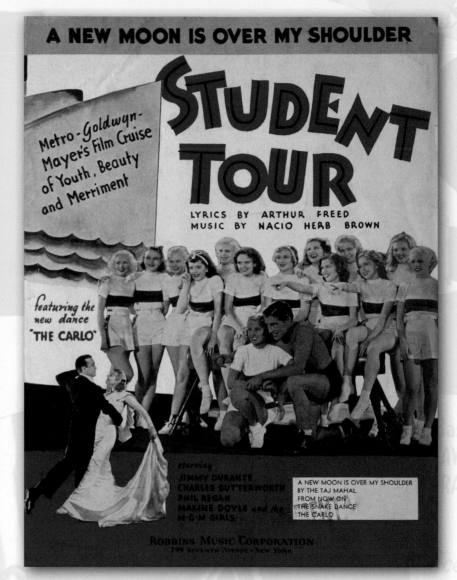

Gee, But I'd Like To Make You Happy (1930)

The early MGM talkie *Good News* was based on a 1927 stage production, and is centered around college life in general and football in particular. The spirited cover by cartoonist John Held reflects the irrepressible energy of the Jazz Age of the twenties, with the dancing flappers and cheerleaders.

A New Moon Is Over My Shoulder (1934)

With a plot about a female college rowing team on an ocean voyage to compete in England, *Student Tour* was not that successful despite the cover blurb: "M-G-M's film cruise of youth, beauty and merriment." The highlight of the show was the big singing and dancing number "The Carlo."

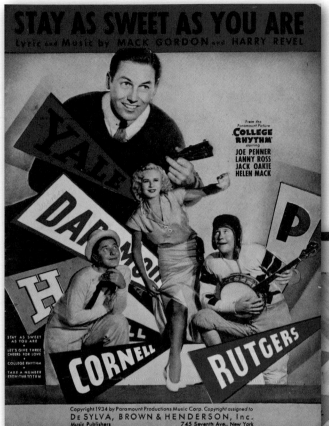

Maybe It's Love (1930)
With the 1929 All-America football team pictured and listed on the cover, *Maybe It's Love* also featured the beautiful Joan Bennett and Joe E. Brown, the comedian. At the time, college football was *the* big thing.

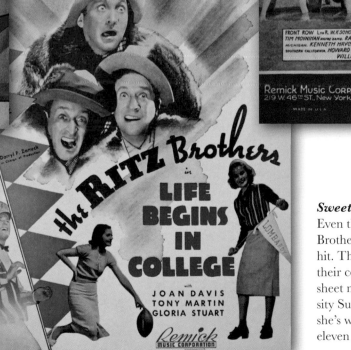

Stay As Sweet As You Are (1934)
In *College Rhythm*, there's a lot of competition, on and off the field. It's the usual struggle between the studious nerd and the jock for the affections of the same girl. Famous college pennants are seen on the cover, along with the cast. Other songs include "Let's Give Three Cheers For Love" and "Take A Number From One To Ten."

Sweet Varsity Sue (1937)
Even the comedy talents of the headlining Ritz Brothers couldn't make *Life Begins In College* a hit. They were never as successful, or funny, as their contemporaries, the Marx Brothers. The sheet music contains a description of Sweet Varsity Sue that covers her allegiance (through what she's wearing) to colleges across the country in eleven different choruses!

Heigh-Ho (The Dwarfs' Marching Song) (1938)
Snow White And The Seven Dwarfs was the real start of the Disney animation empire. The combination of state-of-the-art (for the time) production and the talents of great songwriters would become a Disney trademark. This song was only one of several from the movie to become well-known popular hits. The others were "Whistle While You Work" and "Some Day My Prince Will Come."

Was It Rain (1937)
The cover shows Frances Langford and Phil Regan from the "star-studded production *The Hit Parade*," while also mentioning "and a cast of screen and radio headliners" such as Eddie Duchin with his orchestra, as well as Duke Ellington and his band.

Good Night Angel (1937)
The little known *Radio City Revels* did not lack for an effort of promotion. One of the taglines on the original theater poster read, "More stars of screen and radio than you've ever seen in one mad melodious burst of exciting entertainment!—plus gay romance and rippling rhythm to keep you happy as you laugh till it hurts!" In spite of that, neither the movie nor the songs ever became popular. Image of a skyscraper with panning searchlights, illuminating the individual stars of the production.

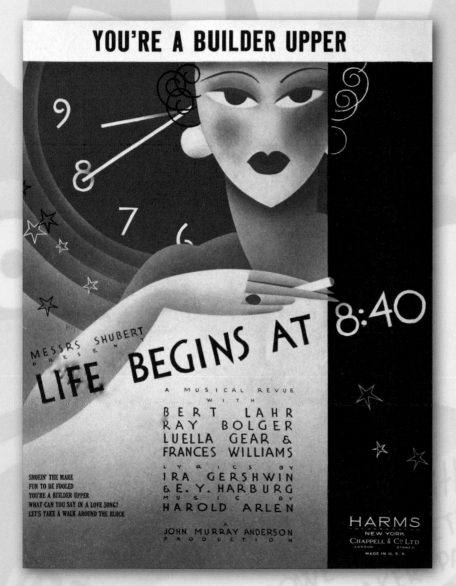

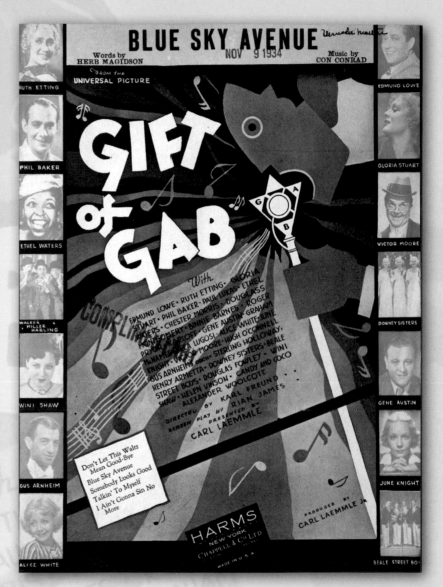

You're A Builder Upper (1934)

Life Begins At 8:40 was a Broadway musical revue, whose title referred to the time that the curtain went up. Running for 237 performances, it gave a big boost to the comedy skills of Bert Lahr, who went on to play the Cowardly Lion in the *Wizard Of Oz*. Great cover by Jorj Harris, with an eye-catching graphic design.

Blue Sky Avenue (1934)

All about a radio announcer who could sell anyone anything. Star-studded cast, including the blues singer Ethel Waters, with cameo appearances by both Boris Karloff and Bela Lugosi. Another wonderful deco cover. Note the call letters of the radio station on the microphone in the illustration: G-A-B.

FORGING THROUGH THE FORTIES

WAR AND RECOVERY

As the forties began, the prevailing music was a continuation of the big bands of the thirties, though the beat slowed down and the sound became mellower. With the world and the country soon at war, the excitement could not be sustained. Gradually, because of expense, groups became smaller, and we saw the emergence of singing stars, like the Andrews Sisters, Dinah Shore, Jo Stafford, and especially Frank Sinatra.

Entertainment was centered on the war effort. Both music and movies had themes, not only of military heroism, but also of separation and longing for home. Sheet music helped keep the cause in the public's eye (and ear).

Logo that appeared on many wartime sheets.

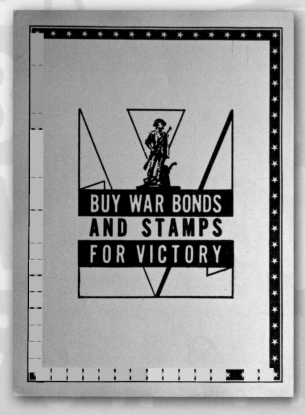

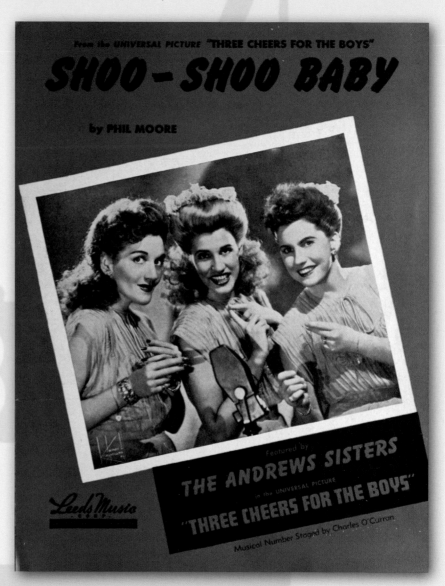

Shoo-Shoo Baby **(1943)**
The distinctive close harmonies of the Andrews Sisters created an identifiable sound that is immediately connected with this time period. *Three Cheers For The Boys* was made by Universal to boost morale on the home front and entertain the troops abroad with an all-star cast.

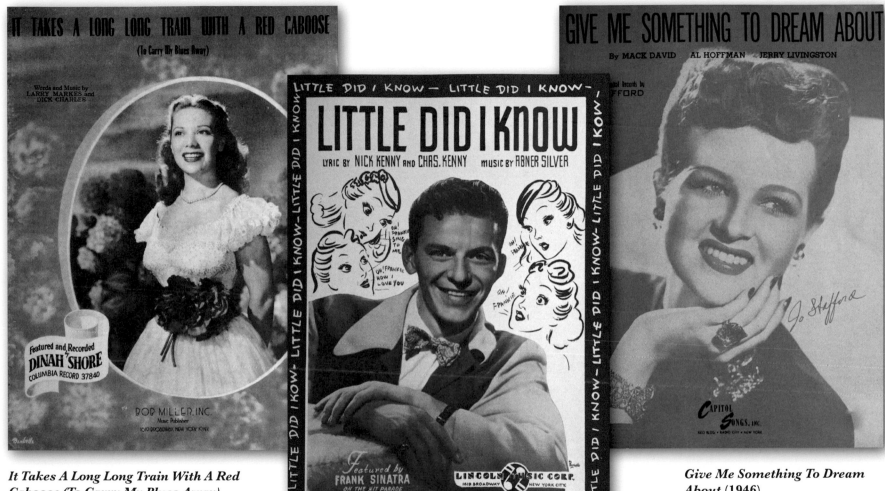

It Takes A Long Long Train With A Red Caboose (To Carry My Blues Away) (1947)
Dinah Shore had great success on radio shows in the early forties, and also participated in many USO tours to support the troops. This song is predictably about the sorrow of having a loved one leave, still a popular theme after the war. Large photo of a very pretty Dinah Shore on the cover, with a flowered waistband.

Little Did I Know (1943)
Starting as a singer with the Harry James and Tommy Dorsey big bands, Frank Sinatra went out as a solo artist and was the idol of the fanatical bobby soxers. Drawn on the cover are female figures who are saying, "Oh! Frankie," "Oh! Frankie, sing to me," and "Oh! Frankie, how I love you." He went on to fame and fortune, both as a singer and an actor.

Give Me Something To Dream About (1946)
Another postwar song about needing something to remember. A versatile vocalist, Jo Stafford was also the radio host for the "Chesterfield Supper Club" airing on NBC, starting in 1945. She never did much acting, concentrating instead on singing.

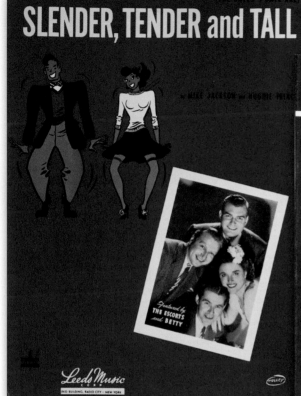

Slender, Tender And Tall (1942)
Featured by the Escorts and Betty, in photo. The song contains choruses for both a man and a woman to sing. They share their thoughts about the attributes of an ideal companion, with the consensus being slender, tender and tall. Somewhat comic illustration of a couple swing dancing, by Holley.

Brooklyn Boogie (1946)
Not only was Louis Prima a talented trumpet player and musician, but he was also a consummate entertainer. In his career, he covered many different music styles, and is probably best known for his Las Vegas lounge act in the fifties, with Keely Smith and saxophonist Sam Butera and the Witnesses.

Oh! My Achin' Heart (1947)
Perry Como started his successful career in the early forties as a pop crooner, and became one of the biggest-selling solo recording artists of his time. He went on to host a weekly musical variety show from 1949 to 1963, and his seasonal specials were one of his hallmarks.

I'm Gonna See My Baby (1944)
A song with a typical war sentiment: looking forward to victory and peace and being reunited with a loved one. The Three Sisters (Bea, Margie, and Gerri) were a "softer" version of the Andrews Sisters in their song presentation and style.

G.I. Jive (1943)
Humorous song from the viewpoint of an army recruit. The illustration by Holley follows the mood of the song, with a drill sergeant looking on with disgust as a recruit on mess duty has stopped peeling potatoes to dance to some music while holding a picture of his sweetheart. Louis Jordan recorded a hit version of this in 1944.

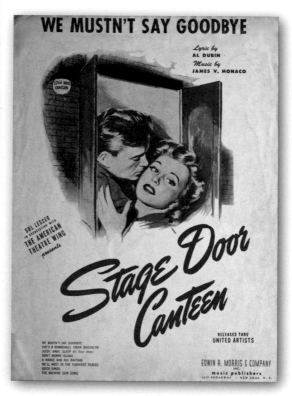

We Mustn't Say Goodbye (1943)

A host of cameo appearances were in this film about the *Stage Door Canteen*, a well-known recreation center for servicemen on leave. Other songs listed from the show are "She's A Bombshell From Brooklyn," "The Machine Gun Song" and "Sleep, Baby, Sleep (In Your Jeep)."

As Time Goes By (1931)

Written over a decade earlier, "As Time Goes By" will forever be identified with the movie *Casablanca*. The classic 1942 war romance featured the song, which soon became a standard. Cover layout and design by Holley, with Bogart and Bergman in a melancholy embrace.

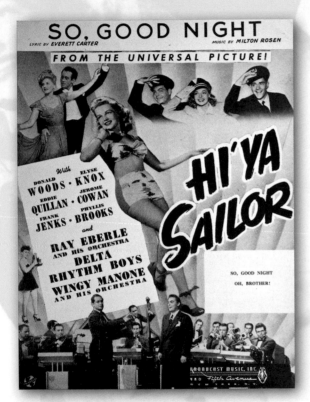

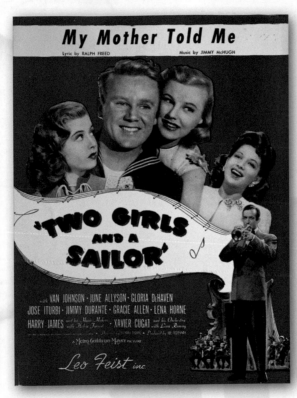

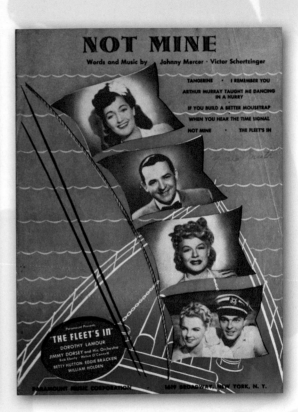

So, Good Night (1943)

This fairly obscure movie, *Hi' Ya, Sailor*, displays a mixture of different musical styles—blues, jazz, and swing. Not much information is available about this production, especially since there were no big-name stars in it. Large central image of a woman wearing a somewhat provocative, for the time, two-piece swimsuit.

My Mother Told Me (1944)

With a plot about two sisters (and a mysterious wealthy admirer) who set up a canteen to entertain soldiers, *Two Girls And A Sailor* was not much more than an excuse to have swinging musical numbers and comedy skits. Performances by Harry James and His Music Makers, Xavier Cugat and His Orchestra, Jimmy Durante, Gracie Allen, and Lena Horne.

Not Mine (1942)

The Fleet's In was another wartime movie musical, starring Dorothy Lamour and Betty Hutton, in her first feature. The movie was a simple, escapist diversion, with musical interest provided by Tommy Dorsey and His Orchestra. It was one of the biggest box office successes of 1942, in spite of still being filmed in black and white.

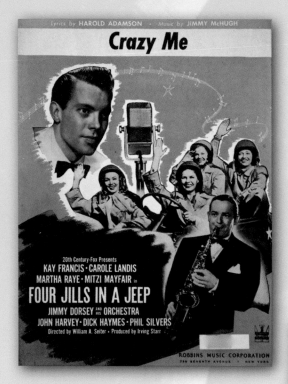

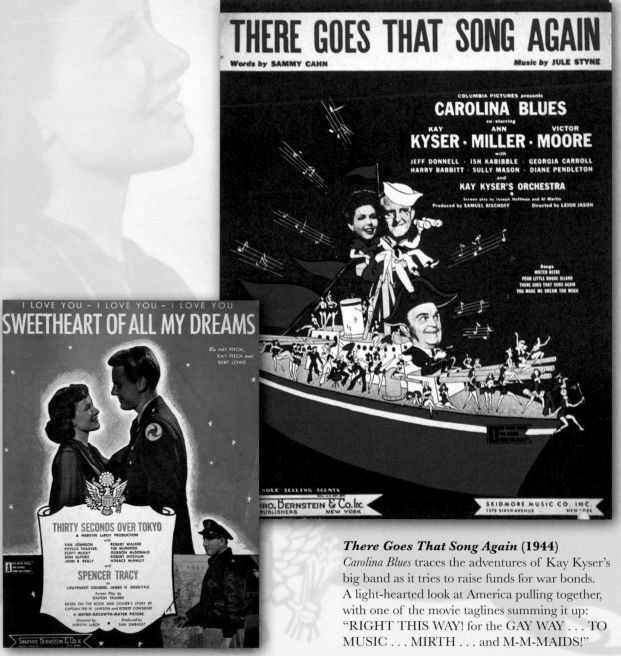

Crazy Me (**1944**)
Four Jills In A Jeep is based loosely on a true story
of female USO performers and their experienc-
es entertaining the troops in Europe and North
Africa during the war. Music was provided by
Tommy Dorsey and His Orchestra.

Sweetheart Of All My Dreams (**1944**)
Thirty Seconds Over Tokyo was a remarkably ac-
curate portrayal of the Doolittle raid on Japan,
based on the book by one of the actual raiders,
Captain Ted Lawson. From all accounts, very
little was changed to create any dramatic effect,
letting the story speak for itself.

There Goes That Song Again (**1944**)
Carolina Blues traces the adventures of Kay Kyser's
big band as it tries to raise funds for war bonds.
A light-hearted look at America pulling together,
with one of the movie taglines summing it up:
"RIGHT THIS WAY! for the GAY WAY . . . TO
MUSIC . . . MIRTH . . . and M-M-MAIDS!"

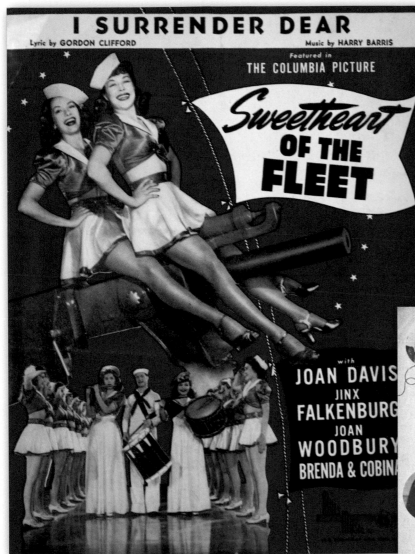

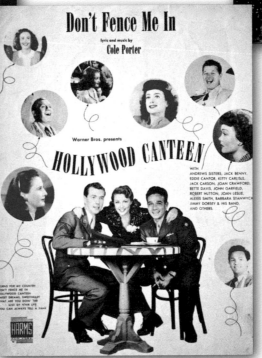

I Surrender Dear (1932)
Older song used in the 1942 movie *Sweetheart Of The Fleet*.
Cases of impersonation and mistaken identity abound in
this musical comedy romance. The meaning of the pose of
the two women at the top eludes me . . .

Let's Take The Long Way Home (1944)
Twin sisters join the Waves (the women's version of the Navy) in *Here Come The Waves*, and both fall in love with the same Navy crooner, played by Bing Crosby.

Don't Fence Me In (1944)
The movie *Hollywood Canteen* was made about the West Coast version of the Stage Door Canteen, a free entertainment club open to servicemen. This production was full of many cameos by the performers who regularly appeared there.

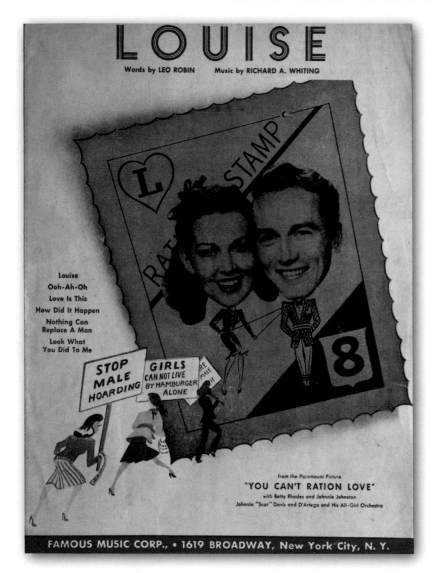

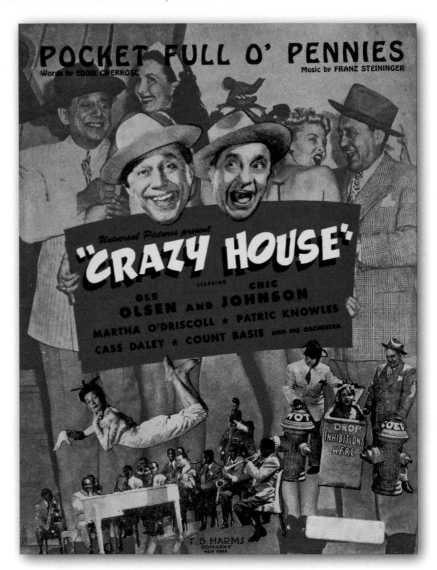

Louise (1929)

Made famous by Maurice Chevalier in the twenties, the song "Louise" was added to the 1944 movie *You Can't Ration Love*. Since rationing scarce resources for the war effort was an important aspect of life, the theme provided a humorous premise for the movie—a school that limits male companionship for women.

Pocket Full O' Pennies (1943)

Crazy House is an aptly named feature about the antics of the slapstick comedy duo Olsen and Johnson. They are down on their luck and try to make a movie, but always end up in the silliest possible situations. Note the cover, with hot and cold fire hydrants, and a woman emerging from a bin labeled "drop inhibitions here." Count Basie and His Orchestra are the featured musical talent.

Humpty Dumpty Heart (1941)
Released less than two weeks after Pearl Harbor, *Playmates* never really caught on with the public. It wasn't that special of a movie to begin with, being basically just a reason to highlight the band leader Kay Kyser (who gets top billing) and his music.

At Last (1942)
Orchestra Wives is notable for being a more realistic and serious view of life behind the stage than would normally be seen in movies of this era. Glenn Miller and His Band were the featured band, with Cesar Romero (bottom left) cast as his piano player. Famous romantic ballad "At Last" was used throughout the movie, and was also a huge hit when recorded by blues singer Etta James in the early sixties. It became her signature tune.

Milkman, Keep Those Bottles Quiet (1944)
A very tongue-in-cheek request from the movie *Broadway Rhythm*. Employed in a factory for the war effort, she sings that she's been working all day building a bomber to help the country win the war. When she gets home her much-needed rest is disturbed by the milkman making a racket with his delivery of milk. Yes, milk was brought to your house, in glass bottles.

Magic Is The Moonlight (1944)
Swimming sensation Esther Williams was featured prominently, in her bathing suit of course, for the promotion of *Bathing Beauty*. Music sequences in the movie were performed by Harry James and Xavier Cugat.

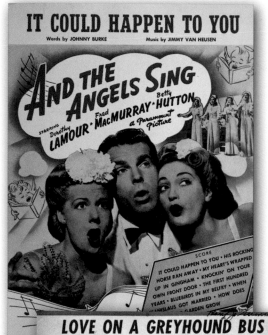

It Could Happen To You (1944)

The basic premise of *And The Angels Sing* is the rise of a singing sister group (whose last name just happens to be Angel) and their trials and tribulations. Other songs from the show are listed as "His Rocking Horse Ran Away," "Bluebirds In My Belfry" and "Knockin' On Your Own Front Door."

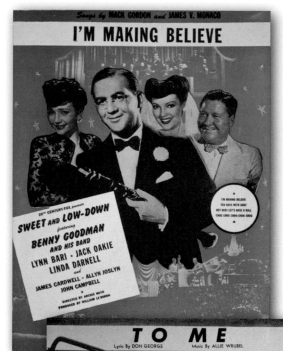

I'm Making Believe (1944)

Once again, there's not much of a plot to this movie, but *Sweet And Low-Down* is a pretty good showcase for Benny Goodman and his band. Other songs listed are "Hey Bub! Let's Have A Ball," and "Ten Days With Baby."

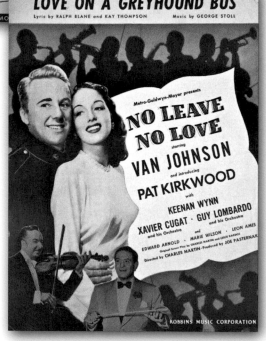

Love On A Greyhound Bus (1945)

In *No Leave, No Love* a Marine returns home from the Pacific to find that his girlfriend has gotten married. In true movie fashion, it doesn't take long for him to fall in love with someone else, to the music of Xavier Cugat and Guy Lombardo.

To Me (1946)

The Fabulous Dorseys is a fictionalized biography of Tommy and Jimmy Dorsey, in which they starred as themselves. It was billed as "the life of two giants of swing era jazz." There is also a cameo appearance by Paul Whiteman, who by now had been around for over twenty years and was still being billed as the "King of Jazz."

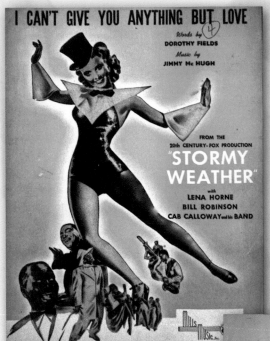

I Can't Give You Anything But Love (1928)

The 1943 musical *Stormy Weather* was important for the use of many black performers in lead roles, which was unusual for the time. On the cover are Lena Horne, Cab Calloway, Bill "Bojangles" Robinson, and Fats Waller, who died shortly after the film was released.

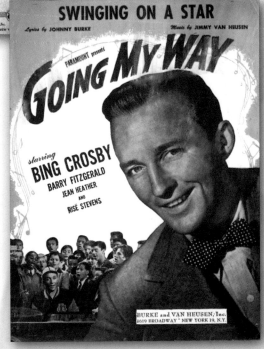

Swinging On A Star (1944)

Winning seven Academy Awards, *Going My Way* cemented Bing Crosby as one of the top box office draws of the forties. This is one of the five songs he sings in the movie. The following year, he also appeared in the sequel, called *The Bells of St. Mary's*.

Blues In The Night (1941)

The title song from this unsuccessful melodrama, which had the unfortunate timing of being released just a few weeks before the attack on Pearl Harbor on December 7. The song was probably the best part of the movie. It gives advice to both sexes about the fickle nature of the opposite sex. Cover layout by the illustrator IM-Ho.

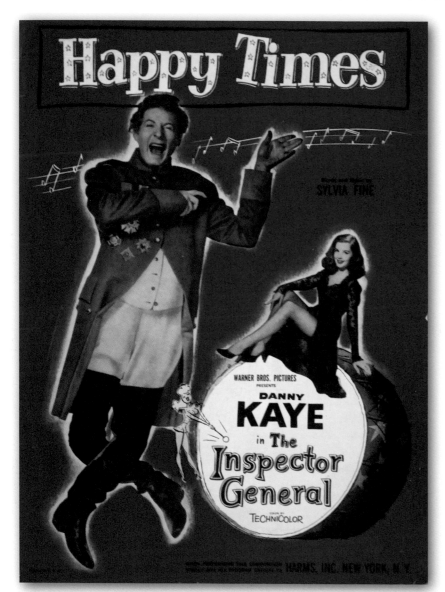

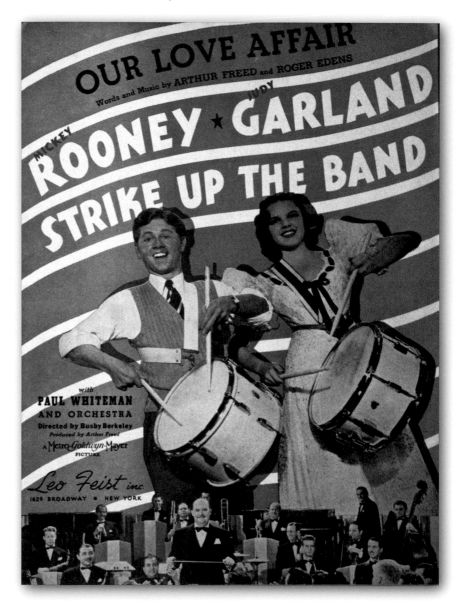

***Happy Times* (1949)**
In *The Inspector General*, it's a case of mistaken identity that leads to all sorts of humorous situations. Danny Kaye's character plays right into this with his quick-talking and clever delivery (plus he sings well).

***Our Love Affair* (1940)**
Mickey Rooney and Judy Garland in one of their movie pairings called *Strike Up The Band*; also featured Paul Whiteman and His Orchestra.

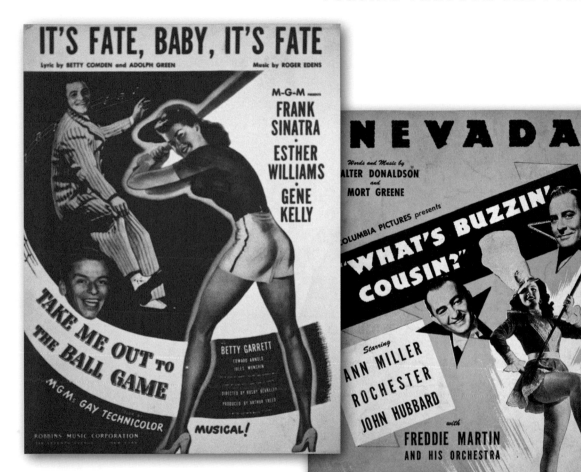

The Third Man Theme (1949)
The Third Man is one of the classic movies of the film noir genre. That refers to a style of picture, usually a crime story or melodrama, that was shot in an atmospheric black-and-white style, with strong performances and moody music. This theme became an international hit, played on a zither, an unusual European folk instrument.

It's Fate, Baby, It's Fate (1949)
The trio of Frank Sinatra, Esther Williams, and Gene Kelly star in this feature about baseball, with the appropriate title *Take Me Out To The Ball Game*. The lyrics of this song reflect the inevitability of love, at least from the singer's perspective. The cover shows Esther Williams in a rare non--bathing suit outfit.

Nevada (1943)
Two of the taglines from the original movie poster for *What's Buzzin' Cousin?* read "Freddy MARTIN and his jivin' gentlemen playing sweet and hot!" and "Ann MILLER dancing dynamo of rhythm!" Not a very successful film, but it featured music by bandleader Freddy Martin and His Orchestra.

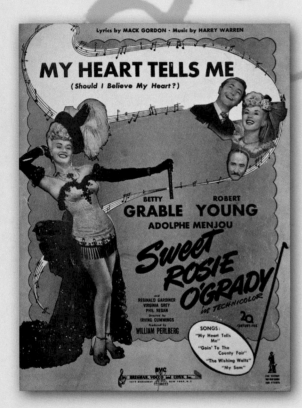

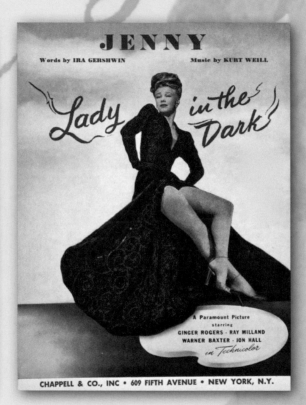

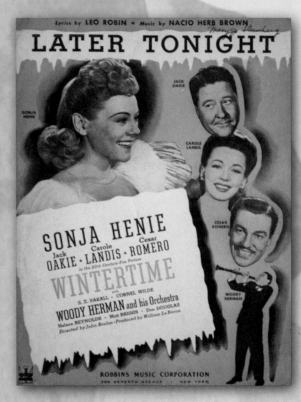

My Heart Tells Me (Should I Believe My Heart?) (1943)

When *Sweet Rosie O'Grady* came out, Betty Grable was the biggest box office attraction of the era. It helped that she was also one of the most famous World War II pin-up girls. The movie is a costume drama, set in the late nineteenth century. The song "My Heart Tells Me" brings up the eternal question "Is this love real?"

Jenny (1941)

The 1943 film of *Lady In The Dark* was based on the earlier (1941) Broadway musical of the same name by Kurt Weill. In the movie, the character played by Ginger Rogers transforms from plain to gorgeous while showing off some of her best assets, as you can tell from the cover.

Later Tonight (1943)

World-famous Norwegian ice skating champion, Sonja Henie, starred in a number of movies that involved skating sequences (no surprise). She was attractive, talented, and in spite of her accent, a fairly good actress in films like *Wintertime*. Woody Herman provided the musical entertainment.

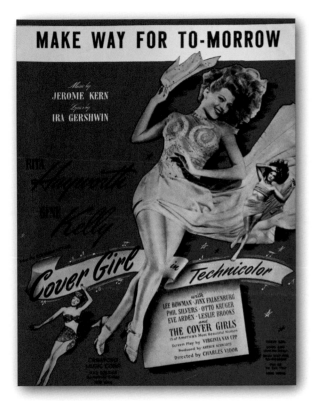

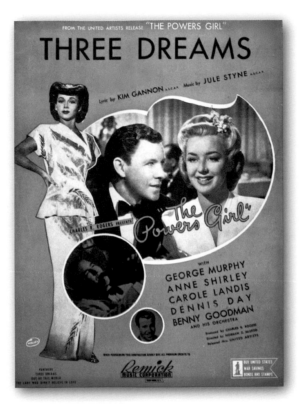

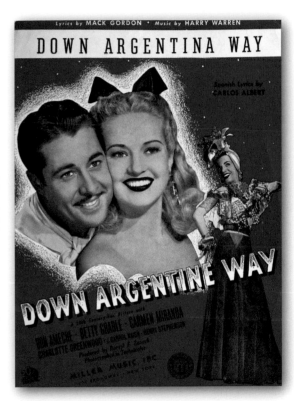

Make Way For To-Morrow (1944)

Basically a showcase for Rita Hayworth and her dance partner Gene Kelly, *Cover Girl* was Columbia Pictures' first Technicolor musical. It was a huge hit with audiences and critics alike, becoming the most popular musical during the war years and winning an Academy Award. The sheet music mentions the fact that it also features "the Cover Girls—15 of America's most beautiful women." A smiling Rita is seen on the cover

Three Dreams (1942)

The Powers Girl was a musical comedy about women employed by the real-life John Robert Powers modeling agency. The movie did not have much of a plot, but Benny Goodman and His Orchestra provide plenty of swinging music, with one song sung by a newcomer named Peggy Lee.

Down Argentina Way (1940)

This was the first leading role for Betty Grable, as well as the debut performance for Carmen Miranda, with her fruit-laden headpiece, to American audiences. *Down Argentine Way* gives a positive impression of the country, since this was filmed before dictator Juan Peron came into power.

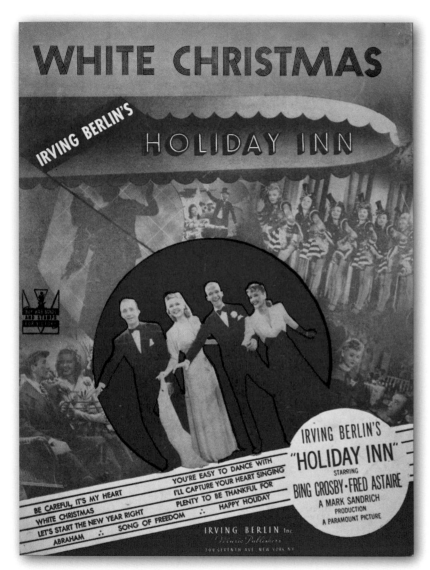

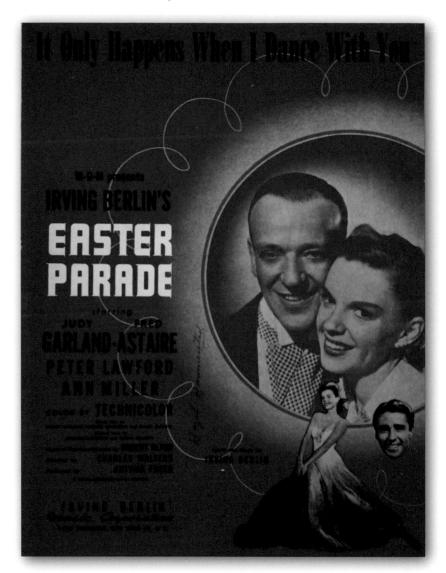

White Christmas (1942)

Irving Berlin scored the entire movie *Holiday Inn*, which produced one of the most-recorded songs ever: "White Christmas." It earned the Academy Award for Best Original Song in 1943. The sentiment of fond remembrance hit a nerve with people distraught and away from their loved ones because of the situations of the war.

It Only Happens When I Dance With You (1947)

Easter Parade was another classic film with all songs by the great Irving Berlin, and that won the 1948 Academy Award for Best Original Music Score. This song was a duet between Judy Garland and Fred Astaire, who are pictured on the cover along with Ann Miller and Peter Lawford.

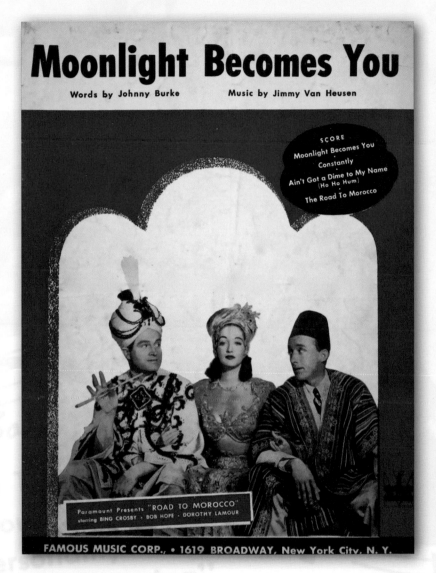

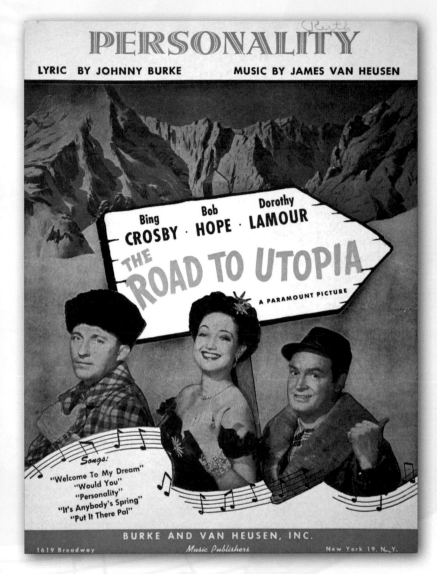

Moonlight Becomes You (1942)

A series of seven "Road" pictures solidified the partnership of Bing Crosby and Bob Hope, and also included Dorothy Lamour. These comedies combined adventure, music, and romance, and even contained many running gags. They were done as satires of some of the more common film genres of the time. *Road To Morocco* was the third.

Personality (1945)

The plots were never quite as important to this series. It was all about the interaction between the three main characters—making crazy plans, doing silly things, and getting into various forms of trouble. The *Road To Utopia* was filmed in 1943 but not released until after the war in 1946, and was the fourth in the series.

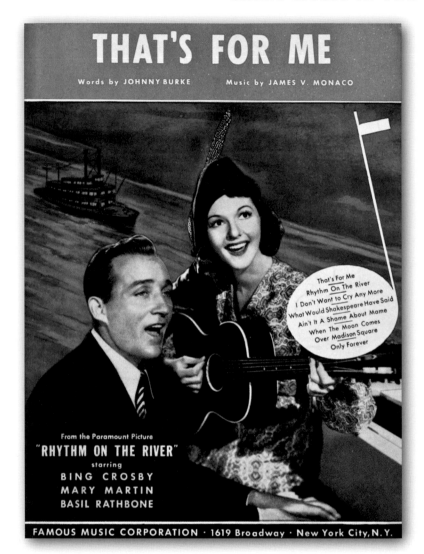

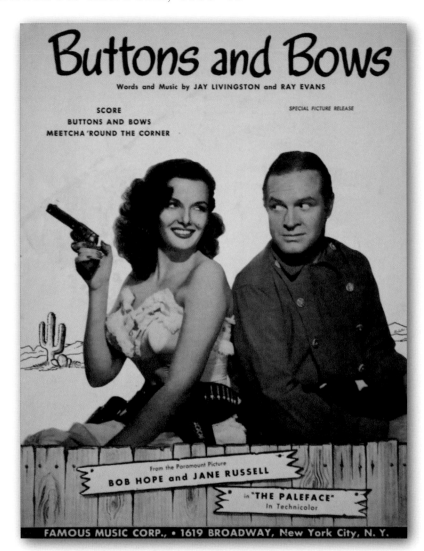

That's For Me (**1940**)

In *Rhythm On The River*, Bing Crosby and Mary Martin are a songwriter and lyricist who work for a common partner yet are unknown to each other. They finally get together and struggle to establish themselves as a team. Much singing follows. Other songs from the movie are "Ain't It A Shame About Mama" and "What Would Shakespeare Have Said."

Buttons And Bows (**1948**)

The comedy Western *The Paleface* features an unlikely couple, with Jane Russell as tough female gunslinger Calamity Jane and Bob Hope as a cowardly and inept dentist from the East. Of course, they end up married, having humorous adventures that always seem to work out. "Buttons And Bows" became a huge hit for Hope, and it won an Academy Award for Best Song.

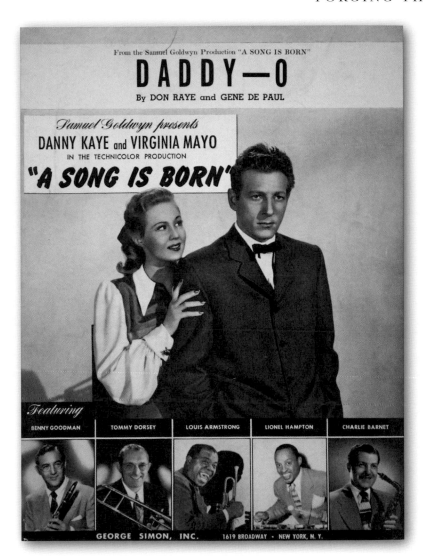

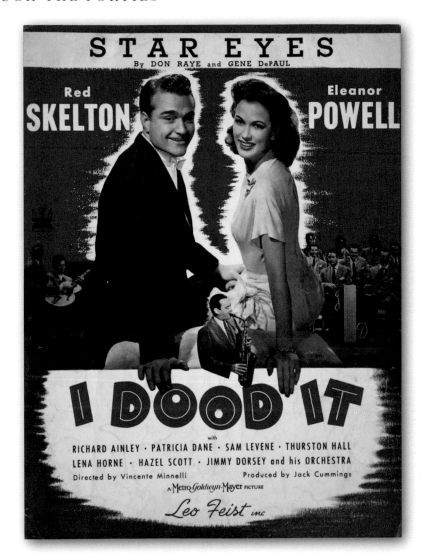

Daddy-O (1948)

A Song Is Born contained almost a who's who of jazz greats, as seen by the photos on the cover. In the movie, Danny Kaye is a mild-mannered professor, putting together an encyclopedia of music. He starts to learn about this new music called "jazz," which gives the plot a large opening to feature performances by all of the above legends and others.

Star Eyes (1943)

The movie title *I Dood It* was a catchphrase taken from one of Red Skelton's radio programs when he was playing a character called "Mean Widdle Kid." Over the course of his career on radio and TV, he established quite a number of unique character parts. In this movie, Skelton and Powell played a fairly mismatched couple, while the featured band was Jimmy Dorsey and His Orchestra. Both are looking back at us from the cover, with the band in the background.

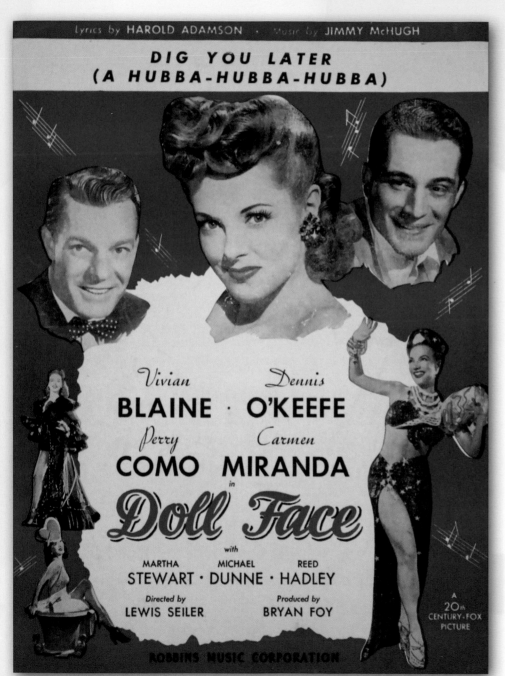

Dig You Later (A Hubba-Hubba-Hubba) (1945)

Based on a play written by the burlesque performer Gypsy Rose Lee, the movie *Doll Face* was more about the extravagant musical production numbers than the plot. This song became a massive hit for Perry Como as a swing-novelty number.

The lyrics are absolutely filled with the slang of the period, while the content of the choruses are basically about both the war and love. References are made to dropping bombs from B-29s on the Japanese in Tokyo, to the other extreme of the then-current fashion of women wearing bobby socks. The song always returns and repeats the song title. Basically, the male singer is trying to make small talk, while trying to convince the woman to go out with him, because he likes her.

Multiple photos of the stars from the movie on the sheet music cover, with a great close-up of the elaborate period hairstyle on Vivian Blaine.

The American people were uprooted in the years after the war—restless. Music was on the move as well. The blues continued to emigrate from the cotton fields to the big cities as more blacks headed there, yet it also went through a change. The music had a newer feel: a jump, a shuffle, raw, shouting. It mixed blues with jazz, and became early rhythm and blues. Performers like Big Joe Turner, Louis Jordan, Wynonie Harris, Roy Brown, and T-Bone Walker helped establish the style.

The distribution and exposure of "race records," as the music was now being called, gradually made its way from urban blacks to the notice of younger white audiences. Other factors came into play, such as the arrival of amplified instruments (especially the guitar), along with the rise of independent record labels. The stage was being set, the foundation poured. The transformation needed a little more time, but it would all happen in the next decade. This music generated a new style that pushed the industry and changed the world.

As the title of the Muddy Waters song goes, "The Blues Had A Baby And They Named It Rock 'n' Roll."

To be continued . . .

Is You Is, Or Is You Ain't (Ma' Baby) (1944)
The cover states, "Universal Pictures presents *Follow The Boys*," which was a studio effort to create a musical film that would be a morale booster for the folks at home and the troops on the front lines. It was an all-star cast, and used almost the entire roster of entertainers that Universal had under contract. The song was cowritten by Louis Jordan, who performed it. Pictures of the stars are shown on the cover, literally in stars.

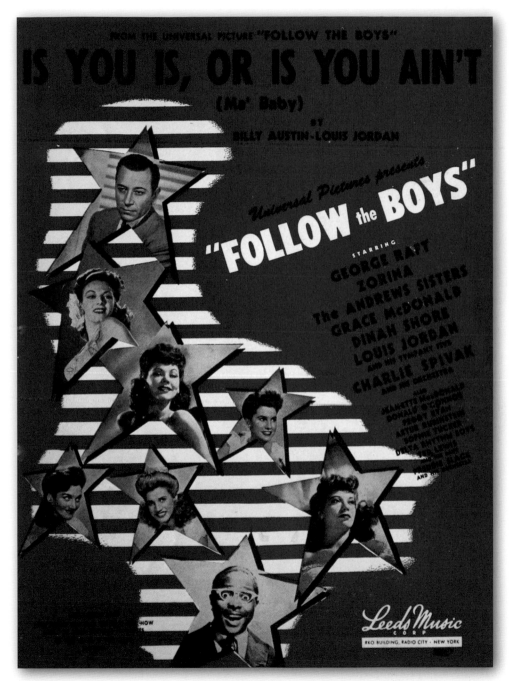

PATRIOTISM AND WAR

"My country 'tis of thee,
Sweet land of liberty,
Of thee I sing"

America (My Country 'Tis Of Thee) (1831)
Words: Samuel Francis Smith

Patriotism was the flag that people rallied around during the two world wars. The emphasis was on boosting morale at the front line and at home. The songs were about pulling together for the common good, sacrifice, duty, keeping hope alive. Pride of country and belief in America ran strong.

The need for military service was promoted and encouraged. Songs about the armed forces and different branches of the service became great recruiting tools. Images of the American flag were everywhere, as were the colors red, white, and blue.

A whole range of emotions is represented. From the initial cocky, patriotic sentiments, to the grieving sadness for loss of life, to the hopeful expectations for the end of the war and the return of the soldiers—these were powerful statements made by the people for the people . . . and for future generations. Americans were never so united as they were during these times of war in the first half of the twentieth century.

The songs made it clear that the determination and will of the country was strong and that America would triumph. This was especially true during World War II, when almost every piece of music bore on the cover the patriotic message "Buy War Bonds and Stamps for Victory."

Arise, Arise, America (1917)
"The world with awe shall see, your sons unite and fight as one, for peace and liberty, and as of old, we shall uphold, the rights of humanity." Words and music by Bernardo Jensen. Illustration by Cravens.

Say, You Haven't Sacrificed At All! (1918)

A wounded soldier points an accusing finger at the people back home who are complaining about war restrictions. In the lyrics he recounts how until you've experienced the horrors of war on the battlefield, any minor inconveniences you have to put up with at home are nothing. *"Have you ever shed a drop of blood for Uncle Sammy? Have you ever charged out there on No Man's Land? Have you ever heard your captain call Over the Top? Till you know how bullets sing, how they ring, how they sting, say, you haven't sacrificed at all."* Lyrics by J. Fred Lawton.

Strike For Freedom (1906)

A march two-step, written for solo piano. Bold lettering with elaborate details on the cover.

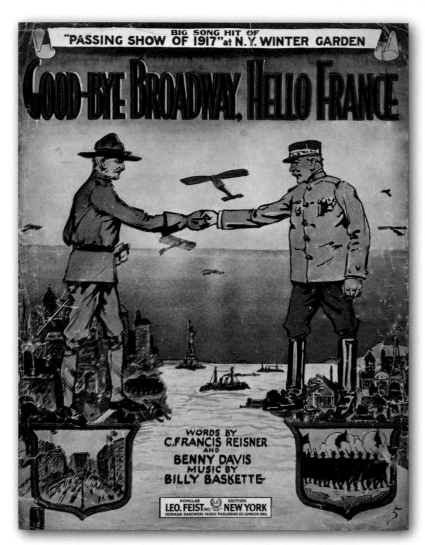

Good-bye Broadway, Hello France **(1917)—front cover**
In a literal "hands across the ocean" illustration, American General Pershing and
French General Ferdinand Foch are shown shaking hands as a sign of coopera-
tion between the two nations. America was just entering the war, and Foch was
the commander-in-chief of the Allies in France. The shields beneath the figures
contain images of Times Square in New York and a group of marching soldiers.
Between them are seen ships, planes, and the Statue of Liberty in the distance.
This song was from the Broadway production *The Passing Show Of 1917.*

Good-bye Broadway, Hello France **(1917)—back cover**
An ad for the pocket songbook *Songs The Soldiers And Sailors Sing*, published by Leo
Feist. The headline reads, *"They Can't Stop Our Singing Army!"* and goes on to list such
songs as "We Stopped Them At The Marne," "Where Do We Go From Here," "It's
A Long Way To Berlin, But We'll Get There," "I Want To Go Home," and "Good
Morning Mr. Zip, Zip, Zip," among others. It assures the potential buyer that "You'll
never regret the 15 cents you spend for your copy of this wonderful folio."

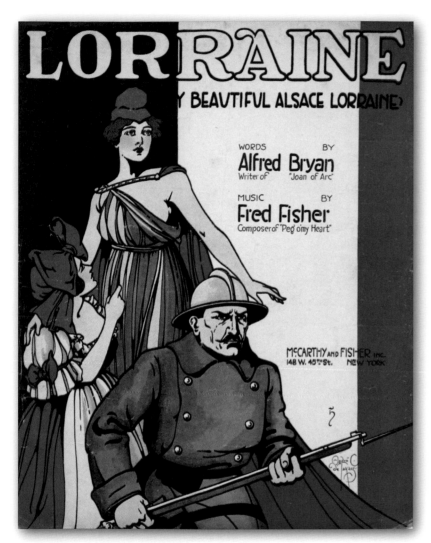

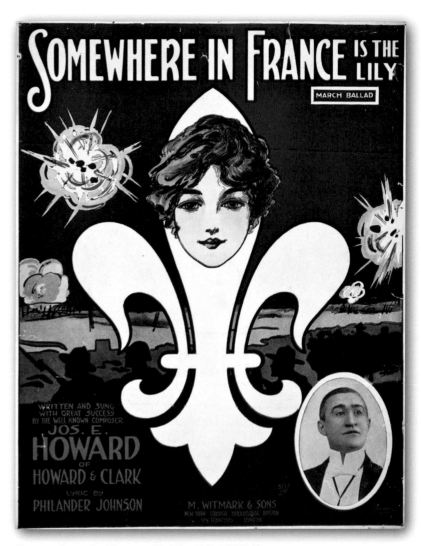

Lorraine (My Beautiful Alsace Lorraine) **(1917)**
A fierce-looking French soldier dreams of the people and places of his beloved country homeland: *"Heart of France, part of France, someday when all of my worries are through, I'm coming to you, Lorraine, welcome me home once again."* Andre De Takacs illustration, with words by Alfred Bryan.

Somewhere In France (Is The Lily) **(1917)**
In the background is a raging battlefield, with exploding shells and smoke. Superimposed is a large fleur-de-lis, which is a stylized lily and recognized as the symbol of France, with a woman's face. The lyrics by Philander Johnson use the analogy of various flowers (English rose, Scottish thistle, and Irish shamrock) to tell us, *"Somewhere in France is a sweetheart, facing the battle's chance, for the flower of our youth fights for freedom and truth, somewhere in France."* Cover by Starmer.

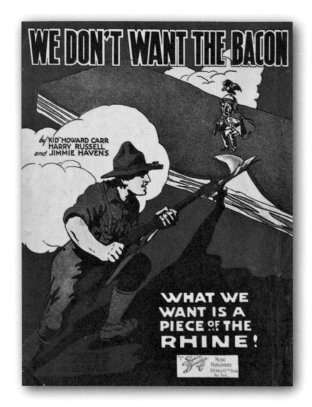

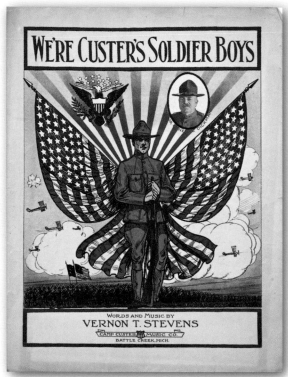

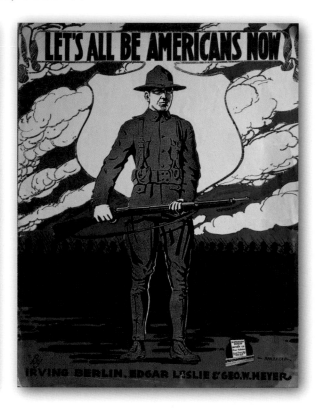

We Don't Want The Bacon (What We Want Is A Piece Of The Rhine) (1918)

A song by Carr, Russell, and Havens with a sly and humorous play on words. The cover shows a doughboy slicing his bayonet into a slab of bacon, on which stands a tiny figure of the German Kaiser. The soldier is cutting off the top layer (pork rind). *"We have always held our own with any foe, we've always brought the bacon home, no matter what they've done, but we don't want the bacon now, we're out to get the Hun."* With typical American confidence, it goes on to say, *"We'll crown Bill the Kaiser with a bottle of Budweiser, we'll have a wonderful time."*

We're Custer's Soldier Boys (1917)

A strongly patriotic cover, with two large American flags and the Official US Seal of an eagle grasping olive branches for peace and arrows for war while bearing the banner reading *E Pluribus Unum* (Out of many, one). Camp Custer was one of the biggest World War I military training facilities, and was named after the famous (infamous?) cavalry officer George Armstrong Custer. Photo inset is of Major General Dickman, the camp commander. *"For we're Camp Custer's fighting soldier boys, we're Yankee Doodle Doos, and when we start a fighting in that foreign land, there is goin' to be a hot time raised by Uncle Sam."* The music was privately published by Camp Custer Music in Battle Creek, Michigan, with words and music by Vernon Stevens.

Let's All Be Americans Now (1917)

Written by Irving Berlin, Edgar Leslie, and Geo. Meyer, this song is a call to action for all Americans who, despite their ethnic backgrounds, need to unite together. *"Now that war's declared, we'll show we're prepared, and if fight we must . . . but you'll agree that, now is the time, to fall in line, you swore that you would so be true to your vow."* Barbelle illustration of a soldier at the ready, with a long line of troops behind him.

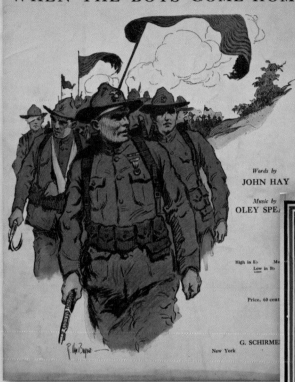

WHEN THE BOYS COME HOME

Words by
JOHN HAY

Music by
OLEY SPE...

High in E♭ Me...
Low in B♭

Price, 60 cent...

G. SCHIRMER
New York

When You Come Back (1918)

With the subtitle "And You Will Come Back, There's The Whole World Waiting For You," it can only be another one of George M. Cohan's strongly optimistic and flag-waving songs. *"We know no fear, we know no tear, and all we hear is the Yankee cheer."* His photo adorns the cover, with the inscription "Sincerely Yours" and his autograph in facsimile.

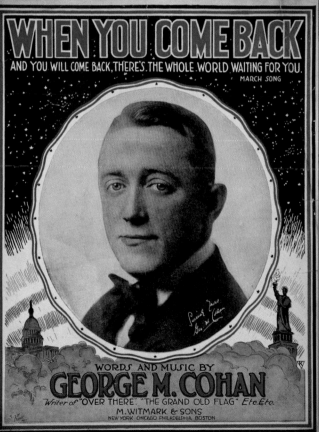

WHEN YOU COME BACK
AND YOU WILL COME BACK, THERE'S THE WHOLE WORLD WAITING FOR YOU.
MARCH SONG

WORDS AND MUSIC BY
GEORGE M. COHAN
Writer of "OVER THERE." "THE GRAND OLD FLAG" Etc. Etc.
M. WITMARK & SONS
NEW YORK CHICAGO PHILADELPHIA BOSTON

THE GREATEST PATRIOTIC BALLAD OF THE SEASON
SAY A PRAYER
FOR THE BOYS "OUT THERE"

WORDS BY
BERNIE GROSSMAN
MUSIC BY
ALEX MARR

Polly Russell

JOE MORRIS MUSIC CO. 145 W. 45th ST., NEW YORK.

When The Boys Come Home (1917)

The lyrics for this song were actually written by John Hay while he was the private secretary to President Lincoln during the Civil War, but they were set to music in 1917. *"The day will seem brighter when the boys come home, and our hearts will be lighter when the boys come home, wives and sweethearts will press them in their arms and caress them, and pray God to bless them."* The artwork of weary, wounded soldiers was by Raeburn Van Buren.

Say A Prayer For The Boys "Out There" (1917)

Advertised as the "Greatest Patriotic Ballad Of The Season." A family sits around the dinner table and prays for all those who are serving in the war. It's interesting to note the empty place setting, the framed image in a military uniform hanging on the wall behind them, and the lone figure walking the perimeter of the camp on guard duty. Inset photo is of Polly Russell, while the illustration is by Starmer.

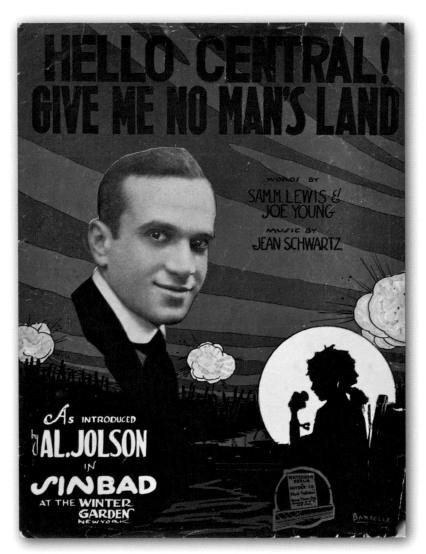

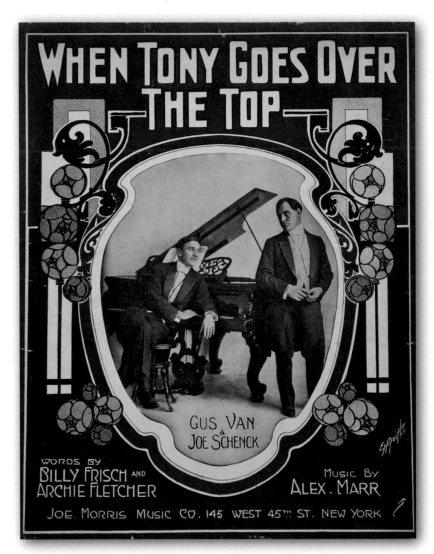

Hello Central! Give Me No Man's Land **(1918)**

"No man's land" was the area between the trenches of opposing forces during the first World War. With the telephone system of the time, a caller needed a central operator to place calls. A small child tries to reach her father, who is off to war, on the battlefield, using these words by Sam Lewis and Joe Young: *"So won't you hurry, I want to know why mamma starts to weep, when I say 'now I lay me down to sleep.'"* Barbelle-designed cover, with Jolson photo.

When Tony Goes Over The Top **(1918)**

Very ethnic-sounding (and politically incorrect) lyrics, written by Billy Frisch and Archie Fletcher, about Tony the Barber and what happens when he goes to war. *"When Tony goes over the top, he no think of the barber shop, he grab-a-da gun and chase-a-da Hun, and make 'em all run like a son-of-a-gun . . . when Tony goes over the top, keep your eyes on that fighting wop."* Pfeiffer-designed border around the photo of the well-known Vaudeville duo of Van & Schenck.

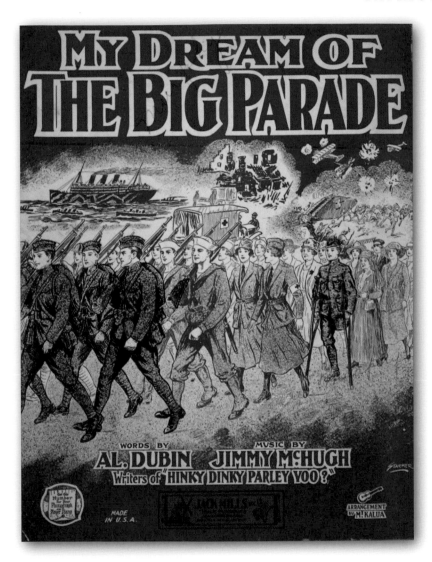

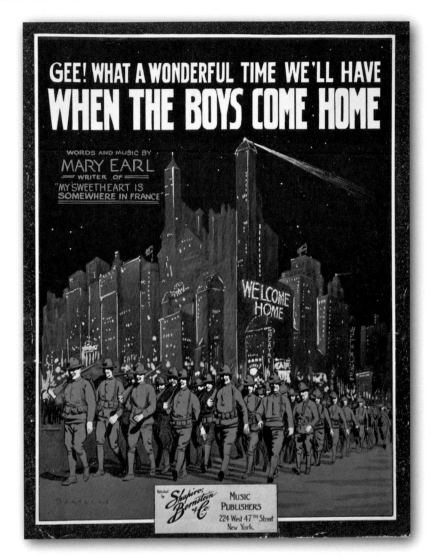

My Dream Of The Big Parade (1926)

Looking back from the vantage point of ten years later, a man sings about the dreams he still has about the war. It's really about the parade of images that are shown, as drawn by Starmer. This has always been a problem for returning soldiers. Includes a separate recitation that can be done over the music, listing transport ships, battlefield conditions, aerial dogfights, Red Cross nurses, marching soldiers (including a one-legged pal), and the relatives of those that did not return. Very sobering.

Gee! What A Wonderful Time We'll Have When The Boys Come Home (1917)

In anticipation of the end of the war, the sheet shows a parade of soldiers marching down Broadway with all the lights lit up to welcome them back. The lyrics by Mary Earl proudly state, *"The flags will fly and the bands will play, we'll all turn out with a smile so gay, and ev'ry one shouting 'Hip, Hip, Hooray!' when the boys come home."* Another Barbelle illustration.

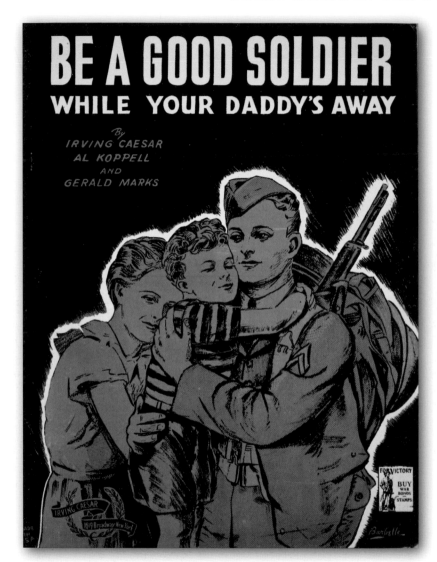

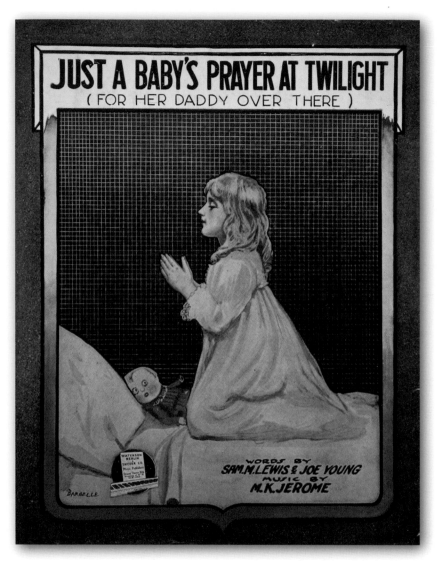

Be A Good Soldier While Your Daddy's Away (1942)
Good wartime songs could convey a message on a very personal level. The anguish of leaving a family behind is felt by everyone, as seen in this poignant image by Barbelle. The soldier going off to war tells his son to obey the orders from his mother while he's gone, and not to cry because that's something soldiers don't do.

Just A Baby's Prayer At Twilight (For Her Daddy Over There) (1918)
A simple request from a child to God as she says her nighttime prayers: *"Oh kindly tell my daddy, that he must take care."* This was written by the same lyricists that wrote "Hello Central! Give Me No Man's Land," Sam Lewis and Joe Young. It's interesting to note that the two covers on this page with very similar subjects were done by the same artist (Barbelle) twenty-four years apart, covering both world wars. The longevity of his career was outstanding.

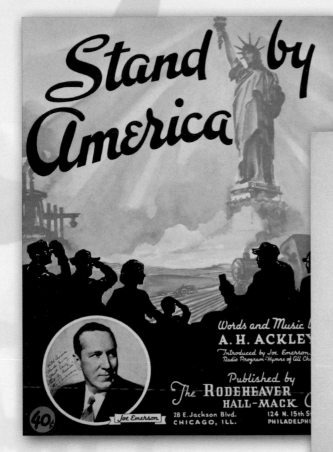

We Must Be Vigilant (1942)
Early on in World War II, we were not getting a lot of positive news from the front lines. This song, featured by Phil Spitalny and His All-Girl Orchestra on the "Hour of Charm" radio broadcast, reinforces the idea that we have to persevere. Photo on the cover shows us images of both him and his vocal orchestra.

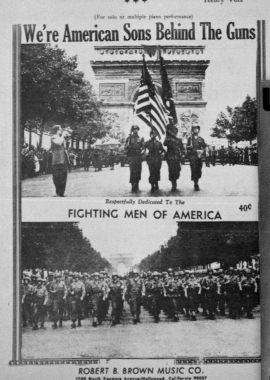

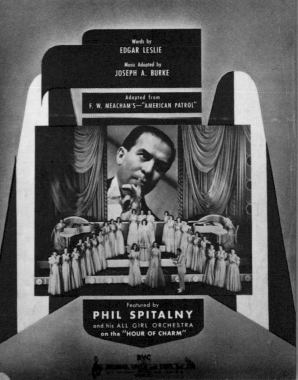

Stand By America (1939)
With the Statue of Liberty in the background, the silhouettes of Americans are saluting her as a symbol for freedom. The song is a plea to help defend and protect the freedoms we have from any enemy. By this time, most of Europe was already at war, while we would shortly be drawn into it as well.

American Peace March (1945)
With the subtitle "We're American Sons Behind The Guns," it is "respectfully dedicated to the Fighting Men of America." The two photos are of the American forces as they triumphantly march through a liberated Paris.

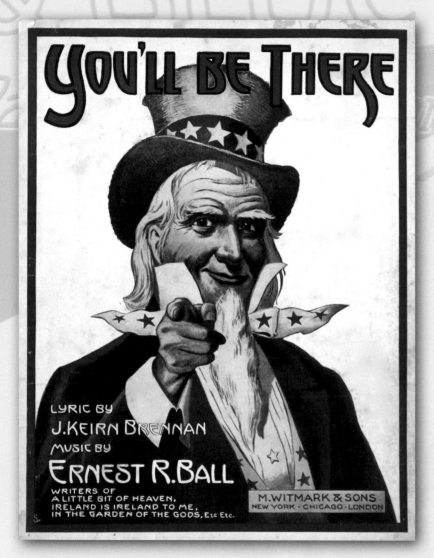

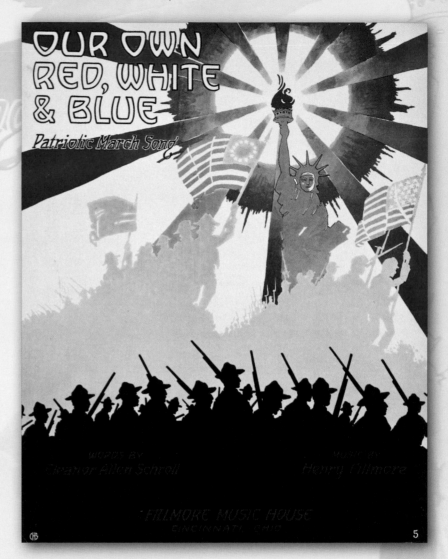

You'll Be There (1915)

Even though the US didn't officially enter the war until 1917, Europe was fighting from 1914 onwards. Factions in our country were for isolationism, but there was a strong feeling for getting involved as well. The figure of Uncle Sam looks at you and says, *"If this peace were threatened by some foe, to stop them, would you go? . . . for our race was never known to run, when they come we'll meet them gun to gun, North and South, yes every mother's son, you'll be there, you'll be there."* Lyrics by J. Keirn Brennan.

Our Own Red, White & Blue (1917)

With the torch from the Statue of Liberty shining like a beacon, we can see three rows of soldiers. In the foreground, they are all dressed like the contemporary World War I soldiers. Middle distance shows ghostlike figures representing the Civil War. Then further back is a line of Revolutionary War soldiers. Using the lyrics of Eleanor Allen Schroll, *"At our country's call, we'll go one and all, and we promise the doubting foe, in our blood is still, the spirit and will, of our fathers of long ago."*

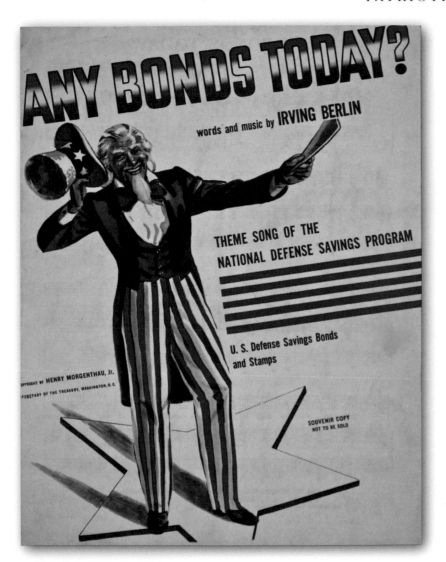

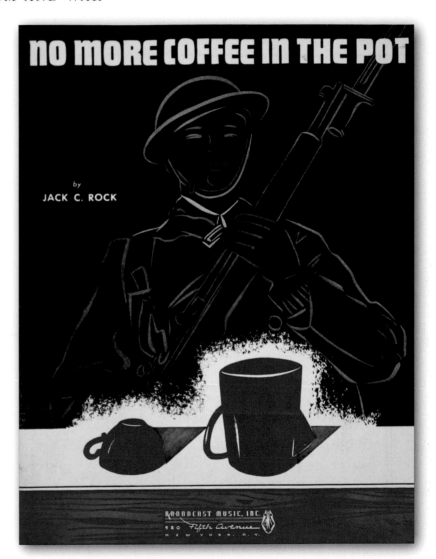

Any Bonds Today? **(1941)**

The great American composer Irving Berlin wrote this song to encourage people to buy bonds in support of the war effort. Of course, the person doing the asking is none other than the very patriotically dressed Uncle Sam himself. The copyright of the song is actually registered to the Secretary of the Treasury, Henry Morgenthau.

No More Coffee In The Pot **(1943)**

A song about the necessity of rationing in order to win the war, with a stark and dramatic cover. Many everyday items were in short supply because of the logistical problems associated with fighting a war on two fronts—European and Pacific. The last thing the government needed was to have unrest at home, and this song was propaganda to make sure people understood the reason.

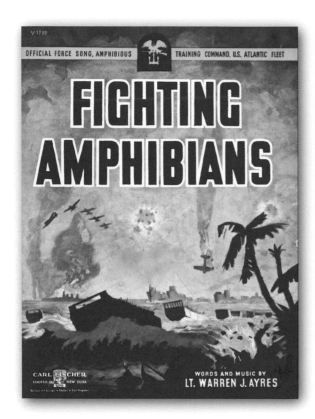

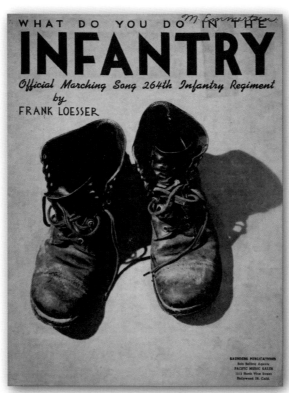

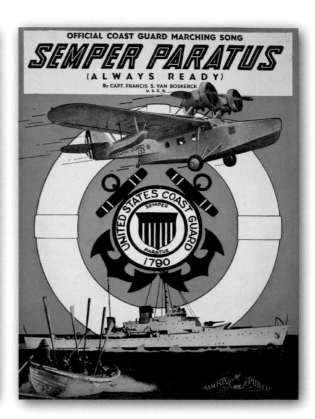

Fighting Amphibians (1944)
This was the "Official Force Song for the Amphibious Training Command, U.S. Atlantic Fleet." Cover shows an action-packed scene of an American landing on a Japanese island. The use of landing craft was essential on both fronts for our invasion forces.

What Do You Do In The Infantry (1943)
Frank Loesser was already famous as a lyricist before he joined the army. As a private, he learned firsthand about the daily toil of a solider. Great cover image for the "Official Marching Song of the 264th Infantry Regiment." He wrote a number of other patriotic and stirring service-related songs, the most famous being "Praise The Lord and Pass The Ammunition."

Semper Paratus (Always Ready) (1928)
While the Official Coast Guard Marching Song was originally written in 1928, this 1942 reprint edition shows the many ways that the United States Coast Guard aids and protects the country. Shown are a seaplane, cutter, and lifeboat, and in the center is their official seal, surrounded by a life preserver.

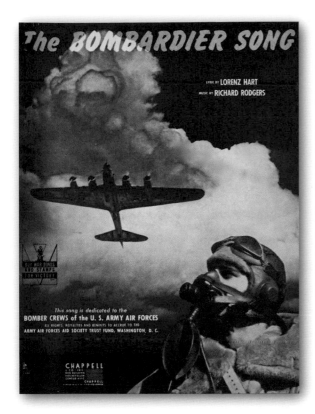

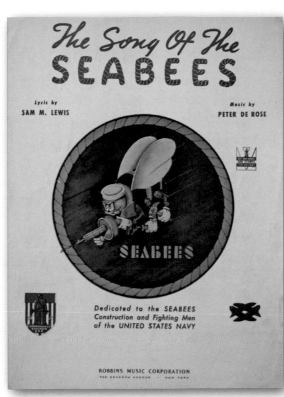

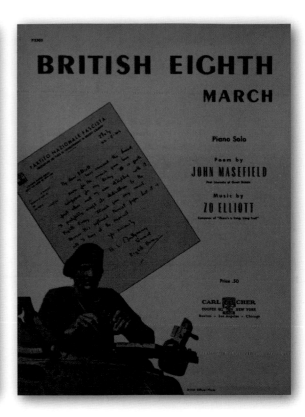

Bombardier Song (1942)

The great popular songwriting team of Rodgers & Hart wrote this and dedicated it to the "Bomber Crews of the US Army Air Forces." Inspiring images of a flying B-17 and a bombardier in his state-of-the-art (for the time) gear, used for unpressurized flight. All proceeds went to an Armed Forces trust fund.

Song Of The SEABEES (1942)

The United States Navy Construction Battalion (CB) was known for building bases, roadways, airstrips, and any other projects needed in a variety of military zones. Centered on the cover is their logo, "Fighting 'Bee,'" which is firing a machine gun in two hands while holding a wrench and a hammer with two others. On the lower left is their official motto, underneath a figure shouldering a rifle while holding a sledgehammer: "—Construimus, Batuimus" (Latin for "We Build, We Fight"). A very identifiable image.

British Eighth March (1943)

According to a note on the inside title page, this march was written and "dedicated to the members of the immortal British Eighth Army and accepted for them by General Sir Bernard L. Montgomery." Montgomery's photo is on the cover, along with a copy of his handwritten acceptance, dated September 22, 1943. It is written on Italian-headed stationery, and he remarks on it in the letter: "Excuse this captured Fascist paper, but it is all I have at the moment." Never really known for his sense of humor, this is as close as he came.

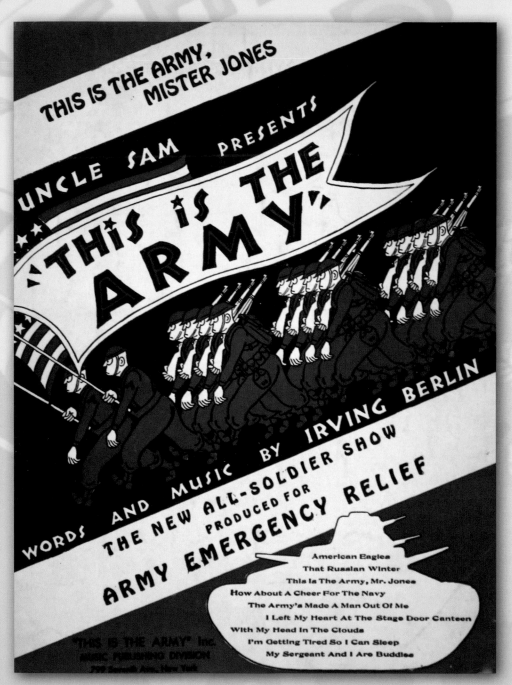

This Is The Army, Mister Jones (1942)

The World War II musical *This Is The Army*, written by Irving Berlin, was a reworked version of his Army show of 1917 called *Yip! Yip! Yaphank*, and was performed by an entire cast of soldiers. It had a loose story line and included tributes to all branches of the armed services. The show started on Broadway but ended up touring the country, raising over two million dollars (in 1943!) for the Army Emergency Relief Fund, while boosting morale and increasing patriotic fervor.

In fact, it became so popular that it was quickly made into a movie, featuring a young lieutenant named Ronald Reagan. Some of the musical highlights in the filmed version include Kate Smith's rousing performance of Berlin's "God Bless America" and Irving Berlin himself singing his song "Oh! How I Hate To Get Up In The Morning."

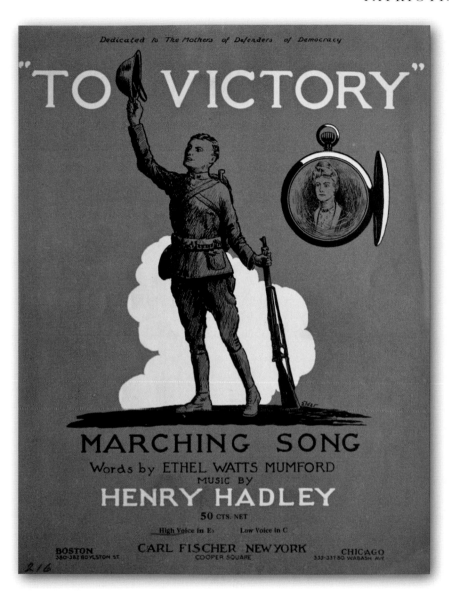

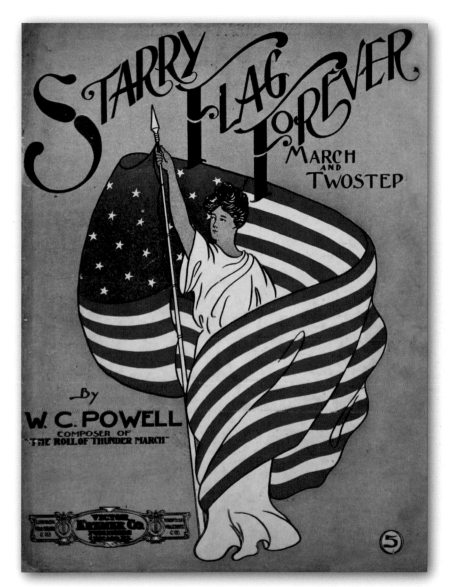

To Victory (**1918**)

A triumphant soldier on the cover, with a picture of his mother inside his pocket watch. *"Then we are going to show the Huns, what lads the Yankees be, we'll break their line, and cross the Rhine, to conquered Germany."* Dedicated to the Mothers of Defenders of Democracy, with words by Ethel Watts Mumford.

Starry Flag Forever (**1902**)

Even without the immediate concerns of a war, America was always ready to "wave the flag" and show the world that we were proud of our nation and what it stood for. The similar poses and sentiments for these two sheets reveal the depth of our American ideals.

NOVELTY SONGS

JUST FOR FUN

The songwriters of Tin Pan Alley were well known for producing many of these silly songs. However, novelty songs can come from anywhere and have just about anything as a topic. These are just the tip of the iceberg.

Novelty songs have always been around. Their very name gives them away. According to the dictionary, a novelty is "something intended to be amusing as a result of its new or unusual quality." When pertaining to songs, some specific qualifications should be mentioned. Novelty songs can be:

—Comic takes on current events or cultural fads.
—Parodies.
—Songs with a gimmick.
—Comedy material, something written as a joke.
—One-hit wonders.
—Certain seasonal or holiday songs.

They might also be considered novelty songs if they:

—Have unusual performers.
—Have strange subjects.
—Have been written to commemorate an event or place.
—Have been used in commercials.

These unconventional songs can be vocal, piano solo, or instrumental. The subject or performer is the key. These types of pieces have always been part of our history, especially in the popular music of the twentieth century. Novelty songs give us the chance to laugh at ourselves, and at the serious and sometimes pretentious nature of music itself. Mostly funny, sometimes silly, always entertaining.

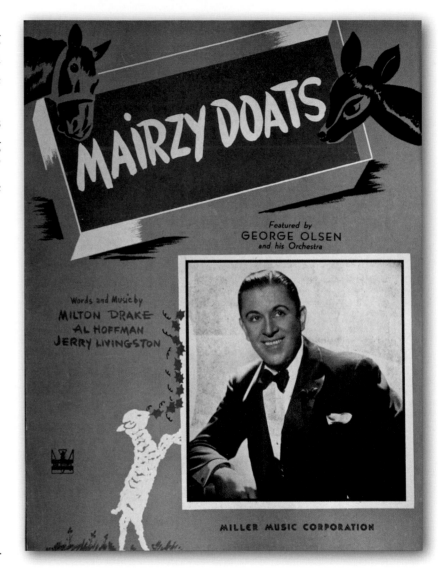

Mairzy Doats (1943)

At the beginning, it appears these are nothing more than nonsense words sung to a simple, bouncy melody. Once they are repeated (and enunciated clearly), the subject becomes clear. Hint: it's about mares and does and little lambs, and what they like to eat. Answer: oats, oats, and ivy (in that order). "Mairzy Doats" was made popular by Bing Crosby.

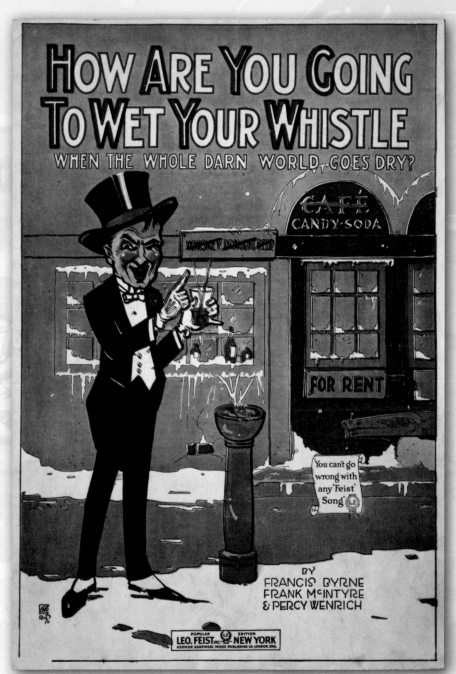

How Are You Going To Wet Your Whistle When The Whole Darn World Goes Dry? **(1919)**
Prohibition was ratified in 1919 and took effect on January 17, 1920. The well-dressed imbiber on the cover, standing in front of a boarded-up café, warns us of the problems this law will cause: *"Ev'ry body seems to talk of prohibition, and what they'll drink when everything is dry, how're you goin' to get around this new condition, and keep a twinkle in your eye?"* Even the water coming out from the fountain is frozen.

He goes on to say, *"What are you goin' to do in the morning, when you need a nip to open your eye? Now what of the wedding and the christening, and the wake when your dear friends die?"* It turns out that he was right, and people soon found sources for illegal liquor, which caused more problems in the long run, and the law eventually was repealed in December 1933. Words and music by Francis Byrne, Frank McIntyre, and Percy Wenrich.

***Save Your Confederate Money, Boys (The South
Shall Rise Again)* (1948)**
Contains many humorous (and tongue-in-cheek) lines refer-
ring to the hidden feelings that are probably still held in some
parts of the South, with sly references to Whitney's cotton
gin, mint juleps, the famous Rebel yell, and seceding from the
Union. Hopefully not too many people took this song seri-
ously at the time, though today might be a different story . . .

***I Faw Down An' Go
Boom* (1928)**
Relates the story in song of
a young gentleman who,
whenever he tries to do
anything (such as play foot-
ball, learn to dance, invest
in the stock market, go out
with a girl) always ends up
with the same result: failure.
The stories all end with the
catch-phrase of the title.
Cover by Lane.

***Gee! It's Tough To Be A Skunk* (1949)**
A song about not being liked because you're different,
through no fault of your own. Looks like an obvious case
of animal discrimination. Featured and recorded by Ziggy
Talent with Vaughn Monroe's orchestra, in photo.

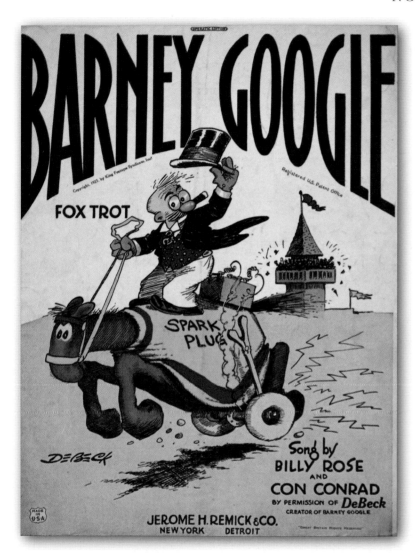

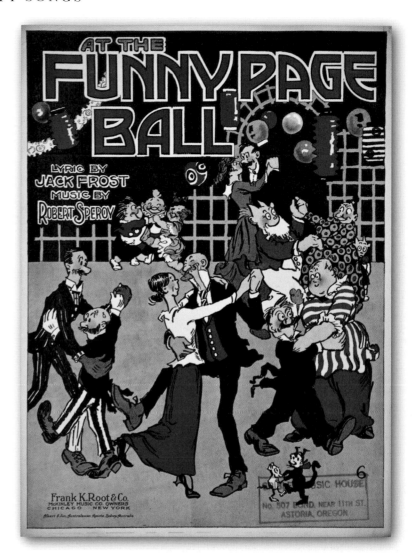

Barney Google (1923)

Cartoonist Billy DeBeck created this comic strip character in 1919. Barney Google became instantly (and internationally) popular, especially after his horse Spark Plug was introduced in 1922. In the song, there are multiple choruses, but it always comes back to mentioning the character's prominent eyes. Not only was the song a great novelty hit, but Barney Google appeared in films, in animation, and eventually even on TV.

At The Funny Page Ball (1918)

A song that was basically a who's who of the comic strip characters of the time. From Mutt and Jeff (the duo of opposites) to the Katzenjammer Kids (Hans and Fritz), Baron Bean, Petey Dink, the goat-headed Old Doc Yak, Happy Hooligan, Abe Kabibble, Andy Gump and Min, and Pa and Mama—and at the very bottom right is Krazy Kat and Izzy Mouse.

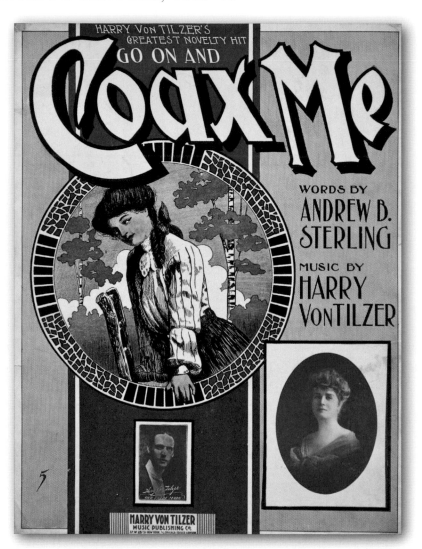

***Here Comes Santa Claus (Right Down Santa Claus Lane)* (1947)**
Written and recorded by the great singing cowboy Gene Autry, this has become a popular standard Christmas song. It also lists some of the other artists who sang this song at the time: Doris Day, Bing Crosby, the Andrews Sisters, and others. Many more have recorded it since then.

***Coax Me* (1904)**
By the standards of the time, the lyrics of this novelty song could be considered risqué or naughty. The man sings verses like: *"On those ruby lips I'd like to press a kiss, just one or two, perhaps a few."* While the woman responds each time with the same chorus: *"But you must coax me, go on and coax me, if you love me madly, want me badly . . . I'll be your tootsie, wootsie, if you'll coax me."* She is illustrated on the cover with a shy but suggestive look. Words by Andrew B. Sterling.

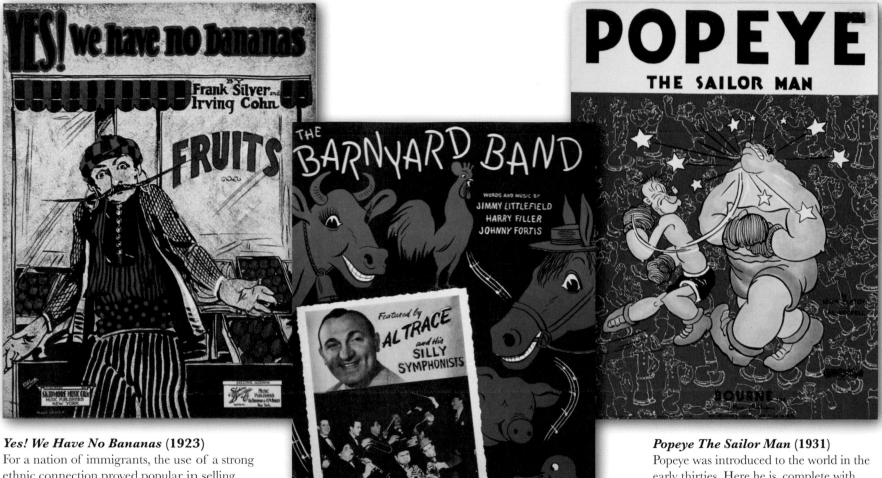

Yes! We Have No Bananas (1923)
For a nation of immigrants, the use of a strong ethnic connection proved popular in selling songs and sheet music. Caricatures and exaggeration helped identify the particular group to be targeted. In this case, the misuse of the English language was the main topic, with the comical expression on the vendor by Wohlmann.

Barnyard Band (1944)
Not only a novelty song, but as you can see by the photo, Al Trace and His Silly Symphonists was a novelty band. They appeared in a couple of mid-1940s Westerns, and provided some comic relief. Apart from his forays into silly songs, this Chicago native had a long and successful music career.

Popeye The Sailor Man (1931)
Popeye was introduced to the world in the early thirties. Here he is, complete with pipe, giving his nemesis Bluto a punch that makes stars appear, in classic cartoon fashion. It never mattered about the size of his opponents or their number; as long as Popeye had his can of spinach, he would win the day . . . and the admiration of his sweetheart Olive Oyl. Look closely to see the background on the cover, made up of many different drawings of Popeye.

You Think Of Ev'rything (1940)

Novelty songs don't *have* to be funny. This sheet is from the New York World's Fair of 1939--40. Held during the two summer seasons, it had attractions based on visions of the "World of Tomorrow," and its slogan was "Dawn of a New Day." The country was just climbing out of the Great Depression, and people were looking for hopeful diversions and exciting entertainment.

Pictured on the cover of this sheet are the two signature landmark buildings that were the center point of the fair. The tall spire, called the Trylon, was over seven hundred feet high, and the round Perisphere contained a model city of tomorrow. It was viewed by visitors traveling on a moving walkway high above the ground.

This fair introduced to the public a number of thrilling new products, including color photography, nylon, air conditioning, the first fluorescent light and fixture, and the View-Master.

Also mentioned on the cover is one of the more spectacular amusements, Billy Rose's "New Aquacade." It was an indoor water extravaganza, which had a spectacular synchronized swimming display, accompanied by a full orchestra. The show also featured two acclaimed swimming stars of the day, Johnny Weismuller and Eleanor Holm, who is pictured. This song was used in the elaborate production, which set the tone for future Hollywood aquatic musicals starring Esther Williams.

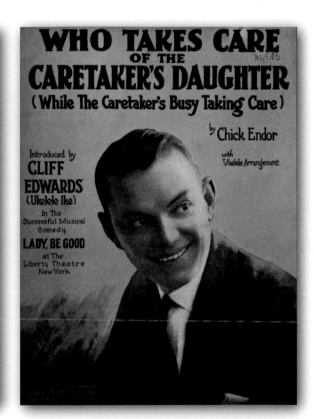

I'm Just Wild About Animal Crackers (1926)
By the time this song came out, the tasty snack treats known as Animal Crackers had already been available for over twenty years. The cover by Barbelle illustrates the singer's fascination (or obsession) with them. Note how the design or pattern on his suit becomes part of the overall background. Photo of Nina Bernard, in a somewhat serious pose.

I've Got A Cross-Eyed Papa, But He Looks Straight To Me (1923)
A Starmer-designed cover surrounds the photo of Sophie Tucker. She was billed as "The Last of the Red Hot Mamas" for the often risqué nature of her songs. This could be considered one of them. In the lyrics, the man is described as not being able to read or write or sing or dance, but the quality she's interested in most (romance) is something he does very well. It may not sound like much to us, but this was 1923.

Who Takes Care Of The Caretaker's Daughter (While The Caretaker's Busy Taking Care) (1925)
Certainly a convoluted title, which is the charm of many novelty songs. The lyrics run down the list of things the singer knows about, covering topical subjects of the day (baseball, boxing, movies), but the one thing he doesn't know (concerning the caretaker's daughter) is what bothers him. Featured by Ukelele Ike, on the cover, in the musical *Lady, Be Good*.

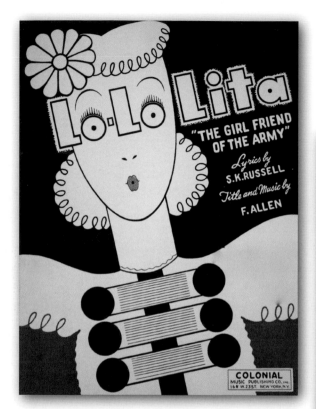

Lo-Lo-Lita "The Girl Friend Of The Army" (1941)
The artist for this uncredited cover does a great job of incorporating the name with her face and expression. As to what she does . . . ? The description in the lyrics have the men ignoring their girlfriends in order to go to a small café, where they grab tables near a stage to watch the mesmerizing Lolita.

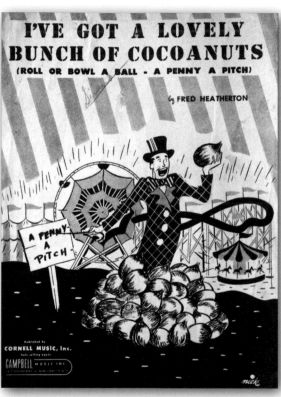

I've Got A Lovely Bunch Of Cocoanuts (1944)
Originally an English novelty song, it became a Top 10 hit in the US in 1949 by Freddy Martin and His Orchestra, which had a young Merv Griffin as the vocalist. Snippets of the song seem to appear sporadically through the years, such as when sung by Ringo Starr boarding the bus in the Beatles' *Magical Mystery Tour*.

Centurama (1946)
This song was taken from the Milwaukee Centurama lakefront show, celebrating Milwaukee's one hundredth anniversary, and was recorded by Lanny Ross and the Murphy Sisters, in photo. Published by the Milwaukee Mid-Summer Festival Corporation.

Ever since Hawaii became a territory of the US in 1898, songs about its unique culture and language have appeared in sheet music. Hawaii did not officially become a state until 1959.

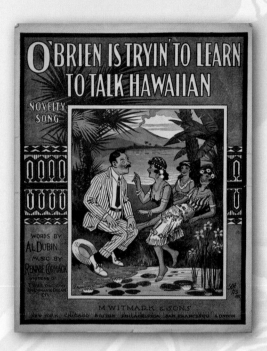

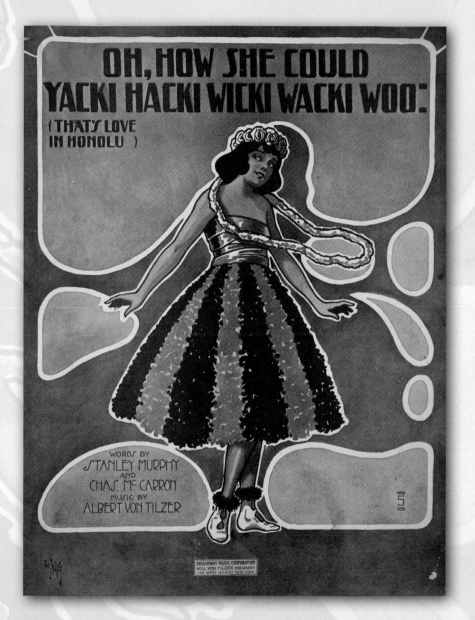

O'Brien Is Tryin' To Learn To Talk Hawaiian (1906)
Off on holiday to Hawaii without his wife, O'Brien meets a hula dancer called Honolulu Lou. *"He's sighin' and cryin', and all the time he's tryin', just to say 'I love you true' . . . but he doesn't get an answer, when he starts to talk and shout, for when Paddy talks Hawaiian, no one knows what it's about . . . if his wife only knew, he'd be in an Irish Stew."* Words by Al Dubin. Delightful cover by Dunk.

Oh, How She Could Yacki Hacki Wicki Wacki Woo: (That's Love In Honolu) (1916)
"She had a Hula, Hula, Hicki, Boola, Boola in her walk, she had a Ukalele [sic], Wicki, Wicki, Waile in her talk . . . I've been tryin' to learn Hawaiian since that night in June, she had a blinky, blinky, little naughty winky in her eye." Cover designed by DeTakas. Clever use of words by Stanley Murphy and Chas. McCarron.

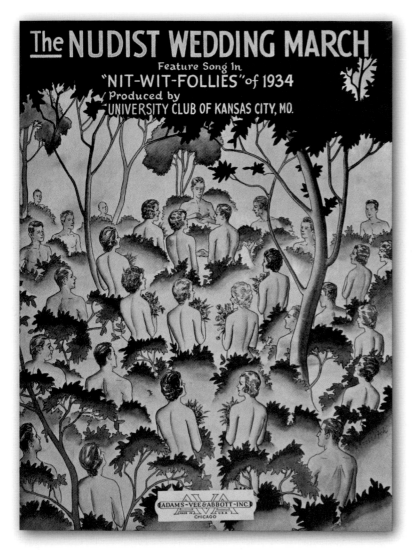

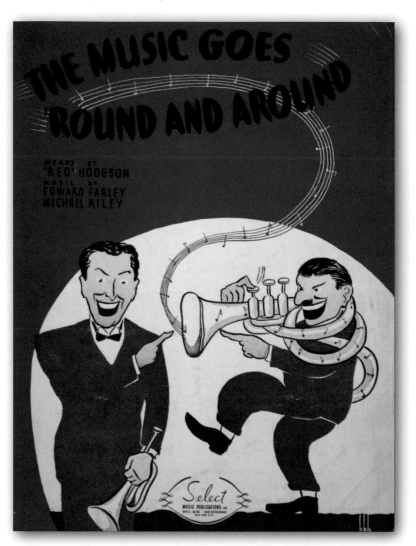

The Nudist Wedding March (1934)

With shrubbery and bouquets strategically placed on the cover, this unusual song comes from *The Nit-Wit-Follies Of 1934*, which was produced by the University Club of Kansas City, Missouri. Another almost-risqué theme and cover, with the singer lamenting the fact that he is not a nudist by nature but needs to be a member of the wedding party.

The Music Goes 'Round And Around (1935)

This was recorded by Tommy Dorsey, among others, and became a hit in 1936. It's a simplification of how to play music with a three-valve horn, simply by blowing in at one end and holding down a valve. The horn player then goes on to demonstrate how the same thing happens when you push down the other valves. The notes are shown traveling through the horn and coming out on a musical staff. If only it were so easy . . .

The Maharajah Of Magador (1947)
A humorous song about a rich (and overweight) maharajah who *has* everything (rubies, pearls, camels, girls), but yearns to learn to do the rhumba. So he advertises for a teacher in *Variety* magazine. A young woman answers the ad, and she soon realizes that he will never be able to do the rhumba because of his condition. Instead she uses her female charms on him, distracting him into giving her all of his wealth. He is left without anything, and still can't do the rhumba.

An interesting side note to the cover is the comment made from one camel to another. It says, "I prefer doctors 2 to 1." This is a sly reference to an advertising campaign promoted by tobacco companies around this time. The industry would actually make health benefit claims for their cigarettes, or at least declare one to be better for you than another. In this case, it was an ad for Camel cigarettes. The promotion went something like, "For their patients who smoke, doctors prefer Camels two to one."

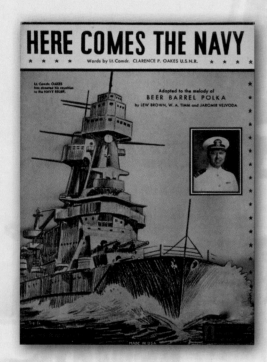

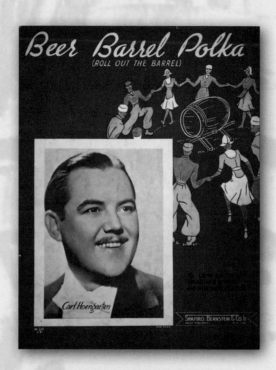

Here Comes The Navy (1942)

Adapted to the melody of the "Beer Barrel Polka" by Lt. Comdr. Clarence P. Oakes, pictured on the cover, this was a wartime effort to gain support and funds for the Navy. All of his royalties were donated to the Navy Relief. The normally fun chorus becomes very serious and patriotic, with a dramatic drawing of a battleship knifing through the waves.

Beer Barrel Polka (Roll Out The Barrel) (1939)

A well-known popular song about getting together with friends and having a good time . . . and that is all centered around drinking beer! On the cover, ethnically dressed folks circle around the point of interest, with Carl Hoengarten included as well. This is the one polka everyone has probably heard.

Bombardier Polka (1944)

This instrumental piece has a war-related theme that helps create a sense of levity to counteract the harsh realities of the fighting taking place. The cover drawing is of an energetically dancing couple. Written and performed by Brunon Kryger, called the "King of the Polkas," who is shown in the photo. Other pieces listed on the back are the "U.S. Canteen Polka" and the "Jitterbug Polka."

We think of ourselves today as being obsessed with younger performers, but the sheer novelty factor of child stars began with the introduction of vaudeville, silent films, and radio. The larger the audience, the greater the interest. Some of these names have remained with us; others have been lost to obscurity. The fact is that our attention has always been captured by the ability of some children to perform at an early age. And there is also the "cuteness" aspect to consider. Still, success as an adult doesn't always follow.

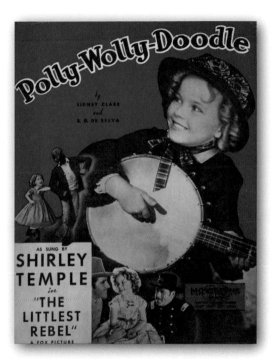

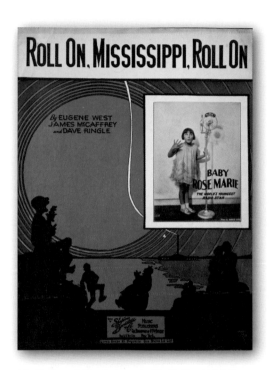

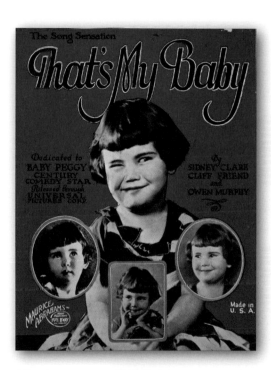

Polly-Wolly-Doodle (1935)
Probably the best-known of the child stars of the twenties and thirties, Shirley Temple sang this nonsense song in *The Littlest Rebel*. The cover shows some photogenic shots of her from the film, surrounded by some of her costars. Her name will be forever identified with a kiddie drink, and on the serious side, she would became a US ambassador.

Roll On, Mississippi, Roll On (1931)
Billed on the sheet music cover as "The World's Youngest Radio Star," Baby Rose Marie started performing at the age of three, by five was on NBC, and appeared in a number of films. She even recorded seventeen songs from 1930 to 1938. Early on, she was backed by Fletcher Henderson's band, which was one of the finest black jazz orchestras of the day. In her adult years she is most remembered for her role as Sally Rogers, the television comedy writer on the CBS sitcom *The Dick Van Dyke Show*.

That's My Baby (1923)
Baby Peggy's career in silent movies was meteoric, both in its rise and its fall. Her first film was made in 1921, and between then and 1923, she made almost 150 short comedy features for Century Studios. By 1924, she was hired at Universal for dramatic roles, and was given a salary of $1.5 million a year, as well as personal appearances and product endorsements. Because of reckless spending by her parents, their shady business partners, and the stock market crash of 1929, she was broke and out of work by the 1930s.

WHAT AM I LIVING FOR

Words and Music by FRED JAY • ART HARRIS

Recorded by RAY CHARLES on ABC Records

I LOVE YOU

Words and Music by
DONNA SUMMER,
GIORGIO MORODER and
PETE BELLOTTE

Recorded by
DONNA SUMMER

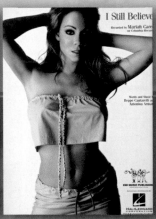

I Still Believe

Recorded by Mariah Carey
on Columbia Records

Words and Music by
Beppe Cantarelli and
Antonina Armato

READY FOR THE 80's

Words and Music by J. MORALI, H. BELOLO, P. HURTT and B. WHITEHEAD

VILLAGE PEOPLE

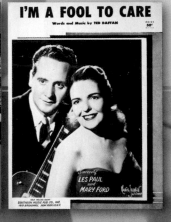

I'M A FOOL TO CARE

Words and Music by TED DAFFAN

LES PAUL
and
MARY FORD

LOOKING OUT FOR NUMBER ONE

Recorded by
TRAVIS TRITT
on Warner Bros. Records

Words and Music by
TRAVIS TRITT
and
TROY SEALS

FIVE HUNDRED MILES

By HEDY WEST

Recorded by
Peter, Paul and Mary
on WARNER BROS. Records

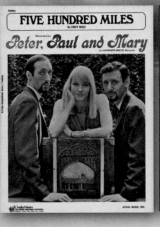

I Turn Away

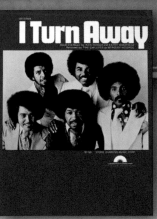

Slip Slidin' Away

Paul Simon

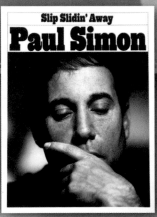

HANDLE WITH CARE

Words and Music by THE TRAVELING WILBURYS

Recorded by THE TRAVELING WILBURYS on

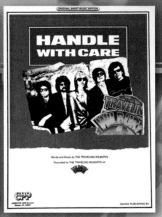

PART TWO

SHEET MUSIC IN THE TWENTIETH CENTURY

1950–99

NOTABLE SONGS, 1950-99

Rock Around The Clock (1953)—Bill Haley & the Comets

Good Vibrations (1966)—Beach Boys

Hotel California (1976)—Eagles

Stairway To Heaven (1972)—Led Zeppelin

Born To Be Wild (1968)—Steppenwolf

Tutti Frutti (1955)—Little Richard

What's Going On? (1970)—Marvin Gaye

My Way (1967)—Frank Sinatra

Born In The U.S.A. (1984)—Bruce Springsteen

Aqualung (1971)—Jethro Tull

All Shook Up (1957)—Elvis Presley

Sunshine Of Your Love (1967)—Cream

Hard Day's Night (1964)—Beatles

What'd I Say (1961)—Ray Charles

Purple Haze (1967)—Jimi Hendrix

The Twist (1960)—Chubby Checker

It's Only Rock And Roll (1974)—Rolling Stones

Give Peace A Chance (1969)—John Lennon/Yoko Ono

Ain't That A Shame (1955)—Fats Domino

Respect (1965)—Aretha Franklin

Great Balls Of Fire (1957)—Jerry Lee Lewis

Whipping Post (1969)—Allman Brothers Band

Heart Of Rock And Roll (1983)—Huey Lewis & the News

Bridge Over Troubled Water (1969)—Simon & Garfunkel

Oh, Pretty Woman (1964)—Roy Orbison

(Sittin' On) The Dock Of The Bay (1968)—Otis Redding

Blue Suede Shoes (1955)—Carl Perkins

Rock This Town (1981)—Stray Cats

Moondance (1970)—Van Morrison

You Really Got Me (1964)—Kinks

PLAYING THE CHANGES

Music rarely stands still. It is like a river with tributaries that rush off in different directions, and in turn it is fed by various sources. It constantly transforms, and only comes into focus when we look back.

So it was in the second half of the twentieth century. Music styles seemed to generate in quick succession. During these fifty years, the scope of music developed from the rough sound of early rhythm and blues into rock 'n' roll; then came rockabilly, doo wop, surf, rock, pop, psychedelic, bubble gum, folk rock, progressive rock, soul, Motown, funk, disco, glam, fusion, reggae, punk, new wave, heavy metal, retro swing, goth metal, rap, alternative, hip hop, and other various offshoots. Yikes!

In conjunction with all these styles were the groups and personalities that became identified with the music we heard. These were the songwriters and performers that led music down an ever-changing path. They were the stars and idols of those who bought the 45s, LPs, eight-tracks, cassette tapes, and CDs.

Sheet music changed as well. By the fifties, the age of the great illustrators was over. The use of photos had gradually replaced the remarkable artwork. The only exception was music from the movies. Many sheets used the theater poster images on the covers, to tie the songs more closely with the productions. In fact, some movies and TV shows became identifiable by their themes (like "The James Bond Theme," "The Pink Panther," "Star Wars," "Hawaii Five-O," and "Mission Impossible"). You can't think of the show without hearing the theme in your mind. The music automatically brings back memories. In many ways, it was a golden age for themes from TV and movies. Because everyone wanted to hear and play them, they sold well in sheet music.

In retrospect, music shows us a reflection of our American experience. From the songs in movies and TV shows to the ones on the *Billboard* charts, music was a sounding board (pun intended) for the feelings and atmosphere of the time. Sheet music was there to document the events and changes that took place. The covers of all these sheets help illustrate a clear "vision" of it all—the Good, the Bad, and the Ugly.

INTO THE FIFTIES

BALLADS, TV, AND THE BIRTH OF ROCK 'N' ROLL

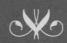

It was a time of relative calm . . . increasing prosperity . . . the American Dream. At the start of the decade, popular music was a little bit of everything—show tunes, movie themes, country hits, folk songs, and even jazz numbers, but especially sentimental ballads by vocal groups and solo performers. With few exceptions, these songs had little variation in scope and were remarkably uniform. Listenable, but somewhat bland.

Meanwhile, into our lives and homes came an exciting innovation that showed us a small, flickering black-and-white image: TV. Production values were crude by modern standards, but the selection of programs available on TV got people hooked into watching it. With variety shows, game shows, Westerns, dramas, and even music performances, TV started to become the center of the household.

By the middle of the decade, the spreading ripples of a new sound, which had been introduced by white performers doing cover versions of black music, began to be felt. This sound blended together other influences from country, gospel, and New Orleans rhythm and blues to reach a wider, mostly younger, audience. Performers like Elvis, Bill Haley, and

Jerry Lee Lewis were joined by Chuck Berry, Fats Domino, and Little Richard. It would be called rock 'n' roll.

Rock 'n' roll seemed to be everywhere, and it delighted the kids and shocked the parents. The music stood for rebellion, and was aggressive in content and delivery. *American Bandstand* kept it in front of a growing TV audience. The effect went far beyond what was heard on records, radio, and television. Previously, popular music was mostly written for an adult audience. This new music appealed exclusively to the growing market of postwar teenage listeners.

The impact of rock 'n' roll—and its successor, rock—reached far and wide into popular culture. There would be no greater influence on lifestyle, language, attitude, and fashion in the next fifty years. It would change the world.

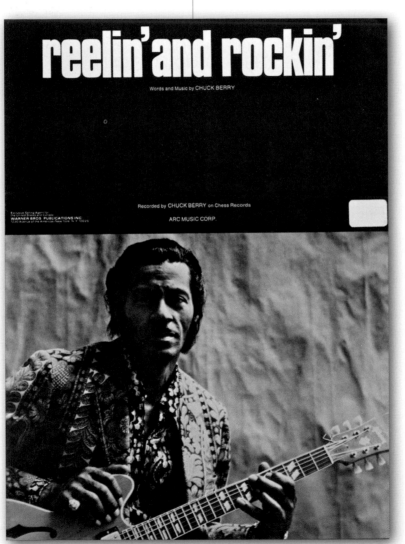

Reelin' And Rockin' (1958)
Chuck Berry was a pioneer of the new popular music as both a composer and a guitarist. He eventually became one of the first to be inducted into the Rock and Roll Hall of Fame.

You're After My Own Heart (1952)
Rosemary Clooney started her singing career in 1946 but only gained prominence in the early fifties. She also was an actress, appearing in the classic movie *White Christmas* with Bing Crosby, as well as on her own syndicated musical variety show on television. She appeared regularly on TV and radio and in concert. This song was a typical love ballad of the time, with lyrics about dreaming and finding the perfect mate.

I'm Going Out On The Front Porch and Cry (1954)
A song about an unhappy breakup, sung by Roberta Linn. The lyrics have the woman not knowing what she did to make her man leave her. Captivating look from her on the sheet music cover. A classic fifties image.

I'm Glad That You're Happy With Somebody Else (But I'm Sorry It Couldn't Be Me) (1951)
During the fifties, Patti Page was *the* best-selling female artist, selling over one hundred million records. While her signature tune was "Tennessee Waltz" (1950), she also had a huge hit with "(How Much Is) That Doggie In The Window?" (1953).

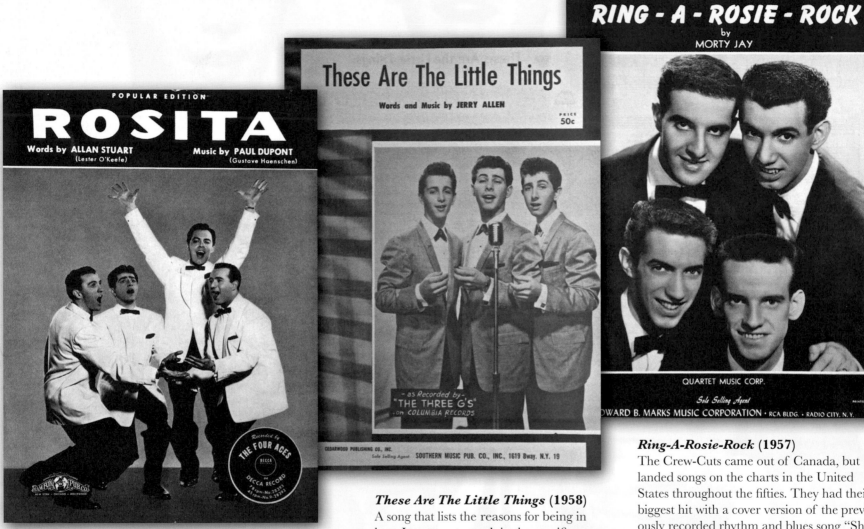

Rosita (1952)
A traditional pop male vocal quartet that had a string of hits during the fifties, the Four Aces continued to tour for decades with a shifting lineup, but they never charted a song past 1959. This one reached No. 24. Dynamic photo of the group singing on the cover.

***These Are The Little Things* (1958)**
A song that lists the reasons for being in love. It goes on to explain the specific things, such as the hair, the look, the clothing, and more. The Three Gs pose for the photo on the cover, in a standard doo-wop stance. They appear *very* young.

***Ring-A-Rosie-Rock* (1957)**
The Crew-Cuts came out of Canada, but landed songs on the charts in the United States throughout the fifties. They had their biggest hit with a cover version of the previously recorded rhythm and blues song "Sh-Boom," and also charted with the song "Earth Angel." They disbanded in 1964, but reunited for a while in 1977. Conventional publicity photo on the cover.

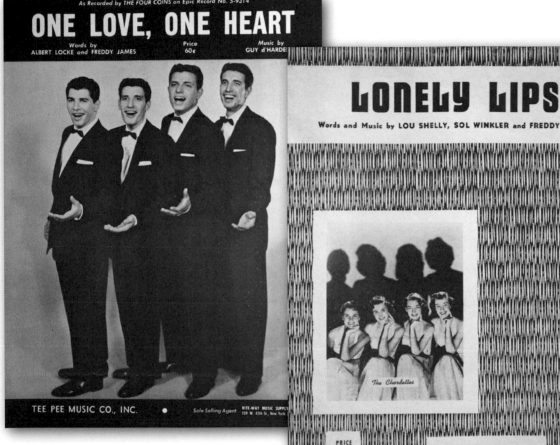

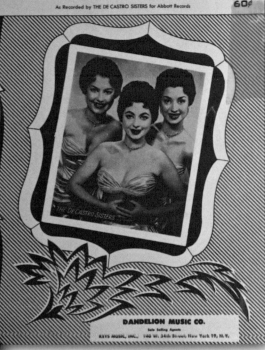

One Love, One Heart (1959)
These four Greek brothers from Pennsylvania performed as a doo-wop group known as the Four Coins. They had rich harmonies, which were usually backed with very lush string orchestrations. Their biggest hit was "Shangri-La" in 1957. This cover has a shot of them singing in a traditional pose.

Lonely Lips (1955)
This female harmonizing quartet, called the Chordettes, came from Sheboygan, Wisconsin, and got their first No. 1 chart hit with "Mr. Sandman" in 1954. They also appeared on August 5, 1957, on the first episode of American Bandstand to be broadcast to a national audience, which helped their career.

I'm Bewildered (1955)
Originally a Latin-styled group (they were raised in Havana, Cuba), the De Castro Sisters became more mainstream in their act by the mid-fifties, when they had a No. 2 chart hit with the song "Teach Me Tonight" (1954). With a singing style much like the Andrews Sisters, they also blended comedy into their performances. This popular trio appeared in Hollywood and Las Vegas and on many TV shows, including *The Ed Sullivan Show*.

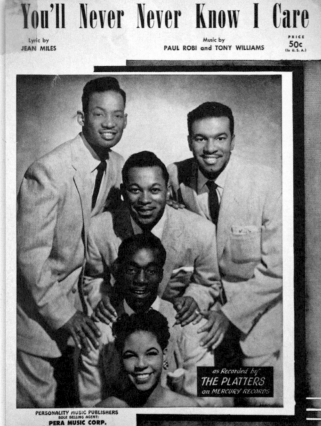

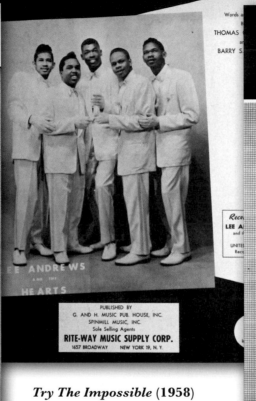

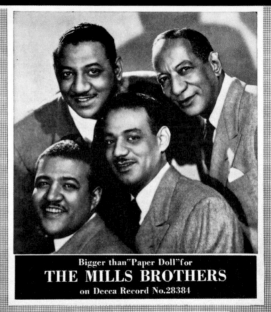

You'll Never Never Know I Care (1956)
The Platters, out of Los Angeles, were one of the
best-known and most successful vocal groups of
this early rock 'n' roll/doo-wop era. This was a
slow song about unrequited love. Artfully arranged
studio photo of them on the cover.

Try The Impossible (1958)
This was the last of Lee Andrews
and the Hearts' three hits, all
of which were released between
1957 and 1958. This Pennsylva-
nia doo-wop quintet started in
1953 and sang primarily smooth
ballads, but only lasted a few
years. On the cover photo, this
black group appears all in white,
including shoes and gloves.

The Glow-Worm (1952)
Originally written for a German operetta in 1902, this
version was updated by the great composer/arranger
Johnny Mercer and became a No. 1 hit for the Mills
Brothers. This jazz/swing vocal group had hits spanning
from 1931 to 1970! Their harmonies smoothly flowed
over the lyrics and created an identifiable sound.

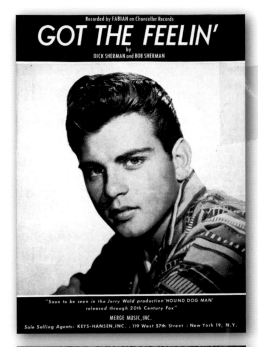

We Got Love (1959)

One of the crop of new "teen idols" that came out in the fifties, Bobby Rydell had the look and the voice to stay on the charts for a while, with this song being his second big hit. Later on he performed in clubs, and was a regular on a number of TV shows.

Got The Feelin' (1959)

Fabian was another one of the teen idols that emerged. Occasionally he was showcased as a "second Elvis"—appearing less threatening and therefore more acceptable to parents, as when he starred in the movie *Hound Dog Man*. He had a number of hits from 1958 to 1963, but they didn't really have the same impact as the songs by Elvis. Possibly Fabian's choice of material (or his lack of talent) made this noticeable.

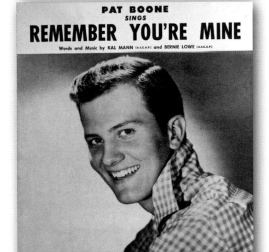

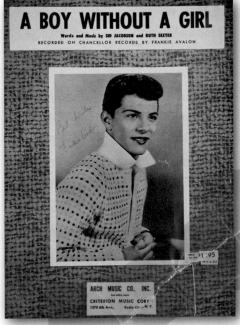

Remember You're Mine (1957)

Even though his "white bread" versions of some of the early rhythm and blues songs pale in comparison to the originals, Pat Boone is credited with greatly increasing the acceptance of this music to the general public. He even had his own half-hour variety show in the fifties, which ran for almost four years. Throughout his career, he was always concerned with upholding his mainstream, conservative, and in later years, Christian image. Shown on the cover in a typical cheerful mood.

A Boy Without A Girl (1959)

Frankie Avalon got his start as a young, singing teen idol, having thirty-one songs chart from 1958 to 1962, but also became identified by his long acting career. The stock publicity photo on the cover is signed "Best Wishes, Frankie Avalon." In referencing a boy without a girl, the song matches the feeling with a list of things that always go together, like day and night, as well as other examples.

Love Me So I'll Know (1957)

An early release by Jimmy Dean that didn't do very well on the charts. His biggest success came in 1961 with the spoken-word song "Big Bad John." He hosted many radio and TV programs in the fifties and sixties, and made numerous guest appearances as well. He also gained fame by starting his own sausage company. The cover photo was taken in a recording studio.

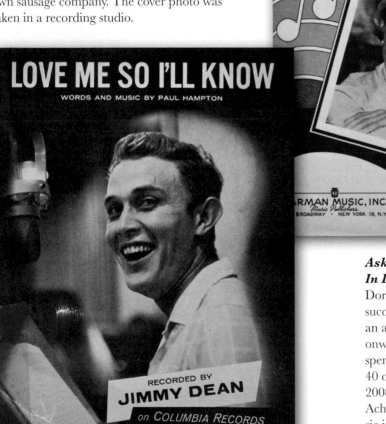

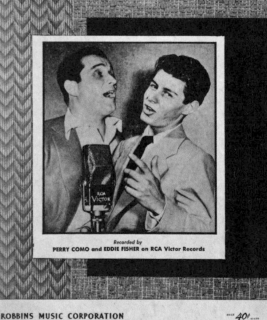

Ask Me (Because I'm So In Love) (1951)

Doris Day had considerable success both as a singer and an actress from the fifties onwards. In total, her songs spent 460 weeks on the Top 40 charts. She was honored in 2008 with a Grammy Lifetime Achievement Award, the music industry's top recognition.

Maybe (1935)

This song was covered by many artists over the years; the sheet here is from the duet version done by Perry Como and Eddie Fisher in 1952. Eddie Fisher was an extremely successful pop singer during the fifties, but slowly faded from the charts after that time. Photo shows both of them "hamming it up" for the camera.

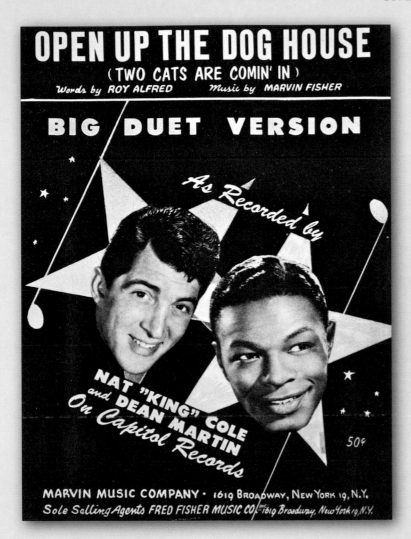

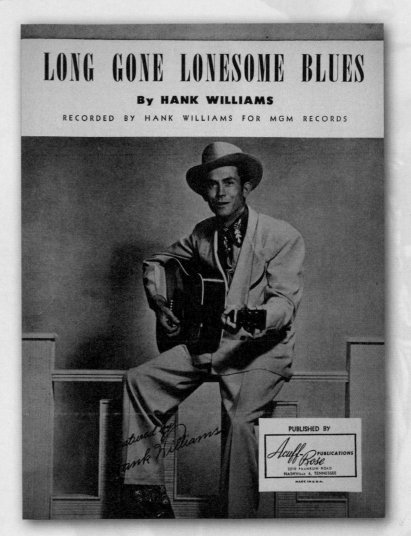

Open Up The Dog House (Two Cats Are Comin' In) (1954)

Two cool cats, for sure. In a successful effort by Capitol Records to broaden his exposure to white audiences, Nat "King" Cole was paired with select performers in the early to mid-fifties. In this song with Dean Martin, they give five verses of reasons why they are in trouble with their wives. It's the old story of being caught in a lie by her, such as mentioning that they were late coming home because they were at the opera, only to have the program from a burlesque show fall out of their pocket. In the doghouse, for sure.

Long Gone Lonesome Blues (1950)

Hank Williams is now considered a legend, and one of the most important figures in country music history. This song was only his second No. 1 on the country and western chart, yet his short career only lasted a few more years. He died in 1953, at the age of twenty-nine. This classic song was written by him, but recorded by many others over the years. Signed photo of him used on the sheet music cover.

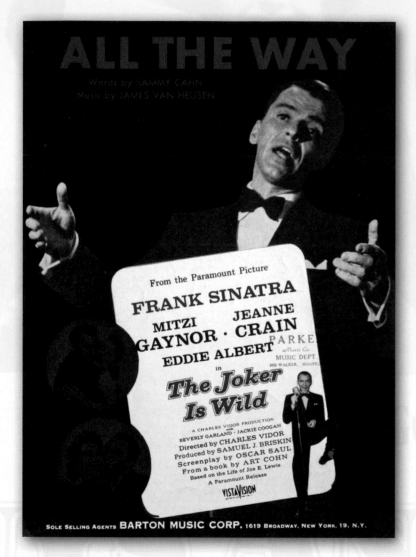

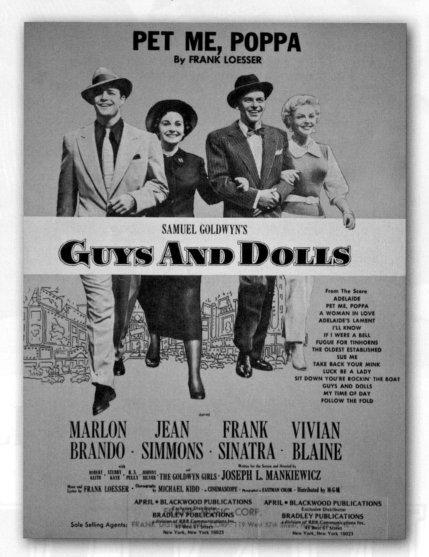

***All The Way* (1957)**

The movie *The Joker Is Wild* was based on the life story of Joe E. Lewis, a singer and comedian from the late twenties to the early fifties. Frank Sinatra gives a strong performance, singing this soon-to-be classic Cahn/Van Heusen song called "All The Way." It ended up winning the Academy Award for Best Original Song in 1957. Another example of Ol' Blue Eyes putting his special stamp on a song. Multiple shots of him on the cover.

***Pet Me, Poppa* (1955)**

This was the film version of the Broadway musical *Guys And Dolls*, by Frank Loesser. "Pet Me, Poppa" was one of three new songs written for the movie, which was a commercial success both here and overseas. The plot is based around the schemes of some professional gamblers, criminals, and mobsters in New York at the end of the forties. Another song listed in the score was "Luck Be A Lady," also recorded by Sinatra and part of his repertoire for years.

Have You Met Miss Jones? (1937)

Another older song that was reintroduced in 1955 in the movie *Gentlemen Marry Brunettes*, a follow-up to *Gentlemen Prefer Blondes*. Although it did star Jane Russell, it missed the screen presence of Marilyn Monroe. It's the story of two showgirls (sisters Bonnie and Connie Jones) who decide to look for love and fame in Paris.

A Little Girl From Little Rock (1949)

With the talents of both Jane Russell and Marilyn Monroe, this 1953 film adaptation of a 1949 stage musical (itself based on a book from 1925!), was a huge hit from the start, with both moviegoers and critics. In *Gentlemen Prefer Blondes*, one of the most remembered moments in movie history is the sequence with Marilyn singing "Diamonds Are A Girl's Best Friend." Timeless. Eye-catching cover as well.

Cherry Pink And Apple Blossom White (Love Theme From Underwater!) (1951)

What better way to showcase the considerable assets of Jane Russell than to put her in a two-piece bathing suit? In the film *Underwater!*, released in 1955, she spends a fair portion of her time in that outfit, while two scuba divers search for sunken treasure. Another intriguing cover.

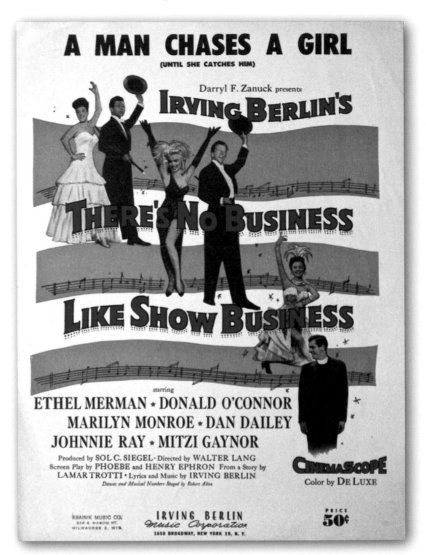

The High And The Mighty (1954)

Theme from the movie of the same name. In this early disaster-type movie (the plane has trouble over the middle of the Pacific and the pilot loses his nerve), John Wayne as the disgraced copilot steps in during this time of crisis and comes through to save the day. More of a character study than drama, with all of the actors putting in strong performances. Pictured on the cover around the image of a plane are the stars of the film, including Wayne and Robert Stack.

A Man Chases A Girl (Until She Catches Him) (1948)

In spite of an Irving Berlin score, the presence of the dynamic singing voice of Ethel Merman, the dancing of Mitzi Gaynor, and the screen persona of Marilyn Monroe, the movie version of *There's No Business Like Show Business*, released in 1954, never really took off. The plot was predictable, though some of the musical numbers were well staged.

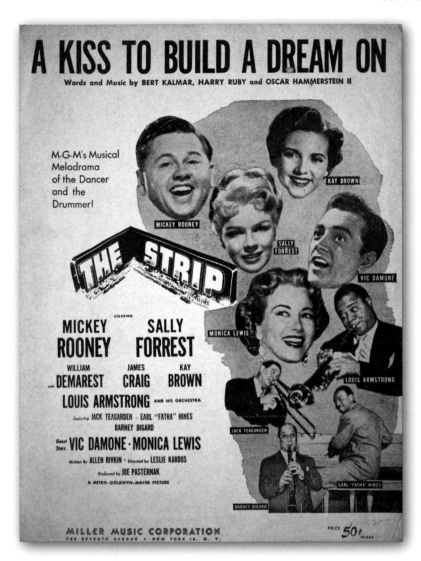

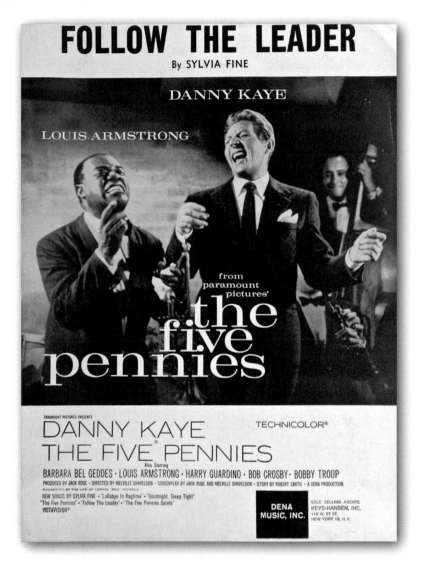

A Kiss To Build A Dream On (1951)

The Strip, in this case, refers to the Sunset Strip in Hollywood, not the Las Vegas Strip. It's a film noir drama that takes place, with musical interludes, at places like the Mocambo and Ciro's, two well-known nightclubs at the time. The sheet music features the cast of Mickey Rooney, Sally Forrest, Monica Lewis, and Vic Damone, along with Louis Armstrong and his all-star orchestra of Earl "Fatha" Hines, Jack Teagarden, and Barney Bigard.

Follow The Leader (1959)

The Five Pennies is based on the life and career of musician/bandleader Red Nichols, who often toured and recorded as Red Nichols and the Five Pennies, a sly play on his name. Danny Kaye, as Red, works at a comeback, but doesn't have much luck until some name players from his past (cameos by Louis Armstrong and Bob Crosby) help him out. It was nominated for four Academy Awards but failed to win any.

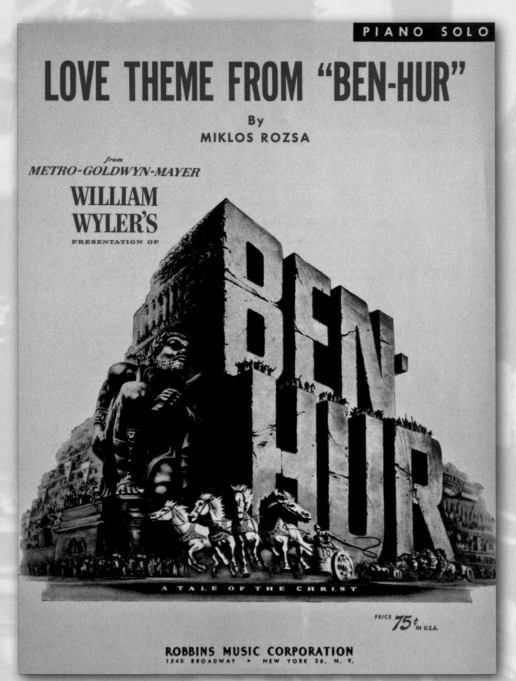

Ben-Hur—Love Theme From (1959)

From all the logistical standpoints, *Ben-Hur* easily set the benchmark for any future movie epics. The sheer amount of money, sets, and extras ("and a cast of thousands") was mind-boggling. Although this is a dramatic film with heavy religious themes, it will be forever remembered for the wild nine-minute chariot race sequence.

This movie set the record in 1960 for winning eleven Academy Awards, one that would not be equaled for almost forty years until *Titanic*. The composer, Miklos Rozsa, did win an Oscar for this score, and went on to compose music for many other films such as *El Cid* and *Quo Vadis*.

The impressive graphics on the sheet music cover reflect the movie poster images.

I Belong To You (1955)

The Racers is a melodramatic movie soap opera with Kirk Douglas as an arrogant race car driver who falls in love with a French ballerina (an odd couple to be sure) but loses her because of his single-minded obsession with winning. Even the song lyrics allude to speed with the idea of time racing by.

Small Talk (1954)

This cover is from the 1957 film version of the hit Broadway musical *The Pajama Game*. It's a high-energy show with lots of singing and dancing. Other songs listed from the score are "Steam Heat" and "Hernando's Hideaway." Attractive cutout of Doris Day on the cover.

It's A Woman's World (1954)

The movie *Woman's World* is a drama about corporate America. It focuses on three couples and, despite the title, shows the wives in what we would consider a sexist view (although probably not far from the reality of life in the fifties). The tagline from the original movie poster reads, "It's a great big wonderful Woman's World because men are in it." Almost like a version of *Mad Men*, but based in the decade before.

Am I In Love? (1951)

A quite funny—and typical—Bob Hope comedy, *Son Of Paleface* is a 1952 sequel to *The Paleface* from 1948, which also starred Jane Russell. Another farcical set of circumstances, with Roy Rogers thrown in the mix as a federal marshal. The cover features all three, with the addition of Trigger, Roy's famous horse.

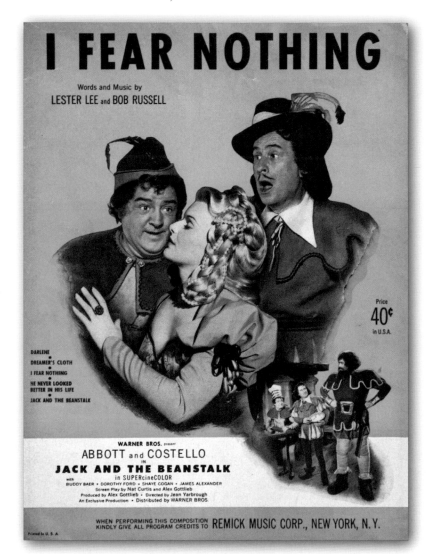

You're Gonna Dance With Me Baby **(1953)**

A screwball musical comedy from 1954, starring the team of Dean Martin and Jerry Lewis when they were in their prime, *Living It Up* has a little bit of everything. Suave Dean croons, and silly Jerry . . . is Jerry. They split in 1956, and made only five more films together after this. Great photos of both on the cover.

I Fear Nothing **(1952)**

The comedy team of Abbott and Costello had their film debut in 1940, and *Jack And The Beanstalk* marked their twenty-ninth film together. It's a humorous retelling of the classic fairy tale. Two scenes from the movie are used on the music cover. This is one of only two films they ever made in color.

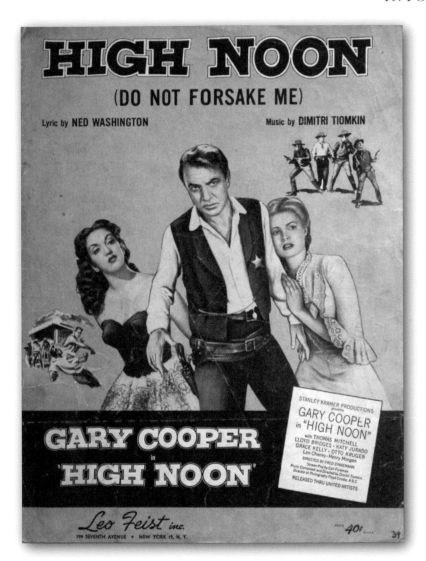

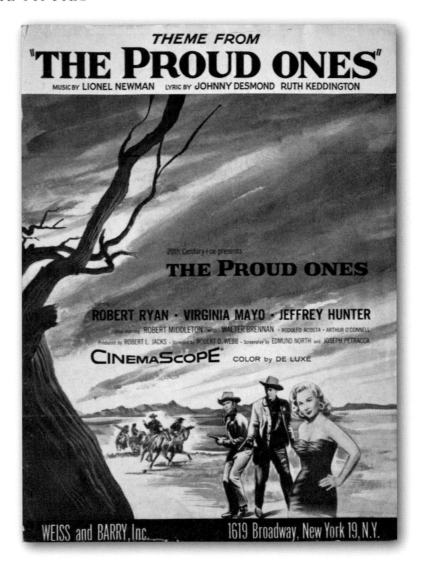

High Noon (Do Not Forsake Me) (1952)

More of a tension-filled thriller than an action-packed Western, *High Noon* pits sheriff Gary Cooper on his own against higher odds, yet overcomes them in the end. This song, which was sung by Tex Ritter, won an Oscar in 1954 for Dimitri Tiomkin. The cover shows a determined Gary Cooper; Grace Kelly, his pacifist Quaker wife; and Katy Jurado, his former mistress. The bad guys lurk in the background.

The Proud Ones—Theme From (1956)

A solid Western about a quiet frontier town transformed into a lawless boomtown by a corrupt gambler and unscrupulous cattle herders. The sheriff tries to keep it all under control while dealing with his failing eyesight. *The Proud Ones*, released in 1956, is complete with plots of revenge, hired killers, and apathetic townspeople. Robert Ryan, Jeffrey Hunter, and Virginia Mayo appear on the cover, in a dramatic landscape.

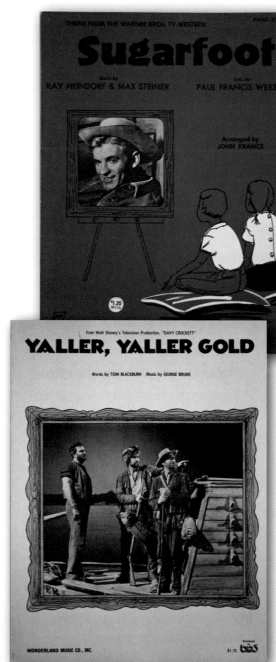

Colt .45—Theme From The Warner Bros. TV-Western (1957)

The series *Colt .45* ran from October 1957 to December 1960 and followed an undercover federal agent tracking down notorious bad guys while traveling as a pistol salesman during the period of the Old West. It starred Wayde Preston as Christopher Colt.

Sugarfoot—Theme From The Warner Bros. TV-Western (1957)

Airing from September 1957 to April 1961, *Sugarfoot* was about a correspondence school lawyer in the West played by Will Hutchins as Tom "Sugarfoot" Brewster, who did not have great cowboy skills (hence the name). While he carried a rifle, he preferred more peaceful means to capture the villains. If he couldn't convince them to give up (?), he would try lassoing them, and he only used firearms as a last resort.

Captain Kangaroo March (1957)

A much-loved daily children's program, *Captain Kangaroo* ran for almost thirty years, with Robert Keeshan in the title role. The show featured various educational and fun activities. Some of the other characters on the show were Mr. Green Jeans, Dennis, Grandfather Clock, Mr. Moose, and Bunny Rabbit.

Yaller, Yaller Gold (1955)

This is from the Walt Disney TV production of *Davy Crockett*, which ran from December 1954 to December 1955. It featured Fess Parker as the savvy frontiersman Davy Crockett, with Buddy Ebsen as his friend and companion George Russell. Both are seen on the cover. This particular song was used in the episode titled "Davy Crockett And The River Pirates."

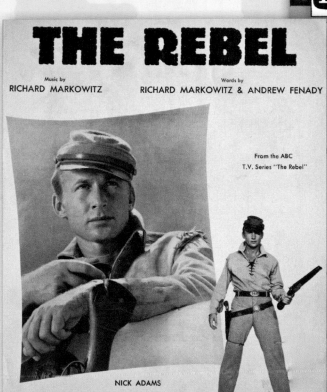

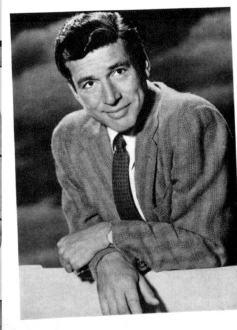

The Rebel (1959)

With Nick Adams as Johnny Yuma, *The Rebel* was another Western-themed TV series, running from 1959 to 1961. Taking place right after the Civil War, the series featured Yuma as a Confederate Army veteran, wandering the West and fighting injustice with his trademark sawed-off double barrel shotgun while keeping a journal of it all.

Adventures In Paradise (1959)

An adventure TV series created by the author James Michener, *Adventures In Paradise* starred Gardner McKay as Adam Troy as he sailed his ship *Tiki III* around the Pacific. It lasted from 1959 to 1962.

77 Sunset Strip (1958)

This crime drama had two private detectives working out of a fancy address in Los Angeles. *77 Sunset Strip* ran for a number of seasons (1958–64). It wasn't all serious, and it even developed a sense of humor about itself, especially when the character of Kookie, the parking attendant from the club next door, stepped in to use some of his rock 'n' roll--inspired slang in his wisecracks. Efrem Zimbalist Jr. is pictured on the cover of the sheet.

The evolution of popular music took a great leap forward in 1954 with Elvis and his work at Sun Records in Memphis, produced by recording pioneer Sam Phillips. Elvis was quickly followed by others who added their own distinctive sounds, ideas, directions. Throughout the fifties, Phillips worked with a wide spectrum of artists from blues, R&B, country, rockabilly, and rock 'n' roll. Roy Orbison, Carl Perkins, Johnny Cash, B. B. King, Ike Turner, Howlin' Wolf, and Jerry Lee Lewis all had a chance to experience the magic of Sam Phillips. The studio is still there and does sessions to this day. It is also open to fans and tourists.

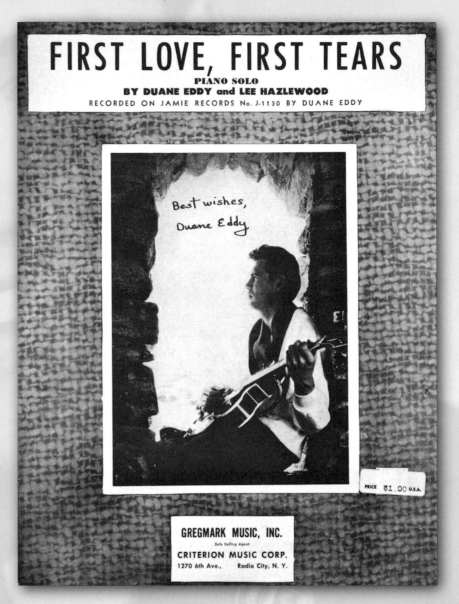

***My Wish Came True* (1957)**
Released as the B-side to "A Big Hunk O' Love" in 1959, "My Wish Came True" was recorded by Elvis with the Jordanaires, a vocal quartet that provided background vocals to many of his songs. His record company had stored enough material to be able to release songs even though he was serving in the Army at the time. Photo is signed by Elvis, with "Best Wishes."

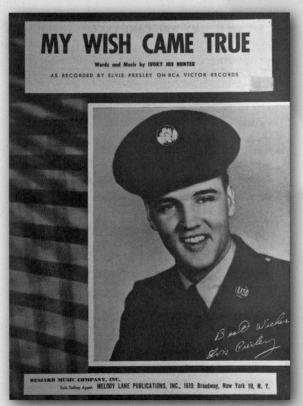

***First Love, First Tears* (1959)**
Removing the vocals, Duane Eddy pushed his guitar to the forefront in his hit records, added some reverb and a honkin' sax, and twanged his instrumental way into the Top 40. His photo on the cover is inscribed "Best Wishes, Duane Eddy."

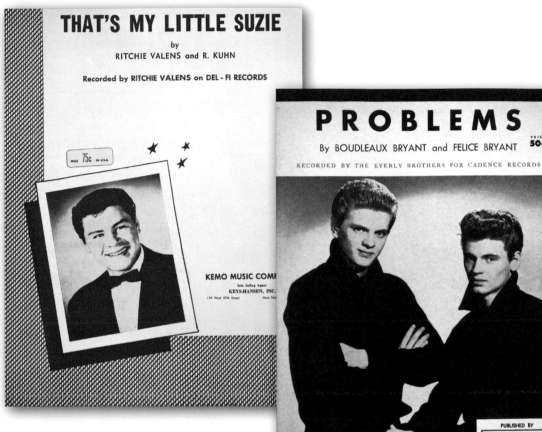

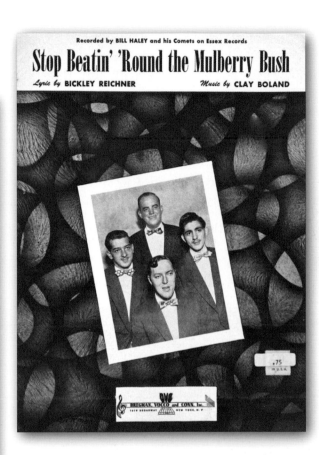

That's My Little Suzie (**1959**)
Rock 'n' roll pioneer Ritchie Valens had great success incorporating Latin American influences into his music, despite his short recording career—barely eight months. His two big hits were "La Bamba" and "Donna." He died in the same plane crash that killed Buddy Holly and "The Big Bopper" on February 2, 1959, known as "The Day the Music Died." He was only seventeen years old. This song was released after his death.

Problems (**1958**)
The Everly Brothers' sound was based on their unique vocal harmonies and their dual acoustic guitar playing, both of which would have a strong influence on music in the early sixties. This song reached No. 2 on the US charts.

Stop Beatin' 'Round The Mulberry Bush (**1953**)
Bill Haley and His Comets could arguably claim to have made one of the first "rock 'n' roll" records in 1951 with "Rocket 88," a few months after Ike Turner recorded the rhythm and blues original at Sam Phillips's studio in Memphis. They followed this song with "Crazy Man, Crazy" (1953) then "Rock Around The Clock" and "Shake, Rattle and Roll" (1954), cementing their place in music history. Known onstage for their energetic performances, Bill Haley and His Comets released this song in 1953, and the photo shows them wearing their "trademark" bow ties.

The serious approach of the Weavers to reviving traditional tunes directly led to a thriving folk scene and to later groups like the Kingston Trio and Peter, Paul and Mary. The covert influence of folk music also contributed another piece to the puzzle that would become "rock" in the next decade.

It added the sense of storytelling or "having a message" that would be an important feature for musicians like Bob Dylan in the sixties, who used it, refined it, and eventually took it electric (to the serious dismay of some of his fans and folk supporters). To some he was a traitor for doing so, to others a hero. Folk music gave him a start.

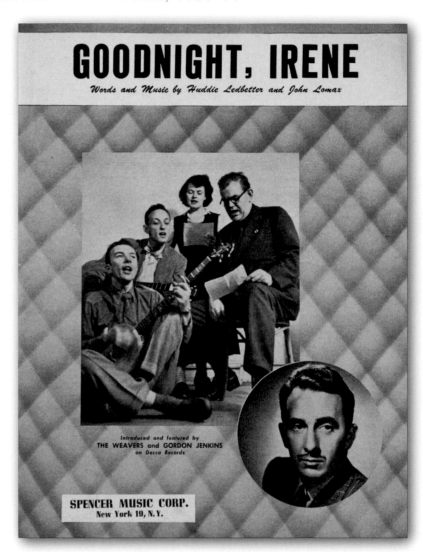

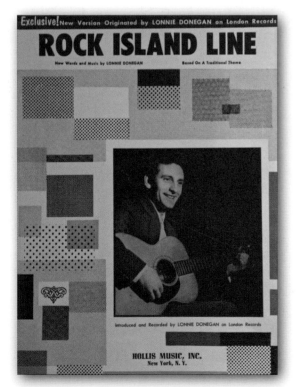

Rock Island Line (1956)

This traditional American folk song became the first big UK hit for Lonnie Donegan in 1956, and helped him popularize a style of rustic folk playing in Britain called "skiffle." This would go on to develop a huge following, and directly result (by their own admission) in the formation of the Beatles. Certainly a landmark sheet, with Lonnie pictured on the cover.

Goodnight, Irene (1936)

The Weavers took many old folk and blues songs and added their own string band arrangements and harmonies with great success. Here they used the tune by the black bluesman Leadbelly (Huddie Ledbetter) and got their first No. 1 hit in 1950. Seen on the cover is the group, with original member Pete Seeger playing the banjo at the front, and Gordon Jenkins, who discovered them and signed them to Decca Records.

As the fifties drew to a close, rock 'n' roll became more established, but at the same time it almost went into limbo. By the end of 1959, some of the major figures and up-and-coming stars were either dead or gone from the public eye.

The tragic deaths of Buddy Holly (age 22), Eddie Cochran (age 21), and Ritchie Valens (age 17!) were a serious blow to the music and the fans. Elvis himself spent two years (1958–60) in the army, away during his peak touring and performing years. Both Chuck Berry and Jerry Lee Lewis had legal problems and scandals that kept them distracted from their music. Even Little Richard "hung up his rock 'n' roll shoes" and announced in 1957 that he was giving up the secular music business for religious/spiritual reasons.

The music industry itself was under tough scrutiny from Congress starting in 1959, with a "payola" (pay for play) investigation that seemed to be linked to rock 'n' roll radio.

The music seemed to lose its momentum and almost didn't recover. It would take some new faces to revitalize rock 'n' roll in the early sixties. It would take an invasion from across the sea, which would start with the Beatles. But we had to wait a few years for that to happen . . .

Don't Knock The Rock (1956)

Released in December 1956, *Don't Knock The Rock* has a simplistic storyline about a musician and a DJ who try to show that rock 'n' roll is harmless (?) and doesn't lead to juvenile delinquency (??). Despite having Bill Haley and His Comets as the headliner, this movie was not as successful as *Rock Around The Clock* (from earlier that same year). However, Little Richard did gain a lot of attention for his wild musical performances of "Tutti Frutti" and "Long Tall Sally." The cover of the sheet music shows all the performers in a montage.

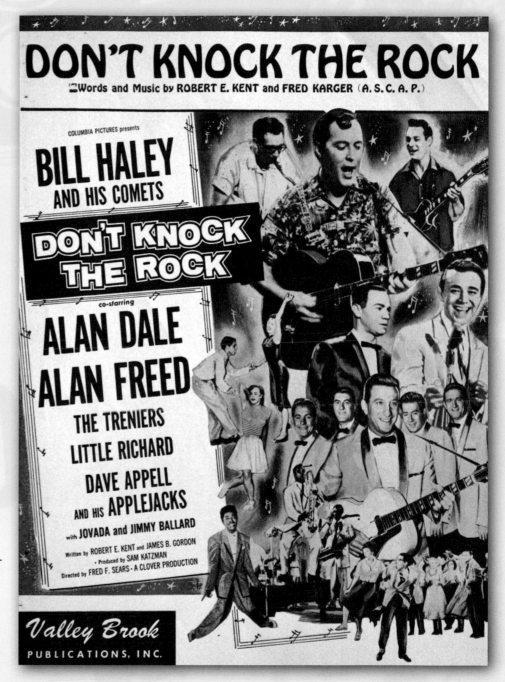

ROCKIN' THROUGH THE SIXTIES

A REVOLUTION IN THE AIR

As rock 'n' roll yielded to the British Invasion, the Beatles and others provided the spark to push the boundaries of music and its audience further. At the same time, Bob Dylan greatly influenced the use of meaningful lyrics. The protest themes found in folk music began to appear in rock, and songs started to take on an "edge" or carry a message of social unrest. The words were becoming more important. Sales of sheet music increased.

Weekly variety shows, like Ed Sullivan's, introduced the nation to many new musical acts, as live performances happened every week right in your living room. It was a chance to see, as well as hear, the newest groups. Music was springing up all over TV, as well as being played by DJs on the hit-oriented radio stations.

A glance at the *Billboard* Top 10 from the sixties shows the diverse nature of the music being heard on the radio. During the week of January 23, 1961, Elvis shared the chart with Lawrence Welk; on March 21, 1964, it was the Beatles and Louis Armstrong; on June 4, 1966, the Rolling Stones faced off against Frank Sinatra. There was a cornucopia of music that could be heard by most people on "standard" radio, before marketing people got involved and decided to concentrate on targeted segments of the listening audience. Radio then became less about the music and all about the ratings (and still is).

There was a major innovation that made all this radio airplay important. The portable transistor radio had begun to reach the marketplace in the late fifties, so by the early sixties it was a common item. Its small size allowed people to hear and enjoy music wherever they went. It began a dramatic change in people's listening habits. No longer was it necessary to huddle around the home radio receiver. Now music could truly be everywhere. Single-handedly, the transistor radio would facilitate the explosion of popular music during this decade and beyond (in addition to all the other things that transistors would make possible).

I Dig Rock And Roll Music (1967)
When Peter, Paul and Mary recorded this song, the transition of popular interest from folk music to rock music was well under way. As one of the biggest folk groups of the time, they used "I Dig Rock And Roll Music" as a vehicle to make fun of the commercialism and shortcomings of rock, using a number of sly references to current groups in the lyrics. Surprisingly, many people took this catchy tune at face value, and it sold very well.

Like A Rolling Stone (1965)
Bob Dylan may not have the most melodic-sounding voice, but his contributions to lyrics, songwriting, and poetic vision are undisputed. A somewhat rumpled-looking and pensive Dylan stares out at us from the photo on the cover.

Happenings Ten Years Time Ago (1966)
The roster of this group included, at one time or another, three guitarists who went on to become some of the most revered players in rock history: Eric Clapton, Jimmy Page, and Jeff Beck. The photo on the cover of this sheet includes Eric Clapton (second from left), but he was long gone by the time this song was recorded.

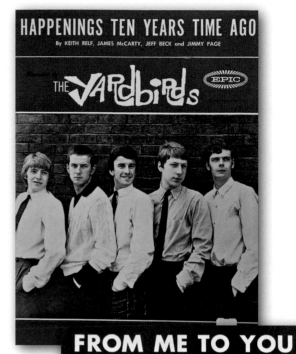

California Girls (1965)
No other group in the sixties was able to capture the spirit of the West Coast lifestyle (surfing, hot rods, romance, etc.) like the Beach Boys. The songwriting talents of Brian Wilson were showcased by the group's spectacular vocal harmonies. They dominated the charts through the early and mid-part of the decade.

From Me To You (1963)
The Beatles were catalysts of change for the direction of music in the sixties—and beyond. Their popularity and influence extended far past the time they existed as a group, topping the charts with albums more than forty years after they disbanded. Music and the world would never be the same because of them.

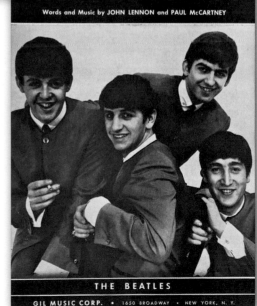

Hello Mary Lou (1961)

Released as the B-side of the No. 1 single "Travelin' Man" and written by Gene Pitney, "Hello Mary Lou" had great chart success for Ricky Nelson as well. Nelson originally gained popularity on the television program *The Adventures Of Ozzie And Harriet* with the rest of his family. He had a string of hits from the late fifties through the sixties and seventies, but would die in a plane crash in 1985 at the age of forty-five.

The Lonely Bit (1961)

This was one of Frankie Avalon's later-charting songs, as by this time he had begun to concentrate on his acting career. He would soon appear with costar Annette Funicello in a series of seven comedy "beach party" movies with titles like *Beach Party, Muscle Beach Party, Bikini Beach, Pajama Party, Beach Blanket Bingo, How To Stuff A Wild Bikini*, and *The Ghost In The Invisible Bikini*. He would also make an appearance in the movie *Grease* in 1978.

Be Mad Little Girl (1963)

Bobby Darin was another singer/actor of the late fifties and sixties who wrote some of his own material. His original hits were "Splish Splash" (1958) and "Dream Lover" (1959), but his biggest success was with the Kurt Weill song "Mack The Knife" (1959), for which he received a Grammy Award for Record of the Year. Even Frank Sinatra, who would record that song as well, considered Bobby's to be the definitive version.

I Feel It (1967)

Peggy Lee started charting songs as a jazz and pop singer in 1941, and continued to until 1974. This song reached No. 7 on the adult contemporary chart in 1967, showing her lasting ability to remain popular. A mature but still attractive Peggy Lee is seen on the cover. Having been involved so long in the music industry, the fitting epitaph marked on her gravestone is "Music is my life's breath."

Live It Up (1964)

A soulful English pop singer who became an icon of the Swinging Sixties scene in London, Dusty Springfield did many covers of Motown songs, including this one by Leon Huff. She became one of the most popular female singers, not only in England, but worldwide. Luckily, she had changed her name from Mary Isobel Catherine Bernadette O'Brien, which would not have fit as well on record labels.

A Sign Of The Times (1966)

Petula Clark performed on radio and TV and in films starting in the late 1940s. She became most popular in the United States through her hit singles in the mid-sixties, receiving a Grammy for "Downtown" (1964) and "I Know A Place" (1965). She was another woman identified with the British mod pop sound.

Hot on the heels of the Beatles' success in America came an invasion of British groups and performers willing to fill the almost insatiable demand for this new pop sound. With some exceptions (like the Rolling Stones), many did not survive past the end of the decade.

Home-grown American bands also hit the charts. All of this produced an unprecedented variety of sounds and styles, often with personnel changes resembling musical chairs.

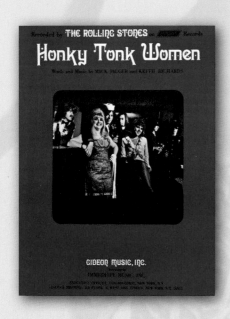

Honky Tonk Women (1969)

The Rolling Stones were the masters of rough and raunchy rock 'n' roll. It's an image that has been successful and stayed with them throughout their career. Very appropriate photo, for the song and for the group, on the cover.

I'm Henry VIII, I Am (1965)

Pronounced, and sung, as "I'm Henery the eighth, I am," this is an old British music hall number from 1910. It enjoyed a new lease on life when revived by Herman's Hermits in 1965, and reached No. 1 on the American *Billboard* chart.

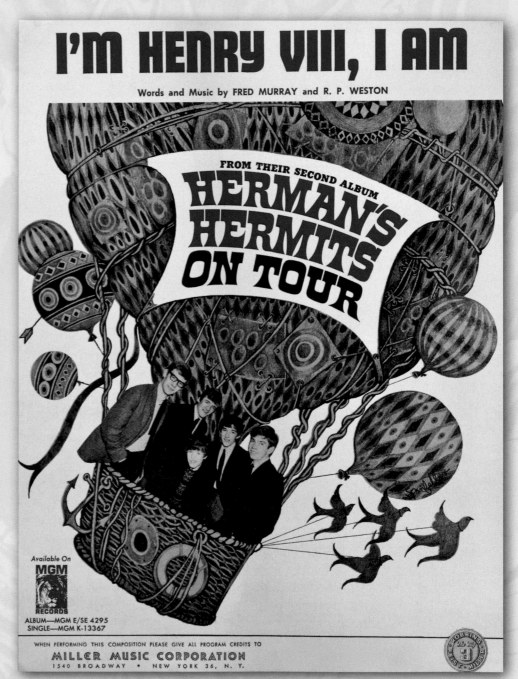

I'm Telling You Now (1963)

A fairly short-lived group, Freddie and the Dreamers took advantage of the American appetite for British pop bands after the success of the Beatles. Originally released in the UK in 1963, this song was not available in the US until April 1965, when it did hit No. 1. Typical silly photo of the group, whose leader, Freddie Garrity (at top), was known for his crazy onstage antics.

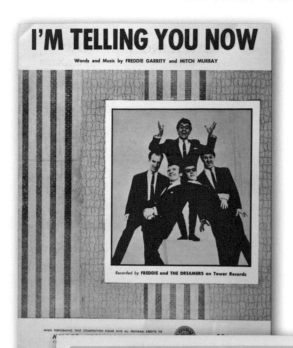

Give All Your Love To Me (1965)

Gerry and the Pacemakers had a remarkably similar background to the Beatles (they were from Liverpool, managed by Brian Epstein, and recorded by George Martin) but could not share in the long-term success. They were even featured in their own movie, *Ferry Cross The Mersey*, which also did not have the same effect. They lacked the personality (and talent) of the Fab Four.

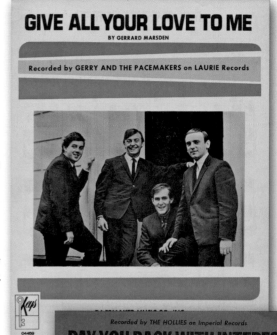

Try Too Hard (1966)

Initially, the Dave Clark Five were more popular in the US than they were in the UK, in spite of being an English group. This title reached No. 12 on the *Billboard* chart in 1966, and prominently featured the drum playing of Dave Clark himself, as did many of the group's songs. In an unusual move for a pop song, the chorus of "Try Too Hard" changes time signature from 4/4 to a measure of 2/4, then 3/4, before switching back.

Pay You Back With Interest (1966)

At times sounding like a blend of the vocal harmonies of the Beach Boys and the jangling guitar of the Byrds, the Hollies changed personnel with regularity. They are one of the few groups that never officially broke up, and they continue to perform. Their most famous member, Graham Nash (1962–68), would go on to work with David Crosby, Stephen Stills, and Neil Young.

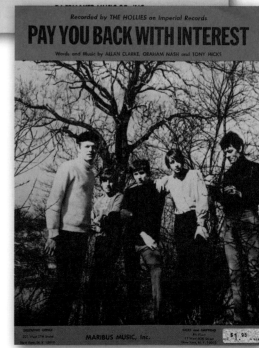

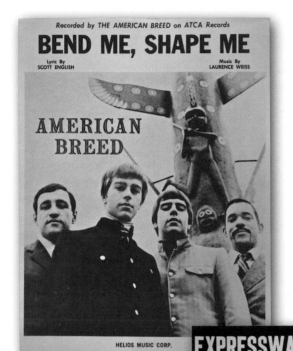

Bend Me, Shape Me (1967)

The American Breed was a band that came out of the suburbs of Chicago and had its biggest success with this song, both here and in the UK. Though the band only lasted from 1966 to 1969, "Bend Me, Shape Me" has resurfaced throughout the years in various commercials, and in an episode of the animated series *Futurama*. Very stylish-looking group in the photo.

Good Thing (1966)

In a clever attempt to play off the name of their leader, Paul Revere, the band members dressed in American Revolutionary War uniforms, and they were marketed as America's answer to the British Invasion. Fortunately, they had the talent to put quite a few hits on the charts, well into the seventies. Paul Revere & the Raiders had a changing cast of musicians, including charter member Mark Lindsay.

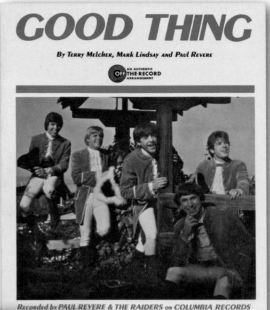

Expressway To Your Heart (1967)

Based out of Philadelphia, the Soul Survivors were greatly influenced by the R&B sound coming out of local soul record producers/songwriters Kenny Gamble and Leon Huff (who wrote this song). This was the group's biggest hit and most successful single, later to be performed by the Blues Brothers as well.

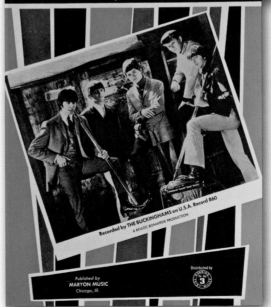

Kind Of A Drag (1966)

The Buckinghams were another Chicago-based pop group. They played in a style sometimes referred to as "sunshine pop," upbeat and cheerful with strong harmonies and a polished performance. Similar-sounding groups of the time were the Association, the Turtles, the Mamas & the Papas, the 5th Dimension, Spanky and Our Gang, and even some later Beach Boys (1965--69).

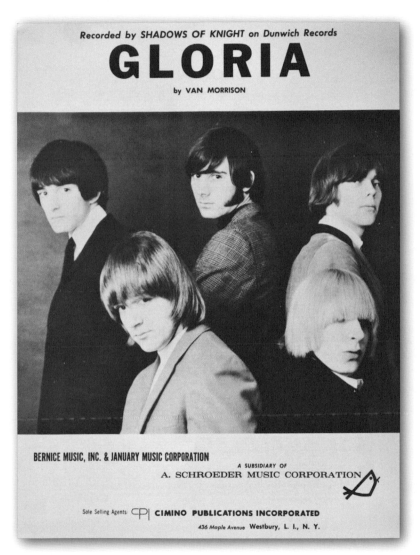

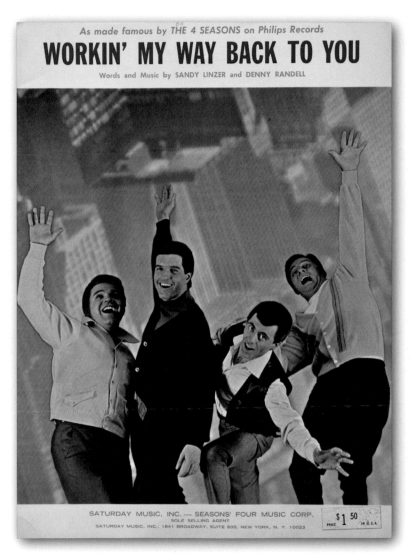

Gloria **(1965)**

In spite of an almost English "mod" look on the cover, the Shadows of Knight were an American, Chicago-area band that recorded a number of old Chess Records blues covers on their debut album in 1966 (just like the Rolling Stones did), along with this Van Morrison classic. The energy they played with on the album comes through even today, and makes the songs still enjoyable to hear. A garage-band song favorite, for sure.

Workin' My Way Back To You **(1966)**

Various iterations of the Four Seasons have been around since the early sixties. Known at times as Frankie Valli and the Four Seasons (since Valli was the lead singer and co--founding member), they still tour to this day as a vocal group. There is even a musical play called *Jersey Boys* based on the lives and music of the Four Seasons. Opening in 2005, it not only got great reviews, it also won four Tony Awards for the Broadway production. On this eye-catching cover, they are posed as if falling. (?)

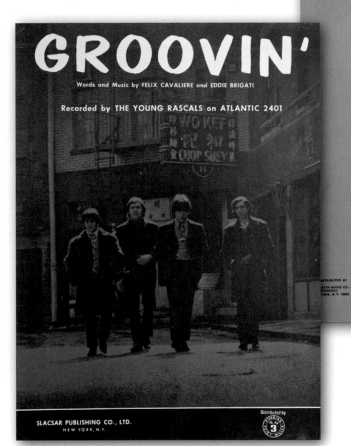

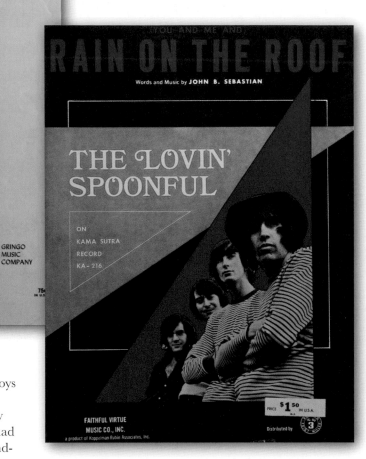

Groovin' (1967)
Released just as the Summer of Love (1967) was beginning, it became the unofficial anthem and a No. 1 hit for the Young Rascals. Their music had a smooth sound that was a mix of blues, soul, and pop. Later on they would shorten their name to just the Rascals.

My Heart's Symphony (1966)
Led by the son of Jerry Lewis the comedian, Gary Lewis & the Playboys reached No. 1 with their very first single, "This Diamond Ring." They made many TV appearances and had a successful career until they disbanded in 1970. Note that the photo on the cover is a photographic trick. Initially it appears that they are standing in front of a reflective pool; however, if you look closely at the figures, they do not match up. It's the same picture, just turned upside down.

(You And Me And) Rain On The Roof (1966)
Led by founder John Sebastian, the pop hits of the Lovin' Spoonful were very acoustic-folk influenced, especially when John would play the traditional autoharp.

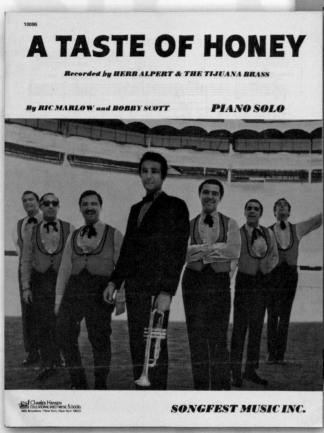

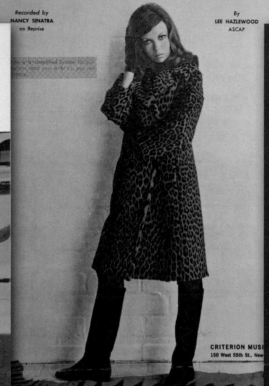

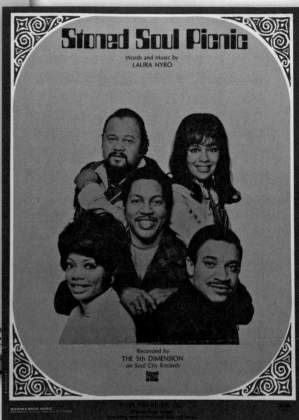

A Taste Of Honey (1960)
This popular instrumental version of a song recorded by the Beatles in 1963 earned Herb Alpert & the Tijuana Brass four Grammy Awards in 1965. Alpert became a music industry executive, and cofounded A&M Records in 1962.

These Boots Are Made For Walkin' (1966)
Nancy Sinatra, famous daughter of Frank, had a number of chart successes in the sixties and beyond, but this one is most identified with her. A stylish Nancy is pictured on the cover. In the following year, she recorded not only a No. 1 duet with her dad ("Somethin' Stupid") but also the theme from the next Bond movie, *You Only Live Twice*.

Stoned Soul Picnic (1968)
The 5th Dimension charted quite a few singles from 1966 to 1975, including five songs by Laura Nyro. This one reached No. 3 in 1968. They were also well represented in the "sunshine pop" category, with its lightweight songs, in recordings like "Up, Up And Away," "Wedding Bell Blues," "One Less Bell To Answer" and the No. 1 song "Aquarius/Let The Sunshine In" from *Hair*.

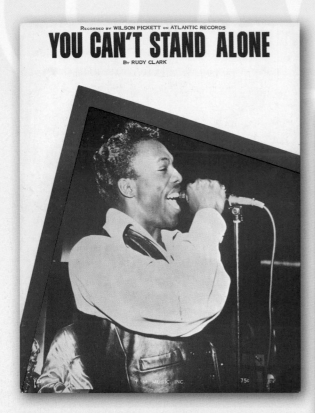

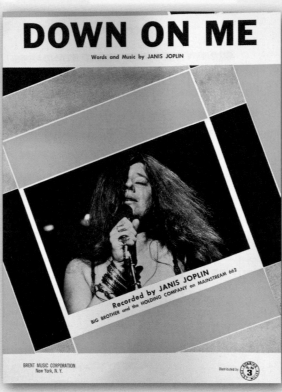

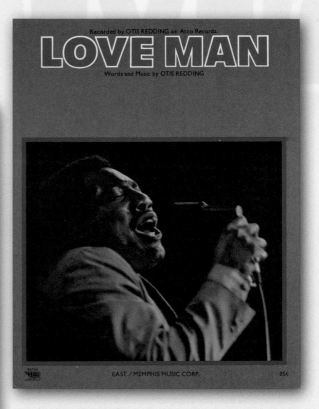

You Can't Stand Alone (1967)

With a career that lasted over forty years, Wilson Pickett recorded in some of the landmark soul studios of the sixties, such as Stax in Memphis and Fame in Muscle Shoals, Alabama. A lot of those famous tracks were completed with the help of guitarists like Steve Cropper and Duane Allman, and producers like Jerry Wexler and Tom Dowd. Some of Pickett's hits include "In The Midnight Hour," "634-5789," "Land Of 1000 Dances," "Mustang Sally," "Everybody Needs Somebody To Love," "Funky Broadway," and a soulful version of the Beatles' "Hey Jude."

Down On Me (1967)

This song was released on the debut album of Big Brother and the Holding Company, with Janis Joplin on vocals. She quickly established herself as *the* premier white female blues singer, and had an electric stage presence, a powerful voice, and a predilection for drugs and Southern Comfort. She died in 1970 at the age of twenty-seven.

Love Man (1967)

Otis Redding is considered one of the greatest soul singers ever. From the early to mid-sixties, he recorded a number of studio and live albums, and had significant success. He personified the soulful Stax sound. But it was only after his performance at the 1967 Monterey Pop Festival that he got maximum national exposure. Unfortunately, he was killed in a plane crash just a few months later. He was twenty-six years old. After his death, the single "(Sittin' On) The Dock Of The Bay," recorded just days before, was released and hit No. 1 on the *Billboard* Hot 100 and R&B charts. It also earned him two posthumous Grammy Awards. The sheet "Love Man" features the title track to one of the albums released the following year.

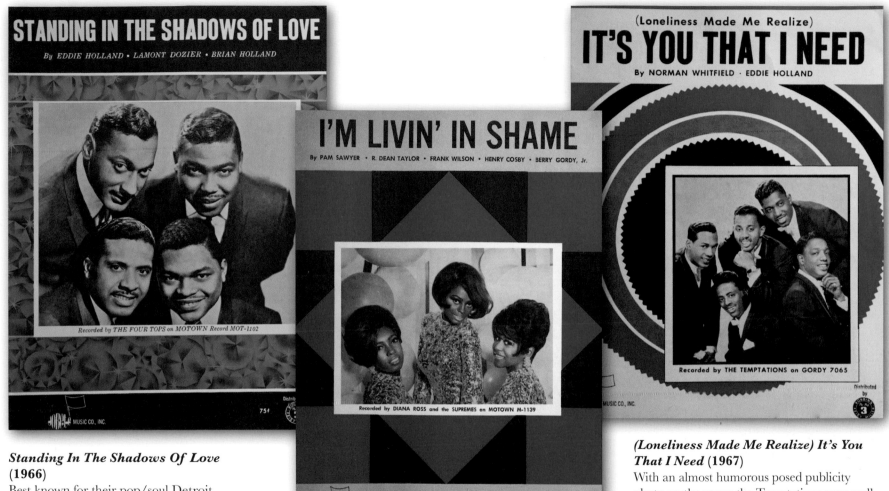

Standing In The Shadows Of Love (1966)

Best known for their pop/soul Detroit Motown recordings in the sixties, the Four Tops were a vocal quartet that was able to keep the same personnel for over forty years, an unbelievable track record for any music group. "Standing In The Shadows Of Love" is one of the most-recognized Motown songs, many of which were written by the famous team of Holland/Dozier/Holland.

I'm Livin' In Shame (1969)

Originally billed in 1961 as the Supremes, they became the most successful of all the Motown artists. In 1967 they were renamed Diana Ross and the Supremes, but by 1970 Ross left and went on to a successful solo career. Great period photo on cover.

(Loneliness Made Me Realize) It's You That I Need (1967)

With an almost humorous posed publicity photo on the cover, the Temptations were well known for their planned choreography on-stage while singing a soulful brand of five-part harmony. Dressed in outfits that were often color-coordinated and extravagant, they helped push the Motown Sound across the country and around the world. In spite of frequent lineup changes, they never lost their popularity, and they still record and appear with one of the original members of the group.

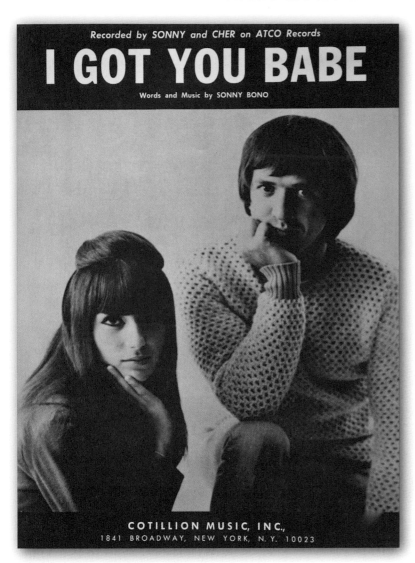

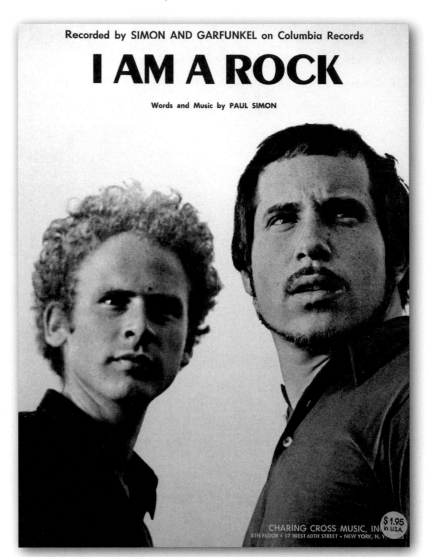

I Got You Babe (1965)

Written by Sonny Bono, "I Got You Babe" became the biggest hit for the husband-and-wife duo of Sonny & Cher (they divorced in 1975), spending three weeks at No. 1. After appearing on their own TV variety show in the seventies, Cher continued a successful singing and acting career, while Sonny was elected to Congress, as a Republican.

I Am A Rock (1965)

Simon and Garfunkel dominated the sixties, but they were another famous duo that split up even earlier than Sonny & Cher, in 1970. As the songwriter and guitarist, Paul Simon always stayed focused on his music, while Art Garfunkel tried acting and singing on his own. They did have periodic reunions every decade or so for special concerts and tours.

Always the trendsetters when it came to music, lifestyles, and fashion in the sixties, the Beatles set the psychedelic tone (or at least reinforced it) for the final three years of the decade with their worldwide broadcast message of "All You Need Is Love" in June 1967.

It was presented as the British contribution to *Our World*, the first-ever live global television link, viewed by over four hundred million people. The song was also on the *Magical Mystery Tour* album, in the film of the same name, as well as in *Yellow Submarine*. It was maximum influence.

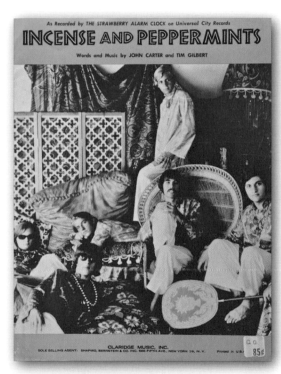

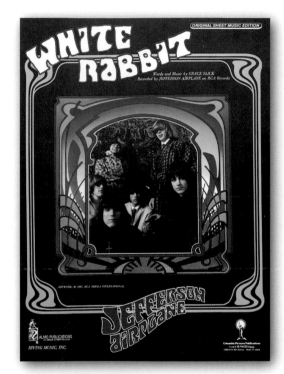

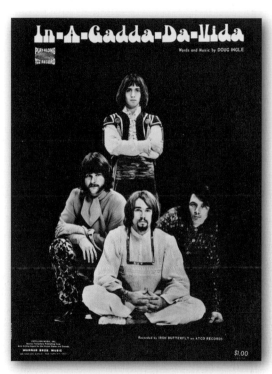

Incense And Peppermints (1967)

The California psychedelic pop band the Strawberry Alarm Clock sounded perfect and looked the part with this song and sheet music cover. Hippie fashions, drug references, way-out lyrics—it all fit together for the time. With lyrics preaching the use of drugs to gain self-awareness, the song "Incense And Peppermints" hit No. 1 in the groovy year of 1967.

White Rabbit (1967)

With the lyrics referencing the characters in Lewis Carroll's novel *Alice's Adventures In Wonderland*, the song "White Rabbit" was an obvious drug trip reference. San Francisco psychedelic rock from the masters, Jefferson Airplane, with their powerful female vocalist Grace Slick pictured on the lower right.

In-A-Gadda-Da-Vida (1968)

Another West Coast psychedelic rock group, Iron Butterfly became famous (infamous?) for the original seventeen-minute version of this song, with extended organ and drum solos, from their album in 1968. Cut to a more manageable 2:52 singles version, it had a riff that, even to this day, remains firmly identified with that era, and it went on to influence the creation of a more heavy metal sound in music. Significant, yes—subtle, no.

Films started to use rock music, as opposed to composed classical music scores, as complete soundtracks. The Beatles' "A Hard Day's Night" proved that pop and rock songs could play a key element in a movie.

Other movies used more traditional film composers, like Elmer Bernstein, Dimitri Tiomkin, Miklos Rozsa, Lalo Schifrin, Ennio Morricone, and the extremely talented and versatile Henry Mancini.

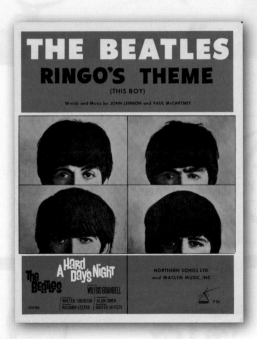

Ringo's Theme (This Boy) (1964)

This was an instrumental version of the Beatles song "This Boy," used during Ringo's big scene in the film *A Hard Day's Night*, which featured the humor and music of the Beatles to great effect. A classic, groundbreaking movie and an iconic image on the sheet music from both the movie credits and original poster.

Listen People (1965)

This song was sung by Herman's Hermits in *When The Boys Meet The Girls*, a light-hearted musical entertainment released in 1965. It boasts an extremely varied cast of musicians, from the above to Sam the Sham and the Pharaohs, Louis Armstrong, and Liberace. The cover shows an interesting photo montage around the main characters, played by Harve Presnell and Connie Francis.

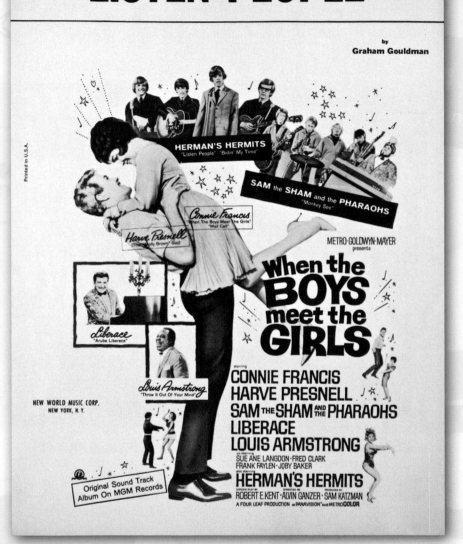

Midnight Cowboy (1969)

John Barry won a Grammy for Best Instrumental Theme for *Midnight Cowboy*, released in 1969. It's a gritty narrative about the unlikely friendship that eventually develops between two mismatched, down-on-their-luck characters named "Ratso" Rizzo (Dustin Hoffman) and Joe Buck (Jon Voight) in New York City. It also won multiple Academy Awards.

Scarborough Fair/ Canticle (1966)

The Graduate, from 1967, is another triumph for Dustin Hoffman, as a directionless and unsure college graduate who gets seduced by an older woman but then falls in love with her daughter. Music by Paul Simon includes the hit "Mrs. Robinson," along with this gentle folk song interwoven with antiwar lyrics (this *was* during Vietnam). Artful illustration loosely based on one of the film's classic scenes.

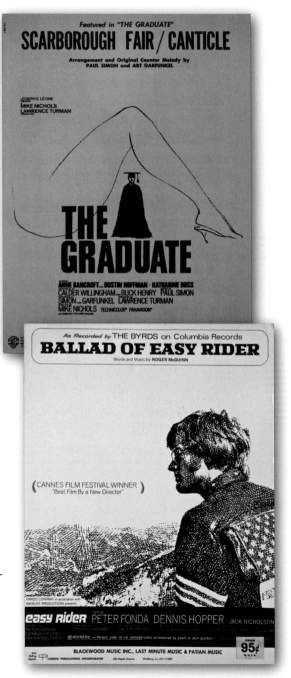

Catch Us If You Can (1965)

Having A Wild Weekend was an unsuccessful attempt to do for the Dave Clark Five what *A Hard Day's Night* did for the Beatles. Released a year later, in 1965, it tried to be more of a serious attempt to find some profound meaning in life, as opposed to the all-out fun and craziness presented by the Beatles. It failed to entertain.

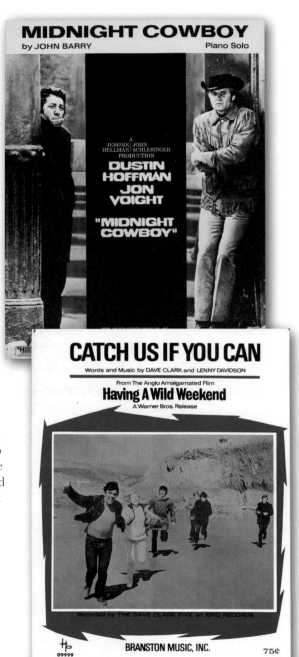

Ballad Of Easy Rider (1969)

A movie that questioned the American Dream and the meaning of freedom, *Easy Rider* reflected the mood of society, and the counterculture, in 1969. The music did as well, with songs by the Byrds, Jimi Hendrix, the Band, and Steppenwolf. With Peter Fonda as the flag-draped Captain America, the movie poster tagline states, "A man went looking for America. And couldn't find it anywhere . . ."

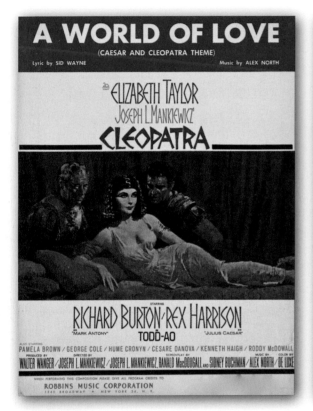

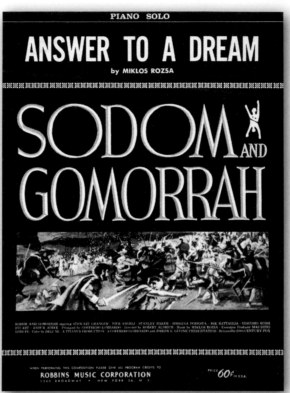

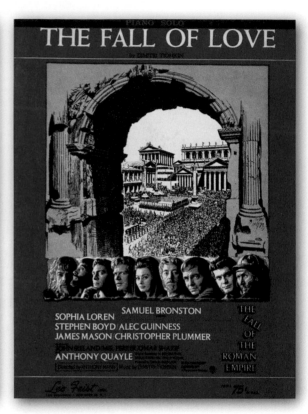

A World Of Love (Caesar And Cleopatra Theme) (1963)

Cleopatra was one of the big box office blockbusters in 1963, and also one of the most expensive films ever made. It grandly presented the struggle of the Egyptian queen Cleopatra (Elizabeth Taylor) against the Imperial power of Rome, through her relationships with Julius Caesar (Rex Harrison) and Marc Antony (Richard Burton). The cover depicts a painting of the three, giving her the spotlight.

Answer To A Dream (1962)

A very melodramatic Biblical spectacle, *Sodom And Gomorrah* was another large-scale movie production released in 1962. It gave a fictional account of the reasons (orgies, decadence, wickedness, torture, etc.) behind the eventual divine destruction of these twin cities. It featured Stewart Grainger in the role of Lot, the Hebrew leader.

The Fall Of Love (1964)

The Fall Of The Roman Empire, released in 1964, was one of the last big epics to be produced for some time in the genre of "swords and sandals," as these were called. The movie was as ponderous as the empire itself, and the acting was not really up to par, despite some well-known names. It was a financial failure, and just another example of Hollywood beating a theme into the ground in an attempt to capitalize on it.

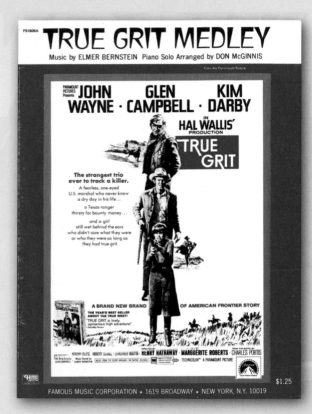

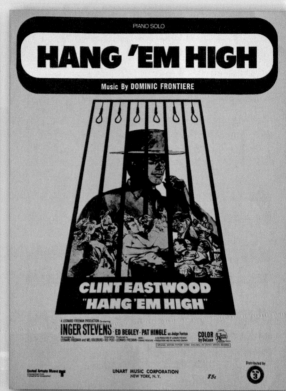

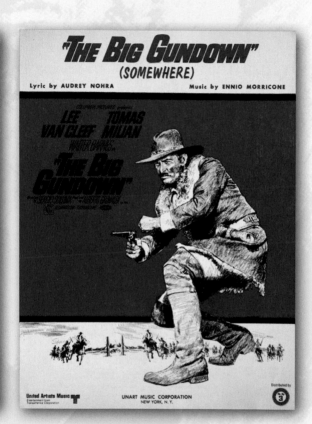

True Grit Medley (1969)
John Wayne, Glen Campbell, and Kim Darby starred as "the strangest trio ever to track a killer," as stated on the cover of the sheet and the movie poster in 1969. This Western was based on a then-current novel, while the music was by the prolific film composer Elmer Bernstein. Because of his performance in *True Grit*, John Wayne won his first, and only, Academy Award.

Hang 'Em High (1968)
The soft-spoken but tough Clint Eastwood wanders the West, looking for retribution against the gang of men who tried to lynch him for a crime he didn't commit. From its release in 1968, *Hang 'Em High* was extremely successful and helped solidify Eastwood's acting persona, and not just for his Western roles.

The Big Gundown (Somewhere) (1968)
Considered by some to be one of the best of the "spaghetti Westerns" (after the Dollars Trilogy with Clint Eastwood), *The Big Gundown* (1966) was Lee Van Cleef's first leading role. This song in English was added for the American release, almost two years later.

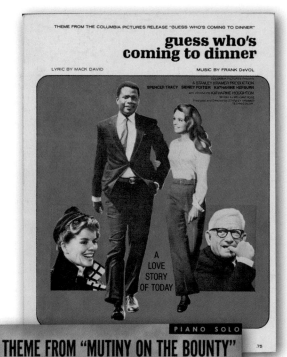

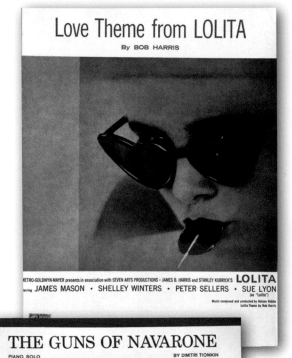

Guess Who's Coming To Dinner (1968)

Listed on the cover as "A Love Story of Today," this movie was a strong challenge to the current (1968) attitudes on the controversial topic of interracial marriage. The four main actors are pictured on the sheet music, and this was the ninth time Katharine Hepburn and Spencer Tracy shared a film. Unfortunately, he died just over two weeks after filming finished.

Lolita—Love Theme From (1962)

Another movie with a controversial subject—that of a middle-aged teacher becoming infatuated with the flirtatious fourteen-year-old daughter of his new wife. Stanley Kubrick directed *Lolita* in his distinctive and somewhat surreal style, as he had to imply or slyly suggest the more intimate or sexual aspects because of prevailing censorship.

Mutiny On The Bounty— Theme From (1962)

This movie was based on the true story of the *HMS Bounty* and the revolt by the crew against their tyrannical captain in 1789. Even without a lot of special effects, *Mutiny On The Bounty* showcased the beauty of the South Pacific and had a great cast of actors, making for an visually entertaining film. Because of high costs, it was never a financial success, but the name of Captain Bligh is forever associated with mean-spirited and cruel leaders.

The Guns Of Navarone (1961)

With a great ensemble cast, the action of the film is centered around a team of commandos determined to destroy a crucial and well-defended Nazi fortress, and the difficulties they have to overcome. It was a huge hit at the box office, and won an Academy Award for Best Special Effects. The sheet music cover carries the original poster art for the film.

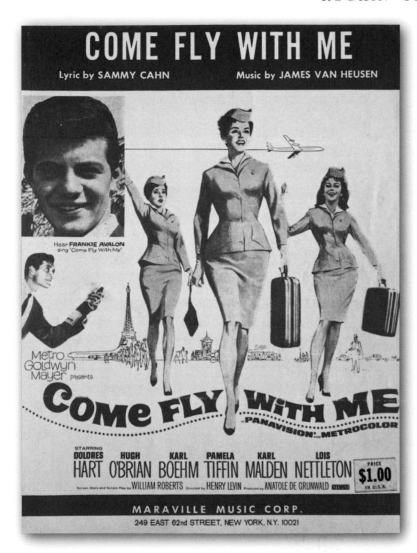

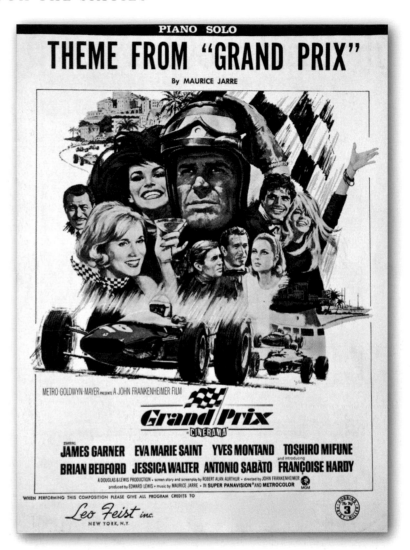

***Come Fly With Me* (1958)**

Even though Frank Sinatra recorded his classic version in 1958, Frankie Avalon sang this song for the 1963 lightweight comedy *Come Fly With Me*. It follows the exploits of three gorgeous airline "hostesses" as they travel internationally, looking for love (and rich men to marry). Playing on the early glamour of this new method of travel by jet, it is somewhat dated, as air travel is now much more mundane (and annoying).

***Grand Prix—Theme From* (1966)**

A story of love and loss on the international racing circuit, *Grand Prix* chronicles the fate of four drivers (and the women who are attracted to them) during the course of a fictional Formula One season. Great effort was spent by the director, John Frankenheimer, to use new camera and recording techniques to provide the viewer with exciting racing sequences, for which the film won three Academy Awards in technical categories.

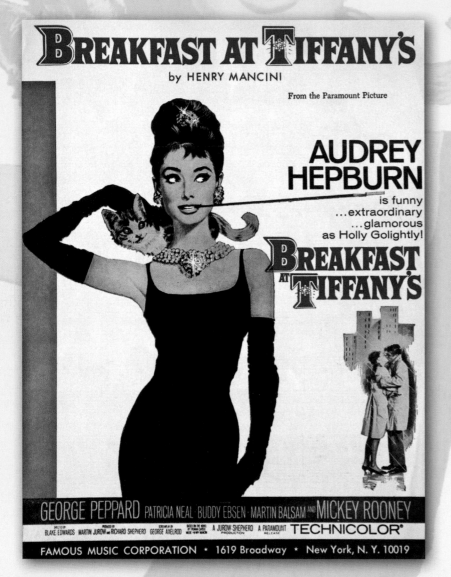

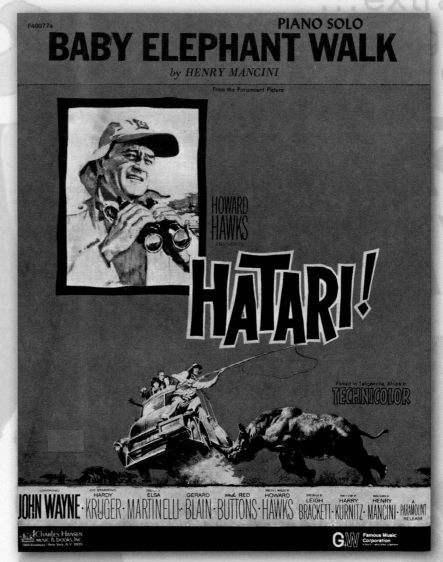

Breakfast At Tiffany's (1961)
Audrey Hepburn thrilled audiences as a lovely leading lady, and that certainly came through as she played the sophisticated yet quirky Holly Golightly in *Breakfast At Tiffany's*. Blake Edwards directed this romantic comedy in 1961, which won two Academy Awards for its music (including the Henry Mancini song "Moon River"). A movie with remarkable charm.

Baby Elephant Walk (1961)
The movie *Hatari* was centered around a group of professionals who captured wild animals for zoos. Even though there were exciting chase sequences across the African plains, *Hatari* was actually part romance and part comedy as well. Another classic Mancini score, which introduced this catchy instrumental pop hit, "Baby Elephant Walk."

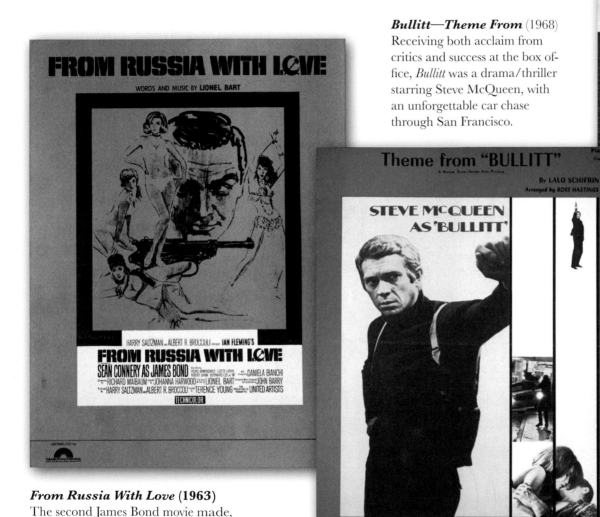

Bullitt—Theme From (1968)
Receiving both acclaim from critics and success at the box office, *Bullitt* was a drama/thriller starring Steve McQueen, with an unforgettable car chase through San Francisco.

Funeral In Berlin—Theme From (1966)
Based on a novel by Len Deighton, *Funeral In Berlin* was an excellent sixties Cold War spy film, and was a follow-up to *The Ipcress File*. Both movies featured Michael Caine. The description on the sheet reads, "It was going to be a lovely funeral. Harry Palmer just hoped it wouldn't be his . . ." The image on the cover is a collage of drawn sketches and photos from the film.

From Russia With Love (1963)
The second James Bond movie made, based on Ian Fleming's 1957 novel, *From Russia With Love*, is considered by some to be the best Bond film ever. It established the Bond style and formula to perfection, without going overboard, and used dialogue intelligently.

On TV, there were an abundance of new programs, and they all had to have a catchy theme. Some shows became classics; others are lost to obscurity. Many themes were published as sheet music, and included a photo or illustration from the production.

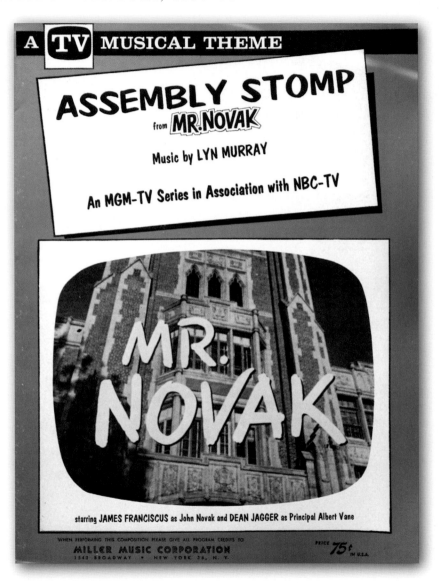

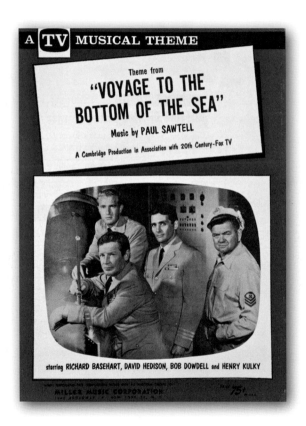

***Voyage To The Bottom Of The Sea* (1964)**
A long-running science fiction/adventure TV program (1964–68), *Voyage To The Bottom Of The Sea* showed the exploits of the crew of the *Seaview*, a supersubmarine of the future. It was based on an Irwin Allen film of the same name, released in 1961.

***Assembly Stomp* (1963)**
The information on the inside cover reads, "The fruitful focal point of *Mr. Nowak* is the fascinating world of our typical high school, the educators who serve these centers of learning so well and the passing parade of teenagers who constantly bring new life and new meaning to our classrooms." It was on TV from 1963 to 1965.

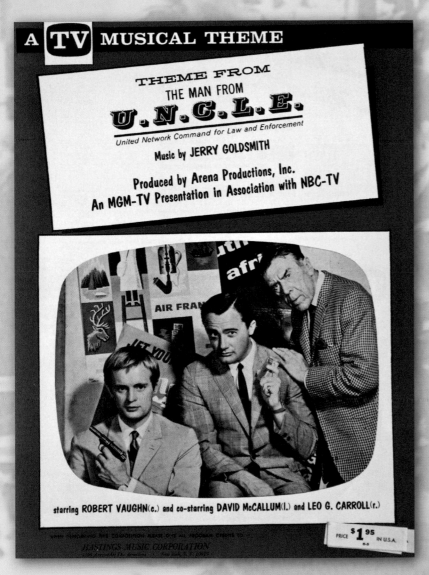

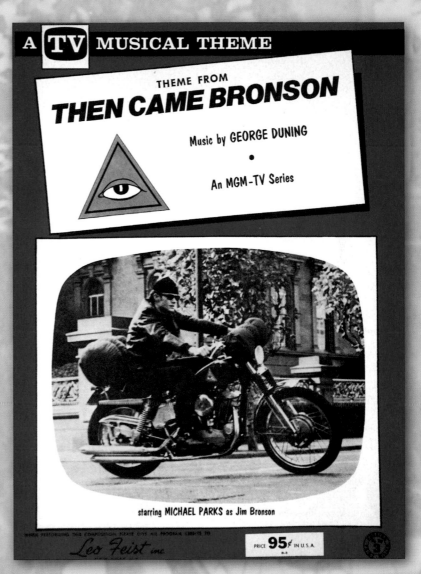

The Man From U.N.C.L.E.—Theme From (1964)
An espionage/spy program running for four seasons, *The Man From U.N.C.L.E.* (United Network Command for Law Enforcement) followed the adventures of a pair of agents—Napoleon Solo and Illya Kuryakin—as they worked for this secret agency.

Then Came Bronson—Theme From (1969)
In *Then Came Bronson*, a disillusioned newspapermen quits his job and travels the country on his Harley-Davidson Sportster, looking for greater meaning in life and helping people on the way. It ran for only one season (twenty-six episodes). The "eye" logo on the cover and painted on the tank of the bike is the Eye of Providence and symbolizes God watching over mankind.

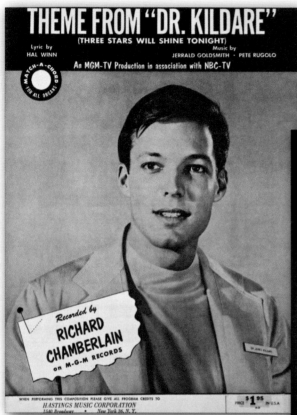

The Brothers' Theme (1967)

The *Smothers Brothers Comedy Hour* was a controversial variety show running for two years from 1967 to 1969. Folk-singing brothers Tom (acoustic guitar) and Dick (string bass) stretched the boundaries of what was allowed on television, thanks to their young staff of writers and the performers they booked to appear. This was especially true relating to politics and the anti--Vietnam War sentiment. Despite their conservative appearance, they reflected many of the views of the counterculture at the time.

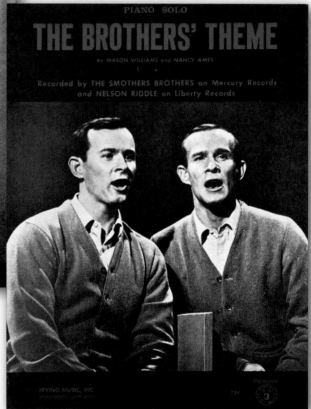

Dr. Kildare—Theme From (Three Stars Will Shine Tonight) (1961)

Against the bustling background of Blair Hospital, young intern Dr. Kildare handles the problems of his patients and tries to deal with the difficulties of working with the other staff personnel, including his boss, Dr. Gillespie (Raymond Massey). At times, it was more of a soap opera than anything, but it kept the viewers watching for five seasons. Richard Chamberlain recorded this vocal version of the *Dr. Kildare* theme.

Johnny's Theme (1962)

The famous theme of the NBC *Tonight Show* was written by Paul Anka and Johnny Carson, who would be forever identified with it as the long-time host. "Heeeere's Johnny"

Music helped define the sixties. American pop, the British Invasion, the Motown Sound—all played a part. The two concerts of Woodstock and Altamont (both in 1969) were a fitting end to the decade. An event that promoted "3 Days of Peace & Music" in August saw that idealized vision for a moment, but it then disintegrated into the chaos that was Altamont in December. Idealism was faced with reality . . .

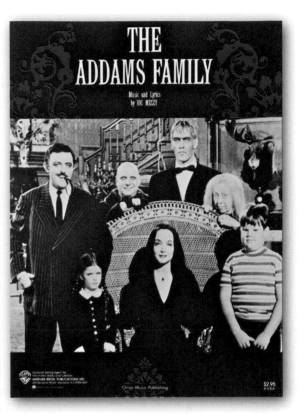

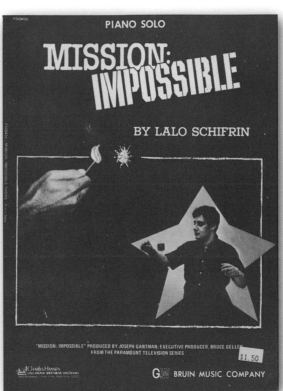

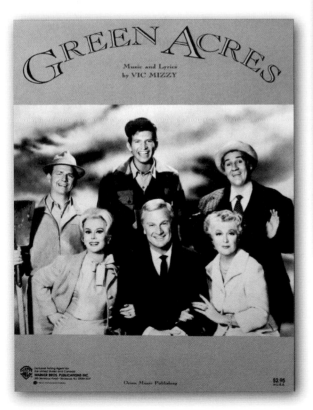

The Addams Family (1964)

Full of unusual characters and macabre humor, *The Addams Family* found a home on TV for two seasons (sixty-four episodes). Based on a long-running newspaper cartoon by Charles Addams, it also eventually spun off a movie series and a musical.

Mission: Impossible (1966)

This is where the movie franchise *Mission: Impossible* started—on TV. Every week we watched as Jim Phelps (Peter Graves) was given an assignment for his crew of Rollin Hand (Martin Landau), Cinnamon Carter (Barbara Bain), Barney Collier (Greg Morris), and Willy Armitage (Peter Lupus) to somehow pull off, and they always did, for seven seasons.

Green Acres (1965)

A sitcom that lasted six seasons (1965–71) about a big-city couple adapting (or not—he willingly, she unwillingly) to country life. *Green Acres* was loosely related to another series at the time, *Petticoat Junction*, and shared some characters and locations. Cast photo on the cover.

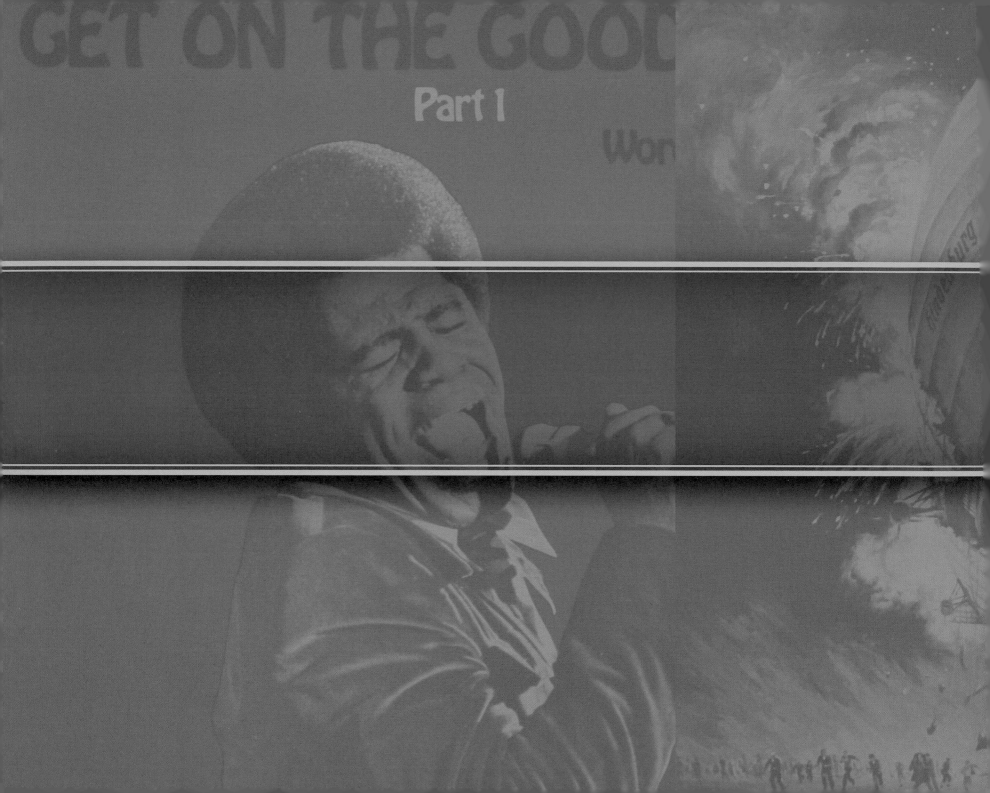

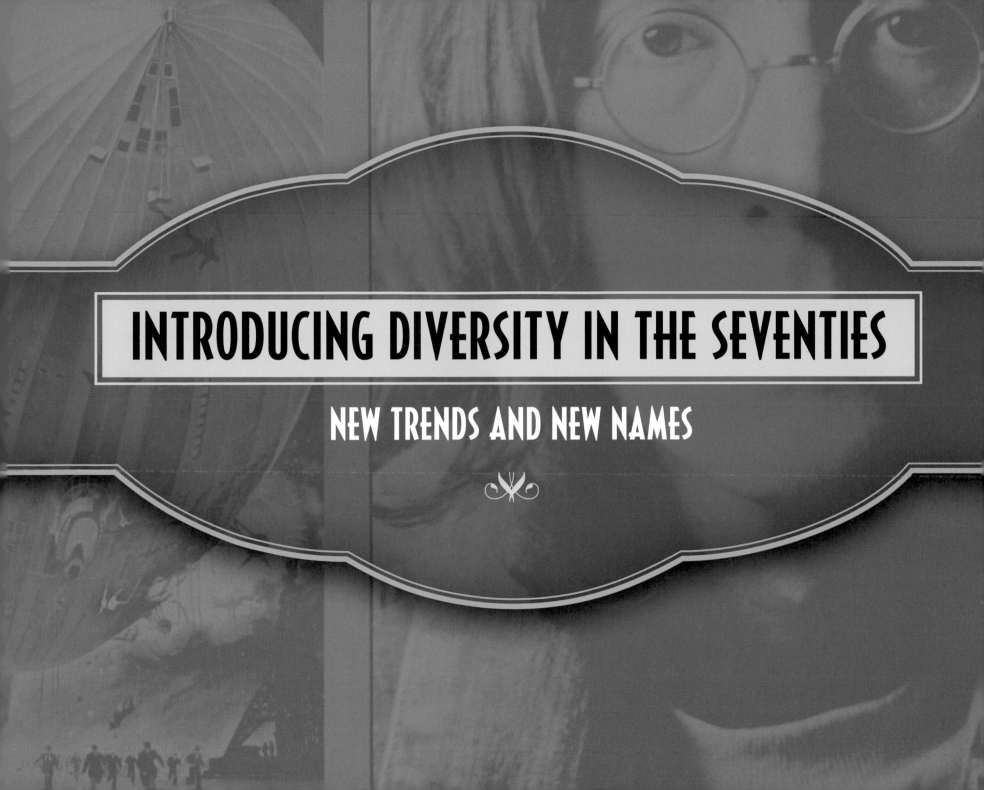

INTRODUCING DIVERSITY IN THE SEVENTIES

NEW TRENDS AND NEW NAMES

The music of the seventies was affected by a number of endings, both musical and otherwise, as well as a shift in the social consciousness. The Beatles broke up in 1970, as did Simon & Garfunkel. Considered at the time to be almost perpetual music-making machines, both groups experienced personal conflicts that split them apart. The devoted fans of each were devastated. Even more dramatic, 1970 saw the deaths of Jimi Hendrix and Janis Joplin, and there was also the loss of Jim Morrison of the Doors a year later. All were iconic performers of the sixties.

The loss of the Beatles as a group did give us the opportunity to follow the music and careers of all four as separate solo artists. Though the sum of the group was certainly greater than its parts, varying degrees of success followed the individual Beatles in the seventies, as would be the case in the years to follow.

The idealism of the sixties was dying. The realities of life intruded on the hopes that society would change quickly. It would be a long, hard process instead. As the decade progressed, the focus began to turn from the world to the individual. A young batch of singer-songwriters emerged, who wrote about the simpler subjects of romantic love, everyday life, and introspective themes.

Music continued to branch out as different ethnic styles caught the public's attention. The rhythms of Jamaican reggae were heard on the radio by the early to mid-seventies, and helped to encourage an interest in other types of "world music."

By the time the movie *Saturday Night Fever* was released in 1977, the age of disco was exploding. Artists like the Bee Gees, who were featured on the soundtrack, dominated the pop charts. A new fad of dancing blossomed, with a whole subculture surrounding it. Lifestyles and fashion were tailored around the new music trends (remember disco clothes? The punk look?) Some things are better left forgotten.

***Stayin' Alive* (1977)**
The Bee Gees really hit the big time with their songs from the *Saturday Night Fever* soundtrack, and this was the one that was most identified with it.

Imagine (1971)

Possibly *the* signature John Lennon song, post-Beatles. This wonderful anthem for world peace was sung to a simple yet catchy piano accompaniment. Lennon had the uncanny ability to go from writing hard-edged rock with gritty lyrics to gentle, almost folklike tunes on the same recording. Photo used on the cover is from the Beatles' *White Album*.

My Love (1973)

When Paul McCartney wrote songs without the influence of John Lennon, the lyrics often came out on the overly romantic, silly, or even sappy side. He was great with melodies, harmonies, and arrangements, but could lose the edge when it came to the content. At times, his solo lyrics lack the ingenuity or poetry he had with his Lennon and McCartney compositions, though he was very successful.

This Song (1976)

Released on his album *33 & 1/3*, George Harrison wrote "This Song" out of the frustration he was feeling during his famous plagiarism court case. It involved his 1970 song "My Sweet Lord" and the supposed similarity it had with "He's So Fine" by the Chiffons in 1963. He lost. The lyrics here are biting and sarcastic in reference to that incident and to his writing of "This Song."

Photograph (1973)

Written by George and Ringo, "Photograph" hit No. 1 on the US charts and was one of Ringo Starr's most identifiable solo successes. He also sang this song during the Concert For George in 2002, in memory of his friend and bandmate, who died the previous year. This song, released on the Beatles' own Apple label, has Ringo on the cover, wrapped as a star.

Some groups from the sixties continued; other new ones formed, disbanded, and then re-formed with different members. Once again, the game of musical chairs was being played. Talent was the deciding factor, although friction points between members sometimes made it difficult.

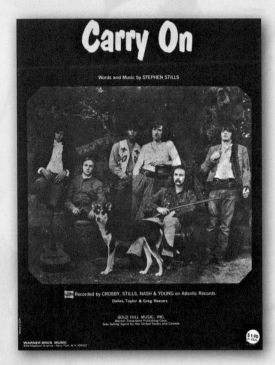

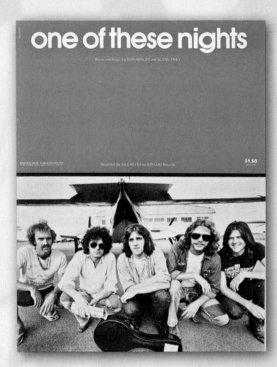

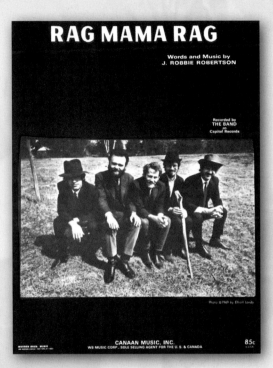

Carry On (1970)

One of the first major albums released in the seventies (March 1970), *Deja Vu* added Neil Young to the previous recording trio of David Crosby, Stephen Stills, and Graham Nash, creating one of the earliest supergroups. These four musicians previously came from stints with Buffalo Springfield, the Hollies, and the Byrds. CSN would continue with only periodic appearances by Neil Young in the future, notably on their live album *Four Way Street*. This single, "Carry On," still held onto some of the optimism of the sixties with its hippie-influenced lyrics about love. The cover is reminiscent of early Western photography.

One Of These Nights (1975)

This was only their second No. 1 single on the US charts, but the Eagles would go on to be one of the most successful bands in history. They would win numerous awards and sell tons of albums over a forty-year time span, in spite of a period of almost fourteen years when they were officially disbanded. Formed in 1971, they changed personnel a few times, but the core songwriting duo of Don Henley and Glenn Frey kept this Southern California country-rock influenced group on top. Distinctive vocal harmonies, catchy melodies, and slick production all were trademarks of this popular band.

Rag Mama Rag (1970)

First known as the backup group for Bob Dylan, this collection of talented multi-instrumentalists were simply called the Band. With the great songwriting talents of Robbie Robertson, their playing of Americana or "roots music" was second to none. They ended their career together by having a farewell concert in 1976 called *The Last Waltz*, playing along with a number of guest stars (including Dylan, Muddy Waters, and Eric Clapton). It was filmed by Martin Scorsese, and is still considered one of the best concert movies of all time. They would never all play together again, but they continued to produce great music regardless.

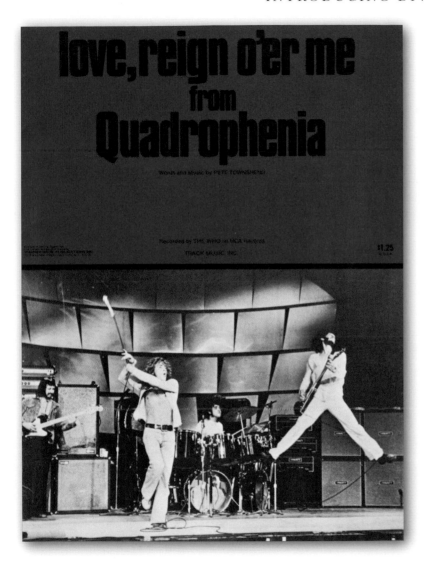

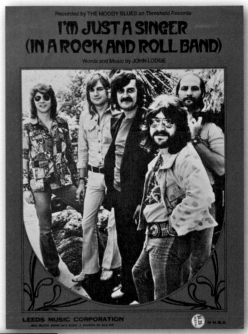

I'm Just A Singer (In A Rock And Roll Band) (1972)

Another carryover band from the sixties, the Moody Blues were considered a more "art rock" band. They were early adopters of instruments like the mellotron, an electronic keyboard instrument that used prerecorded sounds of strings and voices on tape loops. From 1967 on, their songs were rarely blues-based, unlike many of their rock contemporaries.

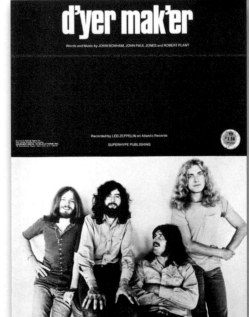

D'yer Mak'er (1973)

Led Zeppelin was one of the most popular and influential rock bands of the seventies. The guitar playing of Jimmy Page and the vocals of Robert Plant set the standard for many of the heavy metal bands to come. Their tours helped establish the trend of bigger productions (along with extreme and wild parties afterwards).

Love, Reign O'er Me (1973)

Originally released as an album in 1973, *Quadrophenia* also became a movie a few years later. Based on teenage lifestyles in vogue in England around 1965, it deals with typical adolescent anxieties and problems. "Love, Reign O'er Me" plays on the words *reign* and *rain*, with their different meanings, interspersing them in the chorus. Photo on the cover captures the Who at a very dynamic moment onstage.

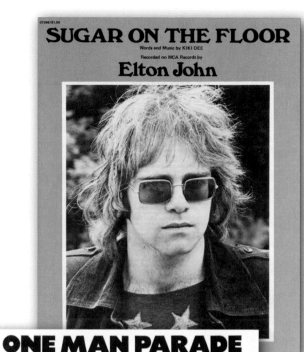

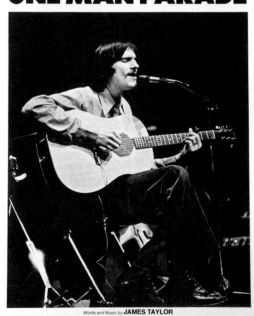

One Less Set Of Footsteps (1973)

Singer/songwriter Jim Croce had a tragically short career. His debut chart hit was "You Don't Mess Around With Jim" in 1972. It was followed quickly by three more within a year. Unfortunately, he died in a plane crash in September 1973, at the age of thirty. He had been quite prolific, with a number of additional singles and albums released after his death.

Jackie Wilson Said (I'm In Heaven When You Smile) (1972)

Van Morrison is the ultimate "blue-eyed soul" singer. He incorporates the styles of rhythm and blues, soul, and jazz, blending them all together with his Irish heritage to produce some amazing music with a deeply spiritual sensibility. This up-tempo song features his occasional nonverbal vocalizations in place of actual lyrics, and is the lead track to his album *Saint Dominic's Preview*.

Sugar On The Floor (1973)

This song is a rare instance of Elton John doing someone else's material, in this case a song by Kiki Dee. He recorded a number of duets with her during the next few decades, notably "Don't Go Breaking My Heart" in 1976. Very early photo of him on the cover of this sheet music.

One Man Parade (1972)

Breaking into the charts with his second album, *Sweet Baby James*, in 1970, his distinctive finger-style guitar playing identified James Taylor as coming from a strong folk tradition. He always had great musicians around him, and he continues to sell recordings and tour.

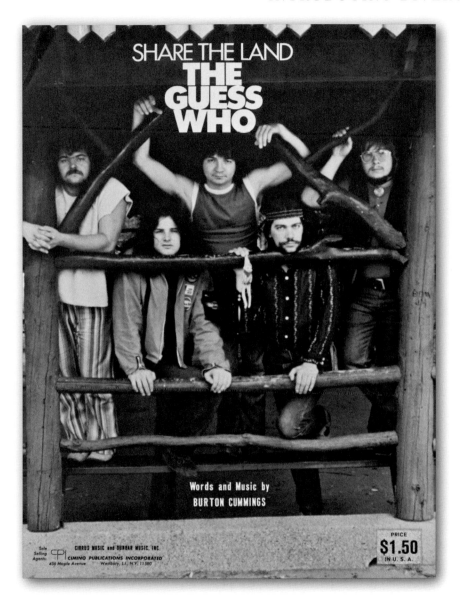

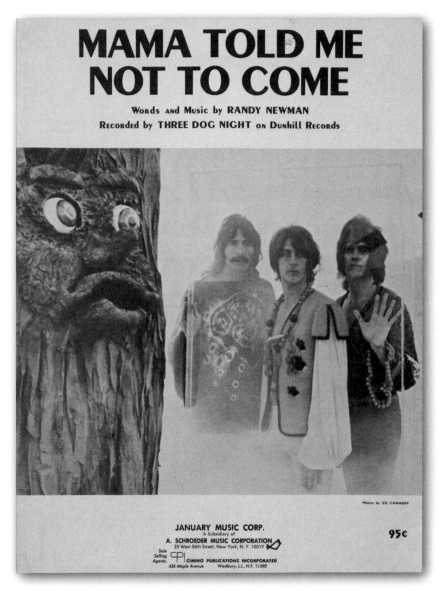

Share The Land (1970)

The single "Share The Land" came from the album of the same name, and reached No. 10 on *Billboard*. It was written by Burton Cummings, the lead singer of the Guess Who, having joined this Canadian band in 1966.

Mama Told Me Not To Come (1966)

Three Dog Night did many cover versions of songs by other composers. They recorded this early Randy Newman song in 1970, and it was their first No. 1 hit. Strange sheet music cover, though . . .

You could have your pop music "family style" if you really wanted it. When producers and record company executives saw an opportunity in the marketplace, they made sure they could provide a product—a perpetual trademark of the music industry.

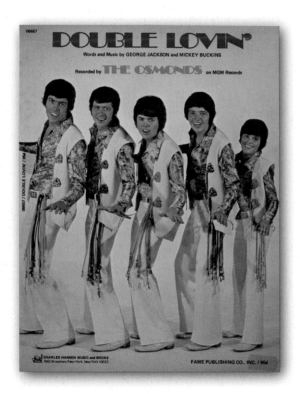

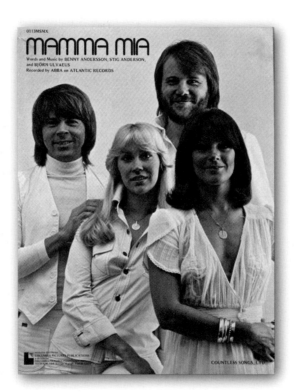

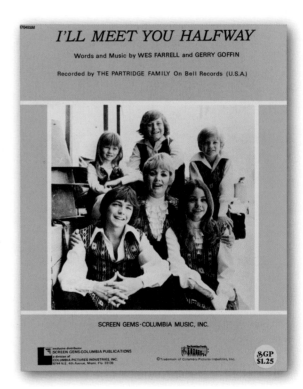

Double Lovin' (1971)
This clean-cut Mormon family group originally toured as the Osmond Brothers but changed their name to just the Osmonds in the early seventies. They were at the peak of their popularity at this time, with little Donny Osmond (far right) going on to the most success as a solo performer. He would also star with his sister in an ABC TV variety program called *The Donny & Marie Show* from 1976 to 1979.

Mamma Mia (1975)
From their first release together in 1972, ABBA went on to be one of the biggest-selling pop groups of all time. They dominated music in the seventies, not only in the US, but around the world. This Swedish foursome ended up being a pair of married couples, until the early eighties when they broke up (both professionally and personally). "Mamma Mia," a No. 1 hit song for them, became the title of a stage musical about their songs, as well as a movie.

I'll Meet You Halfway (1971)
The Partridge Family was a made-for-TV group that played what has been called "bubble gum" pop. They were modeled after the real-life musical family the Cowsills of just a few years earlier. With Shirley Jones as the mother, the main focus was the promotion of David Cassidy (front left) as the next teen heartthrob. The series ran from 1970 to 1974, with many guest stars making appearances on the show.

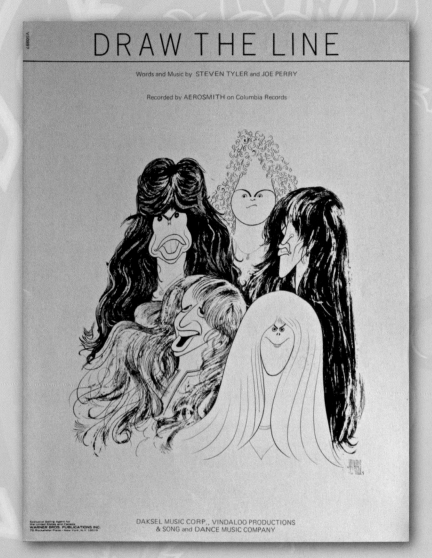

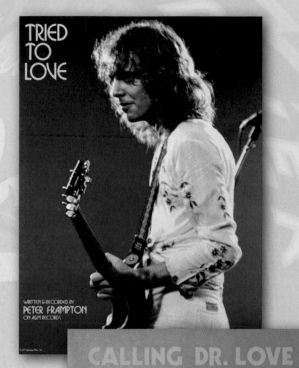

Tried To Love (1977)

Even though Peter Frampton had released a few earlier albums, he hit the big time in 1976 with his double-record live set called *Frampton Comes Alive*. As an electric guitar player, he popularized the sound of the "talk box," which became closely associated with him. This song is from his follow-up studio album, *I'm In You*. He was never able to equal the success of his earlier blockbuster LP.

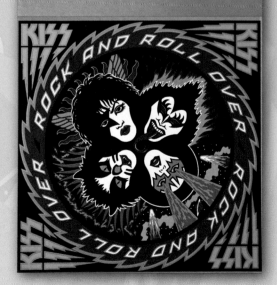

Calling Dr. Love (1976)

With KISS, it's more about the theatrics, costumes, and special effects than the music, but that doesn't deter the legions of fans in the KISS Army (their official fan club). "Calling Dr. Love" was written by Gene Simmons, the best known of the quartet and recognized by most outsiders as "the guy with the tongue." He also gained notoriety with his own reality show on television in 2006.

Draw The Line (1977)

With their debut recording coming out in 1973, Aerosmith would become one of the top-selling rock groups in the seventies (and beyond). The title of their fourth album, *Draw The Line*, is a clever play on words. The image of the group on the cover of both the album and the sheet music is by the famous artist Al Hirschfeld, a celebrity caricaturist who had been drawing these types of black-and-white illustrations for almost eighty years (he died in 2003 at the age of ninety-nine!)

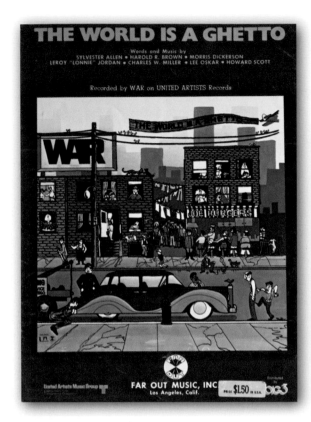

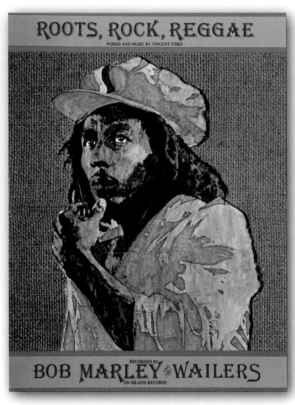

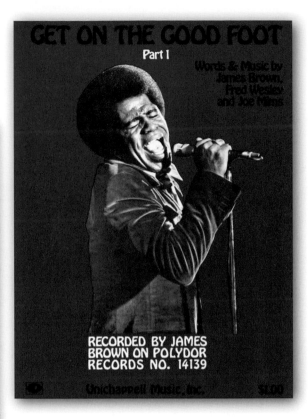

The World Is A Ghetto (1972)

The group War got its start in California in 1969 and was initially called Eric Burdon and War on their first three albums (Burdon was previously with the Animals). They performed many socially conscious/political songs and combined the sounds of funk, Latin, and R&B with rock. After Burdon left in 1971, the band released *The World Is A Ghetto*, which was the best-selling album in 1973 and voted "Album of The Year" by *Billboard* magazine. This sheet is the title track, with cover illustration by Howard Miller. The other hit song from this album was "The Cisco Kid." War changed personnel number of times, but they could not equal their success with this record.

Roots, Rock, Reggae (1976)

The reggae album *Rastaman Vibration* by Bob Marley came out in 1976 and was the biggest hit of his career in the United States. The song "Roots, Rock, Reggae" was the best-selling single from that album and established him as *the* performer of this style. He went on to become the figurehead of the reggae movement around the world, but sadly died of cancer in 1981, at the age of thirty-six.

Get On The Good Foot—Part 1 (1972)

The man they called the "Godfather of Soul" and "The Hardest Working Man in Show Business," James Brown, truly earned it all the hard way, by performing and recording for over sixty years. He was a major influence in the development of soul and funk music, and in the establishment of a strong awareness, identity, and pride in the black community. He remained active until his death in 2006 at the age of seventy-three.

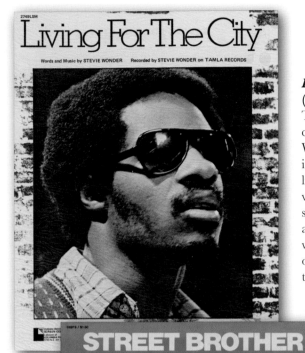

Living For The City (1973)

This song was a biting musical commentary from Stevie Wonder about social inequality for poor blacks. He delivered his message of anger via the medium of a hit pop song. It was released on the album *Innervisions* in 1973, on which he played almost all of the instruments himself, a truly remarkable feat.

Street Brother (1972)

Having started in the sixties with Motown, Gladys Knight & the Pips hit their high point with a string of top records in the seventies, after they switched to Buddha Records, winning two Grammys in 1974 and numerous American Music Awards. They even had a short-lived TV variety program, called, unsurprisingly, *The Gladys Knight & The Pips Show*. The group disbanded in 1989, as Gladys went on to a solo career.

Blame It On The Boogie (1978)

Recording with Motown Records as the Jackson 5 from 1969 to 1976 (for a total of twelve albums!), they changed their name to the Jacksons in 1976 (for seven more albums). Though they usually recorded in a pop/R&B style, this title is more of a straight disco song, taking advantage of the then-current trend. In the photo, Michael Jackson is seen second from the right, before he started any cosmetic alterations. Big afros were in . . .

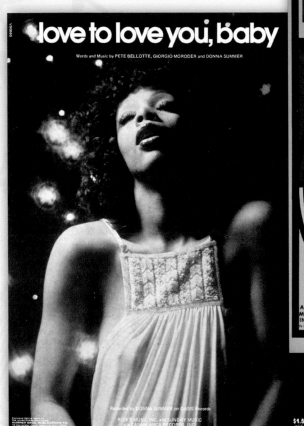

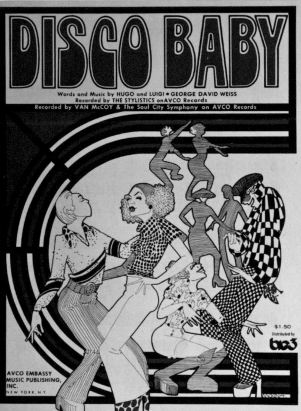

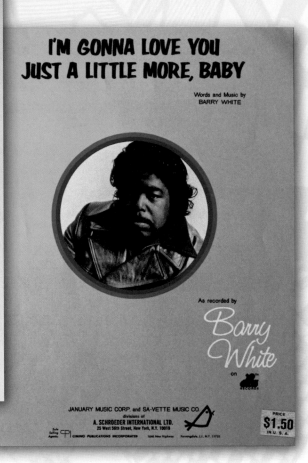

Love To Love You, Baby (1975)

Donna Summer was one of the few artists to gain popularity exclusively through disco music. So many of her early hits were dance songs that she soon earned the name "The Queen of Disco." "Love To Love You, Baby" was her first-ever hit, and she also produced a special seventeen-minute version for club use, complete with R-rated moans.

Disco Baby (1975)

A wonderful illustration providing a close look at the disco fashions being worn as part of the whole club-dancing experience. The platform shoes, bell bottoms, wild-patterned clothes, and even the dance moves themselves are all classic images. Listed on the cover as being recorded by the Stylistics and Van McCoy & the Soul City Symphony. Sheet is signed by the artist at the bottom right as McKinze.

I'm Gonna Love You Just A Little More, Baby (1973)

Barry White's deep bass voice and romantic patter were perfect for use in slow R&B love songs. This featured sheet was his first hit, and set him on a course to create the Love Unlimited Orchestra in 1973. He would then record his biggest hit, "Love's Theme," which many consider one of the earliest disco songs. At times during many of his songs, he would speak the lyrics as if he were talking directly to the female listeners, with very obvious sexual meanings. The essence of Barry White.

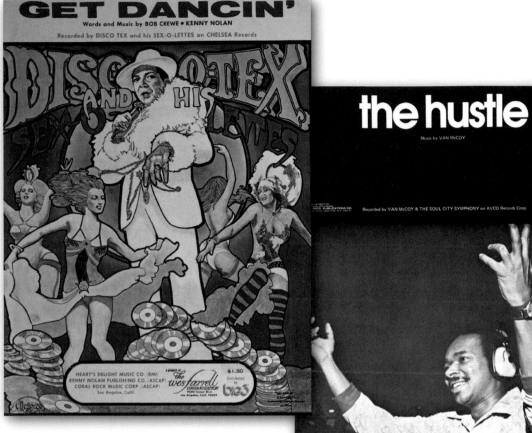

Shake Your Booty (1976)
Another essential song from the age of disco, and one that is still performed today at wedding receptions and other similar get-togethers. Performed by K. C. and the Sunshine Band; the cover depicts the band as caricature drawings (with K. C. at the upper left).

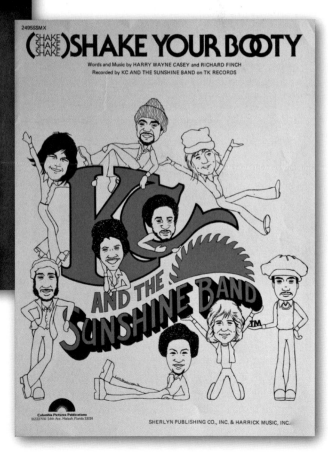

Get Dancin' (1974)
With a name like Disco-Tex and his Sex-O-Lettes, it's no wonder that the cover is as wild and crazy as it is. Extremely camp-looking image of Disco-Tex, surrounded by half-dressed gyrating females caught up in a disco dancing frenzy. One of the early recordings of the disco movement, "Get Dancin'" was his biggest hit.

The Hustle (1975)
This instrumental disco number by Van Mc-Coy & the Soul City Symphony hit No. 1 on the *Billboard* chart in 1975. Not only that, but it won a Grammy Award in 1976 for Best Pop Instrumental Performance. "The Hustle" is considered by many to be the best-known and most popular title of the era.

Movies maintained a strong audience in the seventies, with creative plots from directors who were the rising stars of a Hollywood renaissance (Coppola, Lucas, and Spielberg among others). Music played a large part in the popularity of movies and their success as well. The composer John Williams, who had been around for over a decade writing and conducting music for films, finally gained the spotlight with some tremendous scores and themes in his movie soundtracks during this decade.

From the entire gamut of crazy comedies, disaster epics, suspenseful dramas, and extraordinary new worlds came the personal situations and struggles that kept us going back for more. The chance for a hearty laugh, a good thrill, or a warm feeling (or just an enjoyable story) made many of these films classics at the time, and they remain so to this day.

These wonderful sheet music covers give us the opportunity to remember the productions and recall the themes, even if it was "a long time ago in a galaxy far, far away."

Shama Lama Ding Dong (1978)

Dealing with the crazy capers of the odd mix of characters in the Delta House fraternity at fictional Faber College in the early sixties, *Animal House* is widely seen as one of the best comedy films ever.

A John Landis production from 1978, it used a blend of rock 'n' roll along with rhythm and blues in the soundtrack, in addition to a score by the great film composer Elmer Bernstein. In the movie, "Shama Lama Ding Dong" is sung by Otis Day and the Knights in a roadhouse some of the members visit with their dates, which turns out to be an all-black nightclub. In a film with many memorable lines, one of the most repeated—"Toga . . . Toga . . .Toga"—sums it up best. The detailed cover illustration by Rick Meyerowitz highlights the antics and characters.

Blazing Saddles—Theme From (1974)

Mel Brooks satirized all the conventional Western movie traditions in the comedy *Blazing Saddles*. His use of off-the-wall dialogue, deliberate anachronisms, and actor comments directed to the audience gave this film its unusual (but typical) Mel Brooks style. His humor was at times somewhat crude, and he pushed a lot of boundaries, especially concerning what we today would call "politically incorrect" subjects. Seen on the cover of the sheet, to the very left, is the edge of a coin with the inscription "Hi. I'm Mel. Trust Me."

Transylvania Lullaby (Theme From Young Frankenstein) (1975)

The next subject for Mel Brooks to make fun of was the classic horror film genre, specifically the *Frankenstein* film adaptations. Once again using two of his favorite actors, Gene Wilder and Marty Feldman, he created a hilarious spoof of the serious and scary movies of the past. Music for all three of the films here was written by John Morris, Brooks's longtime composer. The sheet music from *Young Frankenstein* uses the original movie poster as the illustration.

Silent Movie March (1976)

Always willing to be different, Mel Brooks next produced a comedy/satire on silent films, and with the exception of one spoken word, *Silent Movie* does indeed have no spoken dialogue. This third release in three years finds Mel Brooks in his first starring role—along with appearances by numerous Hollywood stars, some playing themselves—and is once again filled with hilarious gags. Very few people have been able to make such lasting comedies in such a short span of time. Great cover as well.

The Hindenburg (1975)

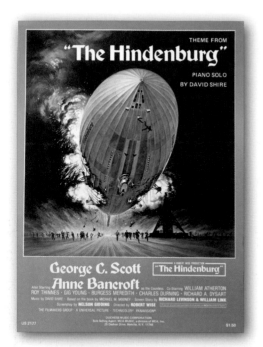

The film *The Hindenburg* was a quasi-thriller that speculated on the cause of the historic explosion of the German airship over Lakehurst, New Jersey, in 1937, suggesting that it was sabotage. Despite being almost universally panned by the critics (and rightfully so), it was received favorably by the general viewing public, which seemed to be in the mood for all types of calamity movies. All I can say to that is, "Oh, the humanity!" Dramatic painting of the moment of the disaster on the cover.

Airport 1975 (1974)

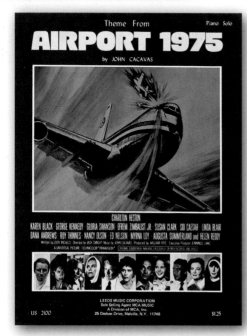

Another film taking advantage of the craze for disaster movies in the seventies was *Airport 1975*. Once again, critics hated it, but it made a lot of money at the box office. Many of the situations and characters involved (a singing nun, a sick child, an incapacitated pilot) ended up being satirized to great effect in the much more enjoyable comedy *Airplane!*, which would come out in 1980.

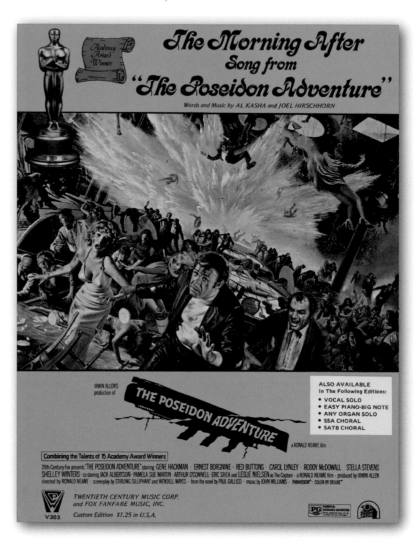

The Morning After (1972)

This was the Academy Award–winning song from *The Poseidon Adventure*, a star-studded action/disaster film produced by Irwin Allen in 1972. Although John Williams composed the music score, he did not write the song. After the ship is flipped upside down by a ninety-foot tsunami, a group of passengers work their way up to the bottom of the ship (?) in order to find a means of escape. Not surprisingly, the film also won an Oscar for special effects. Action-filled, full-color cover mirrors the movie poster.

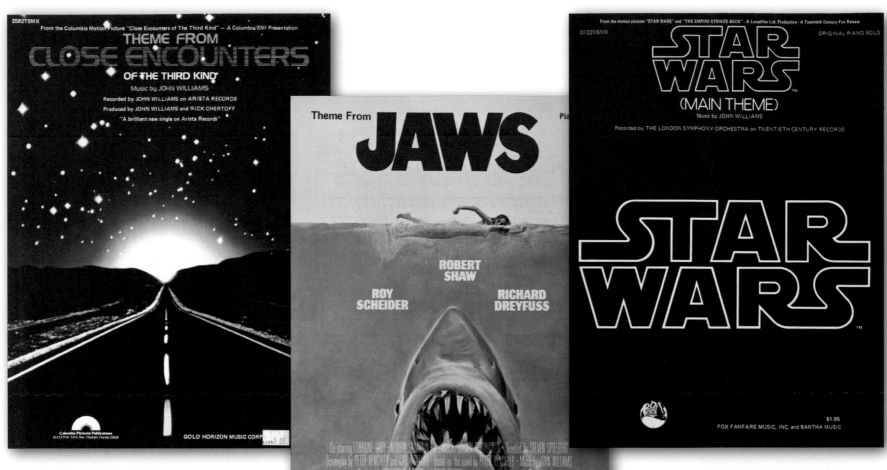

Close Encounters Of The Third Kind—Theme From (1977)

We finally make contact with UFOs in the 1977 science fiction film by Steven Spielberg called *Close Encounters Of The Third Kind*. The main source of communication is via lights and sound, most memorably the five-note phrase that becomes the basic riff of the soundtrack, written by John Williams. Not surprisingly, given the era, there was even a hit disco version of this theme that made the charts.

Jaws—Theme From (1975)

If a series of musical notes can be perceived to imply foreboding or impending doom, the beginning notes to this theme certainly qualify. *Jaws* went on to win numerous awards and set the standard for future summer blockbusters. With a pairing of Steven Spielberg (producer) and John Williams (composer), it's not hard to understand why.

Star Wars (Main Theme) (1977)

From the beginning fanfare that introduces us to the *Star Wars* main theme to the jaw-dropping visuals (for the time) of George Lucas, we are hooked right from the start. The music of John Williams is crucial, and perfect for the action on the screen, even to the point of specific themes written for individual characters (such as Princess Leia and Darth Vader). It was only years later that this film was officially renamed *Star Wars Episode IV: A New Hope*, but for those of us who saw it in 1977, it will always be just *Star Wars*.

The spy exploits of James Bond continued through the seventies, with more films and hit themes and a transition from the suave but gritty Sean Connery to the more playful and humorous Roger Moore. The notorious villains, intriguing gadgets, exotic locations, action sequences, and lovely Bond girls did not change. Also still in use is the identifiable "James Bond Theme," composed in 1962. A classic.

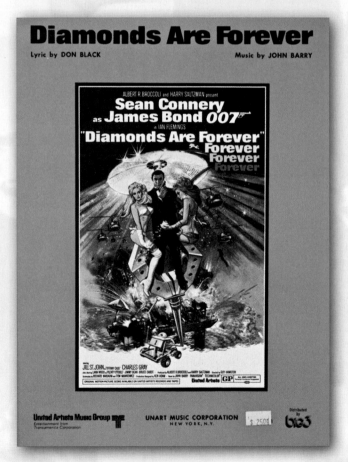

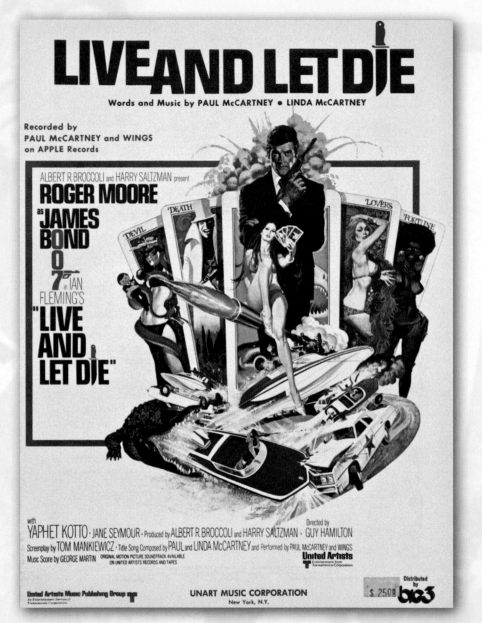

Diamonds Are Forever (1971)
Not considered to be one of the better Bond movies, *Diamonds Are Forever* had its theme song sung by Shirley Bassey, who also sang "Goldfinger" in 1964.

Live And Let Die (1973)
With the title song written by Paul McCartney and performed by his group Wings, *Live And Let Die* was the first Bond movie for Roger Moore.

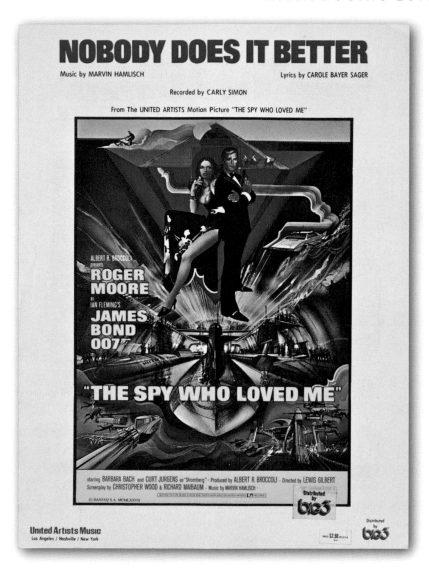

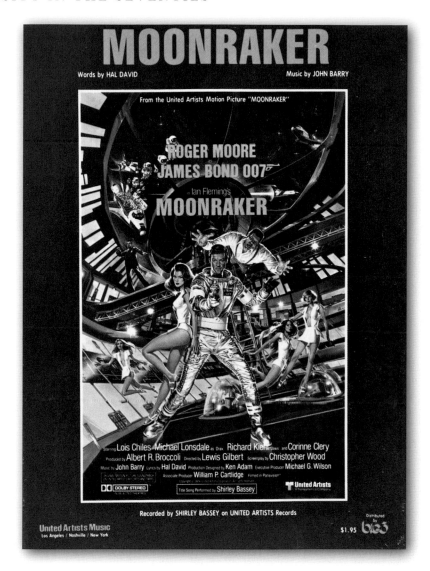

Nobody Does It Better (1977)
Although this song from *The Spy Who Loved Me* was nominated for several awards, it failed to win any, despite being composed by Marvin Hamlisch and sung by Carly Simon. The sheet music itself sold quite well, as the song was easily playable and the romantic theme made it a wedding reception favorite. Probably one of Roger Moore's better Bond films.

Moonraker (1979)
Shirley Bassey was pulled in at the last moment to record the theme to *Moonraker*, making it her third Bond song, and not surprisingly it was her least successful. Though the film made a lot of money, it didn't get favorable critical reaction, given some of the silly action sequences and forced attempts at humor. The cover/poster is probably the best part.

Are You In There? (**1976**)
This 1976 remake by Dino De Laurentiis of the original 1931 film *King Kong* does not feature the giant ape climbing up the Empire State Building. As seen in the action-packed illustration on the sheet music cover, he climbs the recently completed Twin Towers of the World Trade Center instead.

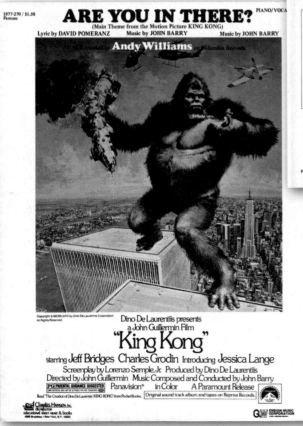

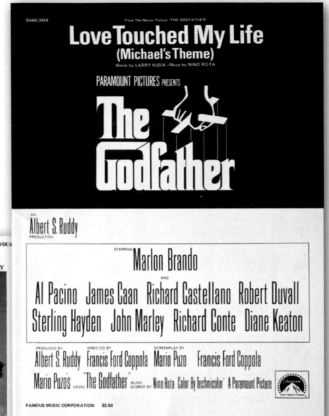

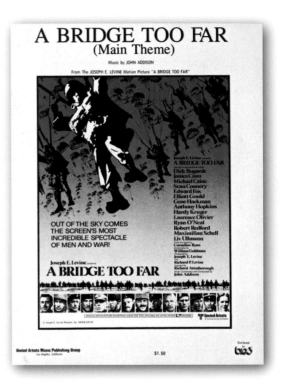

Love Touched My Life (Michael's Theme) (**1972**)
Winner of three Academy Awards, *The Godfather* is considered one of the best and most influential films *ever*. This crime saga, directed by Francis Ford Coppola and released in 1972, followed the Corleone family from 1945 to 1955, revealing how they consolidated their New York underworld power.

A Bridge Too Far—Main Theme (**1977**)
Operation Market Garden was a failed Allied attempt during World War II to land troops behind the German lines in the Netherlands in 1944. Based on the Cornelius Ryan novel and directed by Richard Attenborough, the 1977 film *A Bridge Too Far* documented the problems and mishaps that occurred, using a huge all-star cast and running almost three hours. The movie tagline states, "Out of the sky comes the screen's most incredible spectacle of men and war!" The sheet music cover reflects the movie poster, with a listing of cast members and photos.

One Flew Over The Cuckoo's Nest— Main Theme **(1975)**
One Flew Over The Cuckoo's Nest was one of the few films in history to get a clean sweep of all five major categories at the Academy Awards (Best Picture, Best Director, Best Actor, Best Actress, and Best Screenplay). There have been only three—the others are *It Happened One Night* (1934) and *The Silence Of The Lambs* (1991).

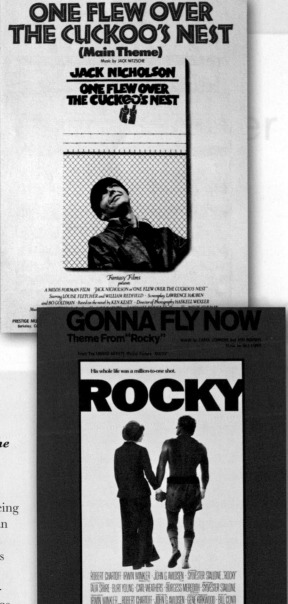

Gonna Fly Now—Theme From Rocky **(1976)**
Winner of three Academy Awards, *Rocky* became the symbol of the underdog being able to realize the American Dream through hard work and perseverance. This was the film that established Sylvester Stallone as an actor—and, unfortunately, was followed by too many repetitive sequels.

Come Back To Love (The Chief's Death) **(1979)**
"I love the smell of napalm in the morning" is probably the most memorable, and oft-quoted, line from *Apocalypse Now*. This 1979 movie was a tough vision of the horrors, brutality, and at times sheer idiocy of the Vietnam War, and the effect it had on the people involved, both civilian and military.

Dueling Banjos **(1973)**
The version of this piece used in the movie *Deliverance*, and on the soundtrack, is actually a duet between a banjo and a guitar. This makes the two parts more distinctive to hear, while still sounding very country/bluegrass. Surprisingly, it became a hit not only on the *Billboard* Country chart but also on the Hot 100 and Adult Contemporary.

BLAXPLOITATION COVERS

The seventies was the decade when a new genre of films emerged that had a direct music connection, represented in a number of distinctive sheet music titles. Created by the rising social consciousness of "Black Power" in the late sixties, this style of cinema initially catered to black urban audiences. Some main features were a primarily black cast and the use of a funky, soulful soundtrack, usually given prominence through the sound of a guitar played with a wah-wah pedal. The term "blaxploitation" comes from a combination of the words *black* and *exploitation*. The movies made millions of dollars for the studios and record companies. They also had a great effect on American film and culture, creating both humorous and ironic parodies.

Cotton Comes To Harlem (1970)
With a mixture of humor and drama, *Cotton Comes To Harlem* is the story of two black detectives named Coffin Ed and Gravedigger Jones. Released in 1970, it has become a cult classic. Great montage illustration on the music cover.

Shaft—Theme From (1971)
Written and recorded by Isaac Hayes, who won both a Grammy and an Oscar for this song. Released in 1971, *Shaft* introduces us to the black private eye John Shaft. The movie is considered one of the key early examples of the blaxploitation film movement and was extremely influential. The sheet music displays a dramatic split photo of Isaac Hayes on the cover.

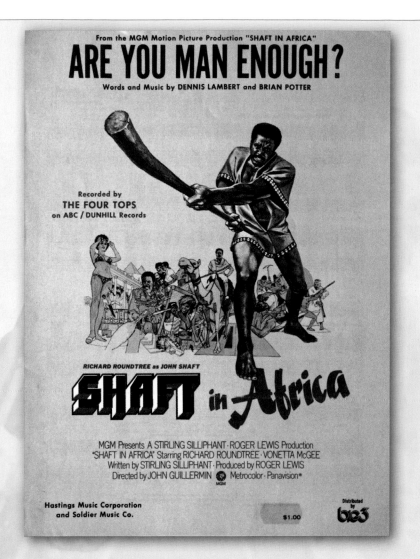

Blowin' Your Mind (1972)

This follow-up from 1972, *Shaft's Big Score*, was a continuation of the big-screen action/adventures of John Shaft. The tagline on the movie poster reads, "You liked it before, so he's back with more, Shaft's Back In Action!" As is typical for a sequel, it doesn't break any new ground but continues the formula. Note the large weapon in Shaft's hand, in an overt Freudian reference to his sexual powers.

Are You Man Enough? (1973)

Shaft In Africa, released in 1973, was the third installment of the Shaft series. The tongue-in-cheek, obvious phallic symbolism used in many of these films is especially apparent on this cover, where John Shaft needs two hands to wield his *huge* stick, under the suggestive title of *Are You Man Enough?*

Television expanded with more sitcoms, as well as new dramas, and developed some long-running series (*M.A.S.H.*, *Dallas*) for us to stay involved with. It introduced us to a cast of characters, some of whom became embedded in our minds and in our culture.

Many of us grew to know the scheming of J. R. Ewing in the wealthy Texas oil community, the outspoken and comedic bigotry of Archie Bunker, the Tootsie Roll Pop–sucking police lieutenant Kojak, and others from the small screen.

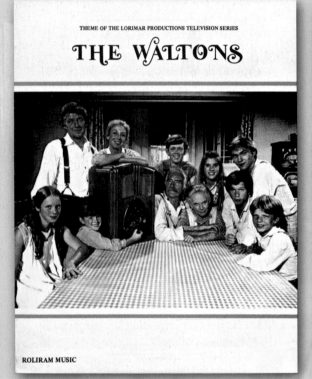

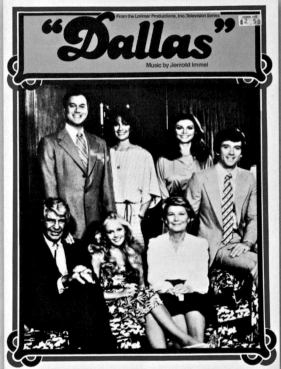

The Waltons (1972)

Winning both a Peabody Award and six Emmys in its first year on the air, *The Waltons* was a TV drama about rural family life from the Great Depression in the 1930s through World War II. This extended, wholesome family faced the highs and lows of life, and reflected the best of American values and ideals. It ran for nine seasons, beginning in 1972.

Dallas (1978)

The Ewing family was quite the opposite of the Waltons. They broke the Ten Commandments on a regular, if not weekly, basis and committed most of the Seven Deadly Sins. This extended family was a prime-time soap opera fixture from 1978 to 1991, featuring J. R. Ewing as the person we all loved to hate on *Dallas*.

All In The Family TV Theme (Those Were The Days) (1971)

In an unusual move, this title song was sung by the cast sitting around a piano at the beginning of every episode. Controversial topics were the order of the day for *All In The Family*. The sheet music shows the actors actually performing the theme.

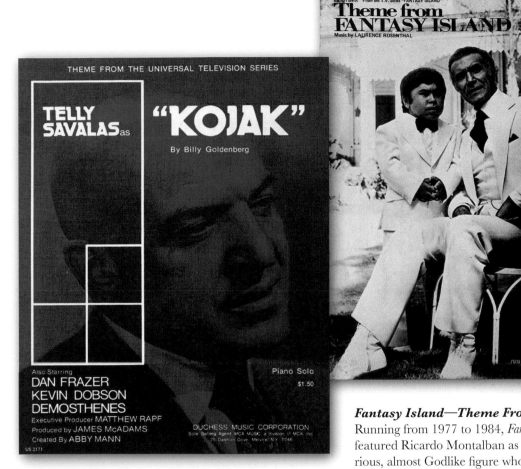

Kojak (1973)

"Who loves ya, baby?" was the catchphrase of fictional New York Police Lt. Theo Kojak, in this TV crime drama, which ran from 1973 to 1978. He was a street-smart cop who had a habit of sticking a Tootsie Pop in his mouth, which became his trademark. Kojak was a tough guy, with a soft side.

Fantasy Island—Theme From (1977)

Running from 1977 to 1984, *Fantasy Island* featured Ricardo Montalban as the mysterious, almost Godlike figure who allowed people to come to the island and live out their fantasies—for a price. As each episode would progress, he would be there to offer moral advice concerning the visitors' choices and the unexpected results that often occurred. A modern fable, if you will. His assistant, Tattoo, was most identified with the phrase he shouted at the beginning of every episode as the newest arrivals appeared: "De plane! De plane!"

Charlie's Angels—Main Title (1976)

A trio of good-looking female private eyes who work for an detective agency is not necessarily unusual. But when the only way they get their assignments is via an unseen voice (Charlie) over a speakerphone, that does get strange. The fact that they get put into some unusual and difficult situations adds more to the interest factor in *Charlie's Angels*. Starting in 1976, the cast of women changed over the course of five seasons, losing popularity as it did so.

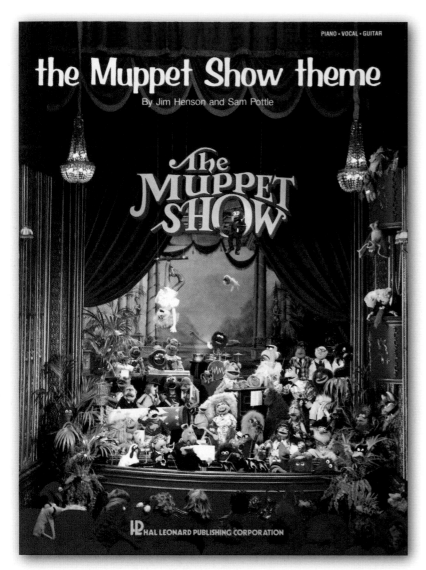

The Love Boat (1977)

The basic plots of *The Love Boat* episodes consisted of adventures, both romantic and humorous, during the voyages of this cruise ship. Centered around a select group of crew members, along with the captain, the show followed the activities of a number of passengers and celebrity guest stars for nine seasons (1977–86). The theme song was sung by Jack Jones.

The Rockford Files (1974)

A TV drama about a part-time private investigator who worked out of a run-down mobile home located on a Malibu beach parking lot doesn't sound like a winning storyline, but it was enormously successful. *The Rockford Files* benefitted from good writers and the talents of James Garner, as well as a theme than stayed on the *Billboard* charts for sixteen weeks, and won a Grammy in 1975 for Best Instrumental Arrangement. The composer, Mike Post, would go on to write many more hit TV themes.

The Muppet Show Theme (1976)

Both *The Muppet Show* and its theme were the work of Jim Henson, a creative genius when it came to this highly unusual but successful form of entertainment. Amusing to both children and adults, the huge cast of Muppet characters, under the supervision (?) of Kermit the Frog, had great interactions with the human guest stars that were featured in every episode. Five seasons of fun, from 1976 to 1981.

Sheet music was published for all of these—popular songs, movie and TV themes. Once again, these titles document the famous and the obscure . . . and everything in between. Their covers bring back memories of or connections with the music of the time, and serve as a reminder of the performers and productions of the seventies, so easily forgotten without these visual prompts.

Music (and tastes) continued to change and evolve. The future would hold new and exciting composers, performers, and productions in the eighties and nineties, but would also see some unexpected and tragic losses. For music fans, there would be more highs and lows to come. The river that is music continued on its journey, and we were carried along by it . . .

Battlestar Galactica—Theme From (1978)

This single-season (twenty-four episodes) science fiction series starred TV veteran Lorne Greene as Commander Adama of the *Battlestar Galactica*. The human survivors of a massive sneak attack are pursued by a race of robot warriors called Cylons, who are dedicated to destroying the human race. Quoting from the narration at the end of every program, "Fleeing from the Cylon tyranny, the last battlestar, Galactica, leads a rag-tag fugitive fleet on a lonely quest . . . a shining planet called Earth." The series relates the numerous battles, close calls, and internal problems that transpire while trying to accomplish this mission.

Looking toward the future, this series was revived and "reimagined" almost twenty-five years later and broadcast on the Sci-Fi Channel in 2005. Running for a total of four seasons, it was critically acclaimed for the writing, the directing, and especially the visual effects, due to advances in technology.

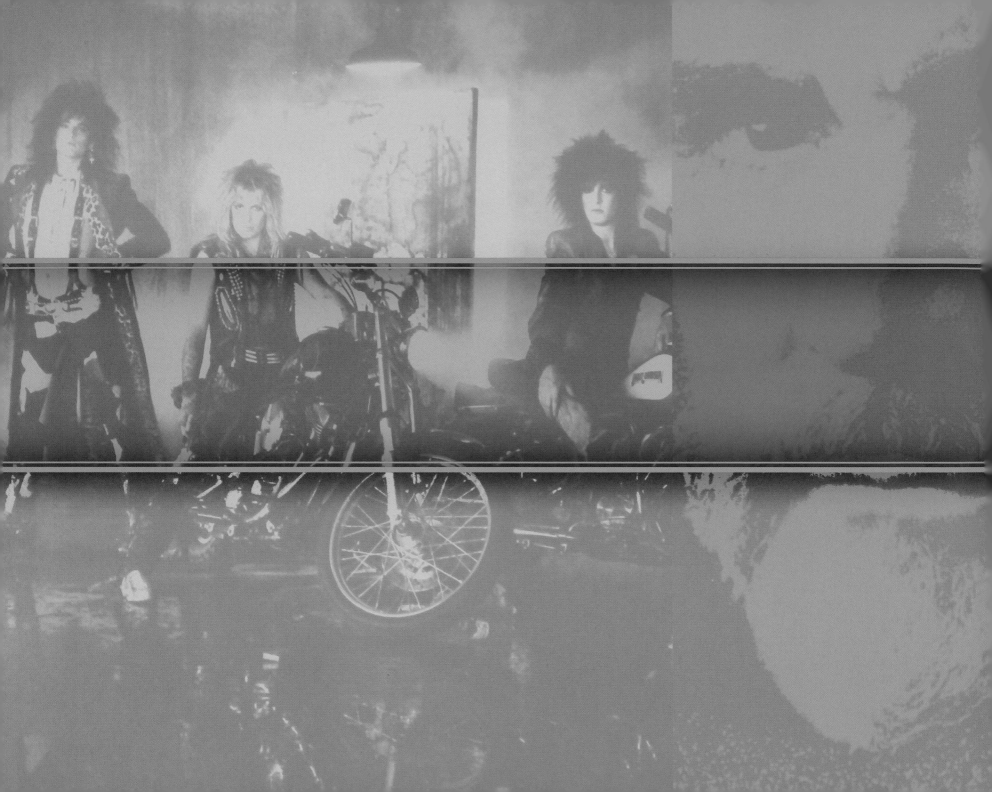

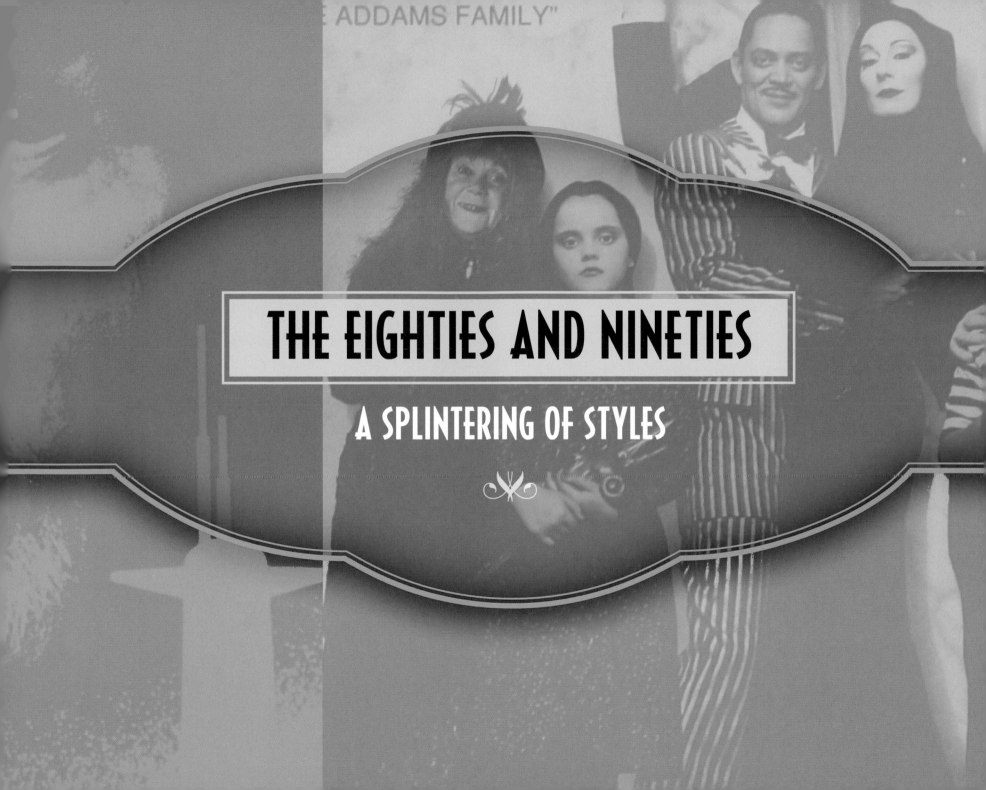

THE EIGHTIES AND NINETIES

A SPLINTERING OF STYLES

The music scene of the eighties opened with a tragic event. On December 8, 1980, John Lennon was senselessly shot and killed by a fanatical follower. The world lost one half of the greatest songwriting duo of the rock era, a vocal proponent for peace, an endlessly imaginative musician—a Beatle. It put an end to all the speculation about a possible reunion. For all Beatles fans, the dream was truly over. Thankfully, Lennon's legacy of music remains with us to this day.

This period accelerated the diversification of popular musical tastes, which continued through the end of the century. During the early eighties, a whole generation got an up-close look at these shifting trends by watching MTV, which launched in 1981. It initially featured only music videos, hosted by VJs, who provided background and music news. It was followed by VH1 in 1985, aiming toward an adult audience with a softer sound. By then it wasn't good enough to just write a song; you needed a visual companion piece to fill it out. Some were serious; others were fun; a few were just strange. These new music videos added a different dimension to songs, and a challenge to musicians (and filmmakers).

Hair bands shared space with club/dance music, new wave with new age, retro-swing with grunge, rock with pop, new with old. However, there was no distinct unifying sound.

Movies and television increased their exposure once again. If a movie was good, then it needed a sequel or two. When a TV program was popular, it had to have a spin-off. More was better, or so it seemed . . .

A change was in the works for the music industry. For the first time, LP records started to lose ground—first to tapes and then, by the late eighties, to the new CD format. In the nineties, these small, shiny discs were the preferred way to buy music.

Sales of sheet music were strong, but they reached a plateau as the century drew to a close. Titles continued to be printed, but it wasn't quite the frenzy of a decade or two earlier.

Every Little Thing She Does Is Magic (**1981**)
Hit single recorded by the Police on their album
Ghost In The Machine.

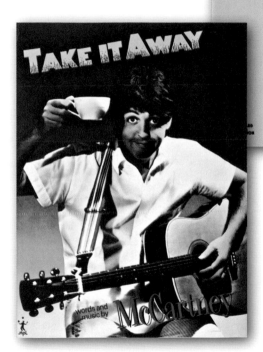

Got My Mind Set On You (**1962**)
"Got My Mind Set On You" was the only one of George Harrison's No. 1 hits not to be written by him. He recorded it for his eleventh studio album, *Cloud Nine*, in 1987, and even did an amusing video of it. Jeff Lynne, who helped produce the album, started working with Harrison after this on a project that would become the Traveling Wilburys, which included not only them but Roy Orbison, Tom Petty, and Bob Dylan. A supergroup for sure.

(Just Like) Starting Over (**1980**)
The single "(Just Like) Starting Over" was released in 1980 on October 20, with the new album, *Double Fantasy*, following on November 17. This was a joint collection of alternating John Lennon and Yoko Ono songs that wasn't well received at first. However, within three weeks of the album hitting the market, John Lennon was dead, and the album went to No. 1. It's more than ironic that after the five years it had been since his last new release, he had finally felt ready to record again. A great loss. . . .

Take It Away (**1982**)
Taken from Paul McCartney's *Tug Of War* album, "Take It Away" was the follow-up single to his duet with Stevie Wonder called "Ebony And Ivory," which stayed at No. 1 on *Billboard* for seven weeks. This song only reached No. 10, and featured both Ringo Starr and George Martin.

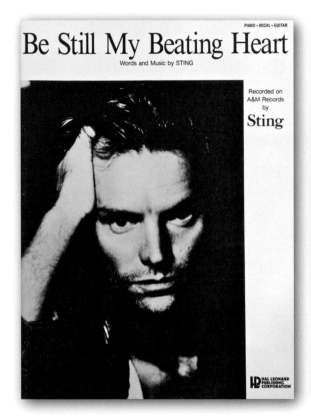

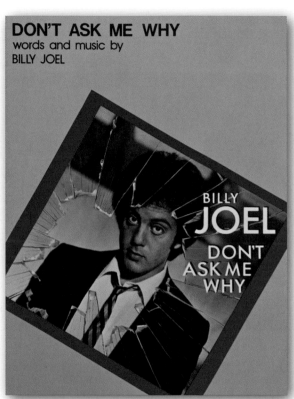

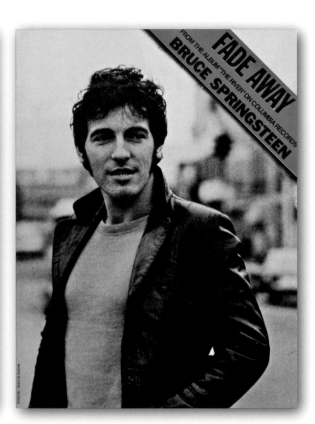

Be Still My Beating Heart (1987)

Having been the front man (singer/songwriter/bass player) for the Police previously, Sting had already established his credentials as a musician before he went out on a solo career. He always had a great sense of the poetic in his lyrics, and coupled with his ability to surround himself with great musicians, this almost assured his future success. He was always interested in mixing the sounds of pop, jazz, and world music to produce songs that still maintained his own identifiable stamp.

Don't Ask Me Why (1980)

Billy Joel was one of the artists who appeared on the music scene in the early seventies and continued to record hit songs for decades to come. With songs like "Don't Ask Me Why," in addition to "Piano Man," "Just The Way You Are," "Only The Good Die Young," "She's Always A Woman," "It's Still Rock And Roll To Me," "Uptown Girl," "We Didn't Start The Fire," "New York State Of Mind," and others, he established a great catalog of hits and standards.

Fade Away (1980)

Written and released with his backup group, the E Street Band, Bruce Springsteen's fifth studio album was called *The River*, and the song "Fade Away" was one of the darker, more pessimistic compositions on it. Regardless of this, the album helped solidify his place as a proponent of working-class ideals and true-blue American pride, living up to the nickname "The Boss." Over the course of time, Springsteen has picked up twenty Grammy Awards, among other accolades.

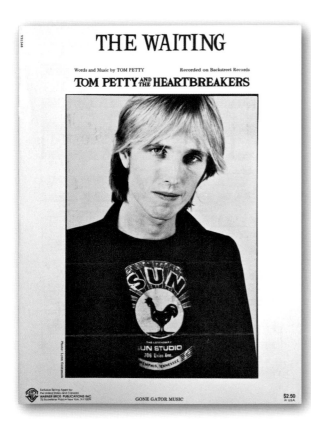

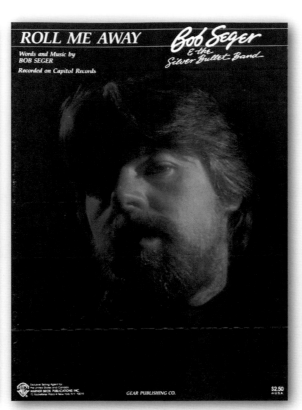

The Waiting (1981)

Tom Petty and the Heartbreakers got together in the mid-seventies and were another band that stayed loyal to the sound of classic rock. Their songs were written and performed in a very straightforward way, and stayed with topics most people could easily relate to. No gimmicks, no flash, just good music. All of that made them one of the best-selling groups in the world. Petty would also record and have some success with the Traveling Wilburys in the late eighties.

Roll Me Away (1982)

Many of Bob Seger's songs read like first-person stories, putting the listener directly into his frame of mind. Seger and his group, the Silver Bullet Band, originated in Detroit, and performed songs with definite Midwest values. The nature of his songs helped him attract a hard-core following, especially in the heartland of America. One of his big hits, "Like A Rock," was used in promoting Chevy trucks for over ten years. He peers down at us from the cover.

Lonely Ol' Night (1985)

Because of a dispute with his manager and record company, Mellencamp ended up going through a progression of names in his recording career. From 1976 to 1982, he was known as John Cougar, until changing his name to John Cougar Mellencamp from 1983 to 1990. Finally, he ended up using his real name, John Mellencamp, from 1991 onwards. While also being involved in social and political causes, he has used his music to raise funds for such organizations as Farm Aid, which he helped establish in 1985.

Working In The Coal Mine (1966)
Written by New Orleans musician Allen Toussaint in 1966, this song has been recorded by quite a few artists, including a version by Devo in 1981. A quirky seventies band from Ohio, they hit their peak in 1980 with their song "Whip It." Using bizarre imagery (art school meets punk rock?) with synthesized music and rhythm, they were the darlings of MTV.

We Got The Beat (1981)
"We Got The Beat" was the first single from the debut album *Beauty And The Beat* by the all-female band the Go-Go's. They ended up having a great influence on the American pop new wave scene. Later on, vocalist Belinda Carlisle would go on to a successful solo career.

Shake It Up (1981)
The Cars was fronted by singer/guitarist Rick Ocasek, and the song "Shake It Up" became their first *Billboard* Top 10 and overall most popular hit. Even though the song was about dancing, it could also refer to how you like your martinis . . . unless you preferred them stirred.

Dr. Heckyll And Mr. Jive (1983)
What a great title for a pop song. The Australian band Men at Work had a number of hit singles in the US from 1981 to 1985, with the first two being the most noteworthy: "Who Can It Be Now?" and "Down Under." They disbanded in 1986, and are pictured on the sheet music cover, along with a bagpiper.

Girls Girls Girls **(1987)**

Typical heavy metal group of the time—big hair and overly glam outfits—here's Mötley Crüe with a song about babes and bikes. Throughout the song are mentions of various well-known strip clubs around the country (and world). The original video made for MTV was banned because of the nudity shown. It was filmed at one of the clubs in the song, the Seventh Veil on the Sunset Strip in LA. Seen with their Harleys are Vince Neil, Nikki Sixx, Tommy Lee, and Mick Mars.

Let's Get It Up **(1981)**

From the album *For Those About To Rock We Salute You* by the Australian hard rock band AC/DC. The lyrics of the song are fairly obvious, given the nature of the song title (and the group . . . and the category of music). The cover photo shows guitarist Angus Young and vocalist Brian Johnson.

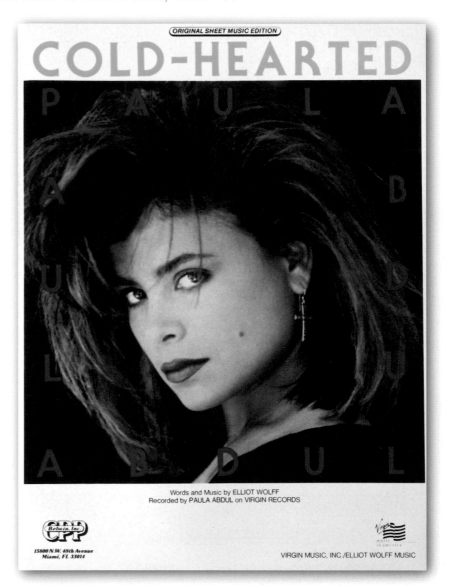

I've Got A Rock n' Roll Heart (1981)

Recorded with the help of legendary producer Tom Dowd, Eric Clapton had moderate success with this song initially, but it has grown to be a concert favorite. "I've Got A Rock n' Roll Heart," which was also used in an advertising campaign in 2010, has now become identified with Clapton.

Cold-Hearted (1988)

Propelled by the strength of a sexy and provocative dance video on MTV, "Cold-Hearted" became a No. 1 *Billboard* hit for Paula Abdul in 1989. Originally a Lakers cheerleader, Abdul did a little bit of everything—singer, songwriter, dancer, and choreographer. Gotta love the eighties hair in her photo.

Who said that America doesn't have royalty? Behold a regal presentation of one song each from a Prince, the Queen of dance music, and the King of Pop.

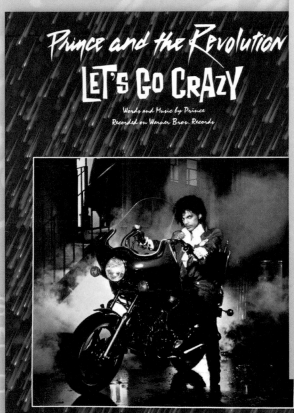

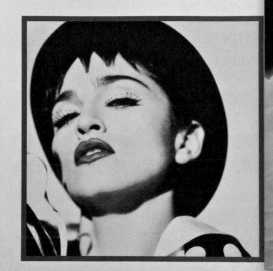

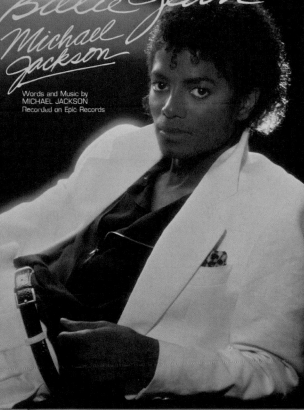

Let's Go Crazy (1984)
This was the opening track from the landmark album and film *Purple Rain* by Prince and the Revolution. "Let's Go Crazy" has stayed one of Prince's most popular numbers, and the entire album is now considered a pop/R&B masterpiece.

Justify My Love (1990)
One of the more controversial songs by an artist who has never shied away from being in the spotlight—Madonna. From her album *The Immaculate Collection*, it features her seductively whispering most of the lyrics, which are concerned with sex and romance, set to a strong dance beat background.

Billie Jean (1982)
The second single from Michael Jackson's *Thriller* album, and its subsequent video, proved to be the key in getting Jackson onto the influential MTV rotation and opening their doors to other black artists. "Billie Jean" was followed quickly by "Beat It" and then by the single "Thriller," all of which lifted him into the international superstardom that stayed with him until his tragic death in 2009. *Thriller* has become far and away *the* biggest-selling album of all time worldwide.

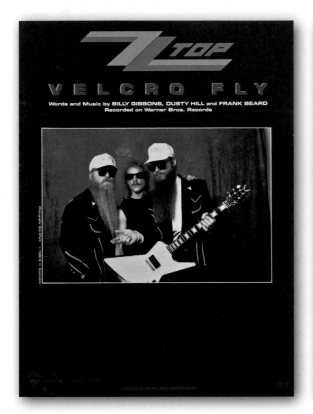

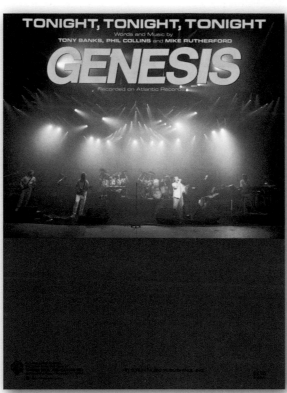

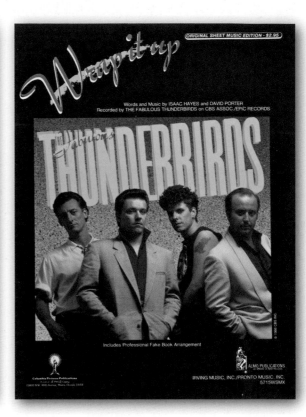

Velcro Fly (1985)

ZZ Top has been billed as "a little ole band from Texas," and has primarily kept to a power blues trio format. The remarkable fact that they have continued with the same personnel since 1971 is often overlooked, but has helped maintain a loyal fan base. Their clever use of suggestive videos in the eighties became almost a trademark for them. In the video for "Velcro Fly," Paula Abdul was the choreographer for the female dancers.

Tonight, Tonight, Tonight (1986)

The transition of Genesis from progressive rock pioneers in the early seventies to a more pop or soft rock sound happened gradually. The departure of singer Peter Gabriel in 1975 and guitarist Steve Hackett in 1977 allowed the remaining three members to evolve a more commercial approach to their music, assisted by hired guns like Daryl Stuermer on guitar and bass and Chester Thompson on drums. Dynamic lighting effects are seen in the concert photo of the group on the sheet music cover.

Wrap It Up (1968)

With Kim Wilson on harmonica and vocals and Jimmie Vaughan on guitar, the Fabulous Thunderbirds brought their own strong blues credentials to this 1986 reworking of an R&B classic by Isaac Hayes. They kept the blues rock flame burning, and managed to add a dose of pop interest with songs (and corresponding videos) like "Wrap It Up" and "Tuff Enuff" from the album *Tuff Enuff*.

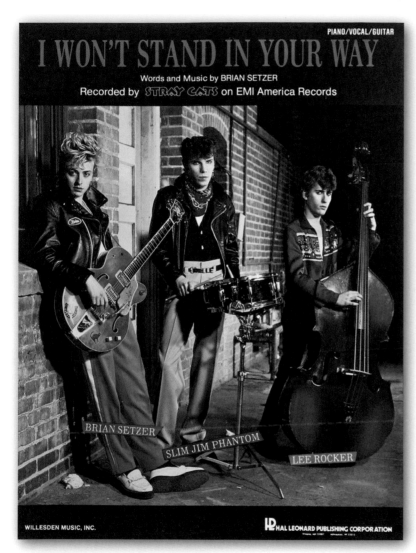

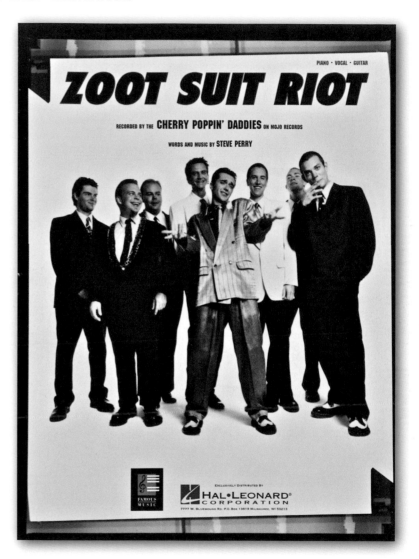

I Won't Stand In Your Way (1983)

Brian Setzer has always remained true to the neo-rockabilly style that he established with the Stray Cats in 1979. The group had the sound and the look, as is apparent from the photo on this sheet music cover. Eventually, he even encompassed the retro-swing movement with the Brian Setzer Orchestra.

Zoot Suit Riot (1998)

The late nineties saw a revival in 1930s-style swing and 1940s jump blues music, as performed by contemporary groups like Cherry Poppin' Daddies, Royal Crown Revue, the Brian Setzer Orchestra, and Big Bad Voodoo Daddy. Everything from the clothing to the actual dance steps was picked up by the fans, and gave concertgoers a chance to recreate a part of music history and have a lot of fun at the same time.

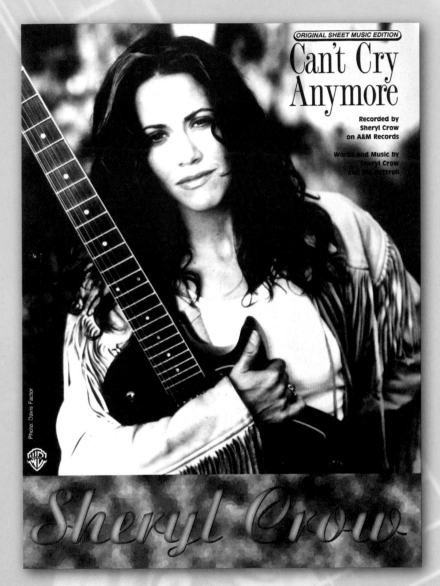

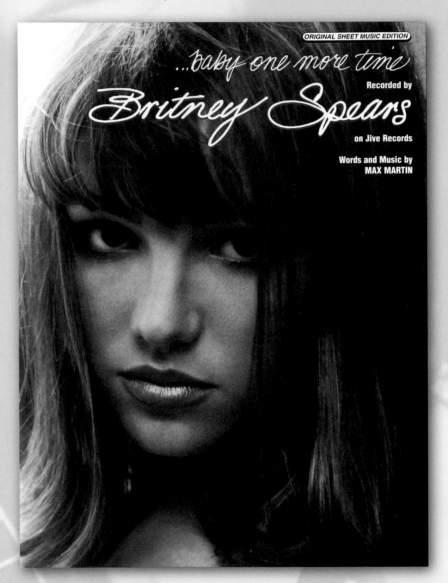

Can't Cry Anymore (1993)
This song is from the 1993 debut album by Sheryl Crow called *Tuesday Night Music Club*, which won three Grammy Awards for Best New Artist, Best Female Vocal Performance, and Record of the Year. Not a bad start to anyone's music career.

. . . Baby One More Time (1998)
A very young (and innocent looking) Britney Spears gazes out at us from the cover of her first single from her debut album of the same name, released in early 1999. This song really got her established worldwide, hitting No. 1 in every country it was released in.

Too Much (1997)

The Spice Girls were a female British vocal group that specialized in pop/dance songs, and "Too Much" was from their second album, *Spiceworld*. Promoting the phrase "Girl power," their music attracted a huge following across the globe, making them the all-time best-selling female group.

Heartbreaker (1999)

Mariah Carey started going with a more R&B flavored hip hop style during this time period. Known initially for her huge vocal range and the almost gymnastic use of her singing voice, she had great success as a pop singer from her first album in 1990 onward.

The word *prolific* is barely adequate to describe the musical output of John Williams in the eighties and nineties. It doesn't imply the astounding sense of melody and dynamics associated with his movie compositions, which won eleven Grammys and two Academy Awards in just twenty years. In addition to these six films, he wrote, scored and conducted the soundtracks to well over a dozen more.

The Imperial March (Darth Vader's Theme) (1980)

From the first few strident and sinister minor chords, this theme exudes "the dark side." It has come to represent the approach of evil whenever it is heard, even outside of this film. Because of its serious and emotional nature, *The Empire Strikes Back* is considered by many to be the best of the whole Star Wars series. Climactic line from the film: "No, *I* am your father."

Raiders March (1981)

Very few modern composers can write stirring marches the way John Williams can. This catchy theme called "Raiders March" was written for the Steven Spielberg--directed *Raiders Of The Lost Ark* in 1981, the first of what would be four installments of the Indiana Jones Chronicles. This action-packed series was a throwback to the movie serials of the thirties and forties. Very few archeologists would normally work carrying a gun and a whip, though they might have the fedora.

E.T. (The Extra-Terrestrial)—Theme From (1982)

A feel-good science fiction story focusing on the friendship that develops between a young boy and a stranded alien, *E.T.* was a huge blockbuster in 1982. Director Steven Spielberg always had a talent for creating magic on the big screen through his ground-breaking visuals, working with the George Lucas company Industrial Light & Magic.

Jurassic Park—Theme From (1993)

Released in 1993, *Jurassic Park* was a wonder of special effects, making the dinosaurs the real stars of this movie. Yet another masterpiece of computer-generated images by IL&M, combining life-size models and superb sound effects, winning three Academy Awards, and making a lot of money! It's not reassuring to know that there are scientists currently at work trying to do the exact same thing today, recreating dinosaurs from ancient DNA. Science fiction becoming science fact.

Schindler's List—Theme From (1993)

Shot like a documentary in black and white, this film offers a serious look at the atrocities committed by the Nazis during the Holocaust, and the attempt by one man to save as many people as he could. It picked up seven Academy Awards in 1994. Steven Spielberg pulled together every detail to make *Schindler's List* a realistic portrayal of this actual event during the Second World War. The dramatic score highlights Yiddish folk music, with this theme played by Itzhak Perlman on violin.

Hymn To The Fallen (1998)

Saving Private Ryan won critical acclaim and was a commercial success when released in 1998. This epic film takes place during the Normandy invasion of World War II, and provided a powerful look at the brutal realism of war, winning five Academy Awards in the process. Like all of the sheets pictured here, it uses the movie poster image on the cover, making it easily identifiable (and collectible).

Day-O (1955)

Originally subtitled "The Banana Boat Song," as written by Irving Burgie and recorded by Harry Belafonte in the fifties, "Day-O" is remembered for the line about wanting to go home at daylight, which is repeated throughout the song. It is used a number of times in *Beetlejuice*, the 1988 Tim Burton fantasy about a pair of ghosts, an odd family, and an even stranger character named "Beetlejuice." Just remember not to say the name three times.

Ghostbusters (1984)

The movie that answers the question concerning who to call for professional help to get rid of ghosts, *Ghostbusters* was a special-effects laden comedy from 1984, written by Dan Aykroyd and the late Harold Ramis, an SCTV alumnus. With Bill Murray playing his usual obsessive and crazy character, the movie did extremely well at the box office. The title song was composed and performed by Ray Parker Jr., though the musical score was done by the veteran Elmer Bernstein.

The Addams Family Waltz (1991)

The 1991 movie of *The Addams Family* was an update and a rework of the old sixties TV series, which itself was based on a long-running newspaper cartoon by Charles Addams. Casting was perfect, creating a new look but maintaining the same "unusual" family atmosphere. Not only did Raul Julia, Angelica Huston, and Christopher Lloyd bring their characters to life (pun intended), the film version benefitted from advances in special effects.

Love (1980)

Whenever you put two top comedy talents like Gene Wilder and Richard Pryor together in the same movie, like *Stir Crazy*, it makes for double the amount of craziness and humor. And so it was here— even more surprising because this is one of only nine films directed by Sidney Poitier, primarily known for his serious acting in the sixties.

The Naked Gun From The Files Of Police Squad!— Theme From (1988)

Lt. Frank Drebin was a bumbling and oblivious police detective portrayed by Leslie Nielsen for the 1982 comedy TV series *Police Squad!*, which ran for only six episodes. Taking it to the big screen in 1988 made all the difference, and allowed the slapstick humor, verbal puns, and visual gags to reach enough of an audience to produce three *Naked Gun* films. All featured a supporting actor role for O.J. Simpson, in some of his last appearances before his legal troubles began.

Soul Bossa Nova (1962)

In the movie *Austin Powers: International Man Of Mystery*, we are introduced to the hilarious Mike Myers spy spoof that would become a cult classic and lead to a number of sequels. Austin Powers is seen on the cover of the sheet music, with many of his sixties catchphrases in the background. The instrumental number "Soul Bossa Nova" was written and recorded by Quincy Jones and His Orchestra. "Yeah, baby."

Danger Zone (1986)

Top Gun ended up being more than just an action movie/drama starring a young Tom Cruise; it was a recruiting tool as well. With the glamorous portrayal of the hot-shot fighter pilot and the aerial footage, both the Air Force and Navy saw a large increase in the number of people interested in joining the services. The movie soundtrack became a best seller, with Kenny Loggins performing "Danger Zone," and the song "Take My Breath Away" done by Berlin winning an Academy Award.

Back To The Future (1985)

Being a science fiction film, a comedy, and a romance (and the only movie to prominently feature a DeLorean motor car), this was one of the most profitable movies of 1985. With the help of Industrial Light & Magic, time travel and the problems of unforeseen circumstances were resolved, and this theme was quickly followed up with sequels in 1989 and 1990. Timing *was* everything in these movies!

Clue—Theme From (1985)

In a strange twist of reality, the movie *Clue* was based on an already-existing popular murder-mystery board game. The film was originally issued to theaters with only one of the three possible endings included, but the commercial release on VHS and DVD provided all three in a sequence that made the outcome that much more interesting and fun. Great performances by the entire ensemble have made this into another classic cult film.

I'm Alright (Theme From Caddyshack) (1980)

Revolving around golf and gophers, *Caddyshack* played a huge part in starting Rodney Dangerfield on an acting career, as he previously had only been known as a stand-up comedian. The song "I'm Alright" was written and recorded by Kenny Loggins, pictured above the movie characters, and has become one of his standard pieces in concert.

Hymn To Red October (Main Title) (1990)

The movie takes place during the Cold War era. Sean Connery gives a strong performance as a top Russian submarine commander trying to defect with his state-of-the-art ship, called *Red October*, while Alec Baldwin is the American trying to predict his motives and moves. Based on the books by author Tom Clancy, *The Hunt For Red October* is truly an action thriller. The cover depicts a determined-looking Connery.

The Right Stuff (1983)

The plot from *The Right Stuff* was taken from the Tom Wolfe book about early test pilots like Chuck Yeager, and the selection process of the crew of seven Mercury astronauts for our first manned space flights. The voice of the narrator during the film is Levon Helm, the drummer/singer/songwriter from the Band.

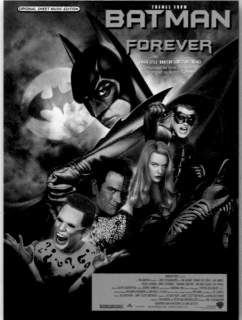

Batman Forever (1995)

Batman Forever was produced by Tim Burton in 1995 and starred Val Kilmer as the Caped Crusader. This third film in the series was a little bit more like the comic book, with performances by Jim Carrey, Tommy Lee Jones, and Nicole Kidman. It earned more money than the previous darker movie, showing that audiences preferred a campier version.

Independence Day—Themes From (1996)

The basic premise of Earth being invaded by unstoppable aliens who are only overcome by a simple virus has been around since the dawn of science fiction literature. This was the plot of *War Of The Worlds*, written by H. G. Wells in 1898. In the effects-laden *Independence Day*, it was a computer virus that weakened the aliens enough to allow a nuclear bomb to destroy them.

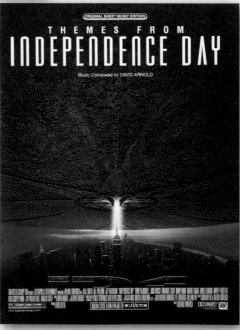

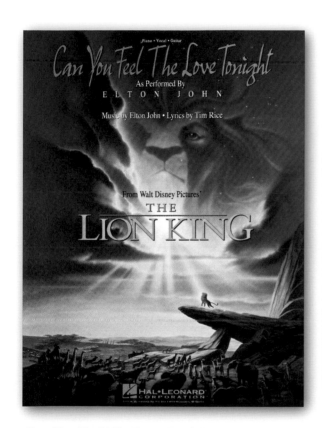

Can You Feel The Love Tonight **(1994)**
Performed by Elton John, "Can You Feel The Love Tonight" was a massive hit song from the animated Disney feature *The Lion King*. Released in 1994, the movie earned praise for both the story and the music, winning two Academy Awards, and had a number of related spin-offs, including a live Broadway stage production.

Forrest Gump—Main Title (Feather Theme) **(1994)**
Because the time period this movie covers is a few decades in the life of Forrest Gump, the popular music used on the soundtrack is wide ranging. It contains thirty-two songs from the fifties through the eighties on two CDs, and sold over twelve million copies. The movie itself won six Academy Awards, plus numerous others awards.

My Heart Will Go On (Love Theme From Titanic) **(1997)**
Like the ship itself, this movie and song were *huge*. Reaction to *Titanic* was so favorable that it went on to win eleven Academy Awards, equaling *Ben Hur* (1959) for most ever. Sales of the sheet music for "My Heart Will Go On," recorded by Celine Dion, reached levels that were rarely seen at the time and have not been seen since.

A total of eight more Bond films were released during these two decades. Once again, while the standard formula stayed the same, a procession of actors played the title role: Roger Moore (three), Timothy Dalton (two) and Pierce Brosnan (three). A whole generation had now grown up and taken for granted his standard self-introduction of "The name is Bond, James Bond."

For Your Eyes Only (1981)
Reviews of this Bond film were mixed. A little grittier than previous Bond films in terms of themes of revenge, *For Your Eyes Only* had some good stunts and props, but it was considered an average effort overall. The title song was recorded by Sheena Easton. One of the best Bond sheet music covers, taken from the somewhat controversial original movie poster.

All Time High (1983)
Octopussy was another lightly regarded James Bond adventure. Rita Coolidge sang "All Time High," which is one of only a few Bond theme songs that don't use the film's title as their own. Roger Moore would play Bond once more after this before handing the reins over to Timothy Dalton.

Tomorrow Never Dies (1997)

In his second role as James Bond, Pierce Brosnan faced an opponent who was a media mogul aspiring to control and direct the course of world events, all the while creating the news so that his network and papers would get the exclusive coverage. Probably a better Bond, a smarter plot, and a more believable villain than had been seen in some time. The song "Tomorrow Never Dies" was written and recorded by Sheryl Crow.

The World Is Not Enough (1999)

Excessive chase sequences and special effects did not help a somewhat confusing, convoluted plot, along with some unusual casting (Denise Richards in tight shorts and a bouncy tank top as a nuclear scientist?). *The World Is Not Enough* managed to do well at the box office, and the title song was performed by the group Garbage.

The Simpsons—Theme From (1990)

From the creative mind of Matt Groening came the animated prime-time series that would go on to a special place in history: *The Simpsons*. Clever, crude, smart, silly, musical, quirky, satirical, and more, it hit the screen in December 1989. Having won dozens of awards, it is now in its twenty-fifth season! We've grown up with this show, and have learned to appreciate it for what it really is—namely, witty entertainment for adults that parodies and comments on the world we live in. Has every episode been perfect? No. Has the show had periods of declining quality (over twenty-five years)? Yes. But when the writers are at their best, they're brilliant. Life wouldn't be the same without Homer, Marge, Bart, Lisa, Maggie, and the entire cast of supporting characters. Classic family portrait on the sheet music, with music by film and TV composer Danny Elfman. "D'oh!"

Tiny Toon Adventures Theme Song (1990)

Lasting for three seasons, *Tiny Toon Adventures* was an effort to create a new generation of *Looney Tunes* cartoon characters. Living in a town called Acme Acres and attending Acme Looniversity, the young characters are taught by the "older generation" (Bugs, Daffy, Wile E. Coyote, etc.) to carry on the WB tradition of cartoon comedy and slapstick. Unfortunately, they did not have the staying power or attraction that the original characters had with the public. Pictured on the cover are Babs Bunny and Buster Bunny.

Futurama (1999)

Coming out just as the century was drawing to a close, another ingenious Matt Groening creation called *Futurama* appeared in early 1999. It ran for seven seasons and 140 episodes, gaining both popular acceptance and critical praise. Taking place in the future (the thirty-first century), the TV show follows the exploits of Fry, Leela, Hermes, Dr. Zoidberg, Amy, and Bender the robot as they work at an interplanetary delivery company called Planet Express, owned by Professor Farnsworth. The scope of their adventures knows no bounds, from the beginning to the end of time, or from Earth to the farthest reaches of the universe. Leela, Fry, and Bender can be seen on the cover of the music.

Star Trek: The Next Generation (1987)

Taking place further in the future, almost seventy years after the final original Star Trek stories (from the sixties), *Star Trek: The Next Generation* featured a new crew and a new starship *Enterprise*. We saw seven years of Captain Picard (Patrick Stewart) following the directive laid down by Captain Kirk (William Shatner) all those years ago, but this time "to boldly go where no *one* has gone before."

I Believe (1994)

Baywatch hit the beach from 1989 to 1999. Starring David Hasselhoff, along with a bevy of bouncing beauties, it showed us LA lifeguards at work. The show was popular worldwide; running in slow motion never looked so good. Hasselhoff sang this song from the show, with the help of Laura Branigan, and is pictured on the cover (third from the right) with Pamela Anderson (second from the right), along with the rest of the cast.

Beverly Hills 90210—Main Theme (1990)

The series followed a group of Beverly Hills teens as they made their ways through the trials and tribulations of high school and college in this swanky LA neighborhood. In the ten seasons between 1990 and 2000, *Beverly Hills 90210* covered a host of topical subjects, featuring an ever-changing cast.

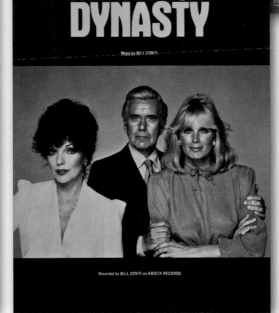

Dynasty—Theme From (1981)

Another prime-time soap opera like *Dallas*, *Dynasty* ran from 1981 to 1989. Although it was based in Denver, a lot of the same family squabbles and situations developed, especially when Joan Collins got in the act. Also on the cover are John Forsythe and Linda Evans.

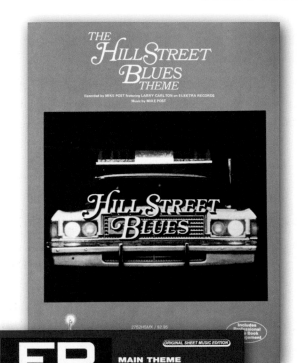

Hill Street Blues Theme (1980)

One of the most influential police/crime shows of all time was *Hill Street Blues*. In a seven-year run, it changed the way these dramas played out, opening up new possibilities with creative writing. The theme, written by Mike Post and played by guitarist Larry Carlton, got on the *Billboard* Hot 100 Chart in 1981 and hit No. 10.

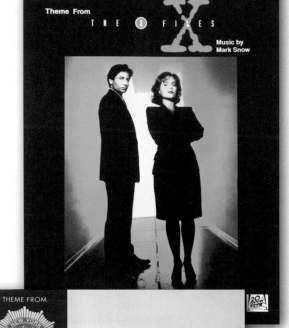

X Files—Theme From (1993)

Agents Mulder and Scully (one a believer, the other a skeptic) investigate and try to prove or disprove un-usual happenings that involve paranormal activity. Conspiracy theories, shadowy characters, hidden agendas, strange creatures, and more populated *The X Files* for nine seasons, from 1993 to 2002.

ER—Main Theme (1994)

Where would we be without a good old medical drama on TV? From the days of *Ben Casey; Dr. Kildare; Marcus Welby, M.D.*; and *St. Elsewhere*, to *House, M.D.* and *Grey's Anatomy*, it has been a staple of prime-time TV. Winning twenty-three Emmys and one Peabody Award (among others), the program *ER* ran for an unbelievable fifteen seasons, outliving all of the others in terms of series longevity. Cover depicts the main cast.

NYPD Blue—Theme From (1993)

Twelve seasons of *NYPD Blue* proved that this police drama had plenty of staying power, with stories about difficult situations both inside and outside of the department. Music was written by Mike Post. Cast photo on the cover.

As the end of the twentieth century approached, music continued its changing ways. Throughout the final two decades alone, the pendulum of popular music swung from the heavy metal "hair bands" of the eighties to the "unplugged" acoustic artists of the nineties. Yet by the year 1999, we would be on the cusp of an even greater transformation of music—and the world. Production and sales of sheet music began a long, slow decline.

You must remember, before we hit the year 2000, there were no such things as iTunes or iPods or digital downloads. *American Idol* (and all the many music show variations) didn't exist. The events of September 11, 2001, and the worldwide changes it generated could not even have been imagined. All of that was still part of the future, and who could have predicted any of it? Through all of this, music played on, but how we began to access it would start to change as well.

***Hercules: The Legendary Journeys* (1995)**
Through six seasons, we followed the exploits of the mythological figure Hercules in a very tongue-in-cheek production. It presented us with a little of everything—drama, action, fantasy, romance, sword and sorcery, humor—and mixed it all with good storytelling and usually an uplifting message. Pictured on the cover is Kevin Sorbo as Hercules.

***Xena: Warrior Princess* (1995)**
Coming as a spin-off of the *Hercules* series, *Xena* was similar in nature and content, but focused more on the darker aspects of Xena's character. We are presented with her struggle to change the perception of the people with whom she comes into contact while trying to make up for the sins of her past. Running for six seasons, the show developed an almost cult following. The music for both these shows was skillfully composed by Joseph LoDuca. Lucy Lawless stars as Xena on the sheet music cover.

PATRIOTISM, POLITICS, AND PROTEST

During the first half of the twentieth century, patriotism was an accepted element in society. Songs about unity, perseverance, and support in times of trouble and war were universal. There was very little question about it.

However, starting in the fifties, a number of "undeclared" wars and conflicts led to a growing uneasiness within society. As the sixties wore on, a shift in popular sentiment began. Groups of younger people questioned the political decisions and demanded a focus on peace instead. Radicals appeared, on *both* sides. Pro-war, anti-war, wave the flag, burn the flag— every faction had songs to establish and promote its message to the world.

A polarization of beliefs about race, politics, and war led to an anti-establishment culture, which made itself heard through the songs that were produced. For the first time, protest songs were heard on the radio and appeared on the pop charts. The flash points of Nixon and the Vietnam War led to social unrest. The importance of equal rights for blacks and women, ecology, peace, different lifestyles—all helped generate songs on a wide scale. Social upheaval with a music soundtrack.

Live Free Or Die (1987)
This song is based on the official motto of the state of New Hampshire, and is respectfully dedicated to the residents of that state.

Live Free or Die

Lyric: FREEMAN COHN

Music: PAUL GIASSON

galleon press
Sole Selling Agent: THE BOSTON MUSIC COMPANY, Airport Drive, Hopedale, MA 01747

The Pledge Of Allegiance (1973)

What could be more appropriate to this chapter than a piece of sheet music by the Duke, who portrayed the very image of an American hero in many of his various acting roles?

In 1973, John Wayne released an album called *America And Why I Love Her*. On the album, he recites in his distinctive drawl a number of stirring patriotic speeches based on the poems of John Mitchum (the younger brother of the actor Robert Mitchum), with inspiring music playing in the background.

Heavily infused with references to the best of human values and combined with descriptions of the natural beauty of the American landscape, the tracks created an emotional and uplifting sense of pride for many people about the American way of life.

In "The Pledge Of Allegiance," Wayne starts by reading the words straight through and then goes back on a line-by-line basis, making comments and expanding the meaning of each phrase in a dignified patriotic manner before continuing with the next.

Some of the other tracks on the album are "Why I Love Her," "The People," "An American Boy Grows Up," "Face The Flag," and "Why Are You Marching, Son?" It stayed on the *Billboard* Album Chart for sixteen weeks during the time when the Watergate scandal was coming to light, which led to President Nixon's eventual resignation in 1974. With the increasing number of antiwar protests going on, this was a very turbulent period for our nation, and a time when patriotism and flag waving were not on everyone's list.

THE PLEDGE OF ALLEGIANCE

Recorded by JOHN WAYNE on the RCA Record, "AMERICA AND WHY I LOVE HER"

Original Text by Francis Bellamy (1892)
Additional Text by John Mitchum (ASCAP)

Music by Kenneth F. Nelson
Arranged by Billy Liebert

Photo courtesy of David Sutton

STUDIO P/R publications recordings

Sales and Shipping: STUDIO P/R, Inc., 224 S. Lebanon St., Lebanon, Ind. 46052

PRICE: $1.00

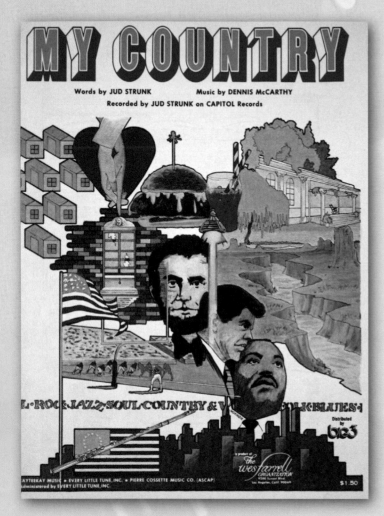

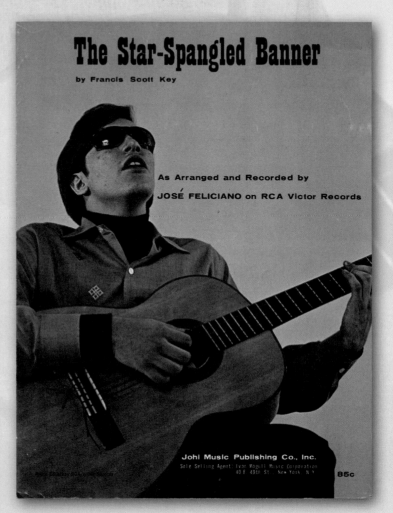

My Country (1974)

Jud Strunk was best known for his pop songs ("Daisy A Day") and comedy material ("The Biggest Parakeets in Town"). As a singer/songwriter he had performed on *Rowan & Martin's Laugh-In* and other variety shows, though his career only lasted a few years. "My Country" was a serious and deeply patriotic song, running through a list of both important and everyday events that make up our culture and history. Unfortunately, Strunk died in a plane crash in 1981 at the age of forty-five.

The Star-Spangled Banner (1968)

Blind, Puerto Rican--born virtuoso classical guitarist and singer José Feliciano hit the American charts in a big way with his Latin-tinged version of the Doors' "Light My Fire" in early 1968. Later that year, he performed "The Star-Spangled Banner" in a similar manner and solely accompanied by his guitar, at the start of Game 5 of the World Series in Detroit. The song was recorded and released, and ended up on the *Billboard* Hot 100 for five weeks. This influenced others to play the national anthem in different styles. A year later, Jimi Hendrix did his famous solo electric guitar version at Woodstock, including improvised sound effects.

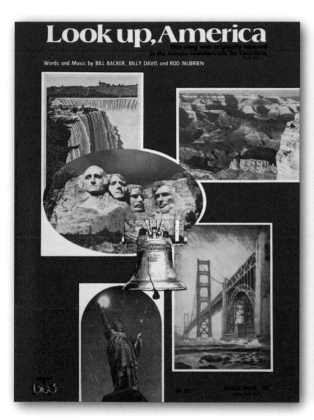

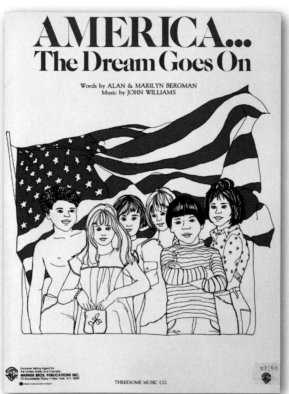

Look Up, America (1974)

This song was originally featured in the famous commercials for Coca-Cola®, according to the blurb on the cover of this sheet. Pictured on the front, around the Liberty Bell, are photos and illustrations of famous landmarks around the country: Niagara Falls, Mount Rushmore, the Grand Canyon, the Golden Gate Bridge, and the Statue of Liberty.

America . . . The Dream Goes On (1987)

Written by the hit songwriting duo Alan and Marilyn Bergman along with John Williams, this was recorded by the Boston Pops Orchestra and Choir. The cover illustration depicts an ethnically diverse group of children representing the hope for the future, standing in front of an American flag.

Take Pride In America (1987)

Released on the Oak Ridge Boys album *Greatest Hits, Volume 3* in 1989, this promotional single never reached the charts. The song was recorded to encourage people to help clean up the environment and preserve the country's natural beauty and wildlife.

America Is (1985)

This was the official song of the Statue of Liberty-Ellis Island Foundation, which was formed to raise funds for the restoration of the national landmark. Songwriters Hal David and Joe Raposo donated their royalties to the foundation, as did the singer B. J. Thomas.

The collaboration celebrated the centennial in 1986 of the statue, which was given to the United States in 1886 as a gift from the people of France.

Lady Liberty has always stood as a symbol of freedom and welcome to the immigrants who came here over the years. She had fallen into disrepair and neglect over the course of time, and was badly in need of a makeover.

In 1976, our country celebrated its two hundredth birthday with a series of events and activities called the Bicentennial Celebration. Starting approximately a year earlier, it finally culminated on July 4, 1976, with special network TV programs and televised fireworks from Washington, DC.

The colors red, white, and blue were everywhere, and an increased awareness of patriotism was evident. There was an official logo that was used on a multitude of licensed merchandise items, from lunch pails and coffee mugs to postage stamps and T-shirts.

America! Two Hundred Years Young (1976)
Listed on the cover as "Winner First Prize Liberty Ball Bicentennial Competition," this sheet shows an American astronaut during a space walk, with the Earth in the background.

Spirit Of '76 (1975)
Cover illustration of Revolutionary War figures in front of a large American flag, with sketches around the sides of modern American progress and our natural wonders.

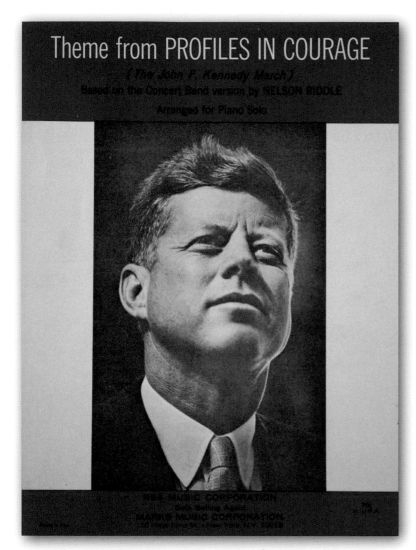

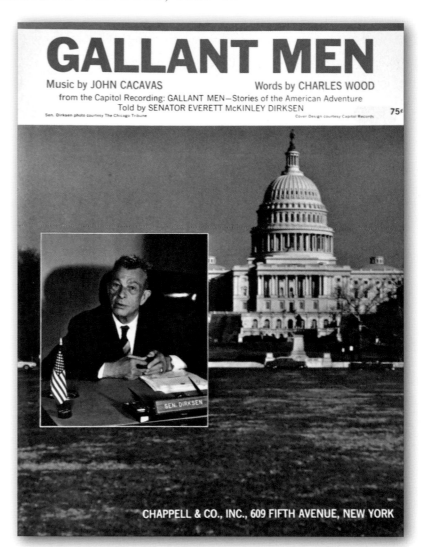

Profiles In Courage—Theme From (The John F. Kennedy March) **(1964)**
The book *Profiles In Courage* was written by Kennedy in 1955 and turned into a historical series for TV after his death. On the air from 1964 to 1965, the show ran for twenty-six episodes, and examined real figures from American history who took unpopular stands during times of crisis. Nelson Riddle wrote the music and performed it with his orchestra.

Gallant Men **(1965)**
A lifelong politician, Illinois Senator Everett Dirksen recorded a number of spoken-word albums while he was in office, using his deep bass voice to dramatic effect. *Gallant Men* was his most successful, recounting the true stories of some of the figures who were prominent in American history. The album reached No. 16 on the *Billboard* Album Chart, and also received a Grammy Award for Best Documentary Recording.

Bring Us Together, Go Forward Together (1968)

This may be one of the rarest sheets in my collection, especially from the 1950--99 time period. As stated on the cover, it was the "Official Song Selected by the Inaugural Ball Committee, 1969." The large center seal reads, "INAUGURATION OF PRESIDENT AND VICE PRESIDENT" around the image of the United States Capitol building, surrounded by fifty stars, with an outstretched eagle below holding a banner proclaiming "Nixon/Agnew."

Hey! Mr. President (1969)

A psychedelic rock band of the late sixties, the Electric Prunes had their biggest hit in 1966 with "I Had Too Much To Dream (Last Night)." This song was released right after the election of Nixon, and asked him if he was going to live up to the things he promised in his campaign or just continue doing business as usual. This is a valid question that could be asked of almost any politician from any time.

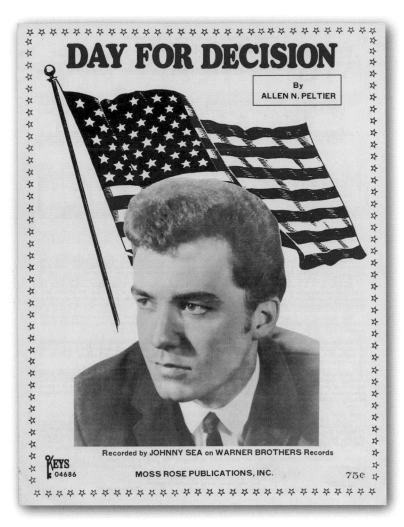

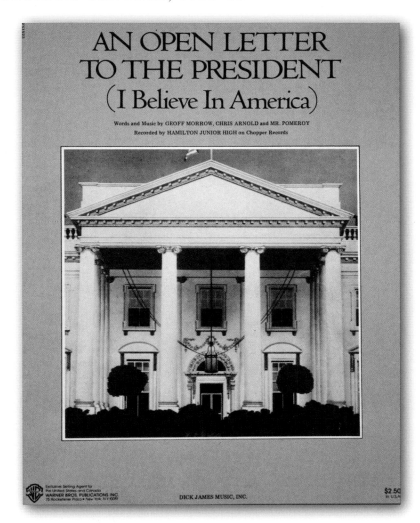

Day For Decision (1966)

Another spoken-word recording, done over a background of patriotic music played at a "brisk march tempo." In this recording, country singer Johnny Sea bemoans the fact that Americans are no longer proud of their country but are cynical instead. According to the lyrics, protesters are destroying the old-fashioned spirit of America, patriotism is dying, and "our enemies" are taking advantage of that fact. Sea leaves it up to us to decide to change. There's nothing wrong with our country, he says; it's what's wrong with us that is the problem. The song ends with a chorus singing a slow, solemn version of "America."

An Open Letter To The President (I Believe In America) (1987)

This song is a mix of sung verses and spoken words, and the cover states that it was recorded by the students of Hamilton Junior High. The children tell the president that they believe in America and in him, but they want to know whether the things that have gone wrong in the country (gas shortages, unemployment, American hostages) will ever go right again, and if so, when that might happen. Obviously, we all know the answer to that . . .

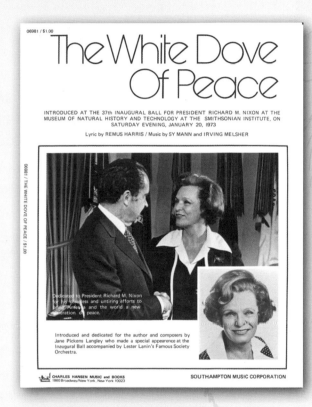

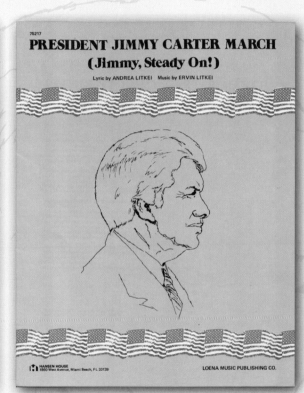

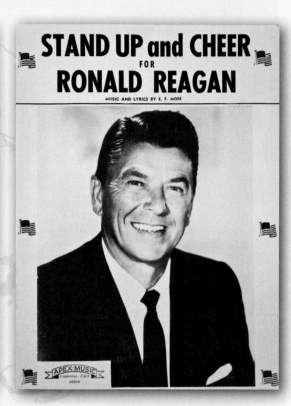

The White Dove Of Peace (1973)

The photo notes, "Dedicated to President Richard M. Nixon for his ceaseless and untiring efforts to bring America and the world a new generation of peace." At this point, we were still actively involved in Vietnam. The sheet also mentions that it was "Introduced at the 37th Inaugural Ball for President Richard M. Nixon . . . on Saturday evening, January 20, 1973." A year and a half later, the president would resign in disgrace because of the Watergate scandal.

President Jimmy Carter March (Jimmy, Steady On!) (1977)

Following the presidency of Gerald Ford (who completed Nixon's remaining term), this ex-governor of Georgia served only one term as president during a difficult time in history. Such events as the Iran hostage crisis, the Three Mile Island nuclear accident, and the US boycott of the 1980 Moscow Summer Olympics all contributed to Jimmy Carter's eroding popularity with the voters and his loss to Reagan in the 1980 election.

Stand Up And Cheer For Ronald Reagan (1980)

Ronald Reagan was president for almost the entire decade of the eighties. His victory over Carter in 1980 (winning forty-four of fifty states) and Mondale in 1984 (taking forty-nine states) proved that he had the personal charm and charisma that years as an actor had developed in him. He was in office at the right time to take advantage of a rising economy in the United States, and to see the dissolution of the Soviet Union leading to the end of the Cold War.

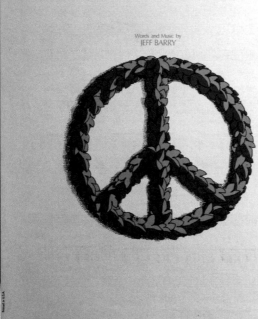

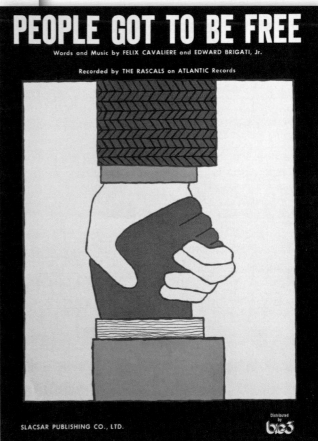

Power To The People (1971)

John Lennon was a master of writing quick and to-the-point popular anthems. In his push for world peace, he felt the need to have a song that people who were fighting the system and the government could sing and rally around. Not necessarily one of his best (even he admitted that), "Power To The People" still provided a catchy tune for their message. Credited on the cover as being recorded by John Lennon & the Plastic Ono Band.

A Summer Prayer For Peace (1970)

Yes, this was recorded and promoted by the Archies, a fictional band taken from the animated Saturday morning cartoon series *The Archie Show*. They hit No. 1 on the *Billboard* chart in 1969 with the bubblegum pop song "Sugar, Sugar," but this title never even charted when released in 1971.

People Got To Be Free (1968)

This bouncy and tuneful appeal for freedom and understanding was the biggest hit for the Rascals during the social unrest of the summer of 1968. Simple yet direct image on the cover of lending a helping hand to achieve those goals.

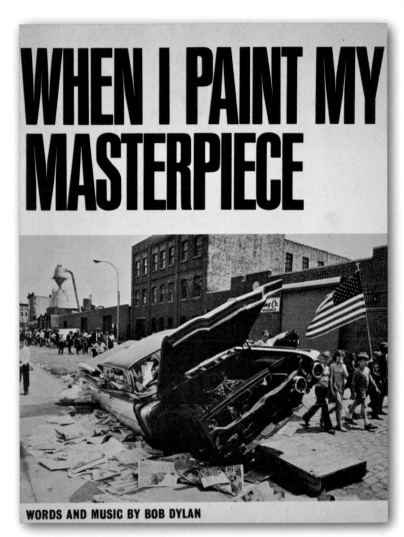

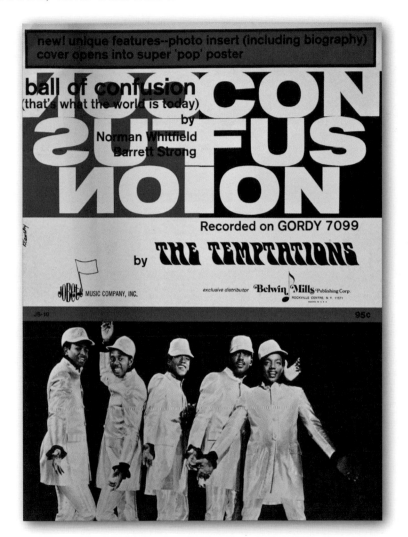

When I Paint My Masterpiece (1971)

Bob Dylan released this song on his album *Greatest Hits Vol. II*, and it was also recorded by the Band on *Cahoots* and their live *Rock Of Ages*. In typical Dylan poetic fashion, it's a title that refers to how things will be better at some point in the future. Dramatic photo on the sheet music cover shows what appears to be an integrated march along an inner city street, going past a trashed and derelict vehicle. Wonderful contrast of the black-and-white photo with an American flag and the words of the oversize title.

Ball Of Confusion (That's What The World Is Today) (1970)

The Temptations are smartly dressed in matching outfits on the cover of this semi-psychedelic-sounding commentary about the social and political problems of the time. Mentions are made of drug abuse, segregation, the Vietnam War, lying politicians, and more. Change the name of the war, and this song could unfortunately be talking about our current situation as well. Good art and powerful music are often timeless.

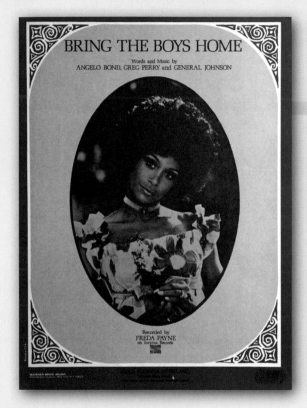

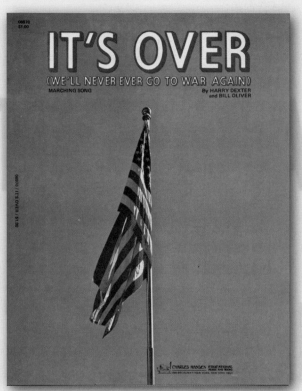

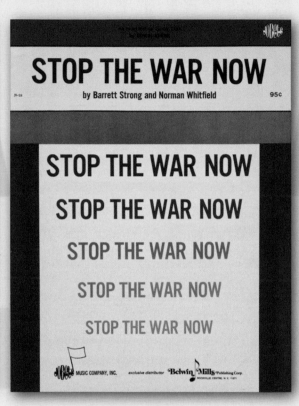

Bring The Boys Home (1971)
Freda Payne (her real name) had experienced her biggest hit, "Band Of Gold," one year earlier. This anti--Vietnam War song reflected the general mood of the country in 1971, and became her second Gold record. It would be a few more years before the boys would come home.

It's Over (We'll Never Go To War Again) (1972)
Overly optimistic sentiment, based on nothing more than hope. Released during the course of the Vietnam War, this song indicated that we should learn our lesson about the senseless nature of war and not repeat the mistakes. Definitely something to strive for . . .

Stop The War Now (1970)
The cover makes sure that the message of this song is obvious and clear. Edwin Starr released "Stop The War Now" as a follow-up to his antiwar protest song called "War," which went to No. 1 on the *Billboard* Hot 100 earlier that year. The sentiments were the same.

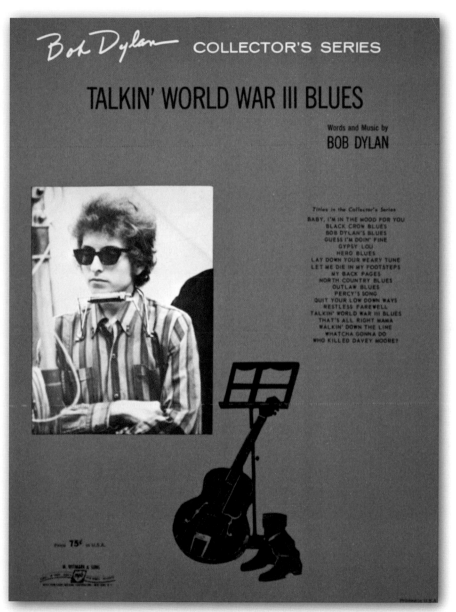

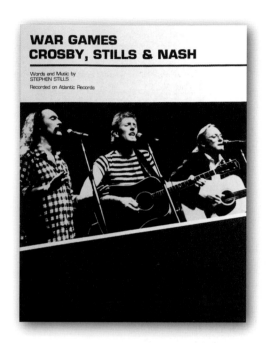

Talkin' World War III Blues (1963)

This is early folk-period Dylan—just him, solo guitar, and harmonica doing a "talking blues" style made popular by Woody Guthrie. It has twelve verses running over six minutes long, and is from his second album, *The Freewheelin' Bob Dylan*, which introduced us to songs like "Blowin' In The Wind," "Don't Think Twice It's Alright," and "A Hard Rain's a-Gonna Fall."

War Games (1983)

Since they formed in the late sixties, the supergroup Crosby, Stills & Nash have made a point of standing up for peace in their songs. Both as a group and as individuals, they have always exposed the stupidity and uselessness of war through the compositions they recorded.

War Song (1972)

Written by Neil Young, who occasionally joined with Crosby, Stills & Nash over the years, and who was also well known for his viewpoints about the subjects of war, peace, and protest. His classic song "Ohio" was written in response to the killing of four student protestors at Kent State University by the National Guard in 1970. Stark image of a wide-eyed baby on the cover, with military grave markers superimposed.

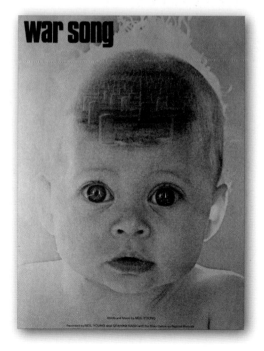

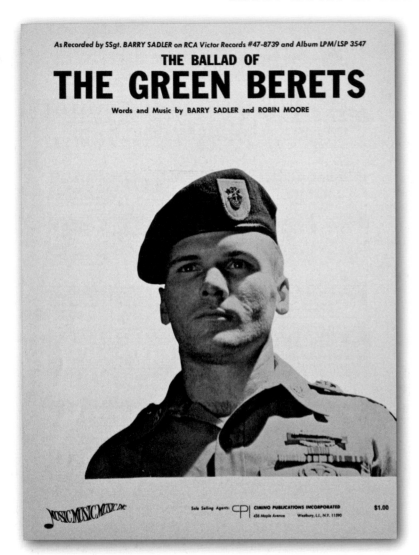

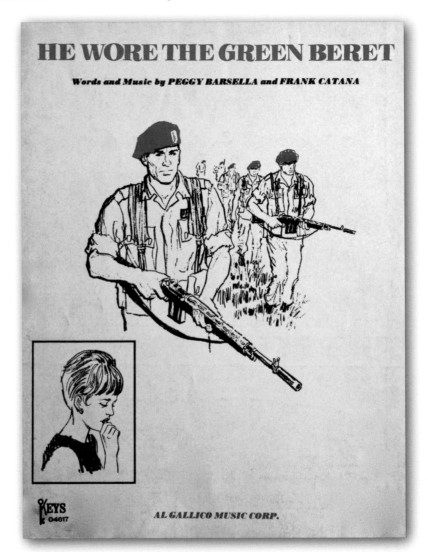

The Ballad Of The Green Berets (1966)

Coming out during the early American involvement in Vietnam, this somber and somewhat maudlin ballad by SSgt. Barry Sadler was the No. 1--selling song of 1966 according to *Billboard*, barely beating out "California Dreaming" by the Mamas and the Papas. In the sixties, very few titles reflected a positive image of soldiers and the war, but this one seemed to connect with many people at the time. Barry Sadler is seen on the cover.

He Wore The Green Beret (1966)

Coming out right after "The Ballad Of The Green Berets," this was sung from the perspective of the grieving woman in that song, who loses her loved one in the war. She is proud of the sacrifice he has made, and vows that their son will follow in his father's footsteps. Performed by Nancy Ames, a folksinger and song-writer, the song did not get the same response. Cover illustrations of the armed Green Berets in the field and an inset of the saddened wife.

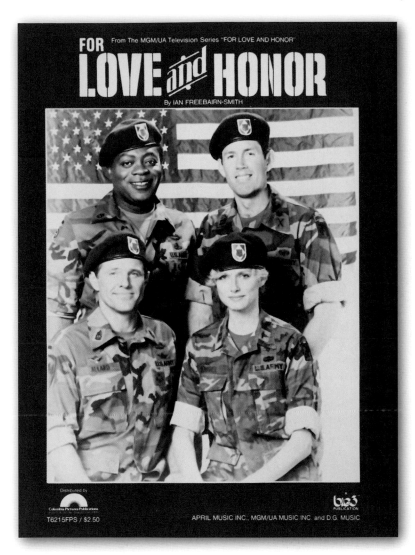

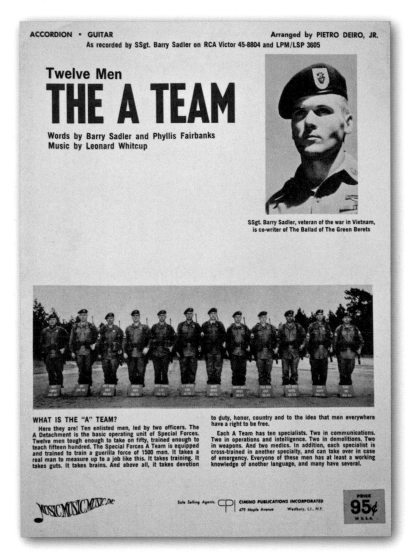

***For Love And Honor* (1983)**

Short-lived TV series about a military base in California, with the main focus on two instructors and their dispute over differing styles of training. Cast photo on the cover features Yaphet Kotto, a character actor from movies and TV in the sixties and seventies, at upper left. Most notably, he played the dual role of the main villain (Mr. Big/Dr. Kananga) in the 1973 Bond film *Live And Let Die*.

***(Twelve Men) The "A" Team* (1966)**

After the tremendous success of "The Ballad Of The Green Berets," SSgt. Barry Sadler quickly followed up with a similar-themed song about a twelve-man Special Forces unit called The "A' Team. Taken from the description on the cover, they were "twelve men tough enough to take on fifty, trained enough to teach fifteen hundred." However, the song did no better than No. 28 on the charts. Pictured are Sadler and a detachment of "A' Team soldiers.

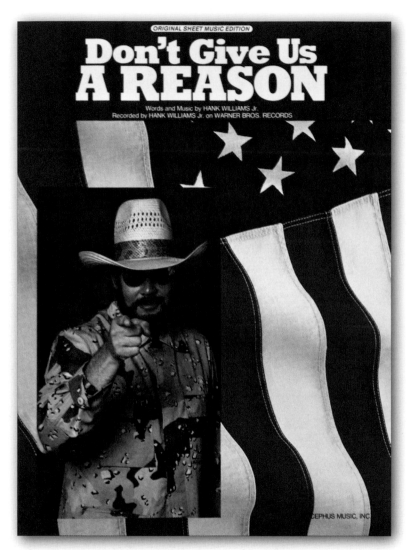

Don't Give Us A Reason (1990)

Right after the start of the First Gulf War in 1990, Hank Williams Jr. released his ul-trapatriotic album *America (The Way I See It)*. On the cover of "Don't Give Us A Rea-son" from it, he's doing his best "Uncle Sam" imitation, dressed in desert camouflage fatigues. With five detailed verses, he directly warns Saddam Hussein, explaining in the chorus that it wouldn't take much for us (the US) to go and take him out. In the long run, it just really wasn't as easy or uncomplicated as we had hoped.

We Are With You (The Desert Shield Song) (1990)

Described on the cover as "a tribute to the Allied Forces in the Gulf," Operation Desert Shield was the period from August 2, 1990, to January 16, 1991. During this time, the United States gradually built up military forces and supplies in the area, in preparation for the coming phase of actual conflict starting on January 17 and to be known as Desert Storm.

More than at any previous time in our nation's history, the subject of patriotism was a double-edged sword in the last fifty years of the twentieth century, and it continues to be so even now. The extreme views of both the right and the left have divided the issue into almost black and white, while the real world generally operates in shades of gray (though in this case, probably not *Fifty Shades*).

Unquestioning devotion is mindless fanaticism, while radical rebellion is complete chaos. There has to be a reasonable and common ground with which to discuss the meaning of patriotism for each of us. A balance needs to be achieved in order for our country to move forward. Criticism can be constructive. Understanding and nurturing our good aspects, while working to minimize and eliminate the bad ones, should be a national goal as well as a personal one.

Whether used to protest or to praise, music gives us the ability to raise our voices together to be heard in a civilized manner. It's up to others to listen and respond . . .

Me And Crippled Soldiers (1989)

Merle Haggard was no stranger to writing songs about patriotism and supporting our troops. One of his most famous compositions was "Okie From Muskogee" in 1969, which he wrote after seeing anti--Vietnam War protesters deride servicemen for fighting (and dying) for an admittedly unpopular cause. Using a somewhat tongue-in-cheek viewpoint in that song, he played up the redneck, conservative Middle American values versus that of the hippie protesters.

In "Me And Crippled Soldiers," Haggard criticizes the fact that a judicial ruling had passed allowing people to legally burn the flag. He mentions in the song that only he and crippled soldiers seem to have respect for it. Image of a decorated veteran in a wheelchair saluting, with the faint image of our flag in the background. The seal in the upper left contains a portrait of Haggard.

NOVELTY SONGS

JUST FOR MORE FUN

Every so often, the listening public seems ready to hear something different, and that's when novelty songs make their mark. They sometimes seem to appear from nowhere and grab our attention. Those here are just the tip of the iceberg.

Novelty songs have always been around. The very name gives them away. According to the dictionary, a novelty is "something intended to be amusing as a result of its new or unusual quality." As pertains to songs, some specific qualifications should be mentioned. Novelty songs can include:

—Comic takes on current events or cultural fads.
—Parodies.
—Songs with a gimmick.
—Comedy material, something written as a joke.
—One-hit wonders.
—Certain seasonal or holiday songs.

Songs might also fall into this category if they:

—Have unusual performers.
—Have strange subjects.
—Have been written to commemorate an event or place.
—Have been used in commercials.

Novelty songs can be vocal, piano solo, or instrumental. The subject or performer is the key. They have always been part of our music culture, especially in the popular music of the twentieth century. Novelty songs give us the chance to laugh at ourselves, and at the serious and sometimes pretentious nature of music itself. Mostly funny . . . sometimes silly . . . always entertaining.

Y.M.C.A. **(1978)**
During the height of the disco craze, the Village People had a number of top-charting hits. They dressed as iconic "cultural stereotypes" and appealed to a largely gay audience, though the music was accepted by all disco dancers. This song is a perfect novelty trifecta: a made-to-order group singing an unusual song and even creating a unique dance.

Ringo (1964)

A spoken-word recording done by Lorne Greene, with the only sung lyric being the chorus, which just repeats the title name. It's about a lawman in the West and his encounter with the legendary outlaw Johnny Ringo, told in eight verses. The cover photo connects the song with the TV show *Ponderosa*, which starred Lorne Greene and was a big hit at the time.

Rubber Bands And Bits Of String (1974)

Another actor, another spoken-word song. Narrated by Telly Savalas, this is a series of remembrances, recited over a minor-key melody, about a loved one who has left. Everything he sees, all of the mundane items around the house, remind him of her, but he can't bring himself to throw anything away, even the simple things listed in the title as "Rubber Bands And Bits Of String."

Leader Of The Laundromat (1965)

Released as a direct response to the hit single from 1964 called "Leader Of The Pack" by the Shangri Las, this humorous parody makes fun of a style of song concerning teenage love that ends tragically. In the first song, the protagonist is the head of a motorcycle group, and he dies in a motorcycle accident, while in the second one, she operates a Laundromat and gets killed by a runaway garbage truck as she runs outside with her boyfriend's laundry. Recorded by the fictitious group the Detergents.

Kookie, Kookie (Lend Me Your Comb) (1959)

This novelty song was recorded with Connie Stevens, after Edd Byrnes became famous on the fifties TV show 77 *Sunset Strip*. He portrayed a wise-cracking, slang-filled (and constantly hair-combing) parking lot attendant named Kookie, who assisted the main characters in solving crimes. His appearance and attitude became a national sensation, giving him celebrity status. His photo graces the sheet music cover.

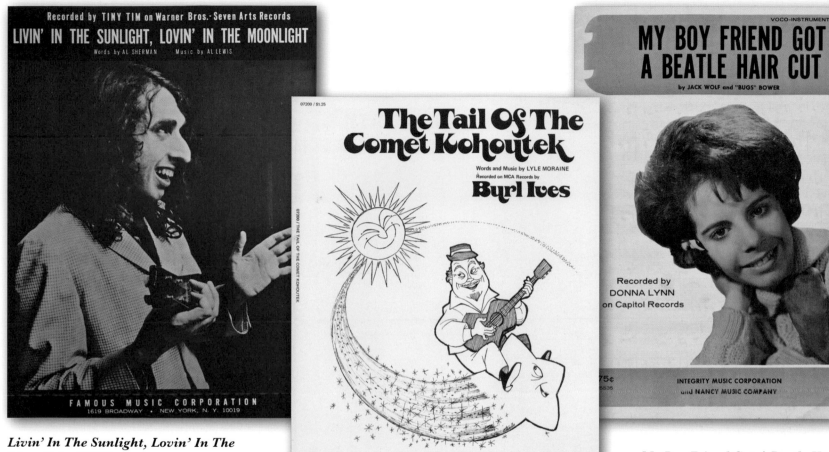

Livin' In The Sunlight, Lovin' In The Moonlight (1930)

Originally written decades earlier, this song was covered in 1968 by Tiny Tim. He became famous for performing songs in a high, falsetto voice with a lot of vibrato while playing the ukulele. His eccentric image and approach gained a lot of exposure through appearances on the TV variety/comedy show *Rowan And Martin's Laugh In*, which ran from 1968 to 1973.

The Tail Of The Comet Kohoutek (1973)

The comet Kohoutek was first discovered in early 1973 and reached its closest point to Earth in December of that year. Originally predicted to be a very spectacular display in the night sky, it never lived up to the expectation, and the name became identified with much-hyped flops. Burl Ives, a traditional folk singer since the thirties, recorded this song and is featured on the cover illustration, riding on the comet itself.

My Boy Friend Got A Beatle Hair Cut (1964)

One of the most identifiable features of the early Beatles was their mop-top haircuts. Donna Lynn, pictured on the cover, recorded this song in which she bemoans the fact that her boyfriend gets a similar look, and now all the girls are attracted to him. This sheet is unusual in that it contains not only a standard piano/vocal arrangement, but also ones for guitar, organ, accordion, and B♭ instruments. It follows in true publisher tradition of trying to appeal to as large an audience as possible.

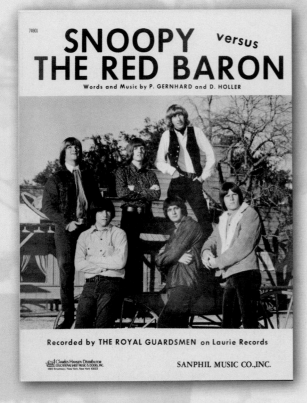

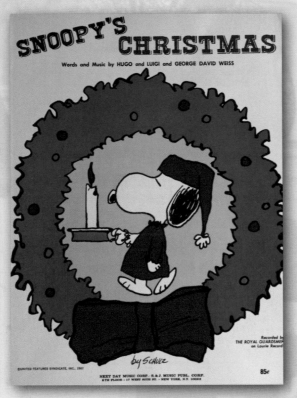

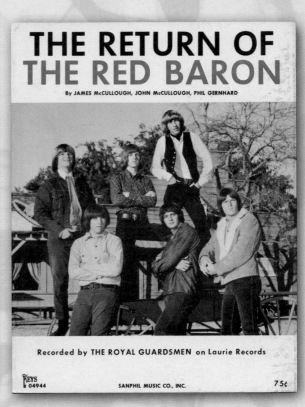

Snoopy Versus The Red Baron (1966)
Snoopy was the pet beagle of Charlie Brown, a character in the Charles Schultz--illustrated cartoon strip called *Peanuts*. The Royal Guardsmen were a group from Florida whose claim to fame rested on this series of songs about Snoopy. This is the first, and it reached No. 2 on the *Billboard* Top 100 Chart. It describes a World War I encounter between Snoopy as a fighter pilot and the famous German flying ace, in which Snoopy shoots him down (but not fatally).

Snoopy's Christmas (1967)
The holiday message contained in the lyrics was an obvious seasonal follow-up to the two previously released songs. Being released in time for the next Christmas season, it continued the World War I theme between the two main characters. This time the Red Baron gets the better of Snoopy and forces him to land behind the German lines, only to wish him a Merry Christmas and salute him with a holiday toast. The cover is illustrated by Charles Schultz himself.

Return Of The Red Baron (1967)
In this second "installment" of the Snoopy saga, Snoopy chases after the Red Baron again and finds him trying to repair his plane. Snoopy lands and tries to engage in a pistol duel, only to have the Baron shoot at him, miss, and then run away. The action is left unresolved, but a warning is given to both in the chorus, with the idea that they will meet again. Photo of the Royal Guardsmen is the same as from the first song, only with a yellow tint.

I'm Hip (1974)

Dave Frishberg was not only a good jazz pianist but also had a great flair for writing humorous and witty lyrics. The wonderful illustration by Brooke on the cover conveys the idea of perception versus reality that the lyrics of "I'm Hip" imply. Other songs by Frishberg include "My Attorney Bernie," "Peel Me A Grape," and the 1969 bossa nova--styled song "Van Lingle Mungo," which was made up entirely of the names of major league baseball players.

Ballad Of Woodsy Owl (1971)

As part of an environmental campaign, the character of Woodsy Owl was introduced to the public in September 1971. Representing the US Forest Service, his original motto was "Give a hoot! Don't pollute." The effort was aimed primarily at children, with the hope they would start Earth-friendly habits that would continue as they grew older. This sheet is inscribed "Thanks for giving a hoot!" and signed "Woodsy."

Santa Claus Is Watching You (1962)

Ray Stevens could rightfully be considered the king of novelty songwriters during these fifty years. Since the late fifties, he has released more than ninety singles from over forty albums, many of which are humorous or just plain silly. Other hits include "Ahab The Arab" (1961), "Gitarzan" (1968), "The Streak" (1973), "Shriner's Convention" (1980), "Would Jesus Wear A Rolex" (1986), "I Saw Elvis In A UFO" (1988), "Too Drunk To Fish" (1997), "Osama—Yo' Mama" (2002), "The Global Warming Song" (2010), and "The Skies Just Ain't Friendly Anymore" (2011). His biggest non-novelty song hit was "Everything Is Beautiful" (1970).

Santa's Using Zebras Now (1968)

According to the lyrics, the reason Santa switched to zebras was that the reindeer did not like taking the sleigh through the heat of Africa and the Tropics. They stayed in the North while Santa delivered presents to the children who lived in the hot climates using the animals more suited to it.

Grandma Got Run Over By A Reindeer (1979)

Recorded by the duo of Elmo & Patsy, this song initially got off to a slow start in the San Francisco area. In a few years, more stations began playing it during the holidays, and it eventually became a national hit. With a companion video, this has become a modern Christmas standard. (?) Not quite in the same league as "White Christmas" though.

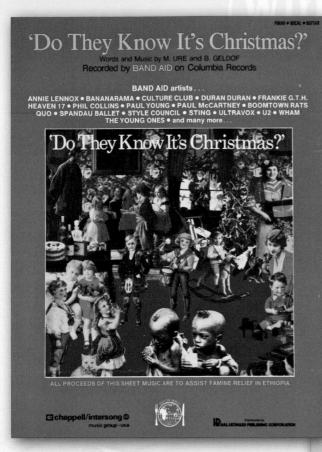

Do They Know It's Christmas (1984)
The eighties and nineties were a time when many charity supergroups were formed to provide help for various social causes. Band Aid was an all-star collaboration of numerous British and Irish bands and solo musicians brought together by Bob Geldof. The focus of this project was to record a song to aid Ethiopian famine victims, and even the sheet music contributed, with the notation at the bottom reading, "All proceeds of this sheet music are to assist famine relief in Ethiopia." The following year, Bob Geldof staged a huge worldwide concert event called Live Aid for the same cause.

Santa Caught A Cold On Christmas Eve (1963)
The silly photo on the cover says it all. The lyrics are interspersed with the sounds of sneezing, as a sick Santa works his way around the world delivering presents while everyone worries about him (including the reindeer).

I Saw Mommy Do The Mambo (With You Know Who) (1954)
I have to believe that this song is directly related to the popular Christmas song "I Saw Mommy Kissing Santa Claus," which was released, and hit the top of the charts, two years earlier in 1952. In this clever retelling of the story, the young boy finds his mother and Santa dancing the mambo, one of the new (at the time) dance fads that had been introduced to the United States by Perez Prado in the late forties and early fifties. It was a highly sensual Latin dance and helped spark interest in other types of Latin music, especially during the fifties. Uncredited but fun-looking cover. Hopefully, that was all he caught them doing . . .

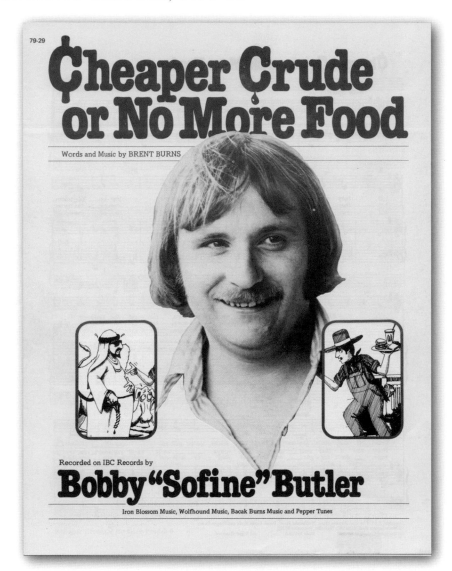

Get That Gasoline Blues (1973)

The band NRBQ (New Rhythm and Blues Quartet) has been around for over forty years, yet the only time they hit the *Billboard* chart was with this novelty song in 1974. During the first OPEC oil embargo crisis, which started in September 1973, gas shortages were common as the price of crude oil sky rocketed (from $3 per barrel to $12). This became an obvious topic for songs.

Cheaper Crude Or No More Food (1979)

The second oil/energy crisis in 1979 was more of the same. The Iranian Revolution decreased the output of oil slightly, but of course everyone in the world got into a panic, so the cost of gas jumped again. The sentiment of this song (shown to perfection in the two drawings on the cover) was a valid point with many Americans. Why not sing a song about it? Bobby "Sofine" Butler did exactly that in 1979.

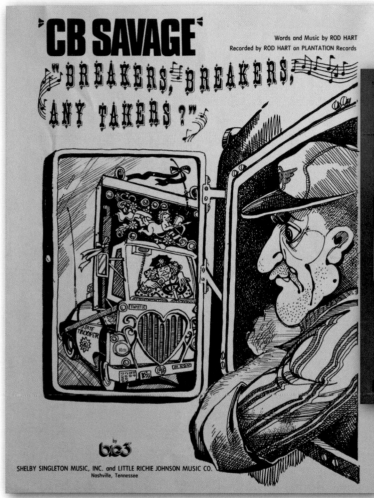

CB Savage (1976)
The CB radio craze got into full swing during the mid-seventies. Truckers in particular used them to alert each other about speed traps (enforcing the new national 55 miles per hour speed limits put in place after the 1973 oil crisis) and to organize convoys and blockades in protest. The song is a recitation over a musical background about cops trying to catch these renegade truckers. Detailed illustration on the music cover shows a trucker looking in his side mirror at a police car poorly camouflaged as a female trucker.

Hey Shirley (This Is Squirrelly) (1976)
Originally billed as the Nutty Squirrels as far back as 1959, this novelty recording act (sounding like Alvin and the Chipmunks) had a number of albums and singles from 1959 to 1964. They hit the charts again in 1976, as Shirley and Squirrelly, with this CB-inspired song, but quickly faded from public notice.

Big Bertha, The Truck Driving Queen (1972)
Songs about trucks and truckers have always been a big part of country music. Here we have a song about an unusual female driver, Big Bertha, recorded by Bud Brewer. By the end of the song, there is enough ambiguity in the lyrics to indicate that Big Bertha might be more than she (he?) appears. "Queen" indeed. The sheet music cover shows Bud posing next to two views of a parked International semi.

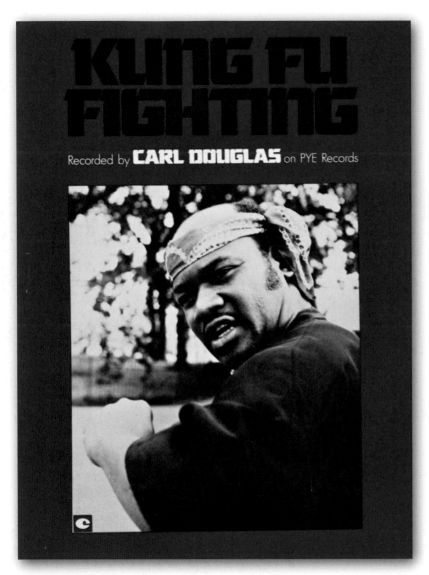

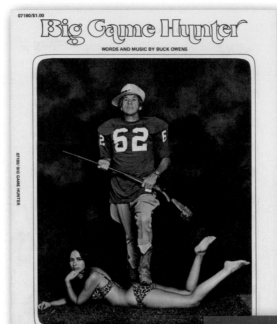

Big Game Hunter (1973)

Standing in the classic pose of the "Great White Hunter" on safari in Africa, Buck Owens uses this title as a clever play on words. The clue is the football jersey he's wearing. The lyrics tell us that his life is centered around catching all the classic college and pro football games, ignoring everything else, including his wife and any suggestions she makes about projects to do around the house. For sure, a non-PC cover.

Another Puff (1972)

As the song begins and the music plays, we can hear someone coughing. Then comes a long recitation about a man considering quitting smoking. He knows it's bad for him, but he always reverts to having "another puff" before he stops. Throughout the spoken part, he often stops and coughs. Written and performed by Jerry Reed.

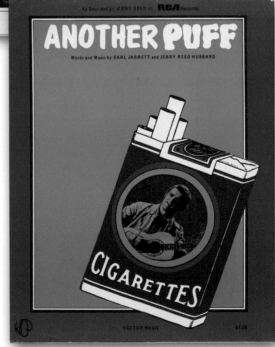

Kung Fu Fighting (1974)

Written and performed by Carl Douglas, this early disco-styled song took advantage of the growing interest in martial art movies at the time. It didn't take off initially, but it kept getting played in dance clubs and gradually worked its way onto the charts, hitting No. 1 in the US and around the world. The record sold in huge numbers, but Douglas was truly a one-hit wonder with this song.

Don't Eat The Yellow Snow (1974)
Almost anything recorded by Frank Zappa
could be considered a novelty song (and I
don't mean that in a bad way). He was a
genius when it came to off-the-wall musical
ideas and concepts, and he carried them off
very well, surrounding himself with top-notch
musicians. His songwriting and guitar playing
were exceptional; it's just that he scorned the
popular musical establishment and refused to
be "normal." He had only three songs that
ever charted on *Billboard:* "Don't Eat The Yel-
low Snow," "Dancin' Fool," and "Valley Girl"
(with his daughter Moon Unit).

This song is from one of his landmark
albums, *Apostrophe*. Zappa took parts of
three songs ("Don't Eat The Yellow Snow,"
"Nanook Rubs It," and "St. Alfonzo's
Pancake Breakfast") and put together an
edited version to be released as a single. It
relates the story of a man, dreaming that
he is an Eskimo named Nanook, who has a
confrontation with a commercial fur trapper.
In response to having a baby seal clubbed
(Nanook's favorite), he rubs "yellow snow"
into the fur trapper's eyes, blinding him.

Hearing the song is much better than
reading a description. The playing is intense
and the words come at you quickly. Different
time signatures pop in (sometimes only for a
measure or two), and the change of accom-
panying instrumentation is nothing short of
spectacular. There's a fine-tuned sense of
humor inherent in this and most of Frank
Zappa's works, and it comes through in the
music. Photo of Zappa on the sheet music.

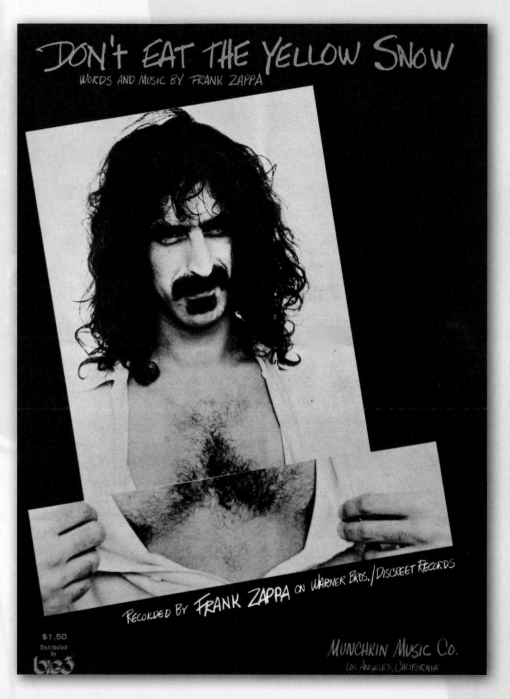

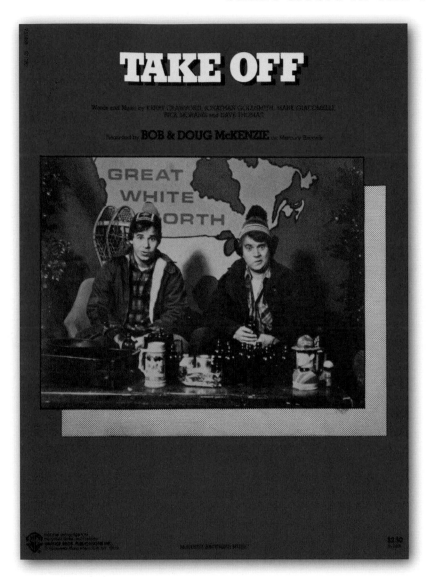

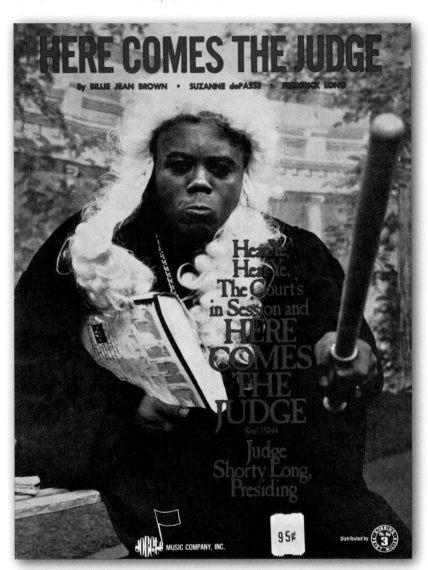

Take Off (1981)

One of the featured skits on the late seventies/early eighties Canadian comedy show SCTV was the constantly beer-drinking pair of Bob and Doug McKenzie, played by Rick Moranis and Dave Thomas. "Take Off" made fun of the speech and habits of those living in the Great White North, and the single hit No. 16 on *Billboard*, with the vocals in the chorus sung by Geddy Lee from the Canadian band Rush.

Here Comes The Judge (1968)

Another song inspired by a comedy show sketch. This was based on a recurring sketch from *Rowan And Martin's Laugh-In* where Flip Wilson would introduce a courtroom scene using the words "Here come de judge." The judge, named Shorty Long, was played by a number of actors, most successfully Sammy Davis Jr., who took over the role with enthusiasm.

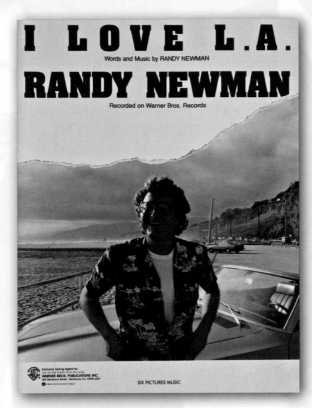

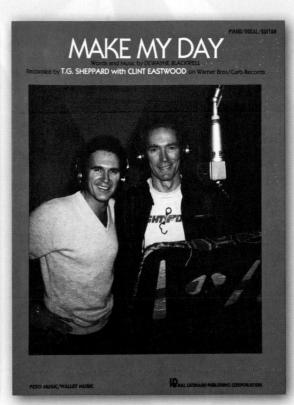

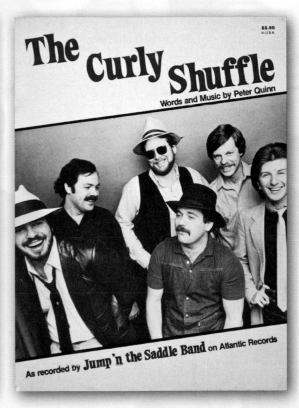

I Love L.A. (1983)

A song about a place can easily become identified as a novelty song, especially in this case, where the accompanying video creates a humorous and distinctive atmosphere. Although somewhat satirical in its message (as is typical of other Randy Newman songs), most times this is used and sung at face value. I guess for people in L.A., "They love it." A smiling Randy Newman on the cover seems to love it as well.

Make My Day (1984)

Country music star T. G. Sheppard used the popularity of Clint Eastwood's famous line "Go ahead, make my day" from the 1983 Dirty Harry movie *Sudden Impact* to write a song that featured those words. He sings four verses describing potential crimes about to be committed, and then at the last moment we hear Clint Eastwood quietly speaking that phrase. The cover shows both Sheppard and Eastwood in the recording studio.

The Curly Shuffle (1983)

A true novelty song from a real Chicago-based country pop group called Jump 'n the Saddle Band. Written by their lead singer as a tribute to the humor of the Three Stooges; he imitated and used many of the catchphrases of the character Curly in this up-tempo song. Although the band had a national hit with this song, they never again had any radio success. Novelty songs can be dangerous as well for a serious band.

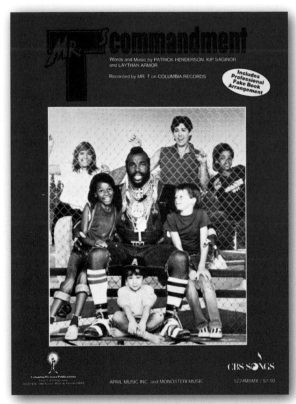

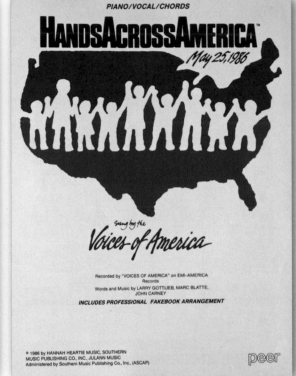

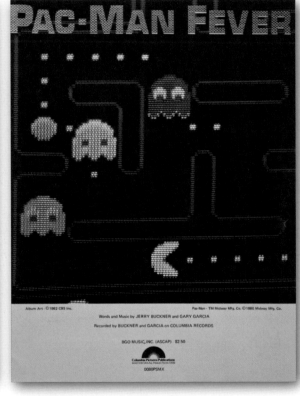

Mr. T's Commandment (1984)

A serious song with a meaningful message, performed by an unlikely source—the actor known as Mr. T. He released an entire spoken-word/rap EP in 1984 aimed at children, giving them positive messages and helpful instructions on living a good life. This particular sheet is concerned with respecting and honoring your parents, and trusting them if you are in trouble. He is pictured on the cover, surrounded by children.

Hands Across America (1986)

This song helped promote a publicity campaign/charity event that happened on May 25, 1986. On that day, over six million people held hands for fifteen minutes in a chain across the United States. Donations were taken, and the proceeds were given to different local charities to help fight hunger and provide shelter for those in need. The song was played that day at 3 p.m. Eastern time on radio stations throughout the country.

Pac-Man Fever (1981)

A tribute to a popular arcade game. Before the advent of home video games, people had to go out to video arcades to play the most "cutting edge" games. Pac-Man, released in 1980, has become the most famous of all. Other titles at the time were Space Invaders, Asteroids, Donkey Kong, Centipede, and of course Ms. Pac-Man. Sound effects from the actual game were used in the song.

Glenn Said "Hello" Instead Of "Good-bye" (1962)

Privately published song that goes on for a total of twenty-six verses about the accomplishment of John Glenn on February 20, 1962, when he became the first American to orbit the Earth. We take space travel for granted these days, but he was on the cutting edge of exploration at the time, with everyone holding their breath until he made it back.

Flying For Me (1986)

On the cold morning of January 28, 1986, the Space Shuttle *Challenger* broke up seventy-three seconds after liftoff because of a failure in one of its "O-rings." All seven members of the crew lost their lives, including Christa McAuliffe, a teacher. John Denver wrote and recorded this tribute to them, all pictured on the sheet music cover.

Tweet And Toot (1953)
Mel Blanc was the talented genius behind most of the character voices from the Looney Tunes and Merrie Melodies shorts during the golden age of Warner Bros. animated cartoons. This novelty song picks up on his ability to create funny sounds and unusual voices. Signed photo of Blanc on the music cover.

The Tra La La Song (One Banana, Two Banana) (1978)
This was the theme song to *The Banana Splits Adventure Hour*, a Saturday-morning children's TV show featuring both live-action characters, in costume, and some animated segments. It ran from 1968 to 1970, with a total of thirty-eight episodes. The main characters were named Fleegle, Bingo, Drooper, and Snorky, and they acted as the hosts and band.

Witch Doctor (1958)

A man asks for advice on love from a witch doctor, who gives him some nonsense words in reply. While Alvin is shown on the cover and the Chipmunks are credited with the recording, that is not quite correct. The original song was done with just Alvin's voice, but later versions brought in the others. The novel use of speeding up the tape to create the high-pitched voices of the Chipmunks started with this song.

Do The Bartman (1990)

Despite no official confirmation, it was strongly rumored that this song was actually written by Michael Jackson, who was a fan of *The Simpsons*. An animated video was released along with it, and the character of Bart firmly established his rebel personality in the minds of the viewing public. Matt Groening drawing on the cover.

Who's Your Baby (1970)

The Archies were another band from an animated series, based on the original cartoon strip and comic book characters of Archie, Reggie, Jughead, Betty, and Veronica, along with their mascot Hot Dog. They took time off from their usual high school antics to put a group together, and scored a *Billboard* No. 1 hit with the song "Sugar, Sugar." Other songs were "Jingle Jangle" and "This Is Love."

Rubber Biscuit (1956)
Originally recorded and released in 1956 by the doo-wop group the Chips, who had a short-lived success with it and toured briefly. They were never able to follow it up, and ended up disbanding by late 1957. The lyrics were primarily nonsense syllables, broken up with some spoken one-liners about eating choices when you can't afford much. Recorded again in 1979 by the Blues Brothers; their version sounded very similar to the original. The cover shows Jake and Elwood (John Belushi and Dan Aykroyd).

Cool Yule (1953)
Written by the talented composer and comedian Steve Allen, this nicely swinging number (the tempo marking on the music is given as "with a driving boogie beat") was recorded by Louis Armstrong on Decca Records in 1953. Superbly funny cover with large head shots of Armstrong and Allen over smaller, drawn bodies. In true jazz musician fashion, they look out and greet us with slang holiday messages.

The sheer variety of music that can be regarded as novelty songs is astounding. The humor in these songs runs the gamut from sly puns to funny situations to outrageous craziness. The fads represented might have only lasted a short time or stayed around for an extended period. The performers might have had long careers or been one-hit wonders. We see events that occurred, both positive and tragic. It is all there, and this sheet music helps us remember (if we were around) or remind us (if we weren't) that music is part of life, and that life is not the same without music.

Earache My Eye (1974)

Truly a complete throwback to the seventies. The comedy duo of Cheech & Chong got their start in 1971 with a brand of humor based on drug references (especially marijuana) and the whole counterculture movement of the late sixties.

One of their best-known comedy songs was "Earache My Eye," where a kid dreams about being a rock star, only to be woken up by his dad, who tries to get him to go to school. When the reluctant kid complains about an earache as an excuse not to go, his father then uses the title phrase. The character Alice Bowie, seen on the cover, is a parody of the outlandish tendencies of performers of the time like Alice Cooper and David Bowie.

This song was often played on the Dr. Demento radio program, which featured odd and unusual songs and comedy. Seems like an obvious choice.

POSTLUDE

The first decade or so of the twenty-first century has not been promising for the future of sheet music. For many reasons, publishers have drastically reduced the production of printed sheets of all types. Compared with even fifteen years ago (1999), the volume and sales of sheet music is sadly diminished. Also long gone are the imaginative and eye-catching covers of the past. When sheet music is published at all, we are presented with mundane or even generic covers. With ever-decreasing margins, the bottom line dictates that publishers need to simplify by reducing costs and cutting inventory. Every year, fewer titles are released.

Published themes for TV programs, once abundant, have almost dried up completely. Songs and themes from movies have slowed to a trickle in sheet music. Only the biggest chart hits are printed. Digital sheet music can now be downloaded from publisher and dealer websites, making access for customers easier and quicker. There's less reason to print and stock music. For the price of convenience, we are losing the future of sheet music.

The music industry itself has changed. On the one hand, we seem to be lacking the great songwriting talents of the past. Gone are the "song mills" of Tin Pan Alley; the individual geniuses of a George Gershwin, Irving Berlin, Cole Porter, or Richard Rodgers; and places like the publishing and songwriting hub centered around the Brill Building in New York during the late fifties and sixties, which itself was a throwback to or reincarnation of the music business as it was during the Tin Pan Alley days. We have no one of the caliber of the Beatles, who grabbed music as it was and collectively changed the course of songwriting and recording.

On the other hand, it's a different world now, with a different style. People sit at home and make their own music demos with the aid of computers and software. Music production is not quite the same, and has become too formulaic. For the most part, the craft of songwriting is down to individual musicians, working somewhat independently, that pop onto the charts, have some successes, and then fade away. A constant cycle of good, but not great, material does not make for a lasting legacy, or the creation of a new group of standards that people would want to play using sheet music.

In general, music touches all our lives. We are surrounded by it, whether by choice or not, from TV, radio, the Internet, or our own portable music devices. In the best of cases, music transports us away from our everyday existence and brings us enjoyment and refuge, if only for a while. Great music has that special power. It always has and hopefully always will.

All of this makes the sheets of the past that much more important. Saving, cataloging, and displaying the titles we have is the least we can do. Because if we lose these, we lose the past and a part of ourselves forever. The visions of music as seen in all of these past sheet music covers reflect this fact, and display for us the shifting face of our music history. These are ephemeral fragments of the past—musical artifacts—transcribed and presented to us on pieces of paper. Hidden treasures just waiting to be discovered. Music archaeology in a piano bench.

With
UKULELE
Arrangement

Words by
JACK YELLEN

BIBLIOGRAPHY/SOURCES

Brown, Charles. *The Art of Rock and Roll*. Englewood Cliffs, NJ: Prentice Hall, Inc., 1987.

Campbell, Michael. *And the Beat Goes On*. New York, NY: Schirmer Books, 1996.

Carallo, Valerie. *Collecting Rock 'n' Roll Sheet Music of the 1960s*. Atglen, PA: Schiffer Publishing, 2006.

Ewen, David. *Panorama of American Popular Music*. Englewood Cliffs, NJ: Prentice Hall, Inc., 1959.

Green, Stanley. *Broadway Musicals: Show by Show*. Milwaukee, WI: Hal Leonard Corp., 1996.

Green, Stanley. *Hollywood Musicals: Show by Show*. Milwaukee, WI: Hal Leonard Corp., 1990.

Short, Marion. *Collectible Sheet Music—Hollywood Movie Songs*. Atglen, PA: Schiffer Publishing, 1999.

Short, Marion. *Covers of Gold: Collectible Sheet Music—Sports, Fashion, Illustration and Dance*. Atglen, PA: Schiffer Publishing, 1998.

Short, Marion. *From Footlights to "The Flickers": Collectible Sheet Music—Broadway Shows and Silent Movies*. Atglen, PA: Schiffer Publishing, 1998.

Short, Marion. *The Gold in Your Piano Bench: Collectible Sheet Music—Tearjerkers, Black Songs, Rags and Blues*. Atglen, PA: Schiffer Publishing, 1997.

Short, Marion. *More Gold in Your Piano Bench: Collectible Sheet Music—Inventions, Wars and Disasters*. Atglen, PA: Schiffer Publishing, 1997.

Stein, Charles. *American Vaudeville*. New York, NY: Da Capo Press, 1984.

Wenzel, Lynn and Binkowski, Carol. *I Hear America Singing*. New York, NY: Crown Publishers, Inc., 1989.

Whitburn, Joel. *A Century of Pop Music*. Menomonee Falls, WI: Record Research, Inc., 1999.

There was a great wealth of knowledge available to me in the introductions to the multiple volumes of the Decade series, and also the Great Songs of series by Milton Okun, all published by Hal Leonard.

Some information was selectively chosen from the following online sources:

IMDB.com (Internet Movie Database)

IBDB.com (Internet Broadway Database)

Wikipedia.org (online encyclopedia)